W9-ATB-030

MICHELANGELO

To Mother
Christmas 1996
Love
Gail

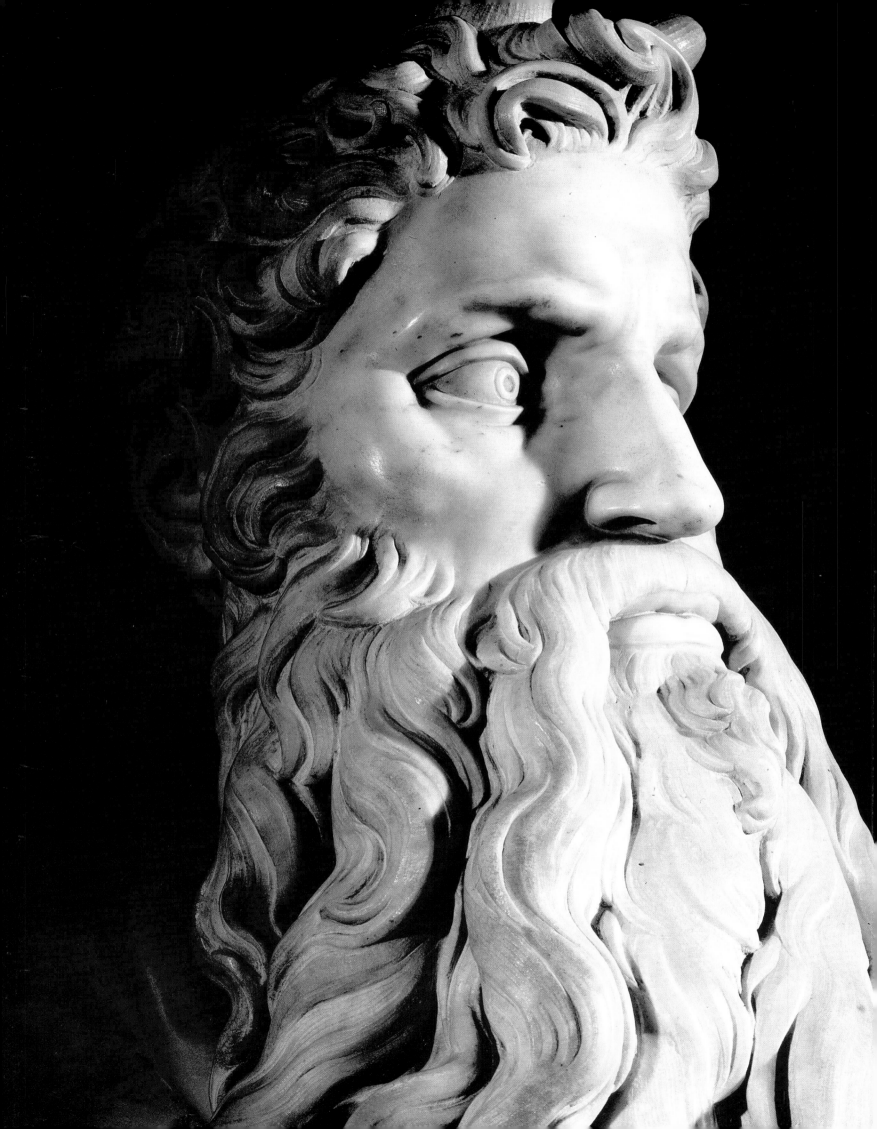

MICHELANGELO

SCULPTOR
PAINTER
ARCHITECT

CHARLES SALA

TERRAIL

COVER ILLUSTRATION (FRONT)

MICHELANGELO

Dawn

Around 1524-1534. Unfinished marble.
Length 3.03 m. (10 ft.).
Tomb of Lorenzo de' Medici, San Lorenzo, Florence.

COVER ILLUSTRATION (BACK)

MICHELANGELO

God Creating the Sun and the Moon

1511. Middle section of the Sistine Chapel ceiling before restoration.
170 x 260 cm. (5 $^1/_2$ x 8 $^1/_2$ ft.). Vatican.

PREVIOUS PAGE

MICHELANGELO

Moses

Detail. 1513-1516. Marble. Height 235 cm (8 ft.).
Tomb of Julius II. San Pietro in Vincoli, Rome.

OPPOSITE

MICHELANGELO

Sketch for the fortification of Florence

Around 1528-1529. Pen and ink, wash, with traces of red chalk.
41 x 57 cm. (16 x 22 in.). Casa Buonarotti, Florence.

FOLLOWING PAGE

MICHELANGELO

The Prophet Isaiah

1509. Fresco. Sistine Chapel ceiling before restoration.
Height 380 cm. (12 $^1/_2$ ft.). Vatican.

Editors: Jean-Claude Dubost and Jean-François Gonthier
Art director: Marthe Lauffray
English adaptation: Jean-Marie Clarke
Editing: Aude Simon and Malina Stachurska
Composition: Graffic, Paris
Filmsetting: Compo Rive Gauche, Paris
Lithography: Litho Service T. Zamboni, Verona

English edition, copyright © 1996
World copyright © 1995
by
FINEST S.A./EDITIONS PIERRE TERRAIL, PARIS
A subsidiary of the Book Department
of Bayard Presse S.A.
ISBN: 2-87939-069-9
Printed in Italy

All rights reserved. No part of this publication may be reproduced or transmitted
in any form or by any means, electronic or mechanical, including photocopying,
recording or by any information storage and retrieval system,
without permission in writing from the publishers.

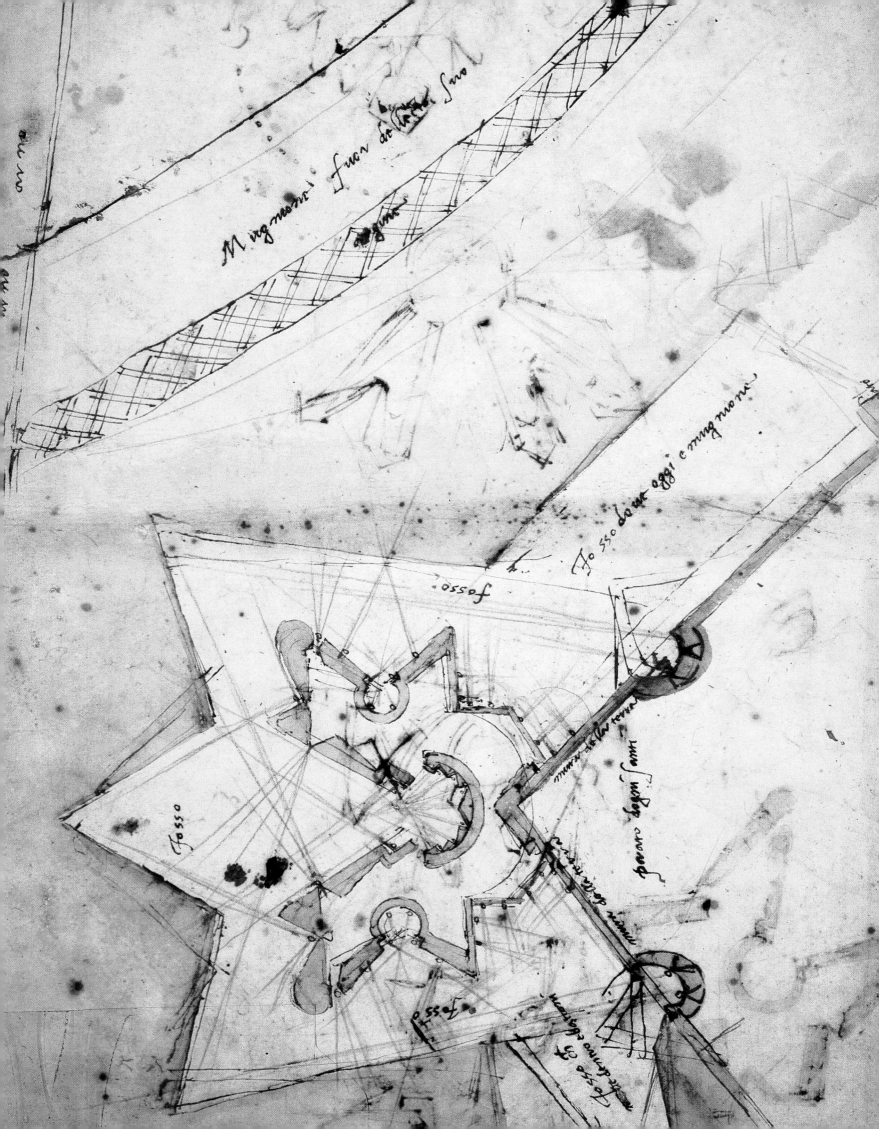

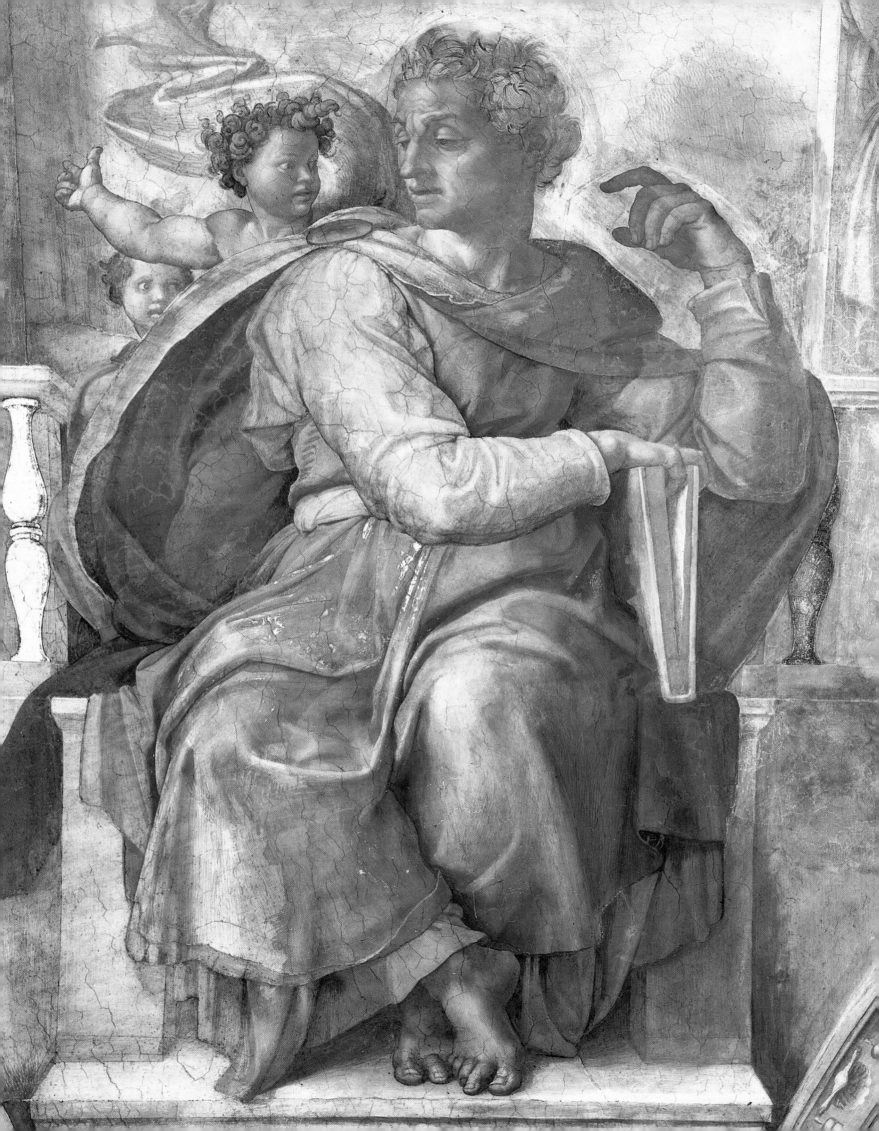

TABLE OF CONTENTS

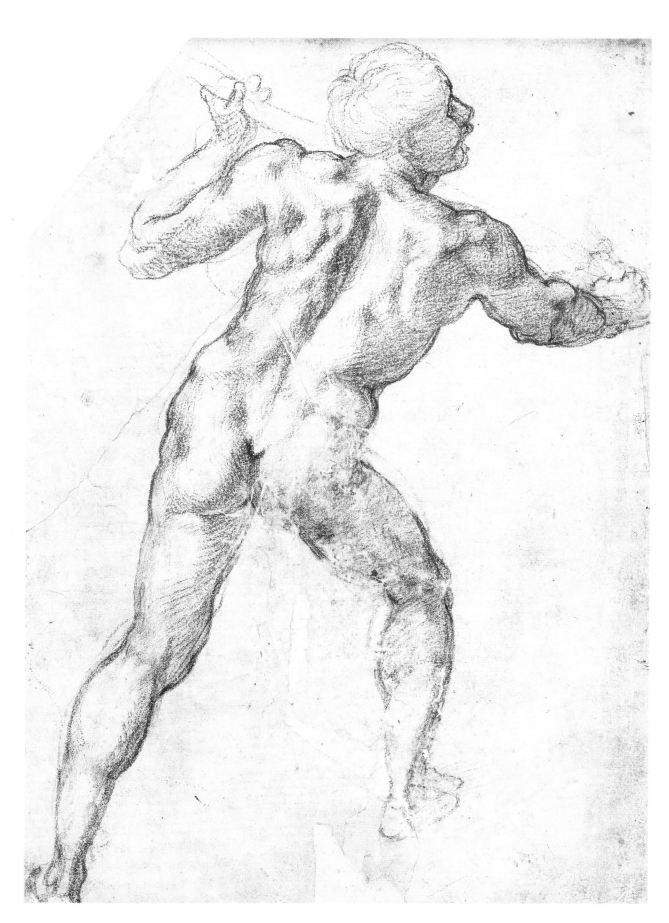

MICHELANGELO

**Study for
the *Battle of
Cascina***

Around 1504.
Black pencil.
28.2 x 20.3 cm.
(11 x 8 in.).
Department
of Drawings,
Louvre Museum,
Paris.

INTRODUCTION

In late October 1512, Michelangelo Buonarotti climbed down for the last time from the scaffolding on which he had spent three years of his life painting the Sistine Chapel ceiling. His body was broken, his steps unsteady and his sight impaired. Unlike other great Renaissance masters, most of whom worked with the help of many assistants, he had insisted on painting alone – or virtually alone – a fresco covering an area of a thousand square metres with over three hundred figures illustrating the Old Testament Book of Genesis. Twenty years later, he added to this masterwork a monumental fresco on the altar wall of the same Sistine Chapel representing The Last Judgment, a swirling mass of anxious figures surrounding Christ on the Day of Reckoning. The fame of this unprecedented pictorial achievement spread immediately and, although both criticized and admired, it has never been equalled.

However, the author of this ambitious fresco cycle was not a painter but a sculptor. Against his will, Michelangelo had had to submit to the injunction of Pope Julius II, a man of no less an impulsive and authoritarian character than his own. Yet this tension may well have contributed to the greatness of the achievement. Painting, at the beginning of the fifteenth century, was still basically synonymous with the Tuscan school. Its style was based on linear perspective, invented eighty years earlier in Florence, and on rendering the complexities of the human figure, as we can see from the frescoes of the side walls of the Sistine Chapel executed at the end of the Quattrocento by Botticelli, Perugino, Ghirlandaio, and many more. In his monumental work, which often simulated sculpture carved in relief, Michelangelo transgressed aesthetic conventions, upset established expectations and created a radically new iconography. In this, he was quite the opposite of Raphael, whom he considered his rival and who had brought the Quattrocento tradition to its culmination in the Stanze at the Vatican without breaking the rules of either anatomy or Christian decorum.

Not so Michelangelo, who threw prudery to the winds, reshuffled chronology, juggled with space and inflicted poses on bodies that range from a crude eroticism to figures of ecstasy and despair. Using the triumphant human body as his building block, he erected a radically new theological architecture in the Sistine Chapel that left no one indifferent. In his own chosen field of endeavour – sculpture – he had already liberally transgressed the rules established in the previous century; the mute vehemence of the statues decorating the Medici Chapel in San Lorenzo are ample testimony of this.

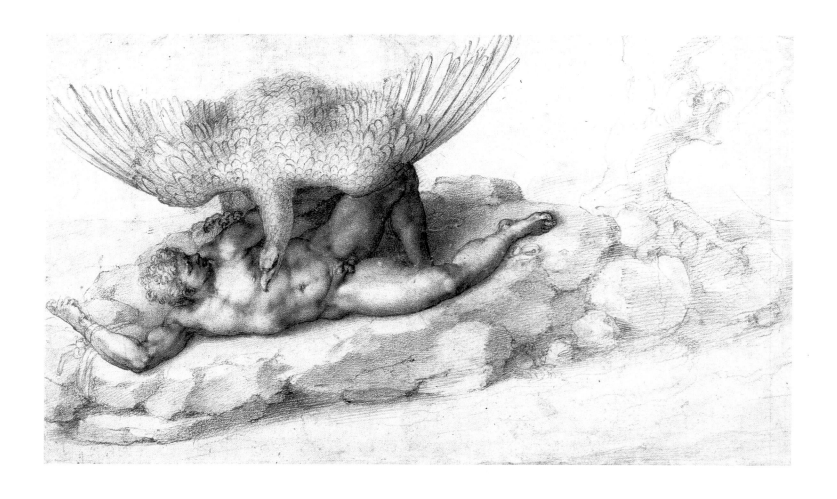

MICHELANGELO

The Punishment of Tytos

1532. Charcoal.
19 x 33 cm. (7 $^1/_2$ x 13 in.).
Reproduced with the kind permission of
Her Majesty Queen Elizabeth II.
Royal Library, Windsor.

No wonder he was called the "divine." Yet it was his fate to live in times of momentous and tragic upheavals, with spiritual values threatening to collapse under the brunt of the conflicts that swept through Europe and Italy. In 1475, at the time of his birth, Christendom was in the throes of its own contradictions and striving to consolidate its ranks. And at the time of his death, eighty-nine years later, Martin Luther's efforts had profoundly and durably undermined the traditional spiritual edifice: in Florence, the preacher and monk Savonarola had been burned at the stake for heresy, while Rome had fallen prey to the ransacking hordes of the Bourbon forces. Michelangelo's work illuminated these dark times with its flaming trajectory. After its passage, the art of the Renaissance, based on the confident humanism of the Quattrocento, had been transformed into a disquieting laboratory for formal experiments of extreme complexity inspired by a pervasive spiritual dismay.

The pessimism that he so admirably expressed in his poems also appears in the figures of Slaves which he sculpted for the tomb of Julius II, a project which would never be completed as planned. These figures, some only barely sketched out, seem to be struggling against dark, irrational forces, as if against the formless matter that opposes its blind inertia to the blows of the chisel. Like the figures on the Sistine Chapel ceiling, they no longer aspire towards redemption, but towards a freedom that transcends the human condition.

Raised in Florence, the cradle of Renaissance architecture, Michelangelo was given the opportunity – much against his will – to prove his worth as an architect and innovator. His design for the interior of the Laurentian Library in Florence, which included the staircase and the reading tables, and for the dome of St. Peter's, which was built posthumously, are among the masterpieces of world architecture.

As sculptor, painter, architect and poet, he continued the tradition of the early Renaissance and pushed it to its extreme. Although working for princes, lords and pontiffs, he turned the traditional status of the artist from that of a craftsman subordinated to the wishes of his patron into that of a creator with the ultimate power to make aesthetic decisions, prepared to risk his career for the sake of individualism and freedom. Art, for him, was not only a display of skill and knowledge, but also a way of giving formal expression to the spirit of his time. Like his poems, it was a form of philosophy. A tireless worker and perfectionist, he anxiously postponed the moment of starting work, and not infrequently left it unfinished. He sought the forms trapped in their marble shells and strove to free them from their material bonds.

Michelangelo's artistic achievements so impressed his contemporaries that, five months after his death in Rome, on 18 February, 1564, a solemn service in his memory was celebrated at the church of San Lorenzo in Florence. It was a grandiose ceremony fit for a king; his bier was decorated with paintings and statues by the leading artists of the city, and a contingent of eighty painters and sculptors stood in attendance. Giorgio Vasari, the painter and first art historian, wrote to the Grand Duke Cosimo I de' Medici: "This morning, 14th July 1564, were held the funeral services of the divine M.A. Buonarotti.... The church of San Lorenzo was brimming with important people, noble ladies and foreigners. It was a marvel to behold...."

Although considered by his contemporaries as the greatest artist since the days of classical Antiquity and admired throughout Europe, Michelangelo once described himself as a "poor, ignoble and mad wretch." One memorable self-portrait shows him in the form of the flayed skin of St. Bartholomew, and in his writings he called himself the most miserable being in all of Creation.

Behind the official image of the famous artist lurks a recluse, a passionate but solitary lover, a miser who nevertheless lavished a fortune on his family, an anxious and impetuous man. In other words, the exact antithesis of that perfect courtier, Raphael. Michelangelo marked the beginnings of the modern artist, the artist who claims total freedom with no compromise.

The Mannerists of the sixteenth century, the Baroque artists of the seventeenth, and Rodin recognized him for what he was and have ensured that his glory will never fade.

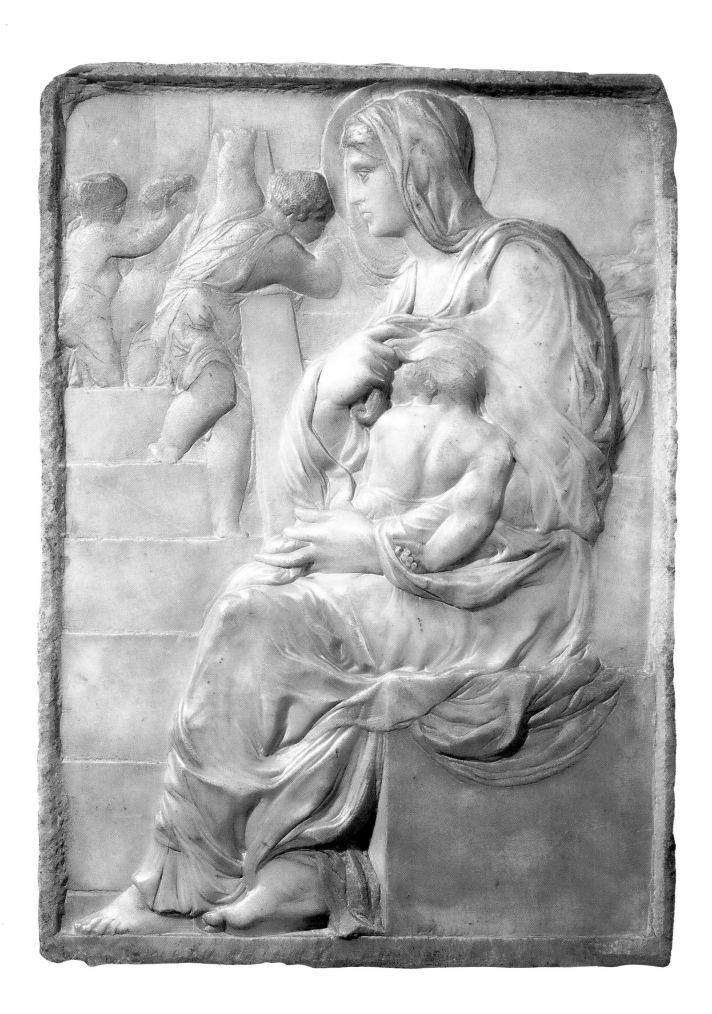

1 UNDER LORENZO'S WING

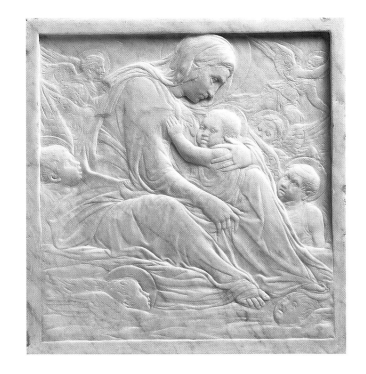

By the beginning of the year 1504, as he was preparing to paint a very important and original work, the *Doni Tondo*, for the wedding of a wealthy Florentine, Agnolo Doni, Michelangelo's career was already well on its way. His name was mentioned in Pomponio Gaurico's book *De Scultura*, which was published in January of that year. As he neared his thirties, he was contemplating works of great scope for his pontifical patrons at the Vatican. Around this time, he was working on two bas-reliefs, both circular, the *Pitti Tondo* and the *Taddei Tondo*, both very important for the understanding of his art.

Yet, several years later, this extraordinary sculptor was forced by the Pope to demonstrate his skill in the field of fresco painting by undertaking the decoration of the Sistine Chapel ceiling. What kind of man was this? Ascanio Condivi, his pupil and biographer, wrote in his *Life of Michelangelo*[1]: "His father was Lodovico di Leonardo Buonarotti Simoni, a good and religious man, who was rather old-fashioned; while he was *podestà* of Chiusi and Caprese in the Casentino, his son was born in the year of our Lord 1475, on 6th March, four hours before daybreak, on a Monday." Michelangelo's father stayed in Caprese, a small town in eastern Tuscany, for only a short time. A few days after the birth, the family

1. Ascanio Condivi, *The Life of Michelangelo*, (first ed. 1553), trans. by Alice Sedgwick Wohl, ed. by Hellmut Wohl, Phaidon, London 1976.

DONATELLO

Virgin and Child

Around 1425-1435.
Marble bas-relief.
33.9 x 32.4 cm. (13 x 12 ¾ in.).
Gift of Don de Quincy Adams Shaw,
The Museum of Fine Arts, Boston.

Opposite

MICHELANGELO

The Madonna of the Stairs

Around 1491-1492. Marble bas-relief.
55.5 x 40 cm. (22 x 16 in.).
Casa Buonarotti, Florence.

MICHELANGELO
Saint Peter
After Masaccio's *Tribute Money.*
1489-1490. Pen and ink with red chalk.
31 x 18.5 cm. (12 x 7 in.).
Graphische Sammlung, Munich.

OPPOSITE
MICHELANGELO
Two Figures
After Giotto. Around 1489-1490.
32 x 19.7 cm.(12 x 7 ³/₄ in.).
Department of Drawings,
Louvre Museum, Paris.

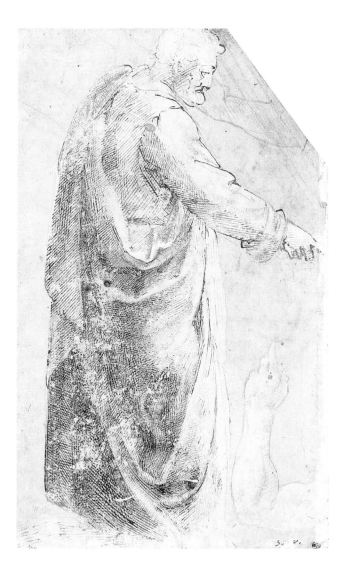

left the region and moved to Florence. The new baby was entrusted to a wet-nurse in Settignano; her husband and father were both stonemasons. Was this the hand of fate, or just an extraordinary coincidence?

Michelangelo was thirteen years old and had already learned the rudiments of grammar when he announced that he wanted to embark on a career as an artist. Brooking his father's objections, he began an apprenticeship in the workshop of the painters Domenico and Daniele Ghirlandaio, both well-established masters in Florence at the time. Although Michelangelo did not acknowledge this apprenticeship in his later years, the training in drawing and the knowledge of the great masterpieces of the past that he received there were decisive in his development. It gave him the dual opportunity to demonstrate his great precocity in the arts and to gain independence from his family. His own artistic tastes tended more toward the monumentality and power of the artists of the previous century than toward the fey melancholy of fashionable painters such as Botticelli and Filippino Lippi. Also around this time, fate struck him a blow of a different kind: Pietro Torigiani, a fellow apprentice, one day reacted to Michelangelo's constant jibes with a punch that left him with a deformed nose for the rest of his life.

Although the teenage Michelangelo had signed a three-year contract with the Ghirlandaio brothers, he left their *bottega* after a year to pursue his overwhelming desire to become a sculptor. This change marked the beginning of the second phase of his art-training, which was to be both deeper and more significant for his future development. His talent as a sculptor eventually became known to Lorenzo the Magnificent, who invited him to lodge in his palace in the Via Larga and treated him like one of his own sons: Condivi writes: "The boy would draw first one thing then another at random, with no fixed place or course of study. One day he was taken by Granacci to the Medici Garden at S. Marco, which Lorenzo the Magnificent, the father of Pope Leo and a man of unique excellence, had adorned with ancient statues. When Michelangelo saw these works and savoured their beauty, he never again went to Domenico's workshop but worked in the garden all day as if it were the best school."

The execution of the works in the garden had been entrusted to Bertoldo di Giovanni, a student of Donatello, and signs of the influence of this pioneer Quattrocento artist

soon appeared in two of Michelangelo's works: *The Madonna of the Stairs* and *The Battle of the Centaurs*. These remarkable early efforts also display the intellectual influence of the humanist circles, which included such illustrious thinkers and theoreticians as Marsilio Ficino, who translated Plato's dialogues and the works of Plotinus into Latin, Angelo Gini, better known as Politian, a poet, author of the *Stanze* and the tutor of Lorenzo de' Medici's son, and Pico della Mirandola, a philosopher and theologian famed for his prodigious memory.

With their formal dynamics and conceptual implications, the two bas-reliefs anticipate much of Michelangelo's future work. They display an uncommon power which gives them a degree of transcendence rarely found in other Florentine sculptures of the day.

In the *Madonna of the Stairs*, a work of fairly small dimensions, we have an example of an extremely low-relief technique inspired by Donatello, a technique that is in fact more graphic and pictorial than sculptural. Michelangelo, however, left Donatello's example behind and struck out on his own, composing the space into a series of three distinct planes. He created a pensive, stoic, almost heroic figure of the Virgin, the prototype of many of his future female figures. The Christ Child, who displays a remarkably muscular back, buries his head in his mother's breast, fusing with her corporeal essence, as if to ward off the spectre of his martyrdom. The dynamic axes of the bodies and draperies follow a balanced *contrapposto* rhythm, or formal counterpoint. All of the tensions seem to be resolved and eased in the region of the throne and stairs, where two *putti*[2] stretch a cloth that may be a prefiguration of the Messiah's shroud.

The postures and gestures transcend their literal function as representation to become signs of a conceptual and spiritual order. Donatello's achievements have been transformed and surpassed in the work of a seventeen-year-old adolescent with scant formal training in sculpture and painting. A first attempt that emphatically proclaimed a very strong artistic personality.

In a work such as the *Battle of the Centaurs*, Michelangelo was faced with an entirely different sculptural problem involving not just the subject-matter but also the

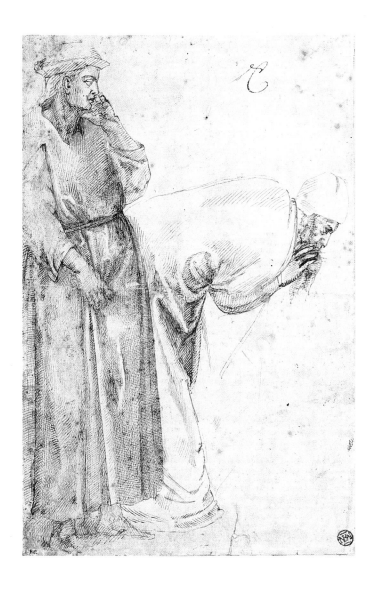

2. The fifteenth century saw the invention of a new type of angel, the *putto* (pl. *putti*). These puffy-cheeked and often wingless children had more of a decorative than a sacred function.

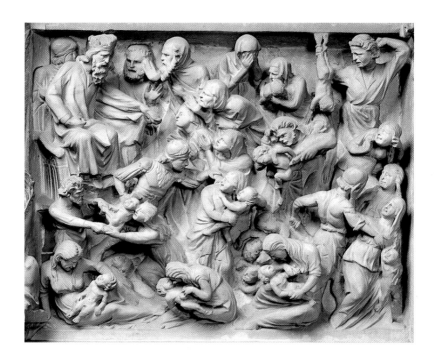

GIOVANNI PISANO
The Massacre of the Innocents
Detail. Around 1302-1311.
Marble bas-relief.
Pulpit of Pisa Cathedral.

OPPOSITE
MICHELANGELO
Battle of the Centaurs
Around 1491-1492.
84.5 x 90.5 cm. (33 x 36 in.).
Casa Buonarotti, Florence.

formal handling of the materials. This bas-relief is horizontal and gives the impression of being part of a larger whole, like one face of a parallelepiped, as in a Roman sarcophagus. This gives the effect of a strangely fragmented perception.

The subject of the scene, the rape of Hippodameia by the centaur Eurytion, or the rape of Deianeira by the centaur Nessus, was probably inspired by Politian. Some scholars believe it depicts an episode of the battle between the Centaurs and the Lapiths. At first glance, the surface seems to be almost entirely filled, composed of an endless series of sinusoidal lines, lines which resolve into a tangle of bodies engaged in a life or death struggle, expressing in their attitudes and muscles the fundamental tensions of life, with its vitality, sensuality and aggression.

There are three different finishes, and so of meaning, in this composition. First there is the flat background, which is coarsely handled with diagonal slashes, the raw marks of the sculptor's chisel, and which indicates the realm of indeterminacy. Then come the figures handled in *mezzo-rilievo*, or shallow relief, just emerging out of formless matter. Finally, there are figures handled almost entirely in the round, all but detached from the ground. The basic progression displayed leads from formlessness to a formal dynamic. Vasari mentions this technique used to excellent effect by the Pisano brothers at the baptistery in Pisa and by Ghiberti for his Gate of Paradise in the Florence baptistery.

16

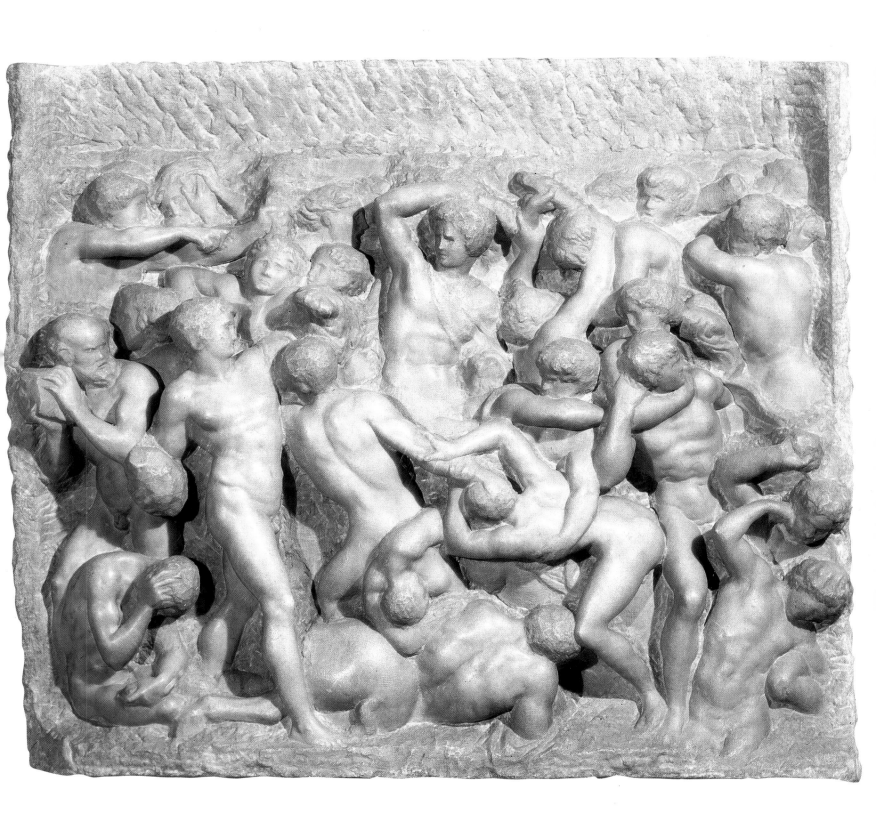

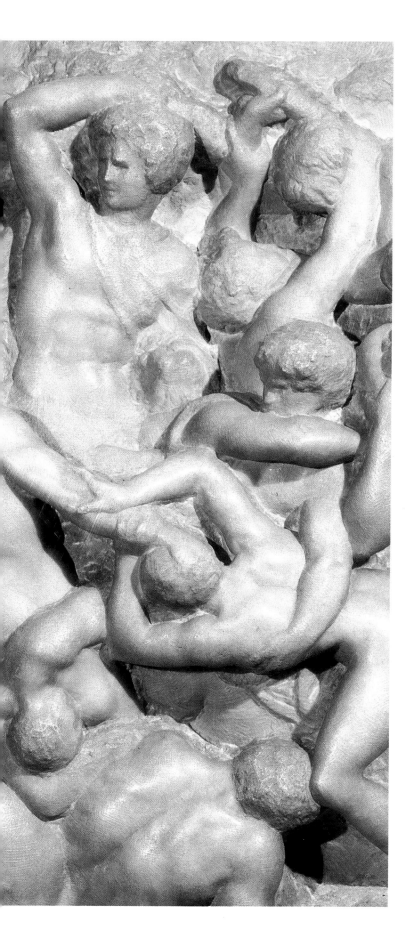

Once more Michelangelo surpassed his predecessors by his personal rendition of technique and subject-matter.

The mythological subject was a pretext, a spark that enabled the artist to give full rein to the creative process which surpasses the initial subject and makes it almost secondary. The result is a powerful field of bodily tensions, charged with a formal potential emanating from the material matrix itself, the source of all creation. It matters little whether we can distinguish the Centaurs from the Lapiths, the male from the female figures, the human from the composite creatures. Michelangelo created a progression starting from raw matter – the starting point of the artistic work – and evolving towards form, to compose an image which is contained entirely in the marble while transcending it. The battle in question concerns not the mythical protagonists, but the artist pitted against the non-significance of the inorganic block of stone. Expressed in these terms, we see the scope of the challenge. And so artistic creation becomes comparable to divine creation, the source of human existence.

Finally, the "unfinished" parts proclaim a wholly new approach and aesthetic, for leaving the forms in an unfinished state was a means of remaining in communion with their potential qualities, those that are often manifest at sunset, at the end of a day or of a life.

With the death of Lorenzo de' Medici in April 1492, a momentous page in the history of Florence was turned. Michelangelo gained his aesthetic freedom, returned to live with his family and worked on more sculpture projects. He perfected his knowledge of human anatomy by performing dissections. Although this was expressly forbidden by the Church, the prior of Santo Spirito, for whom he had carved a wooden crucifix, provided him with the necessary corpses. During this period, too, he may well have attended the galvanizing sermons of the Dominican monk Savonarola, who wanted to establish a theocracy but was burned at the stake in front of the Signoria in 1498. When the Medici family was banished from Florence in 1494, Michelangelo was safely away in Bologna, where he executed some minor works and devoted his time to reading the great writers of the Italian vernacular: Dante, Boccaccio and Petrarch. He was the guest of the nobleman Gianfrancesco Aldovrandi.

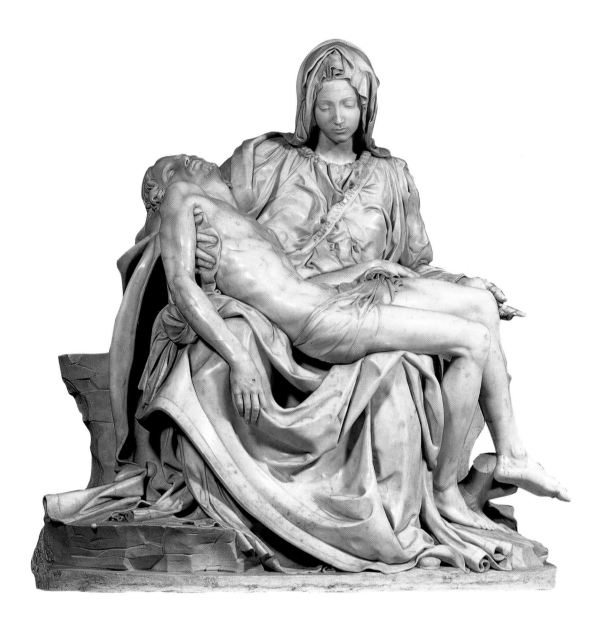

From the end of 1496, and probably until the spring of 1501, the young sculptor lived in Rome and created the undoubted masterpiece of this period: the *Pietà* which can be seen today in St. Peter's. This work, commissioned by the French cardinal Jean Bilhères de Lagraulas, marked a turning point in his already brilliant career. The cardinal, the ambassador of Charles VIII to pope Alexander VI, wanted a *Pietà* for his own funerary chapel in the church of Santa Petronilla near the sacristy of the old St. Peter's. This sculpture group was completed in 1499 and met with immediate acclaim. At the age of twenty-four, Michelangelo found himself at the peak of his fame as an artist. Condivi wrote in this connection: "Through it, he acquired such great fame and reputation that in the opinion of the world he not only far surpassed his contemporaries and those who preceded him but even rivalled the sculptors of Antiquity."

MICHELANGELO
Pietà
Around 1498-1499. Marble.
174 x 195 cm. (5 $^3/_4$ x 6 ft.).
Basilica of St. Peter, Vatican.

OPPOSITE
MICHELANGELO
Battle of the Centaurs
Detail.

19

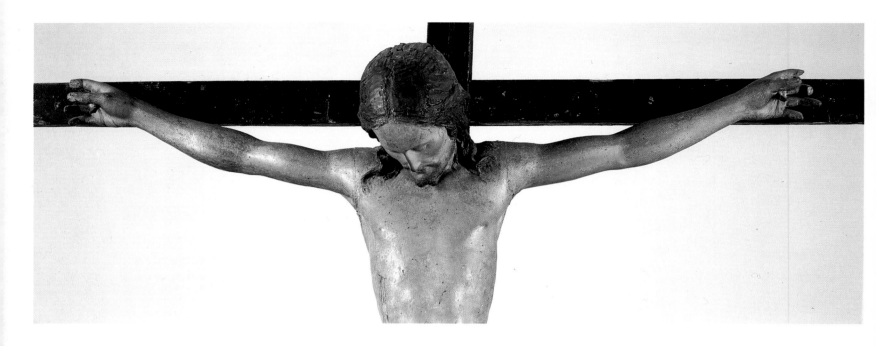

MICHELANGELO

Crucifix

1493. Polychrome wood.
Height 134.5 cm. (4 ¹/₂ ft.).
Casa Buonarotti, Florence.

OPPOSITE AND OVERLEAF

The Vatican Pietà
Details.

During his Roman sojourn Michelangelo changed his orientation and aesthetic approach. He now sought his inspiration in Antique sculpture, although still attracted by the realism and exquisite technique of the great Florentine sculptors of the Quattrocento. His *Pietà*, which combines monumental effect with dynamic formal qualities, has an almost otherworldly perfection. Mary is represented sitting on a throne-like rock which was interpreted by his contemporaries as the base on which the Cross was erected. This is the sculptor's only signed work; on a ribbon running diagonally across the Virgin's breast, we can read the inscription: "*Michael Angelus-Bonarotus-Florent-Faciebat.*"

The subject of this sculpture has a long tradition stretching back to the antique myth of Meleager, later transmitted though the Byzantine and medieval traditions, and more concretely in an iconographic type invented in fifteenth-century Italy. This is not a depiction of the Virgin in majesty; her lowered gaze and the sensual abandon of her attitude seem to indicate melancholic submission to the divine will. The group refers not so much to the historical martyrdom as to the theological idea of the *Mater Dei* and the *Corpus Domini*. Her facial features are strongly reminiscent of the Christ in the wooden *Crucifix* which Michelangelo executed for Santo Spirito in 1493. The head has the same pointed chin, the same classical nose, and the same closed, narrow lips; only the shape of the eyes is different.

The Vatican *Pietà* is a perfect example of the ideal for which Michelangelo was then striving: an extremely close, yet fragile union between two people. The line of

20

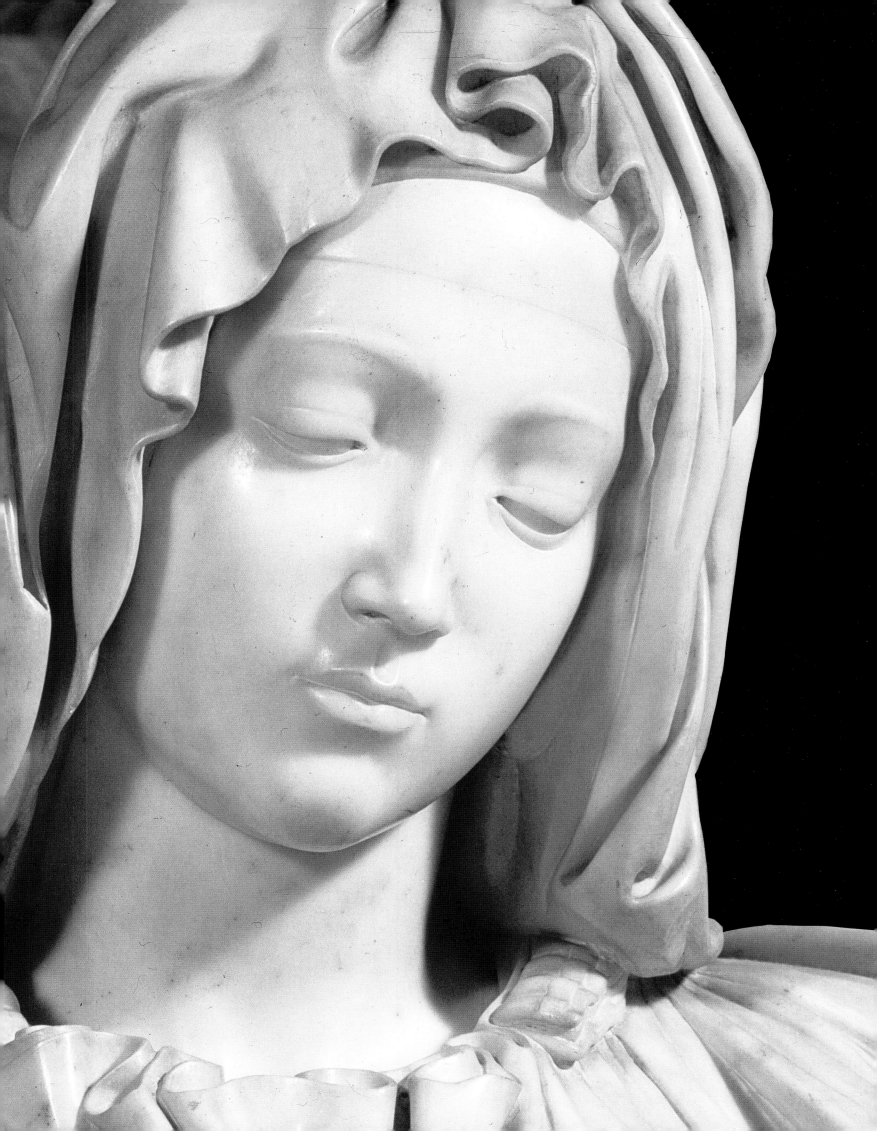

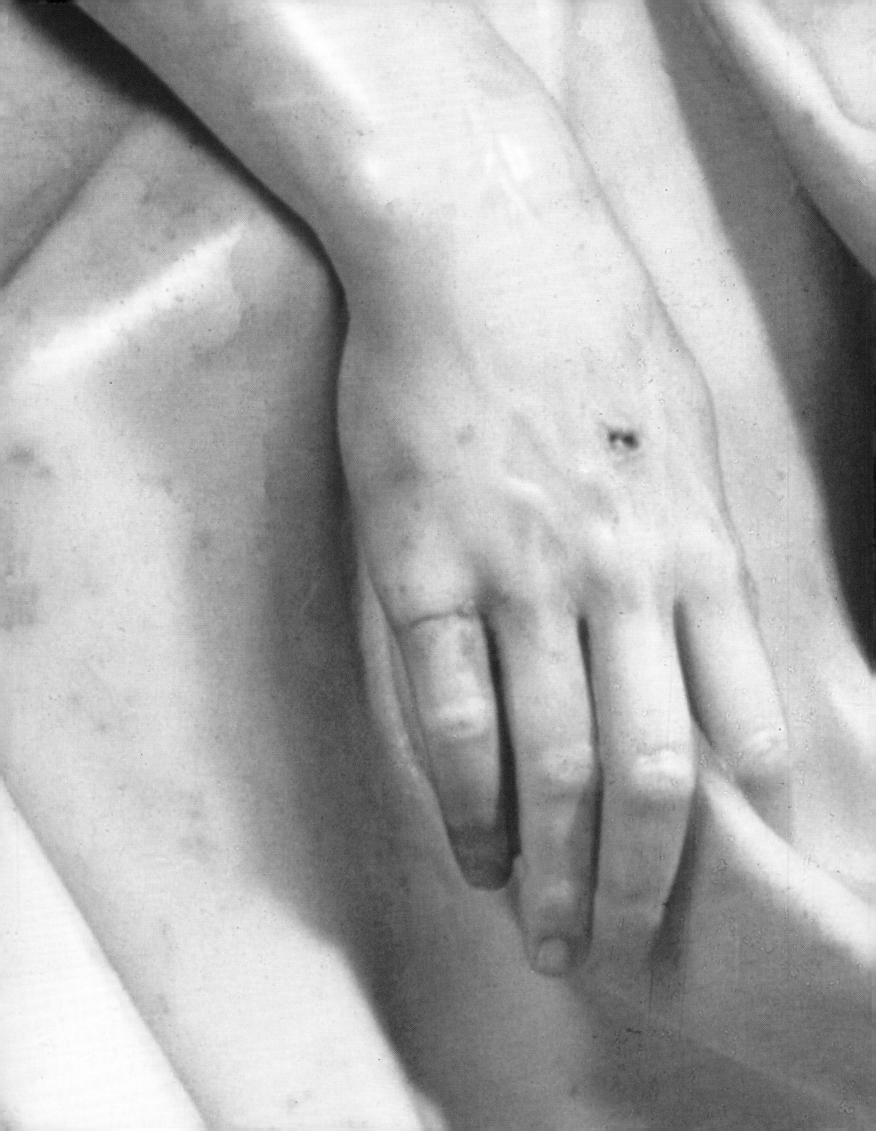

Christ's body, which is articulated into three parts, conforms to his mother's body and flows into the folds of the drapery, giving formal expression to the idea of exemplary compassion. The Virgin is portrayed almost as young as her son, a seeming paradox which Condivi resolved by quoting the sculptor's own words: "Don't you know that women who are chaste remain much younger than those who are not? How much more so a virgin who has never been touched by even the slightest lascivious desire which might alter her body?" This fixation of the figures in an ideal, eternal youth is a fitting demonstration of the *divine concept* which informed the artist's entire work. The surfaces of the marble are perfectly polished, smooth even in the smallest interstices. This group, the first of a series of *Pietàs* that spanned his career, is also his most finished work. No other sculpture better recapitulates and crowns the achievements of the Quattrocento, or better anticipates the new directions of a century that promised to be an eventful one.

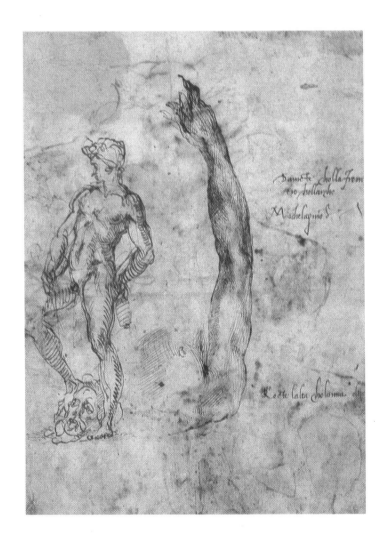

MICHELANGELO
**Sketch for a bronze David
and for the arm of the marble David**
Around 1501-1502. Pen and ink.
26.5 x 18.7 cm. (10 x 7 in.).
Louvre Museum, Paris.

In the spring of 1501, Michelangelo left Rome and returned to Florence at the invitation of the republican government. The next four years would see the full blossoming of his technical mastery and artistic persona. His sculptural idiom became more severe, more classical in its moderation; and it proclaimed itself emphatically in a bold new model.

On 16 August 1501, Michelangelo signed a contract with the *operai* of Santa Maria del Fiore for the execution of a marble figure of *David*. Condivi wrote: "The *operai* of Santa Maria del Fiore owned a block of marble nine *braccia* high, which had been brought from Carrara a hundred years earlier by an artist who, from what one can see, was not as experienced as he should have been...." No one had ever had the courage to work on something that had been started and abandoned. Agostino di Duccio tried in 1464, and Antonio Rossellino in 1476, but both artists gave up and the block remained in the courtyard near the Cathedral, *male abbozatum et sculptum*, poorly roughed out and sculpted.

Only an artist of Michelangelo's stamina could have taken on so formidable a challenge: tackling the mute formlessness of stone already scarred by unsuccessful attempts at overcoming its brute inertia. In September he probed the block and a month later built a shed around it so that he could work in good conditions. The statue was

DONATELLO
Saint George
Around 1415. Marble.
Height 209 cm. (7 ft.).
Bargello, Florence.

OPPOSITE AND OVERLEAF
MICHELANGELO
David
Around 1501-1504. Marble.
Height 410 cm. (13 $^1/_2$ ft.).
Accademia delle Belle Arti, Florence.

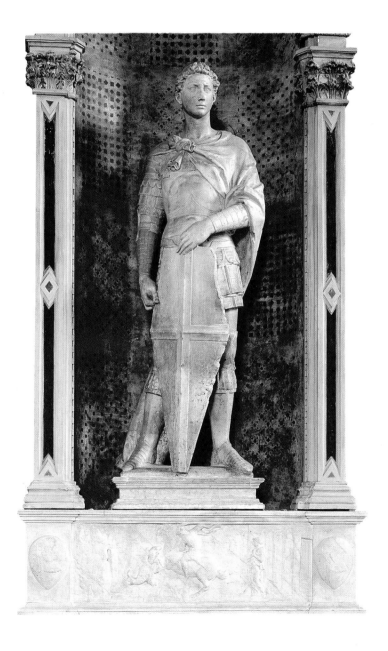

finished early in 1504 and fetched the sum of 400 ducats. On 25th January, a commission comprising the most renowned painters and sculptors in Florence met to deliberate on a suitable site for the *David*. Leonardo da Vinci suggested placing it under the Orcagna arcade, in a special niche with a black background to show it to best advantage. In the end, it was installed in front of the Palazzo Vecchio, replacing Donatello's *Judith and Holophernes*, which was moved to the Orcagna arcade.

The Florentines have always been great admirers of manual skill and technical virtuosity, and Michelangelo achieved an extremely high level of quality and expressivity in his marble *David*. But there is more in this work than a display of supreme talent: this biblical figure embodies a series of formal tensions that suggest an entirely different, much more subtle vision. Over the centuries, the biblical tradition had produced a rich iconography around the figure of King David, Jesse's eighth son. He was, on the one hand, the only young harpist to succeed in assuaging King Saul's anger and melancholy; and on the other, he was the uniter of the Hebrew people and the founder of its capital, Jerusalem. His most powerful and impressive role, however, was as the youth who vanquished the Philistine giant Goliath with a single shot from his sling. David's life became the stuff of legend and, as a prefiguration of Christ's victory over Satan, a central image in the Christian tradition.

The Florentine sculptors of the Quattrocento had already treated this subject with magnificent results. The best-known examples are by Donatello and Verrocchio. Michelangelo, however, deliberately diverged from these famous models and marshalled all his creativity to fashion a balanced figure of intellectual concentration in its most heroic expression. Despite obvious differences, Donatello's *St. George* at Or' San Michele, with its tremendous display of will-power and solid corporeal geometry, was the only statue that came anywhere near the quality of Michelangelo's work. Both figures embody the Renaissance concept of the humanist warrior, master of his own destiny, always prepared to confront the forces of evil, destruction and irrationality.

The Florentine republican faction wanted to use this biblical subject for the purposes of symbolizing a moral stance. The figure and its attitude alluded to very concrete historical circumstances: Florence's uneasy position in being caught between the military might of the Sforzas of Milan and

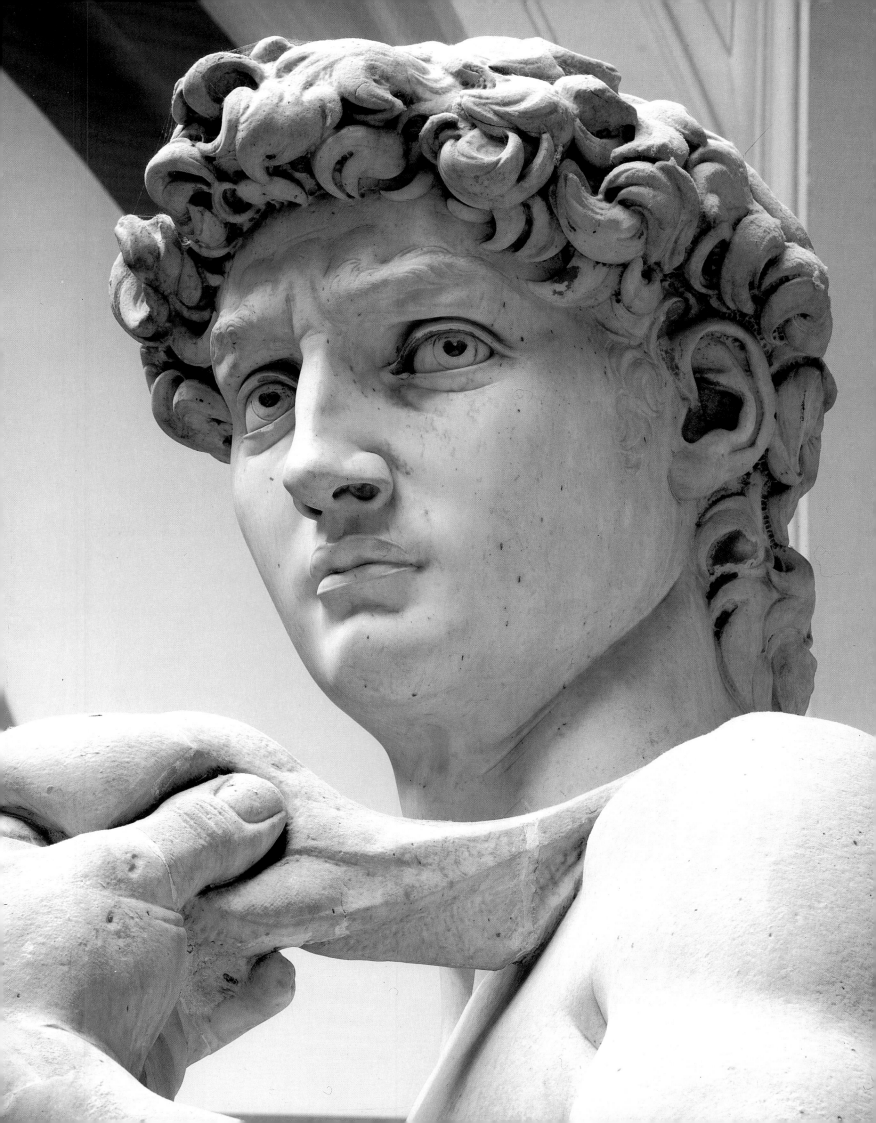

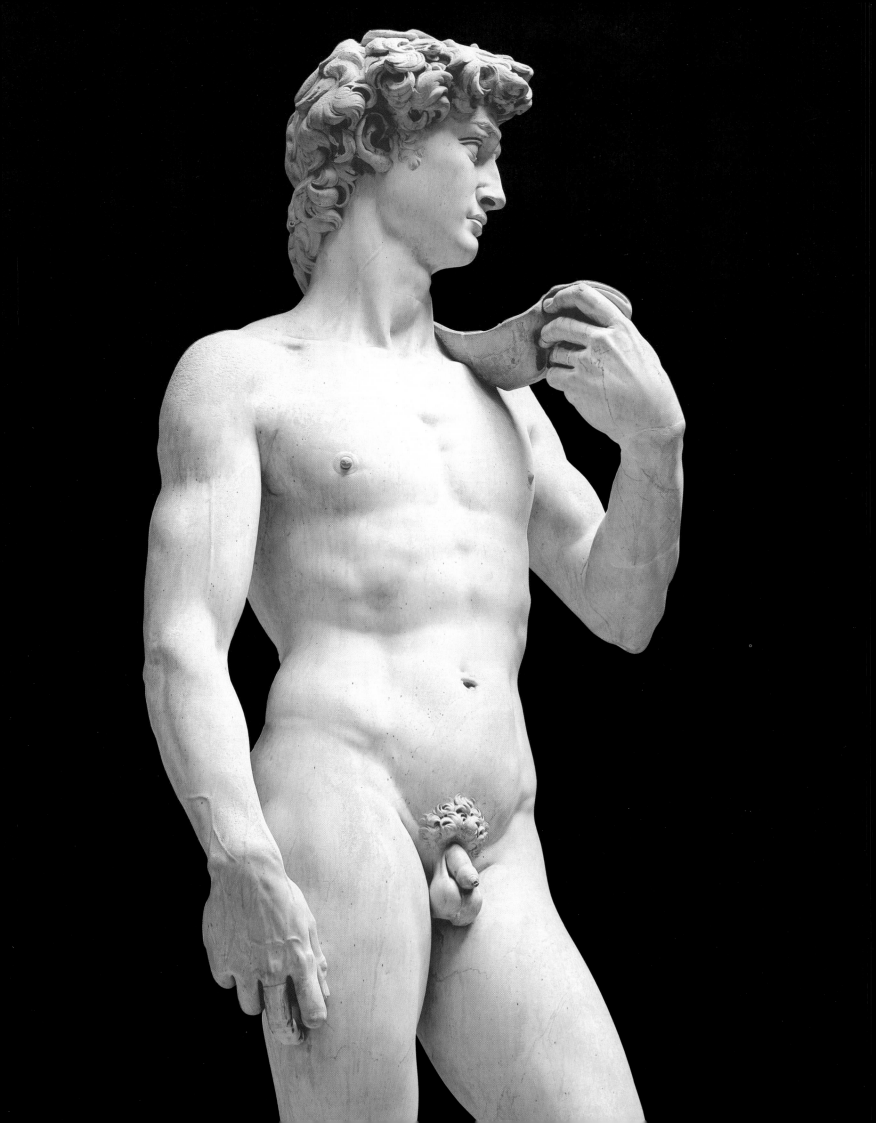

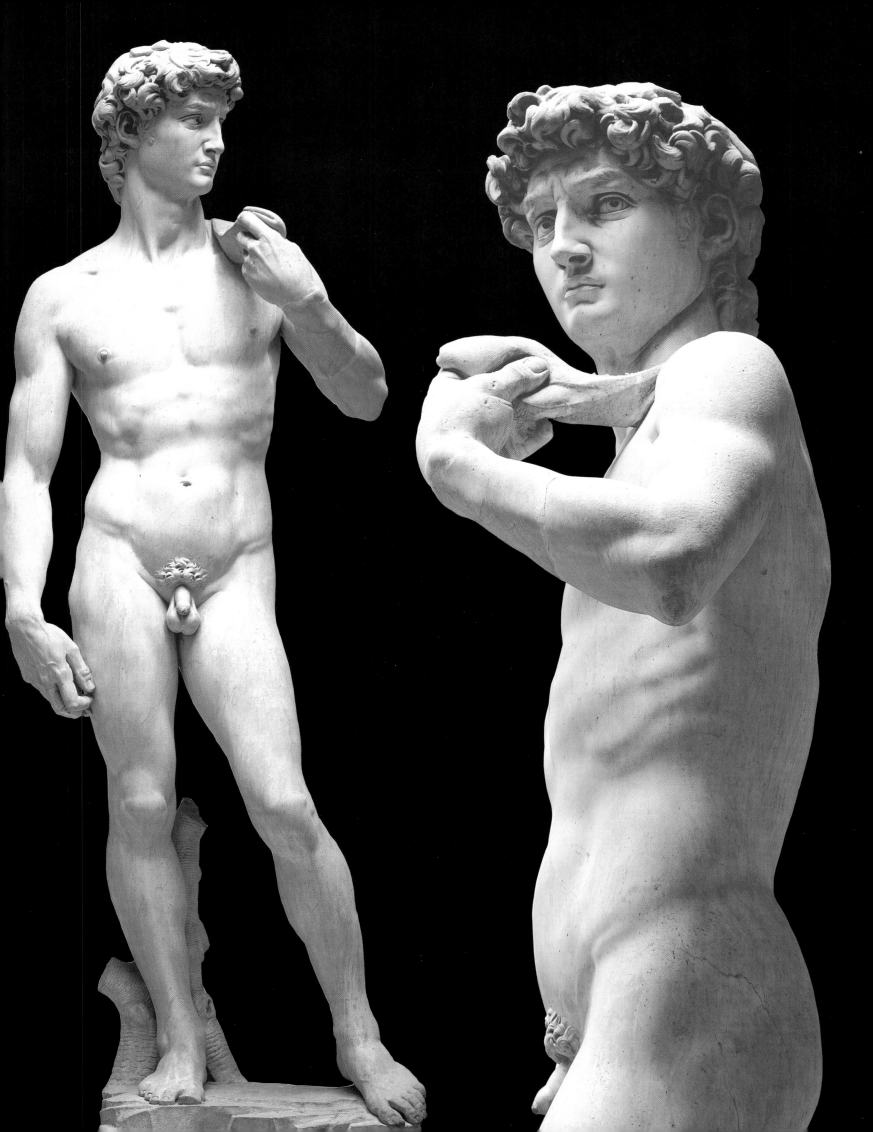

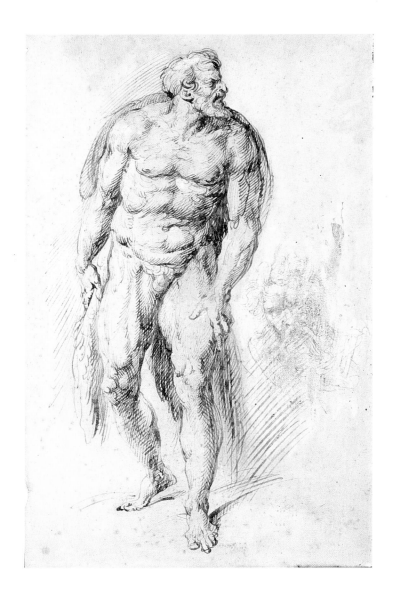

the spiritual and temporal influence of the Roman papacy. It was important in this context to leave out the gruesome detail of Goliath's severed head, which both Donatello and Verrocchio had depicted. The pose had to be noble and serene, but at the same time highly concentrated and charged with a certain tension. It had to convey the hidden resources of guile and a reserved and well-balanced intelligence. The political considerations behind the commission were that the *David* had to provide a model of proper and upright civic conduct.

While symbolizing the political freedom gained in Florence, this figure contains many other references. The sculptural forms combine to stress a meditative stability which is rendered visible by the shifting of the body's weight to the right leg, while the left one is slightly raised. This recalls

the pose of Michelangelo's *Hercules*, a lost statue whose trace is preserved in a drawing by Rubens. The militant citizen gazes concernedly into the distance with his finely-worked eyes, the pupils deeply carved to accentuate his vigilance. The arms, however, are at rest, and the sling hangs in a diagonal across the young warrior's back. The face, with its frowning brow, expresses the pained concentration that precedes violent action. Here stands not just the heroic youth of the Old Testament, but also the symbol of a tremendous civic force that is ready to be unleashed with devastating effect if unduly provoked. The head and the hands, which are slightly larger in proportion to the rest of the body, are an outer expression of the powerful forces within. The figure is complete and polished in every detail, from the surging veins and taut muscles to the convolutions of the hair. Michelangelo used this richness of anatomical detail to give visible expression to human complexity. Although the figure as a whole is motionless, it is untouchable, frozen in a state of perpetual anticipation, yet ready to spring into action.

In his *David*, the Florentine sculptor reached a degree of perfection seldom found even in the works of the great masters of the Quattrocento. This was not lost on the Florentine public, who greeted the statue's arrival on the Piazza della Signoria with great emotion. Some chroniclers described the event dramatically: "On the 14th day of May in the year 1504, a marble giant was brought out of the *operai* of Santa Maria del Fiore; it was brought out around midnight and the wall above the door had to be broken down in order for it to pass through. During the night, some people threw stones at the giant to damage it and guards had to be summoned."[3]

Indisputably, this sculpture effected a synthesis between the various tendencies of the Florentine Renaissance and paved the way for the singular artistic developments to come.

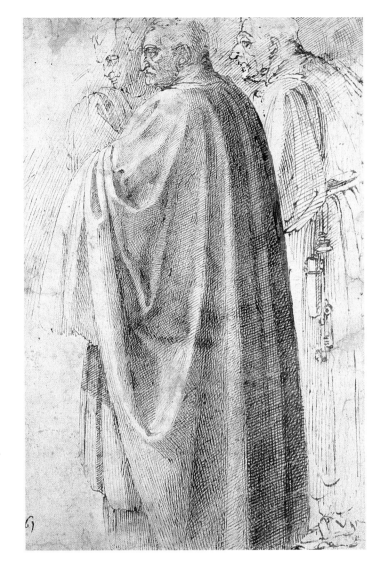

MICHELANGELO
**Drawing of three draped men
after a lost Masaccio**
Around 1501-1503.
28.5 x 20.5 cm. (11 x 8 in.).
Albertina, Vienna.

OPPOSITE (LEFT)
PETER-PAUL RUBENS
Drawing after a lost Hercules by Michelangelo
Pen and ink.
37.5 x 24.5 cm. (14 3/4 x 9 in.).
Petithory Bequest, Bonnat Museum, Bayonne.

OPPOSITE (RIGHT)
MICHELANGELO
Study for the monumental David
Pen and ink.
26.4 x 18.5 cm. (10 x 9 in.).
Department of Drawings, Louvre Museum, Paris.

3. L. Landucci, *Diario fiorentino dal 1450 al 1516*, Del Badia, Florence 1889.

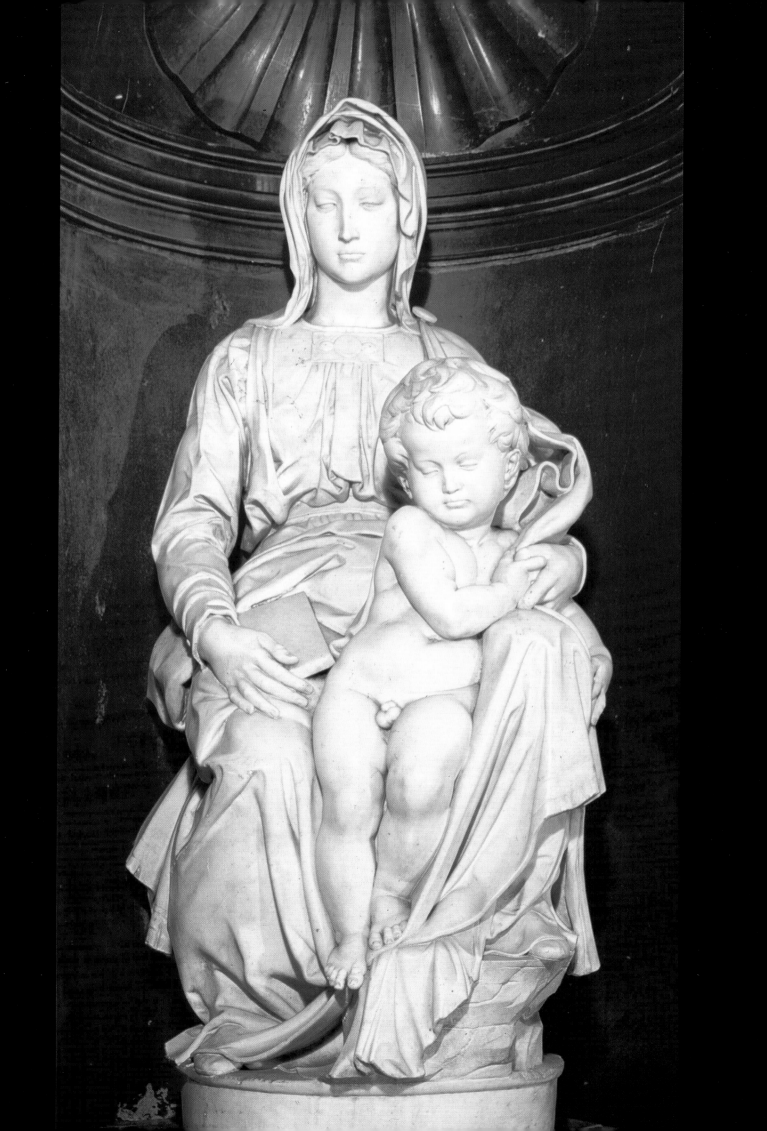

2 THE HOLY FAMILY
Premonitions and enigmas

At the end of 1504, a year rich in artistic achievements, the young sculptor had already begun the Bruges *Madonna and Child*, depicting in a more solemn and monumental mode the relationship between the Virgin and the Christ Child. It is expressed here in her stoic heroism and in his physical strength. He is already more than a child as he turns away from his mother, prepared to accept his fate.

In his Florentine workshop in 1505 were two circular bas-reliefs, the *Pitti Tondo* and the *Taddei Tondo*, as well as a circular painting, the *Doni Tondo*. Although in an unfinished state, the first of these works reveals a complex, intelligent and innovative conception. It was commissioned by Bartolomeo Pitti and probably created at about the same time as the *David*. Its modest size (85.5 x 82 cm.) confirms its ultimately private function, in contrast with the public function of the *Pietà* and the civic function of the *David*.

As in the *Madonna of the Stairs*, the space is articulated on three planes. The background is the least finished part, still marked by coarse diagonal cuts from the chisel. The Child's legs and the head of St. John the Baptist, also represented as an infant, emerge from the middle-ground. The bust of the Virgin stands out in the highest

OPPOSITE
MICHELANGELO
The Bruges Madonna
Finished in 1506. Marble.
Height with pedestal 128 cm. (4 ft.).
Notre-Dame de Bruges.

BELOW

The Bruges Madonna
Detail.

DONATELLO
Virgin and Child
Marble.
Siena Cathedral.

OPPOSITE

TOP

MICHELANGELO

**Virgin and Child with St. John the Baptist
(the Pitti Tondo)**

1504-1505. Marble bas-relief.
85.5 x 82 cm. (3 x 2 ¹/₂ ft.).
Bargello, Florence.

BOTTOM

MICHELANGELO

**Virgin and Child with St. John the Baptist
(the Taddei Tondo)**

1504-1505. Marble bas-relief.
Diam. 121.5 cm. (4 ft.).
Royal Academy of Arts, London.

PAGE 34

MICHELANGELO

The Virgin and Child with St. Anne

Pen and brown ink, brown wash, graphite.
32.5 x 26 cm. (13 x 10 in.).
Department of Drawings,
Louvre Museum, Paris.

PAGE 35

**The Virgin and Child
with St. John the Baptist
(the Pitti Tondo)**
Detail.

relief, and the head, which projects beyond the upper limits of the frame, is almost free-standing with a proud, heroic expression. Many things about this Madonna – her attitude, her diadem in the form of a cherub, her alert and fearless gaze – suggest a prophetess, a prefiguration of the Delphic Sibyl painted on the Sistine Chapel ceiling. The pose and bearing of her upper body suggest a strong, almost imperious character, while the somewhat unnatural position of the legs gives the impression of constraint, of strength hindered or withheld. This opposition is even more evident when we consider the figures of the mother and child together. The infant Jesus, smiling and leaning unconcernedly on the sacred scriptures, represents absolute, contemplative innocence, his smiling face in sharp contrast to the curiously flattened, almost Dionysian mask of St. John the Baptist hovering in its confined space at the upper left.

The *Taddei Tondo*, which is also unfinished in its extant state, is nonetheless a surprisingly original work. It was executed for Taddeo Taddei, the son of a Florentine worthy and *gonfaloniere,* who, like Agnolo Doni, wed a daughter of the powerful Strozzi family. It had been customary in the fifteenth century to represent the Virgin and Child seated on a richly-decorated throne. Michelangelo chose instead to represent her on a rock, more reclining than sitting. The present state of the bas-relief suggests that she was supposed to touch the infant St. John on the right shoulder. The Christ's future baptiser shows him a goldfinch, a symbol of suffering, at the sight of which Jesus instinctively recoils. The spatial composition in this *tondo* is quite free in its conception. The richly-clothed Madonna is as seductive and elegant as a courtesan.

During this period, as Condivi noted, Michelangelo, "so as not to abandon painting completely, did a *Madonna* on a round panel for Agnolo Doni, a Florentine citizen, for which he received sixty ducats." This was also the time when the sculptor composed his famous *rime*, or verses, which he began between 1501 and 1506.

As its title indicates, the *Doni Tondi* was a circular wood panel painted in egg tempera to celebrate the wedding of Agnolo Doni and Maddalena Strozzi. This painting, the only finished work in this medium apart from the frescoes of the Sistine Chapel, was a key work in the development of Christian iconography. The circular format was nothing new in itself; there were already several notable examples of it in

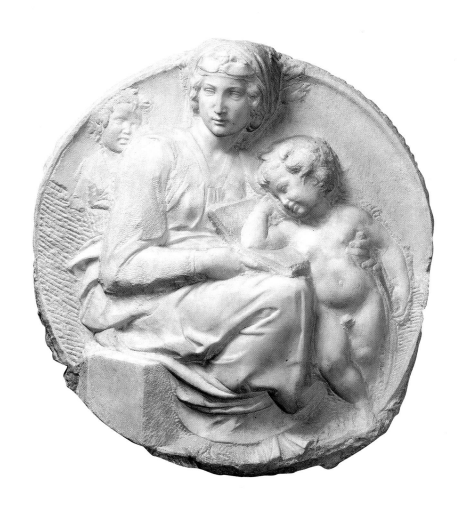

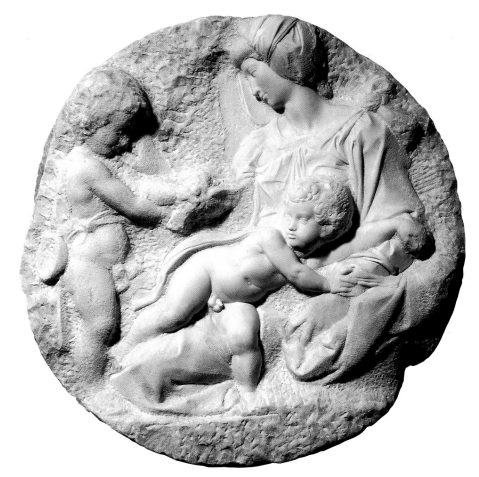

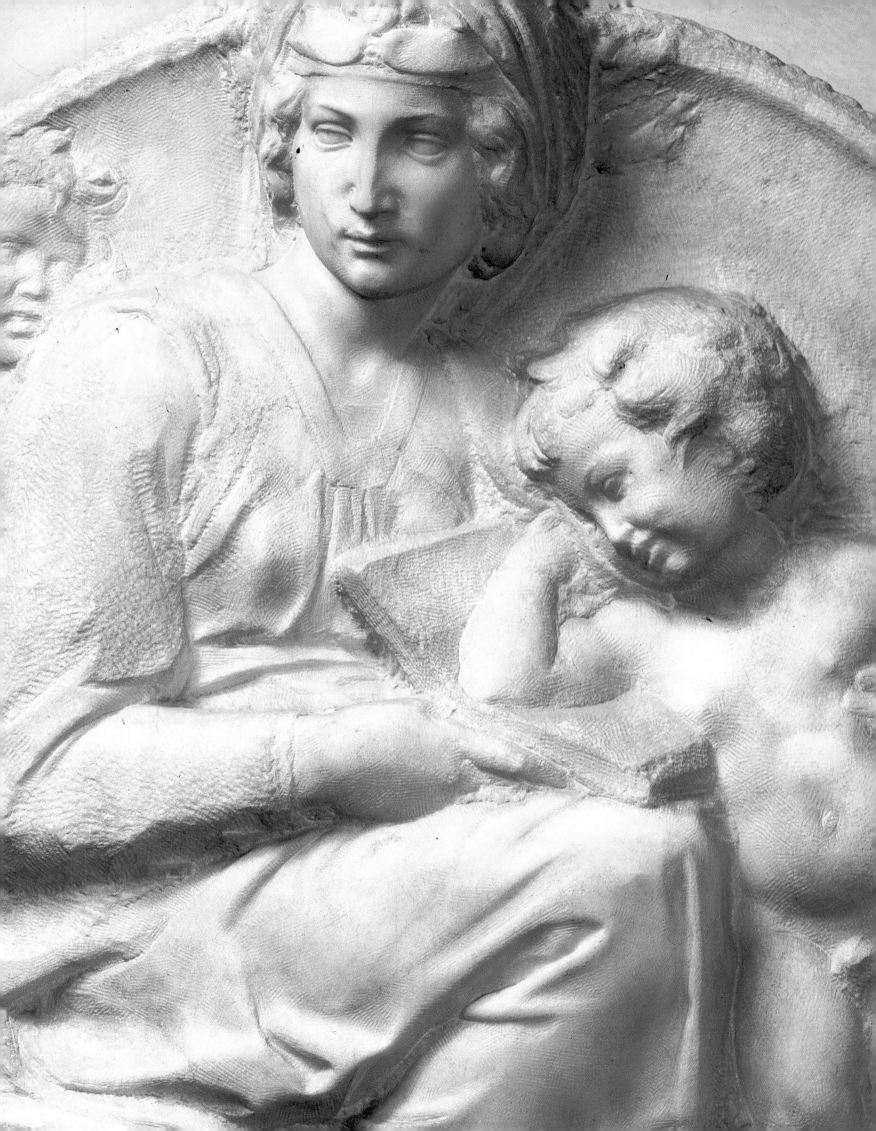

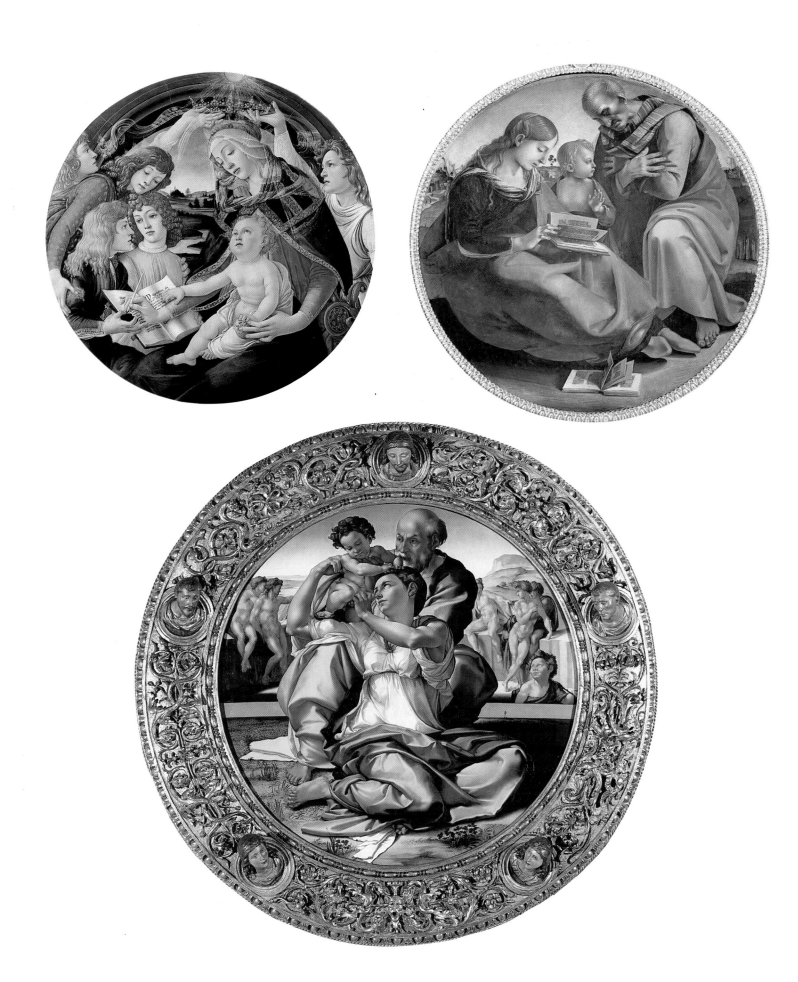

Florentine Quattrocento painting, and in particular Sandro Botticelli's masterful *Madonna of the Magnificat*. In this tondo, the painter used line as the primary vehicle for a harmonious, concentric rhythm. The landscape background in the middle widens and prolongs the space into the luminous distance. The infant Jesus turns his gaze upwards to his mother and rests his right hand on the first page of the Magnificat; in his left hand, he holds a pomegranate, a traditional symbol for spiritual richness and compassionate love.

Another painting in this format which Michelangelo had surely seen and admired was the *Holy Family* painted by Luca Signorelli at the end of the fifteenth century. In this work, Signorelli stressed volume and monumentality at the expense of the graphic elegance that was Botticelli's forte. The figure of the Virgin marks an emphatic diagonal, while Joseph closes the right side and the Christ Child stands majestically in the centre. Three perspective views on the sides and in the middle bring a necessary visual relief from the imposing presence of the sacred trio. With its concentrated and volumetric qualities, this composition anticipates the sculptural power of Michelangelo's *Doni Tondo*. Once again, however, the artist was not content to emulate the works, however effective, of his predecessors. Botticelli's graphically articulated and decorative surfaces were not for him. He kept only the idea of a vast landscape leading the eye towards a bluish distance. He also broke away from Signorelli's static, if monumental, symmetry and strove to establish a clear spatial organization on two distinct planes. The first plane, with the elderly St. Joseph, the young and comely Mary and the vivacious infant Jesus, presents an image of the Three Ages of Man. The figure of the Virgin, which was probably drawn from a male model, has a virile musculature to accentuate her protective role. She reaches up for the Child with a complex twisting motion and gesture that creates an ascending spiral, beginning at her legs and ending with the meditative and abstract figure of Joseph. The painter thus established a dual movement: from the bottom to the top, and from the back to the front, making the Child's body – with its promise of redemption – seem to advance towards the spectator. Where the first plane seems to be occupied by the advent of Christ, in a formal organization that combines concept and the spiral dynamics of the bodies, the second plane opens out onto an entirely original space. After looking at the sparse vegetation on the ground, the

OPPOSITE

TOP LEFT

SANDRO BOTTICELLI

The Madonna of the Magnificat

Around 1483. Tempera on wood.
Diam. 143 cm. (4 $^1/_2$ ft.).
Uffizi, Florence.

TOP RIGHT

LUCA SIGNORELLI

The Holy Family

Around 1490. Oil on wood.
Diam 124 cm. (4 ft.).
Uffizi, Florence.

BOTTOM

MICHELANGELO

The Holy Family (the Doni Tondo)

1503-1504. Tempera on wood panel.
Diam. 120 cm. (4 ft.).
Uffizi, Florence.

OPPOSITE
MICHELANGELO
The Holy Family (the Doni Tondo)
Detail.

eye is halted by a grey band that defines the lower limit of a hemicycle, the upper limit of which is formed by a massive, fluted balustrade. The blue landscape beyond shows no trace of human presence, no trace of civilization. On the far right of the hemicycle appears St. John the Baptist, glancing upward in a gesture that parallels the Virgin contemplating Jesus. Around the balustrade stand or sit various male nudes posed like so many languorous ephebes. One of them holds his friend in a gesture that Michelangelo will later use on the Sistine Chapel ceiling for the sons of Noah. This rather Dionysian intimacy continues on the left with a pair of classical nudes. There are two different worlds in this picture, separated by a grey, horizontal band, yet united by the figure of the child St. John the Baptist, the herald and prefiguration of Christ.

This complexity is not easy to interpret, but one explanation is offered by a purely formal, spatial reading: from the back to the front there is progression from a past order to a present and future order. In other words, humanity *ante legem*, represented by the males nudes, *sub legem*, as personified by Joseph and Mary, and *sub gratia*[1], to be redeemed by the martyrdom of Christ, the Messiah. The shock created by contrasting the complex sensuality of the Antique world with the clarity of the Christian message will be taken up again and amplified by the artist in the biblical cycle on the Sistine Chapel ceiling.

With its extreme spatial and pictorial complexity, its deliberately harsh colour contrasts, its intermingling of the physical, psychological and spiritual, the *Doni Tondo* not only anticipates the painter-sculptor's future works, but also the bizarre Mannerist movement that began to radically complicate and transform the pictorial idiom throughout Europe. Raphael, Michelangelo's great rival, took up the subject of the Virgin and Child with St. John the Baptist several years later in a *tondo* called the *Alba Madonna,* but he was careful to resolve the linear and chromatic tensions that were so dear to Michelangelo.

1. *Ante legem :* before the Law of Hebrew monotheism ; *sub legem :* according to the Law ; *sub gratia :* by the grace of Our Lord.

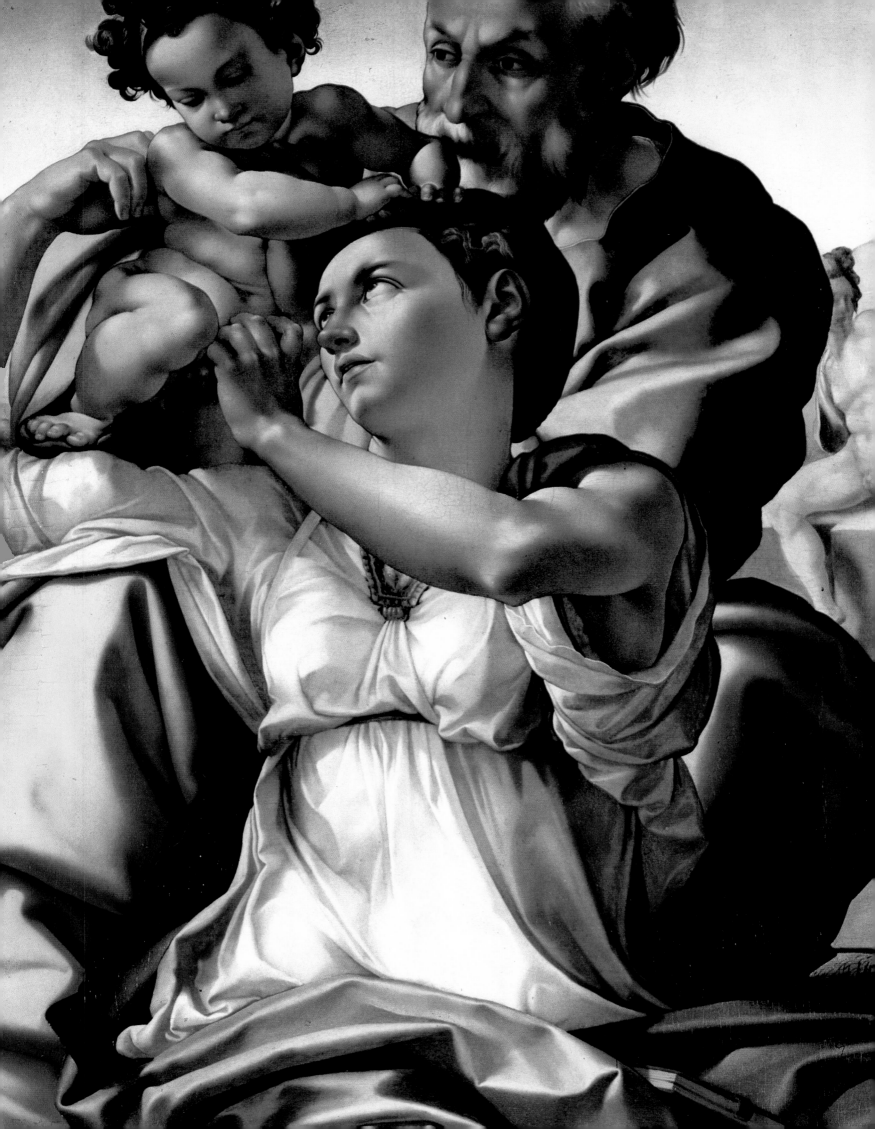

3 IN THE SHADOW OF THE POPES

Julius II, elected to the papacy in 1503, devoted his efforts over the next decade to consolidating the political power and artistic prestige of the Vatican. A great statesman and patron of the arts, he made war on the French on the one hand, and, on the other, protected such artists as Bramante, one of the leading architects of the Renaissance, and Raphael Sanzio, known to posterity only by his first name. In March 1505, he summoned Michelangelo to Rome to entrust him with the execution of his own tomb, a funerary monument so grandiose that it would eclipse the glory of even the greatest mausoleums of Antiquity.

MICHELANGELO

Design for the Tomb of Julius II

Pen and ink with wash.
Lower section of the 1513 version.
Department of Prints and Drawings, Uffizi, Florence.

OPPOSITE

MICHELANGELO

Study for a *putto* and for the right hand of the Libyan Sibyl, with sketch for the Tomb of Julius II

1511-1513. Red chalk, pen and ink.
28.5 x 19.5 cm. (11 x 7 $^1/_2$ in.).
Ashmolean Museum, Oxford.

OPPOSITE

GIACOMO ROCHETTI

**Drawing after Michelangelo's
1513 design for the Tomb of Julius II**

Pen and ink.
52.5 x 39 cm. (21 x 15 in.).
Staatliche Museen zu Berlin.

BELOW

MICHELANGELO

Tomb of Julius II

Finished in 1545.
700 x 692 cm. (23 x 22 ft.).
San Pietro in Vincoli, Rome.

According to Condivi, in that year Michelangelo "remained for some time doing almost nothing in the arts, dedicating himself to the reading of poets and vernacular orators and to writing sonnets for his own pleasure until, after the death of Pope Alexander VI, he was summoned to Rome by pope Julius II and received a hundred ducats in Florence for his travelling expenses." Once in Rome, Michelangelo came up against the pope, an exceptional man whose character and ways resembled his own: he was bold in his views, headstrong in his opinions and with an overwhelming personality. Julius II had brought together the best painters, sculptors and architects of the day, and it was probably the architect Giuliano da Sangallo who drew Michelangelo to his attention.

Buonarotti lost no time in designing a project of suitable scope and ambition: a pyramidal sarcophagus surrounded by no less than forty statues on three levels – victories, virtues, personifications of the arts – all mourning the death of the supreme pontiff. He threw himself with unbridled enthusiasm into the undertaking, spending no less than eight months in the famous marble quarries at Carrara, in the Apennine Mountains, before secluding himself in his studio just a stone's throw away from the Vatican, behind

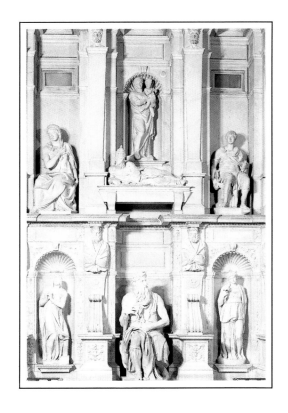

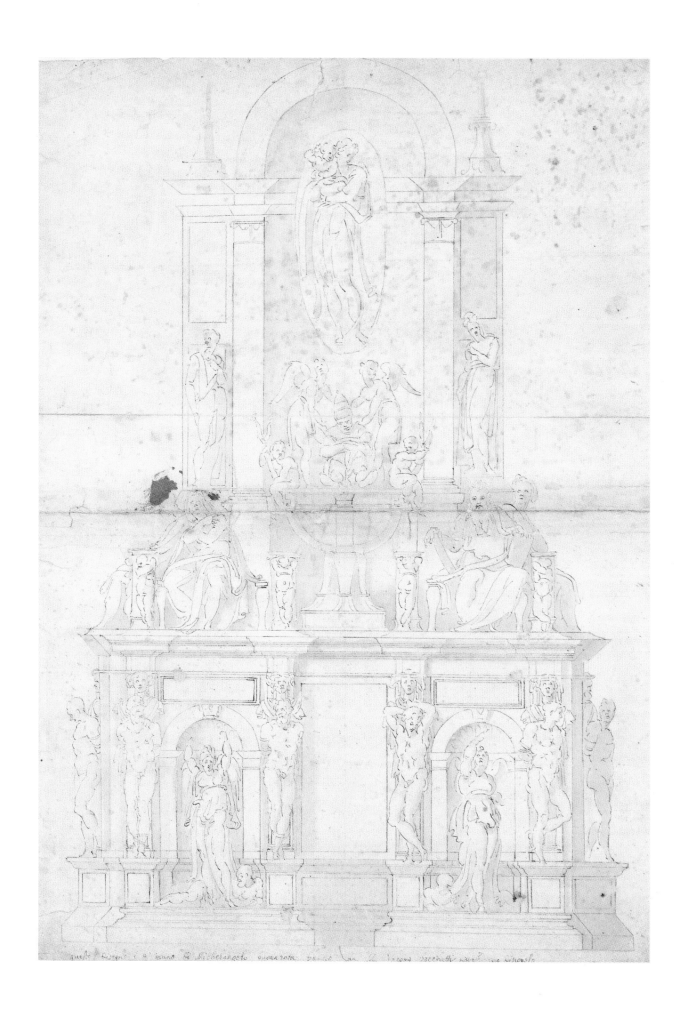

the church of Santa Caterina. Both Condivi and the great artist and art historian Vasari are invaluable sources for this period, which should have been a triumph for Michelangelo, but which ended in tragedy.

The artist's own bitter letters, full of tormented insights, summary sketches and the accounts of his contemporaries help us to recapture the heavy atmosphere at the pontifical court, with its endless intrigues and rivalries. Michelangelo received approval for the first project, quarried sufficient marble to realize it, and sought to accelerate the progress of the work. But just at that time Julius II was preoccupied by his military campaigns against Perugia and Bologna, and impatient to begin construction of the new basilica of St. Peter's, which had been entrusted to Bramante. Condivi gives the details: "Bramante was prompted by envy and also by fear of the judgment of Michelangelo, who had discovered several blunders."[1] "Because he was sure that Michelangelo knew of his mistakes, he constantly sought to have him removed from Rome, or at least to deprive him of the pope's favour and of the fame he might acquire through his work." Weary of this atmosphere and even fearing for his life – "If I had stayed in Rome, I think my tomb would have been finished before the pope's," Buonarotti left the Eternal City on 18th April 1506, one year after his arrival, and without starting work.

The subsequent fate of Julius II's tomb reads more like a sinister novel than the normal progress of an artistic project. When the pope died in 1513, the sculptor prepared a second project with modifications approved by his heirs. In July 1516, a third idea was on the drawing board. Ten years later the pope's heirs were threatening Michelangelo with legal action over a fourth project which was never completed. A fifth project was proposed in 1532, and then a sixth in 1542. The mausoleum that was finally completed in 1545 was a far cry from the ambitious monument announced forty years earlier: it consisted of a two-storey façade erected against a wall in S. Pietro in Vincoli.

The statues were executed by several different sculptors working from Michelangelo's ideas and sketches. His own contribution amounted to six *Slaves* and the famous figure of *Moses*.

1. Condivi tells us that Bramante's luxurious and spendthrift habits drove him to cut costs on construction materials, as a result of which the unsound walls at the Belvedere and at S. Pietro in Vincoli were in danger of collapsing.

Opposite
MICHELANGELO
**Group of three figures
for the *Battle of Cascina***
Around 1504. Pencil, pen and ink.
Department of Drawings,
Louvre Museum, Paris.

The tomb for Julius II had sparked a release of creativity that Michelangelo had until then kept to himself. Still steeped in the creative ferment engendered by his work on the mausoleum, Michelangelo was left with a number of archetypal figures full of meaning and with profound formal and conceptual consequences. The vicissitudes and frustrations of this fiasco left him with a reserve of pictorial and sculptural images. The barrier retaining them was a frail one, ready to yield to any pressure from outside.

Despite Michelangelo's hasty flight from Rome provoked by the tomb project, Julius II lost no time in effecting a reconciliation. In 1508, he again summoned the artist to the Vatican and entrusted him with the decoration of the Sistine Chapel ceiling. The contract was signed on 10th May, and Buonarotti was given an advance of five hundred ducats.

The chapel was built by Pope Sixtus IV, who died in 1484 and gave it his name. It had always had the dual function of a palatine chapel and an advance fortification in the famous Parrot Courtyard, one of the oldest parts of the Vatican Palace. During the Renaissance, it lost its defensive function, but its forbidding aspect remained and can be seen today from the outside of the building. In 1477, the medieval construction was redesigned and given its present appearance, which includes a basement, a mezzanine and the chapel itself, covered by a long barrel vault. The floor-plan of the *cappella magna* is noteworthy for its simplicity: a large rectangle 40.93 metres long and 13.41 metres wide, the same dimensions as those attributed in the Scriptures to the Temple of Solomon in Jerusalem.

Condivi gives us a look behind-the-scenes: "...He came to Rome, where Pope Julius, still resolved not to build the tomb, was anxious to employ him. Bramante and Michelangelo's other rivals tried to convince the pope that he should entrust Michelangelo with the painting of the vault of the chapel of Pope Sixtus IV, which is inside the palace, hoping that he would not commission other sculptures. This was done with malice, in order to distract the pope from sculpture projects. They were certain that either he would turn the pope against him by not accepting such an undertaking or, if he accepted it, he would prove considerably inferior to Raphael of Urbino, on whom they heaped praise out of hatred for Michelangelo, as it was their opinion that

Opposite
PERUGINO

St. Peter receiving the Keys
Detail.
Around 1481-1483. Fresco.
Sistine Chapel, Vatican.

Michelangelo's principal talent was the making of sculpture (as indeed it was)."

Michelangelo did not consider himself a master in the art of painting, and he suggested several times that the pope entrust the task to Raphael, who was then busy painting the *Stanze della Segnatura* in the Vatican. But despite all his entreaties, the pope was adamant and forced him to sign the contract. Between May and the following autumn, Michelangelo worked on many preparatory sketches, only a few of which have survived. It is agreed by most authors, from Condivi and Vasari to present-day historians, that his labour as the painter of the Sistine Chapel lasted four years, from 1508 until 1512, with almost no assistance; although many names have been mentioned in this connection, Michelangelo dispensed with their services after a few months.

When the painter was ready to begin the fresco work, in late 1508, the chapel was already decorated with a remarkable cycle of compositions on the side walls. By 1481, Perugino, Botticelli, Ghirlandaio (Michelangelo's former painting master) and Rosselli had signed contracts to execute a series of fresco panels devoted to the lives of Moses and Christ. These four artists had been assisted by other, no less talented painters, including Pinturicchio, Piero di Cosimo and Bartolomeo della Gatta. Another artist, Piermatteo d'Amelia, had decorated the vault with a plain sky full of stars, which Michelangelo subsequently removed. Around 1481, Perugino executed the decoration of the wall behind the altar, which was to be replaced around 1535 by Michelangelo's *Last Judgment.*.

These frescoes were already complete in 1483, and so when he set to work on the monumental project that led to the creation of over three hundred figures, Michelangelo was competing directly with the great masters of the Quattrocento.

The project initially conceived by the pope was fairly modest: Michelangelo was to paint the figures of the Twelve Apostles on the upper section of the chapel's side walls and decorate the vault with a simple geometric design. But the artist soon proposed a new and entirely original – not to say ambitious – idea that allowed him to bring together in one place all of the figures that already peopled the drawings, sculptures and fresco panels. Adding to the existing fourteen murals from the late Quattrocento, he would cover every surface, from the barrel vault, spandrels and lunettes to the

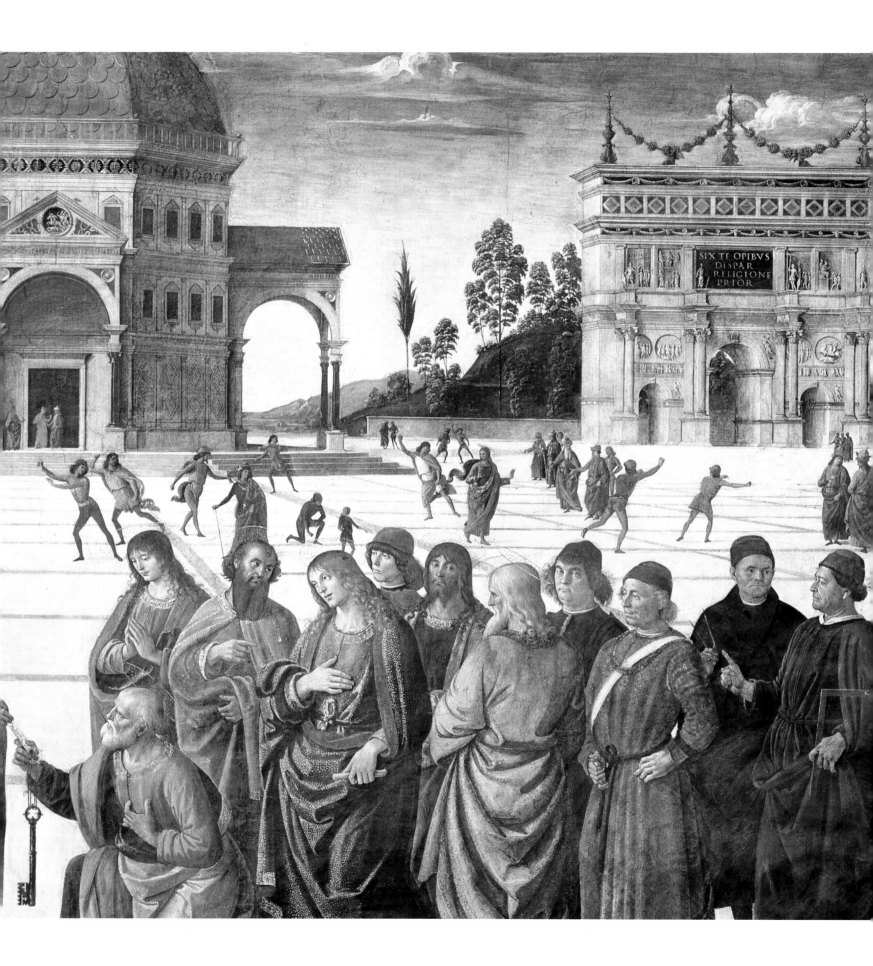

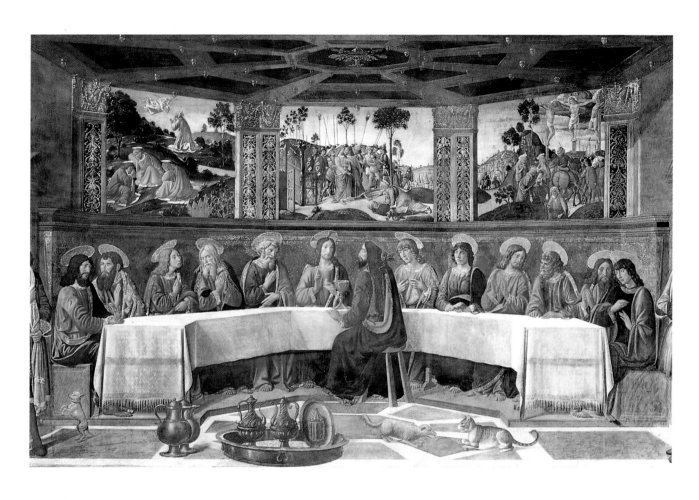

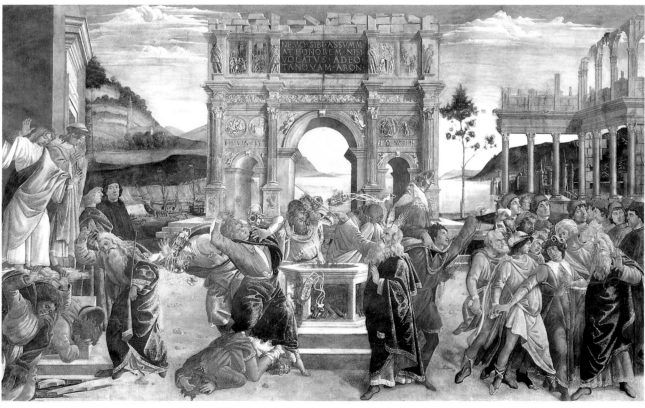

four corner pendentives, with an unprecedented host of biblical figures and architectural ornaments, including a cycle of nine major compositions running down the entire length of the ceiling. Michelangelo had to take into account the iconography of the existing fresco panels on the rear and side walls. Thus the figures in the spandrels and lunettes, the *Precursors of Christ*, serve as a logical transition between the stories of Moses and Christ, the gallery of thirty supreme pontiffs and the ceiling vault itself. But unlike the Quattrocento frescoes, which are rationally arranged and closely associated with the supporting wall, Michelangelo designed a decoration that would be superimposed on the architectural elements of the vault and partially transform them into painted architecture by means of a consummate pictorial illusion. There is every reason to think that the iconography of the chapel was devised by the pope himself or a Vatican theologian. Before painting the ceiling, the artist made cartoons of the general compositions and then transferred the drawings onto a fresh coat of plaster. But for the lunettes, he painted directly on the dry wall. He worked according to techniques described in treatises by the artist and theoretician Cennino Cennini and by Giorgio Vasari, even though, as his student Condivi reports, there were sometimes incidents arising from the preparation of the plaster coating that delayed his progress.

After a Herculean labour, he completed the decoration in the autumn of 1512. In his diary, the Grand Chamberlain de Grassis noted that the Sistine Chapel was opened on 31st October, an event that was greeted with great emotion.

The work as a whole was probably broken down into four distinct phases, each lasting several months. In the autumn of 1509, the artist completed the first three panels in the middle of the vault, and in August the two adjacent scenes. But new difficulties occurred in the months that followed: the pope was away in Bologna and refused to continue financing the work. Between January and August 1511, however, Michelangelo painted four more large compositions, and decorated the lunettes and spandrels during the following year. The ceiling was ready for viewing by All Saints' Day. Vasari wrote of this occasion: "Julius II discovered the vault on the morning of All Saints' Day, when he went to celebrate mass in the chapel, to the satisfaction of the entire city." It

OPPOSITE

TOP

COSIMO ROSSELLI

The Last Supper

Around 1481-1483. Fresco. Sistine Chapel, Vatican.

BOTTOM

SANDRO BOTTICELLI

The Punishment of Core

Around 1481-1483. Fresco. Sistine Chapel, Vatican.

49

Top

PIERMATTEO D'AMELIA

**Design for the decoration of
the Sistine Chapel ceiling
before Michelangelo's frescoes**

Department of Prints and Drawings, Uffizi, Florence.

Bottom

G. TOGNETTI

**Engraving showing the decoration
of the Sistine Chapel in the Quattrocento**

was a gigantic accomplishment, achieved, as we have said, with almost no assistance. But only almost, and not as Condivi claims: "Michelangelo completed the entire work in twenty months, without help, not even for the grinding of the pigments." In fact, he must have been assisted in the more practical tasks by a few *garzoni*, and perhaps even in some pictorial work, but no names have come down to us.

Be that as it may, this colossal undertaking was essentially the work of a single artist working in seclusion, receiving visits only from the pope, whom – much to his regret – he could not keep out. The work never progressed fast enough for the latter, and he climbed the scaffolding to harass the artist. Unfortunately there is no record of how this scaffolding was built. We know only from his biographer and student, that "the pope would climb a ladder and Michelangelo would help him up onto the scaffolding." His confrontations and arguments with the pontiff were often violent, revealing the Pope more as a tyrant than as the spiritual leader of the Roman Catholic Church. Julius II asked him one day when he intended to finish the chapel, to which Michelangelo replied: "'When I can." Enraged, the pope retorted, 'Do you want me to have you thrown down from the scaffolding?' To which the artist replied, 'You shall not have me thrown off.'" By the end of the year 1509, with the work only half finished, the pope could contain his impatience no longer. Despite Michelangelo's objections to showing an imperfect work that needed some finishing touches, the pope had the completed part unveiled for the people of Rome to judge it.

It was probably incidents such as these that fuelled the myth of the *artiste maudit*, the titan chained to his Promethean task, a figure that became a caricature in the writings of the Romantic Age. In fact, as we can see from his letters, the painter must have been working in an altered, visionary state of consciousness and fatigue that only his incommensurate ambition and thirst for fame helped him to bear. He was proud to the point of disdain, showing only completely finished works, unwilling to reveal the progress of his ideas or his preparatory sketches. To protect and perfect his image as a unique artist, he destroyed a major part of his projects and sketches; no one was privy to his hesitations and *pentimenti*. There is no doubt that he wanted to use art to give him access to the highest social circles. Equally certain was his hatred for Aretino, the most

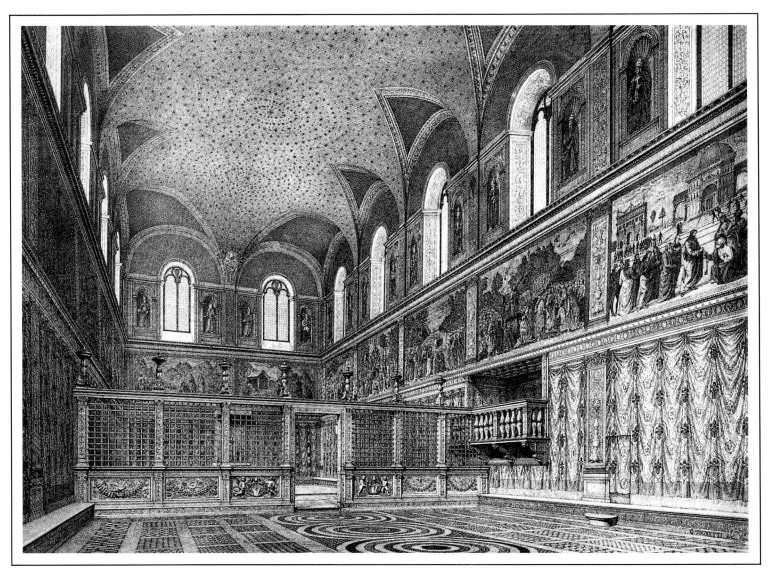

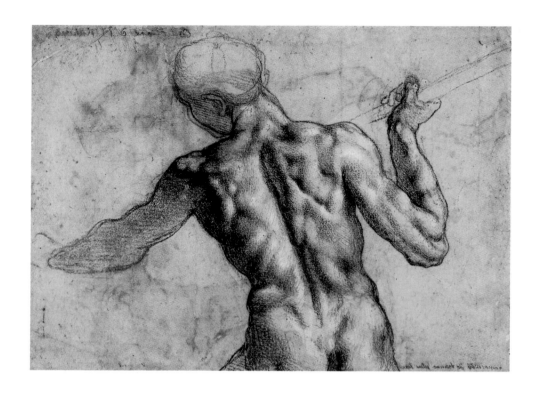

MICHELANGELO

Drawing for the *Battle of Cascina*

Around 1501. Charcoal on stylus outline,
touched up with white.
19.5 x 26.5 cm. (8 x 10 in.).
Albertina, Vienna.

OPPOSITE

MICHELANGELO

Nude study for the *Battle of Cascina*

Around 1504. Pen and ink.
40.8 x 28.4 cm. (16 x 11 in.).
Casa Buonarotti, Florence.

acerbic critic of the day, who wrote of the difficulty of maintaining a serene relationship with the *excellentissimus pictor.* "You who, in order to become divine, shun all human company." To which one Milanesi added: "He frightened everyone, even the popes." The man known variously as "the Unique," "the Divine," and "the Terrible," himself wrote that: "He who knows how to draw well, even if only a foot, a hand, or a neck, will be able to draw anything in the world."[2]

In destroying the traces of his artistic progress, Michelangelo undoubtedly wanted to give the impression of having created works that sprang "fully fledged" from the depths of his genius, as if immaculately conceived. His work at the Sistine Chapel was certainly an unprecedented and extraordinary feat. The museum at the Casa Buonarotti in Florence preserves a caricatural self-portrait of him painting the ceiling in an awkward and uncomfortable position. The drawing also contains an ironic and bitter notation couched in poetic form: "From working all contorted, I developed a goitre, like the cats in Lombardy from drinking the water." It is noteworthy that the artist expressed such scorn for his self-image, not hesitating to compare himself to a sick and deformed animal. In the same poem, he wrote: "This

2. A. M. Bessone, Aureli, *I dialoghi michelangioleschi di Francesco da Hollanda*, Rome, 1953.

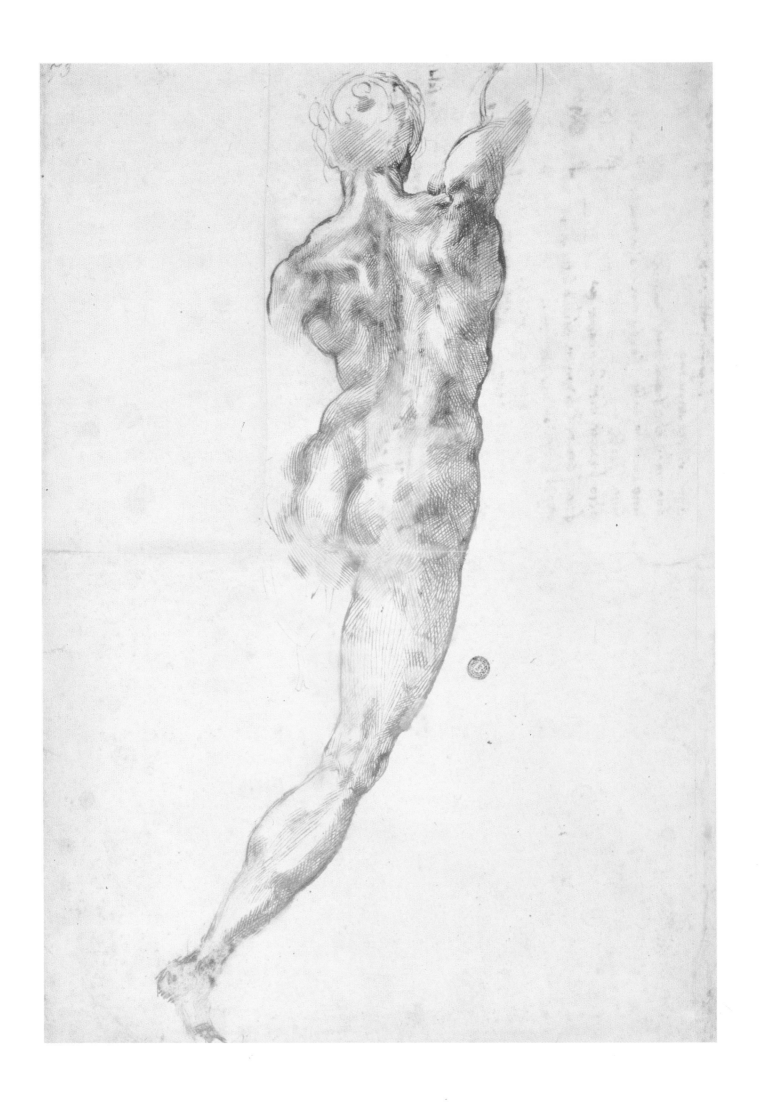

MICHELANGELO

General view of the Sistine Chapel

Before restoration. 1508-1512.
Vatican.

wretched painting you must defend, Giovanni, and my own honour with it: Am I in a good position here, and am I a painter?"[3] Condivi reports that the artist received three thousand ducats for his work, and that his outlay for pigments amounted to twenty or twenty-five ducats. He added that the strain of working on the ceiling by candle-light severely affected his eyesight for a long time afterwards. This same biographer tells us that the pope "loved him with all his heart" and that he watched over him and held him in more esteem than anyone else at his court. This did not, however, prevent him from striking the painter with his cane when he answered that he would finish the work when he could.

The great Vatican Palace itself was in full transformation at the time; Raphael Sanzio had just finished his frescoes in the *Stanza della Segnatura* (the Signature Chamber). In his fresco depicting the *School of Athens*, he paid homage to Michelangelo by portraying him as the tormented philosopher Heraclitus. There was nonetheless a very sharp rivalry between the two painters. Condivi relates that, after seeing the work in progress at the Sistine Chapel, Raphael, using Bramante as an intermediary, tried to obtain from the pope the commission for the remainder of the project. At that, Michelangelo was indignant and "before Pope Julius he gravely protested the wrong which Bramante was doing him; and in Bramante's presence he complained to the pope, describing his persecution at Bramante's hand."

On other occasions, his arguments with Julius II involved more specifically aesthetic questions; thus, one day, the pope asked Michelangelo to retouch certain figures with gold, so that they would not look too poor; the artist retorted that, in fact, they had probably been quite poor in their day. And the matter was left there.

3. This poem was addressed to Giovanni di Pistoia. *The Poetry of Michelangelo*, J. Clements ed., New York 1965.

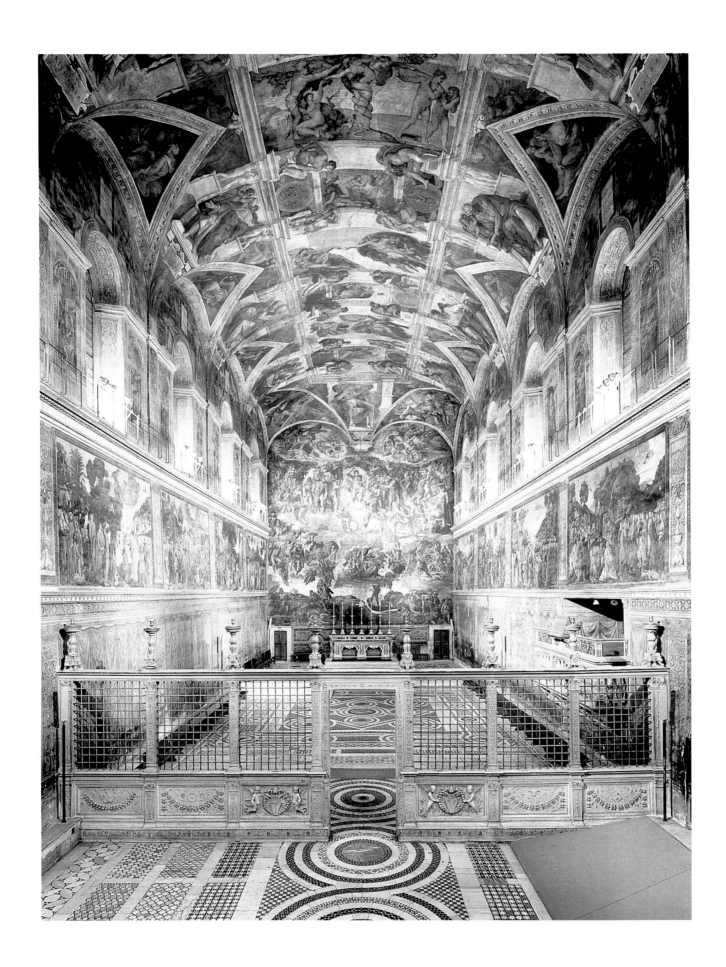

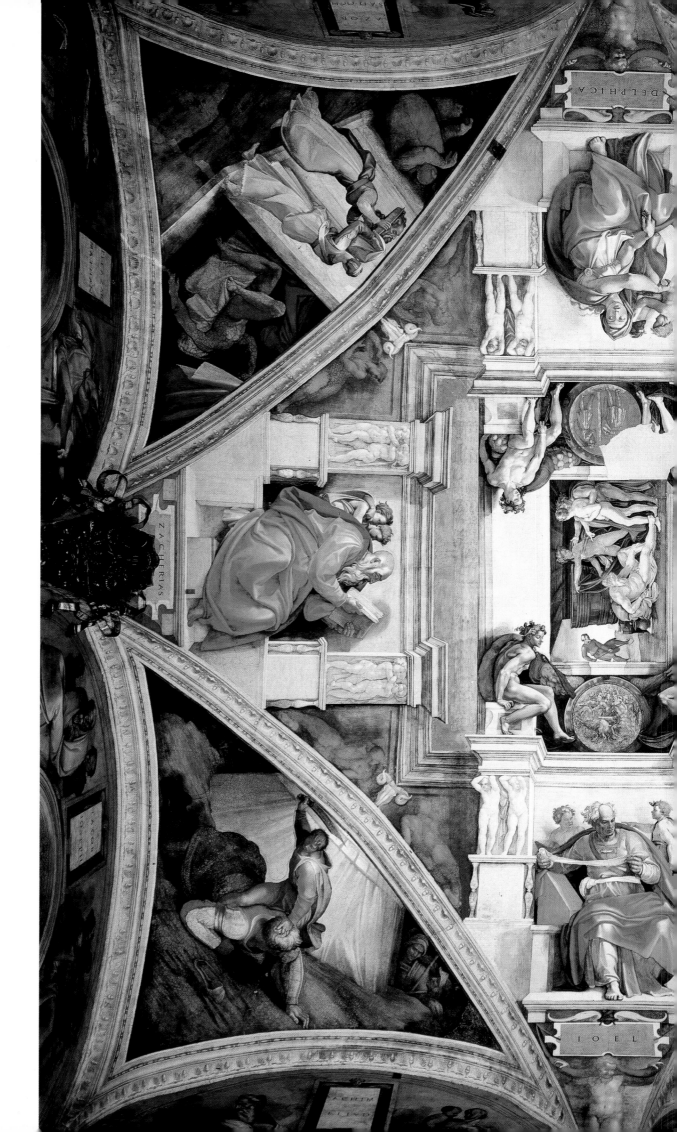

PAGES 56-57 AND 58-59
MICHELANGELO
**General view of the
Sistine Chapel ceiling**

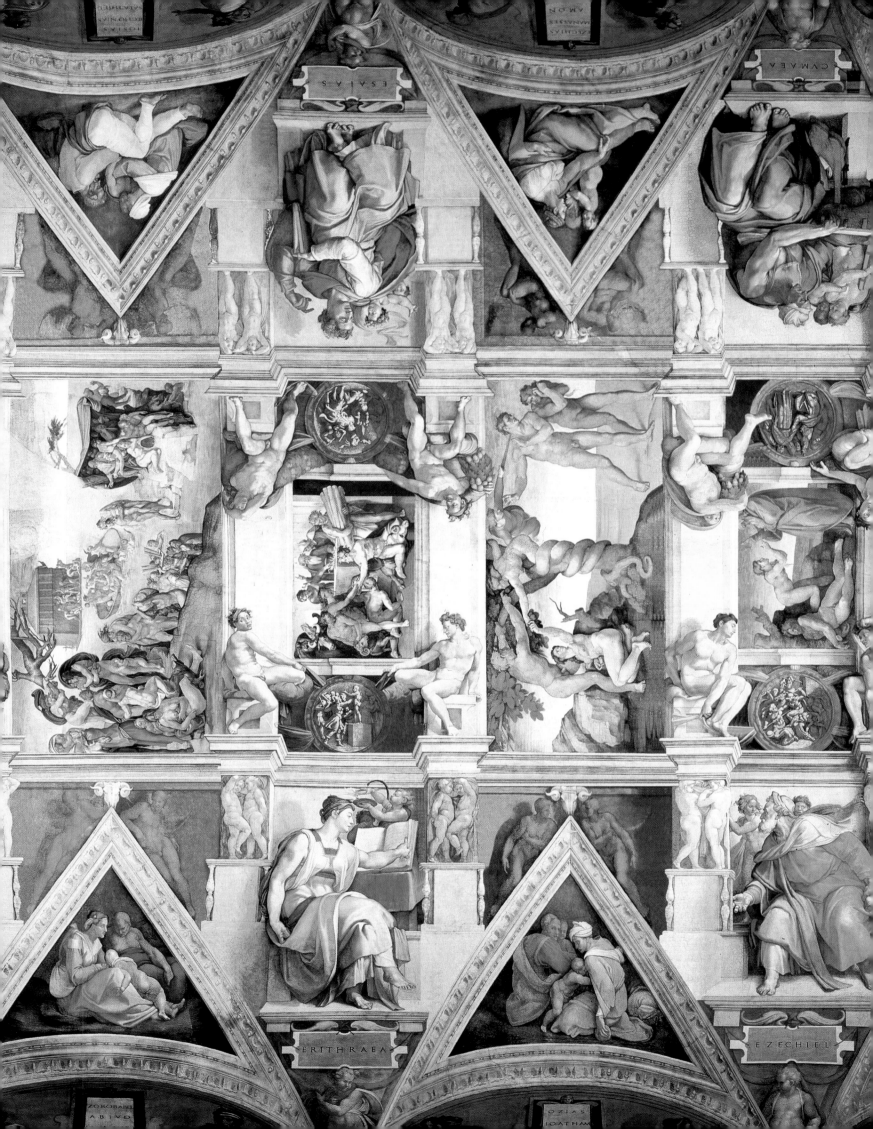

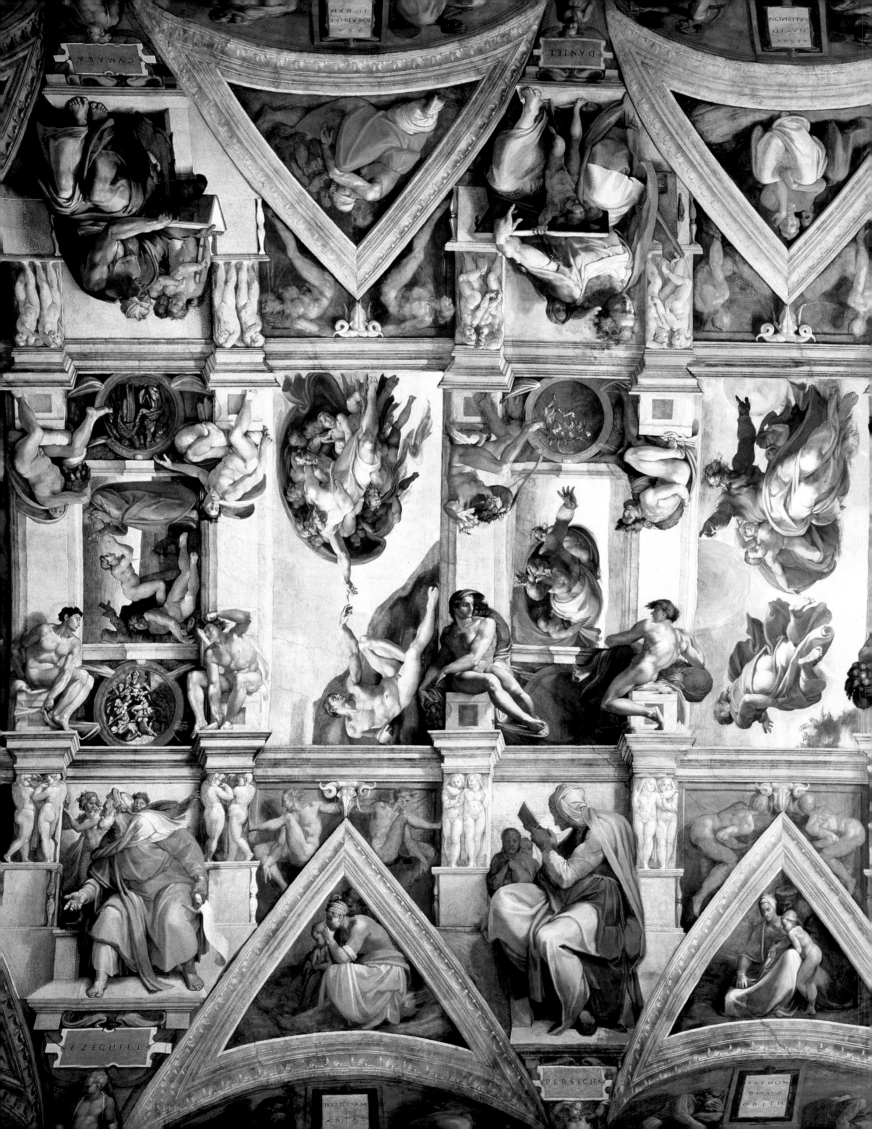

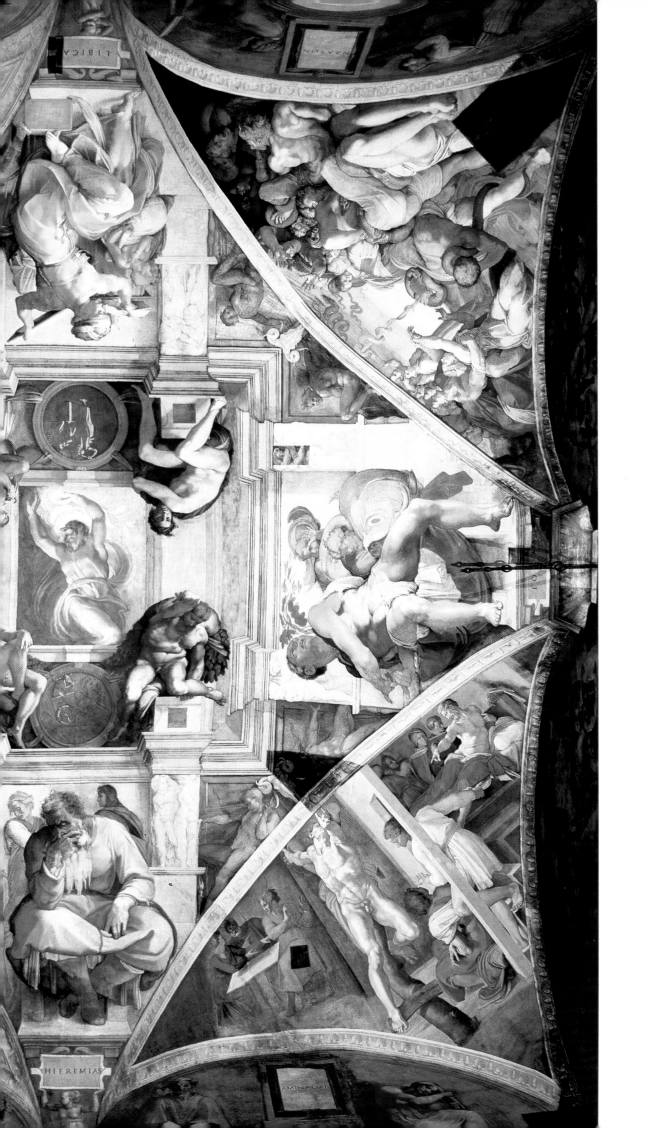

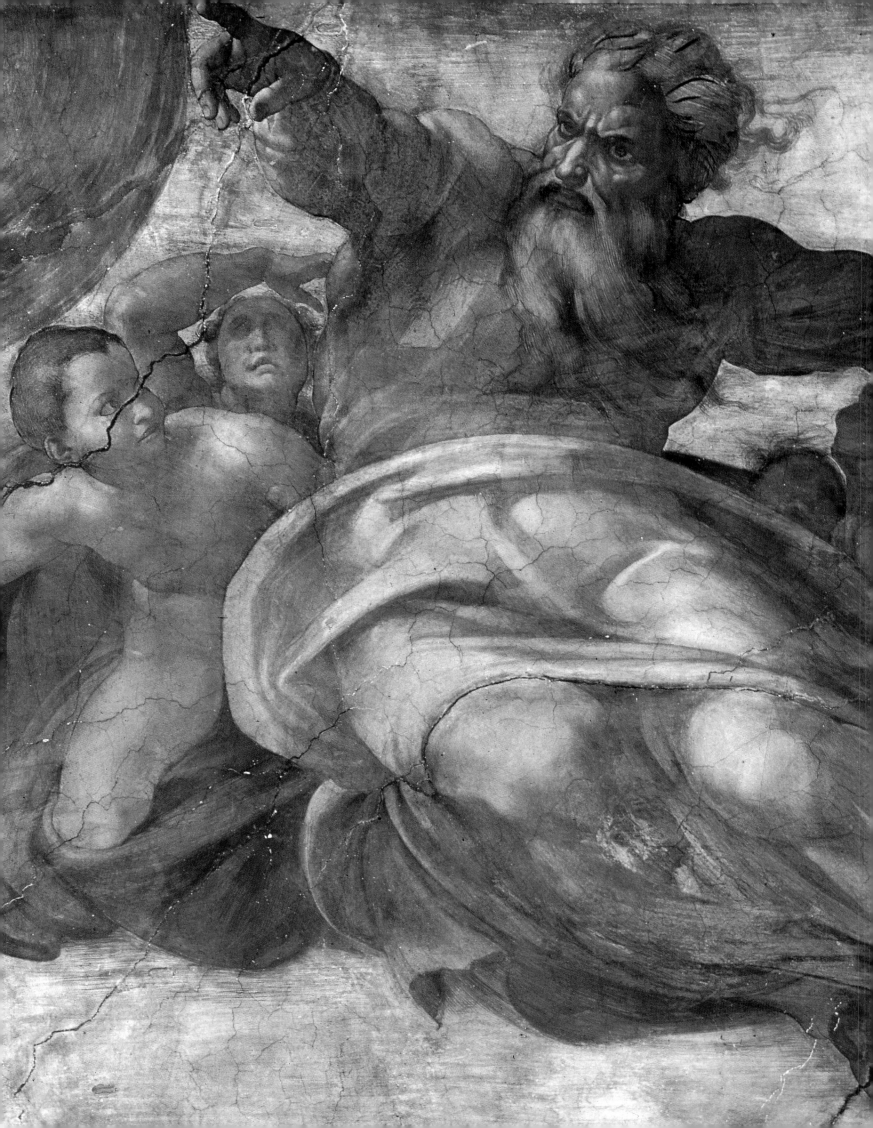

4 THE SISTINE CHAPEL Jehovah, Genesis and Violence

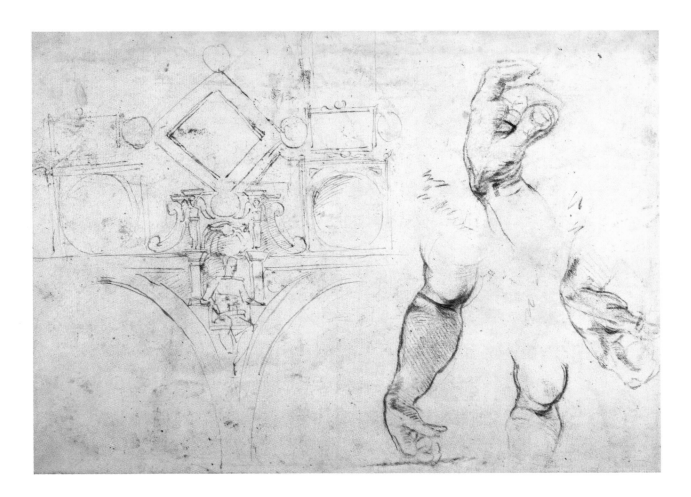

We know that early in 1509 Michelangelo definitively dropped the original project for the Sistine ceiling: the figures of the Twelve Apostles and a vault decorated with a geometric design. This project had been Julius II's own idea, but it was soon overridden by the painter's surge of creative inspiration.

The initially modest design was progressively and radically transformed into a biblical programme comprising more than three hundred figures covering a total surface area of a thousand square metres.

MICHELANGELO
**Sketch for the decoration
of the Sistine Chapel ceiling
with study of arms and hands**
1508-1509. Pen and ink on pencil and charcoal.
27.5 x 39 cm. (11 x 15 in.).
British Museum, London.

OPPOSITE
MICHELANGELO
God creating the Sun and the Moon
Detail. Middle fresco cycle of the
Sistine Chapel ceiling before restoration.

Two sketches by the artist help to throw some light on the change of conception that eclipsed the Pope's original idea. In the earlier sketch, the artist worked directly in the Quattrocento tradition: circular, square and lozenge-shaped panels alternate on the ceiling, while the figures of the apostles occupy the spandrels.

The second sketch shows the results of a major development in the painter's ideas. Instead of being restricted to the sides, the pictorial compositions have taken over the space running down the length of the vault, and we can already see the painted cornices that prolong the thrones of the apostles and act as framing devices on the ceiling. Behind a large superimposed hand on this sketch, there is a large octagonal frame and a smaller rectangular one. At this stage of his design, Michelangelo had not yet worked out how to simulate the cornices; the solution was probably suggested to him by the architecture of the triumphal arches of Ancient Rome. There are two superb examples of this type of arch in the Sistine Chapel in the background of Perugino's 1483 fresco depicting *St. Peter receiving the Keys*. There is every reason to suppose that Michelangelo took his inspiration from there.

Like the first design for the ill-fated tomb of Julius II, the ceiling of the Sistine Chapel presents a complex pictorial and architectural composition marked by harmonies and rhythms that may sometimes appear disjointed, confusing and dissonant. From his earliest sketches, Michelangelo tackled the problem of relating the multitude of figures to the architectural illusion; the profusion of bodies and situations had to be subordinate to a structured and rational order. The solution came with the elaboration of a clear sequence of compositions that both limit and dominate the space as a whole. There is of course no unifying perspective system, for each panel has its own point of view. Analogies to this may be found in the Vatican *stanze* painted by Raphael and his assistants, and in the future compositions of the Mannerists.

There is also great variety in the scale of the figures, which range from near-lifesize to gigantic. Some figures are entirely nude, others discreetly semi-clad, and yet others draped in garments that may not be luxurious but express a tremendous formal energy. The age of the actors in this biblical drama runs through the entire spectrum from infancy to extreme old age, while the faces variously display beauty, realism, idealization or an almost caricatural ugliness.

Opposite

MICHELANGELO

The Garden of Eden

Detail. 1509-1510.
Middle fresco cycle
of the Sistine Chapel ceiling
before restoration.

Certain figures are androgynous, a curious feature that was already present in the artist's sculpture, just as it had existed in the pictorial tradition of the Quattrocento, with its many angels, *putti* and ephebes. But this sexual ambiguity appears with such insistence in this particular work that many Michelangelo scholars have sought to solve the riddle; but no consensus has been reached. There were bisexual beings in Greek mythology, as we know from Plato's famous *Banquet*, and certain esoteric Christian doctrines considered the androgyne a superior being, an ideal to which all should strive.

Michelangelo seems to have had rather limited and fairly negative relationships with women during his life, with the obvious exception of his famous friendship with Vittoria Colonna, which was based on an intellectual and idealistic exchange. One could interpret the appearance of androgynes in his work as the artistic sublimation of his underlying emotional problems and conflicts. They could also be a highly original response to the violent and overwhelming events that marked the first thirty years of the sixteenth century. We need mention only Luther's reforms (around 1520) and the terrible sack of Rome in 1527, when hordes of starving soldiers, some Spanish but mostly Lutheran, mercilessly plundered the Eternal City. With these and other tragic events came a profound crisis in values; the balance achieved during the Quattrocento had been lost, "Renaissance Man," combining artist, scholar and soldier, had become a figure of the past. The result was spiritual desolation, wars of religion and widespread carnage. The hopes raised by Savonarola proved ephemeral, and the Counter-Reformation, with its tribunals and propaganda, was not far behind. Michelangelo found himself at the centre of this maelstrom. His character and the dramatic events of his own life could only increase his sense of the precariousness of all earthly things and deepen his ingrained pessimism.

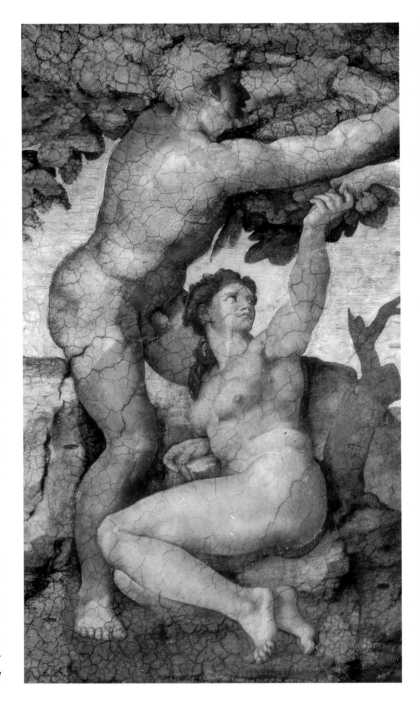

The Sistine Chapel ceiling appears as a long barrel vault dominated by a series of nine major compositions running down the middle and teeming on all sides with figures painted with a strong sculptural feeling. The first three panels illustrate the principal events of the Creation as related in the Book of Genesis: *God separating the Darkness and the Light*, *God creating the Sun and the Moon*, and *God*

The Sistine Chapel Frescoes

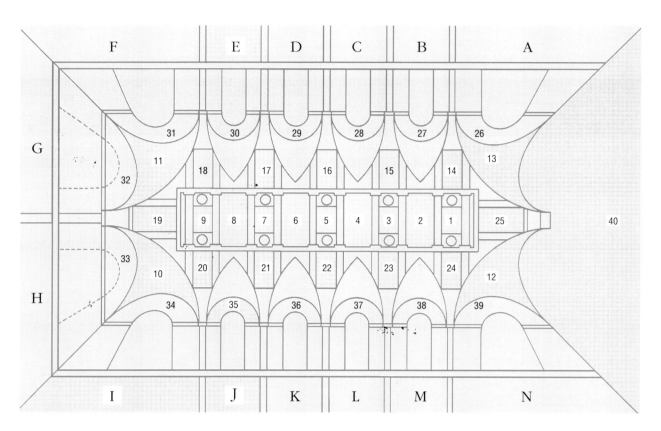

A. PERUGINO and PINTURICCHIO
 Moses' Journey to Egypt

B. SANDRO BOTTICELLI
 Scenes from the Life of Moses

C. COSIMO ROSSELLI
 The Crossing of the Dead Sea

D. COSIMO ROSSELLI,
 ASSISTED BY PIERO DI COSIMO
 Moses receiving the Tablets of the Law

E. SANDRO BOTTICELLI
 *The Punishment of Core
 Dathan and Abiron*

F. LUCA SIGNORELLI
 Moses' Testament and Death

G. MATTEO DA LECCE
 Dispute around Moses' Body

H. VAN DER BROECK
 The Resurrection of Christ

I. COSIMO ROSSELLI
 The Last Supper

J. PERUGINO
 Saint Peter receiving the Keys

K. COSIMO ROSSELLI AND PIERO DI COSIMO
 *The Sermon on the Mount
 The Healing of the Lepers*

L. DOMENICHINO GHIRLANDAIO
 The Calling of the First Disciples

M. SANDRO BOTTICELLI
 *The Temptation of Christ
 The Purification of the First Lepers*

N. PERUGINO AND PINTURICCHIO
 The Baptism of Christ

MICHELANGELO

1. *God Separating the Darkness and the Light*
2. *God Creating the Sun and the Moon*
3. *God Separating the Waters and the Earth*
4. *The Creation of Adam*
5. *The Creation of Eve*
6. *The Garden of Eden*
7. *The Sacrifice of Noah*
8. *The Deluge*
9. *The Drunkenness of Noah*
10. *Judith and Holophernes*
11. *David and Goliath*
12. *The Brazen Serpent*
13. *Haman and Esther*

14. *Jeremiah*
15. *The Persian Sibyl*
16. *Ezekiel*
17. *The Erythraean Sibyl*
18. *Joel*
19. *Zechariah*
20. *The Delphic Sibyl*
21. *Isaiah*
22. *The Cumaean Sibyl*
23. *Daniel*
24. *The Libyan Sibyl*
25. *Jonah*
26. *"Aminadab"*
27. *"Salmon, Booz, Obed"*
28. *"Roboam, Abiah"*
29. *"Ozias, Joatham, Achaz"*
30. *"Zorobabel, Abiud, Eliachim"*
31. *"Achim, Eliud"*
32. *"Jacob, Joseph"*
33. *"Eleazar, Matthan"*
34. *"Azor, Sadoc"*
35. *"Josiah, Jeochonias, Salathiel"*
36. *"Ezechias, Manasses, Amon"*
37. *"Asa, Josaphat, Joram"*
38. *"Jesse, David, Solomon"*
39. *"Naason"*
40. *The Last Judgment*

Frescoes reproduced
in this book.

separating the Waters and the Earth. The fourth shows the *Creation of Adam*, the fifth that of *Eve*, followed by *The Garden of Eden*. The last three panels all involve the story of Noah: *The Sacrifice of Noah, The Flood* and *The Drunkenness of Noah*.

Michelangelo did not follow the chronology of the Old Testament but placed the scenes involving Noah at the entrance and earlier events, such as the Creation of Light, above the altar at the back. The reason for this was that the nudity of the figures – Adam, Eve, and Noah and his sons – would have been considered shocking and incongruous in such close proximity to the altar. The existing separation of the nave into two separate spaces marked by a choir screen led the artist to create a bipartite division in the ceiling as well, with a "profane" part above the entrance and a "sacred" part at the altar end. The nude figures and the Garden of Eden naturally belonged to the former, while depictions of God and the Creation had their proper place in the latter. However, such theological considerations do not fully explain Michelangelo's choices.

But one fundamental aspect of his design is evident to all who follow the scenes from the entrance to the altar: the progression is towards the light and the Supreme Deity, beginning with the earthiness of *The Drunkenness of Noah* and ending with the ethereal Creation of Light by the Almighty. There is thus a liberating progression that moves from coarse materiality to the celestial realm. That this progression was intended seems confirmed by the attitudes of the two prophets at either end: Zechariah, near the entrance, is shown in a serene, almost banal pose, while Jonah at the opposite end, near God the Father, is depicted turning his gaze skyward, as if seized by divine inspiration, in a sort of contemplative ecstasy that charges and animates his muscular body, pointing him towards God and confirming the path from meditation to revelation.

Given the almost complete absence of writings or notes by Michelangelo on his Sistine Chapel frescoes, one of the greatest problems in studying this work is the many interpretations – often contradictory – that have accumulated over the centuries. In addition to the obvious biblical references, authors have cited the influence of Plato and the Neoplatonists, of Savonarola[1], and any number of abstruse

1. According to Charles de Tolnay and Frederick Hartt (see Bibliography).

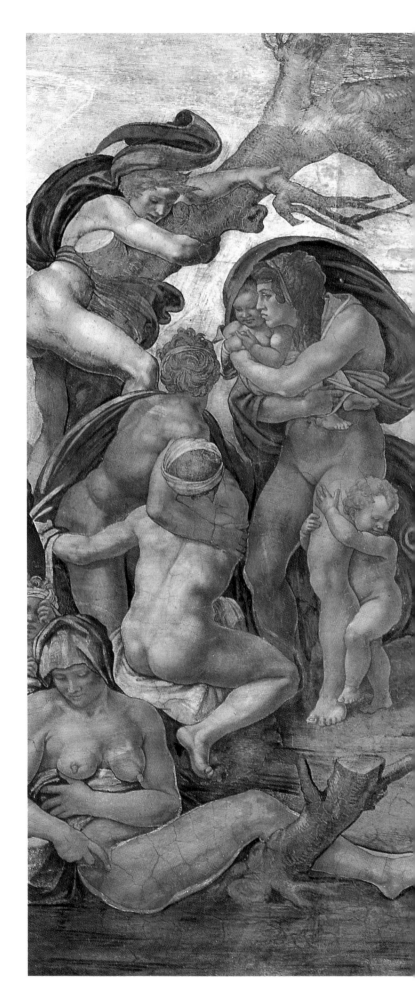

RAPHAEL SANZIO
The Disputation of the Holy Sacrament
1508-1511.
Fresco in the Stanza
della Segnatura, Vatican.

PREVIOUS PAGE
MICHELANGELO
The Flood
1508-1509. Middle fresco cycle of
the Sistine Chapel ceiling
before restoration.

theological speculations. For this reason, it is better to abandon the search for an – at best – elusive meaning or intellectual key and concentrate instead on the visible reality of the images created by the painter: to consider the spaces, the poses and the faces as charged with an immediately accessible meaning, and not as the mere illustration of some theological or philosophical doctrine. In all likelihood, Michelangelo had very little actual knowledge of Plato's thought or of Neoplatonic ideas, and his classical culture was surely as limited as Leonardo da Vinci's. Although he had been a familiar of the great humanists who frequented Lorenzo the Magnificent's court, he seems not to have indulged much in reading the classics of Antiquity.

To fully appreciate the extraordinary complexity of the Sistine Chapel ceiling, it must be remembered that Michelangelo's relationship with religion was as intense as it was conflictual. In fact, it seems never to have brought him much peace, serenity or hope. He once wrote to his brother, "I have no friends, and want none," and often gave vent to his deep-seated pessimism in his *rime* and correspondence. Michelangelo is a unique figure in the history of art because he was one of the first artists to seek isolation for its own sake. He shunned honours, and turned a hostile back to the society that sought him out. Withdrawn into his own world, wary of power and the incessant intrigues it fostered, he was strongly attracted to the Christian message, but considered it his prize alone. To develop it in himself, he had to opt for solitude and poetic meditation. Tormented by the idea of death, yet sceptical of eternal redemption, he lived ascetic-ally, hermit-like, even though he had amassed a considerable fortune.

At the opposite extreme, Raphael Sanzio lived in Rome like a prince, surrounded by a suite of disciples and admirers. His studio was organized along modern lines for the production of pictorial works of greater or lesser format. To help him with his commissions, he had a team of assistants hand-picked and directed by Giulio Romano. Marshalling all of his talent and genius, Raphael endeavoured to fulfil the slightest wishes of his patrons. The painter of *The School of Athens* was a master of perspective as absolute symbol of religious doctrine, as we can see in his *Disputation of the Holy Sacrament.* He put his great technical expertise

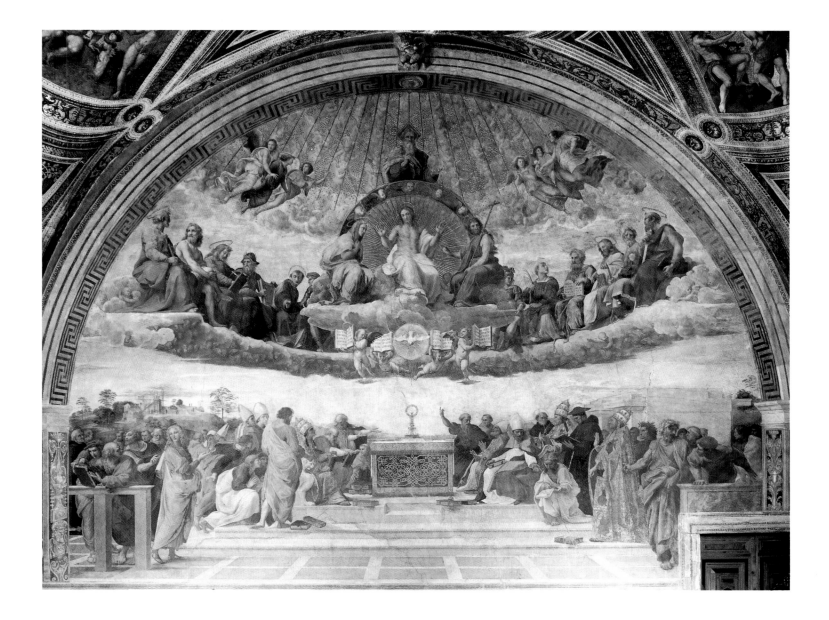

in the service of the Christian ideal, and effected a perfect harmony between its metaphysical message and the newly-reinstated pictorial tradition stemming from Antiquity.

Michelangelo, labouring alone on his images on the Sistine Chapel ceiling, seems to have been in search of a spiritual meaning in figurative form. No two characters were as different as Michelangelo and Raphael, as revealed in this telling – but no doubt apocryphal – exchange between the two artists. On seeing Raphael pass by in the company of his disciples, Michelangelo quipped: "You look like a prince in the midst of his court." To which the elegant Sanzio replied harshly: "And you are returning alone, like an executioner."

The biblical fresco cycle of the Sistine Chapel ceiling is characterized by a great originality, as if informed by a new creative impulse. In one scene from the Book of Genesis

Opposite

Top

MICHELANGELO

The Drunkenness of Noah

1509. Middle fresco cycle of the Sistine Chapel
ceiling before restoration.
170 x 260 cm. (5 $^1/_2$ x 8 $^1/_2$ ft.).

Bottom

MICHELANGELO

The Sacrifice of Noah

1509. Middle fresco cycle of the Sistine Chapel
ceiling before restoration.
170 x 260 cm. (5 $^1/_2$ x 8 $^1/_2$ ft.).

Following pages

MICHELANGELO

The Flood

1508-1509. Middle fresco of the Sistine Chapel
ceiling before restoration.
280 x 570 cm. (9 x 18 $^1/_2$ ft.).

(9:20-27), having survived the Flood and worked in the fields until exhausted, Noah falls asleep, drunk and naked on the ground, where he is found by his son, Ham. Michelangelo first represented him in another part of the panel as a sturdy patriarch tilling the soil, and only in the second part did he show him drunk, leaning against a wine barrel while Ham covers his nakedness with a cloth, and his two other sons, Shem and Japheth, stand together in poses similar to the nudes of the *Doni Tondo*.

Nudity here should not be considered as either indecent or provocative, but, as in the *Doni Tondo*, the natural and spontaneous state of humanity in an ideal Golden Age before the Fall. The realism with which the bodies are represented is remarkable, and there are reminiscences of Dionysian models in this scene.

The following panel chronologically precedes the one just described, for the Bible first speaks of a Flood lasting forty days and forty nights (7:24-8). Traditionally, artists represented the recession of the waters and the appearance of the dove with the laurel leaf as a sign of hope, but Michelangelo chose instead the moment of greatest violence and despair, when no escape seemed possible, and humanity was reduced to the state of beasts fighting for their lives. In all, there are sixty-two figures – and one donkey, a symbol of Christ – swimming and struggling desperately in a flooded landscape from which only a small island emerges and, in the background, Noah's Ark. The artist portrayed a large variety of human types and ages, depicted in every conceivable attitude.

In 1797, an explosion in the arsenal of the Castel Sant'Angelo damaged the upper right section of *The Flood*, leading to the loss of the leafy tree that formerly balanced the remaining barren tree. As it is, landscape elements are few and far between in the Sistine Chapel frescoes, and so the loss of this tree was a major one; all the more so as it probably represented the only sign of hope and renewal in this otherwise bleak vision of the first humans. This intrinsic pessimism also appears in Michelangelo's poetry. In lines from a 1524 poem we read: "My soul speaks with Death, seeking counsel, and because of fresh suspicions becomes each day more sad, my body daily longing to part company." The artist depicted the Flood as the inevitable and constant presence of Evil, the ruthless struggle of brother against brother to prevail and survive in mortal form.

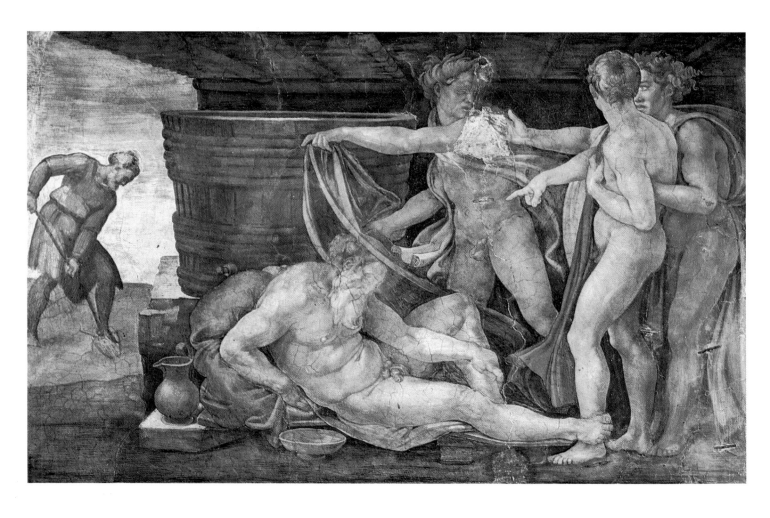

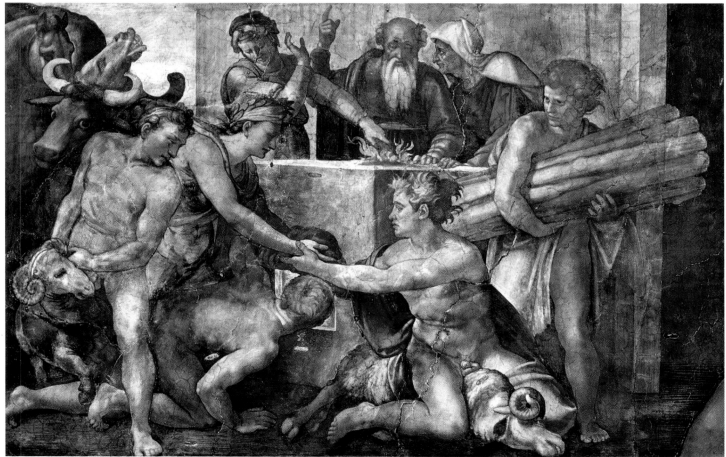

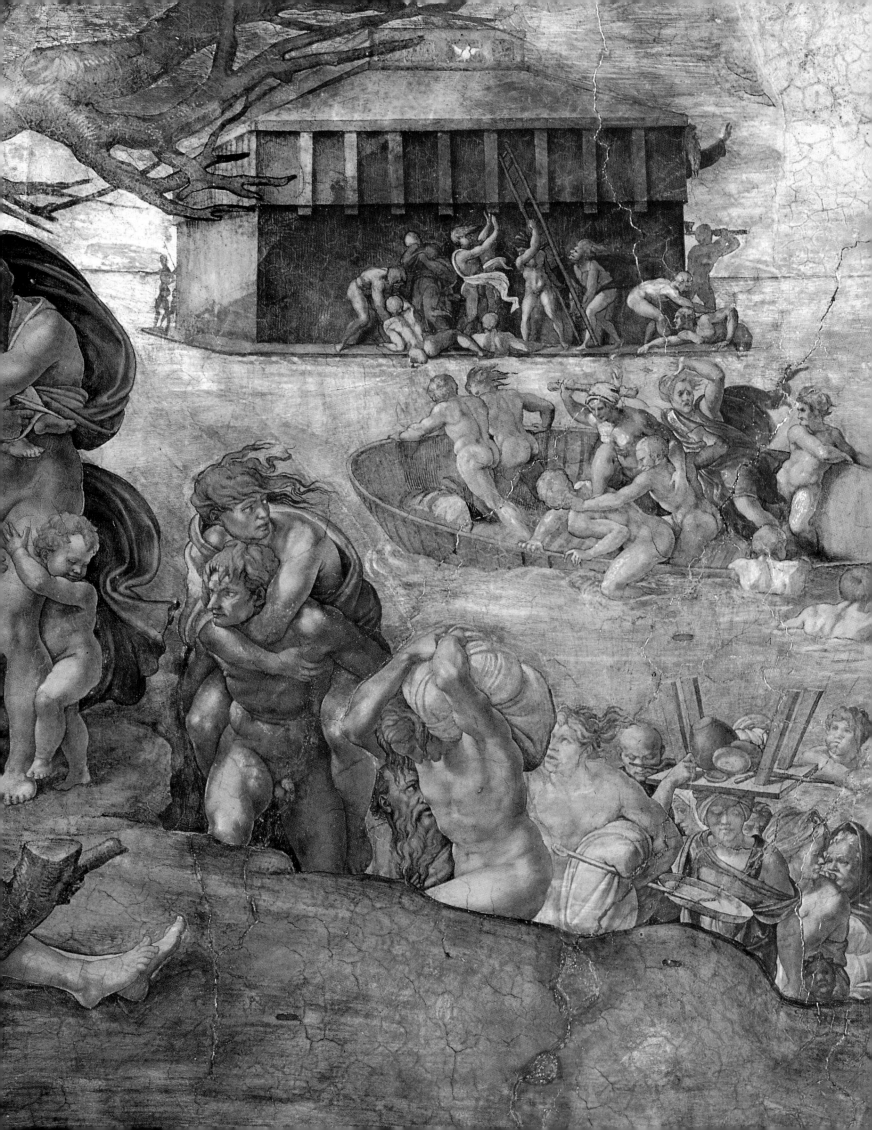

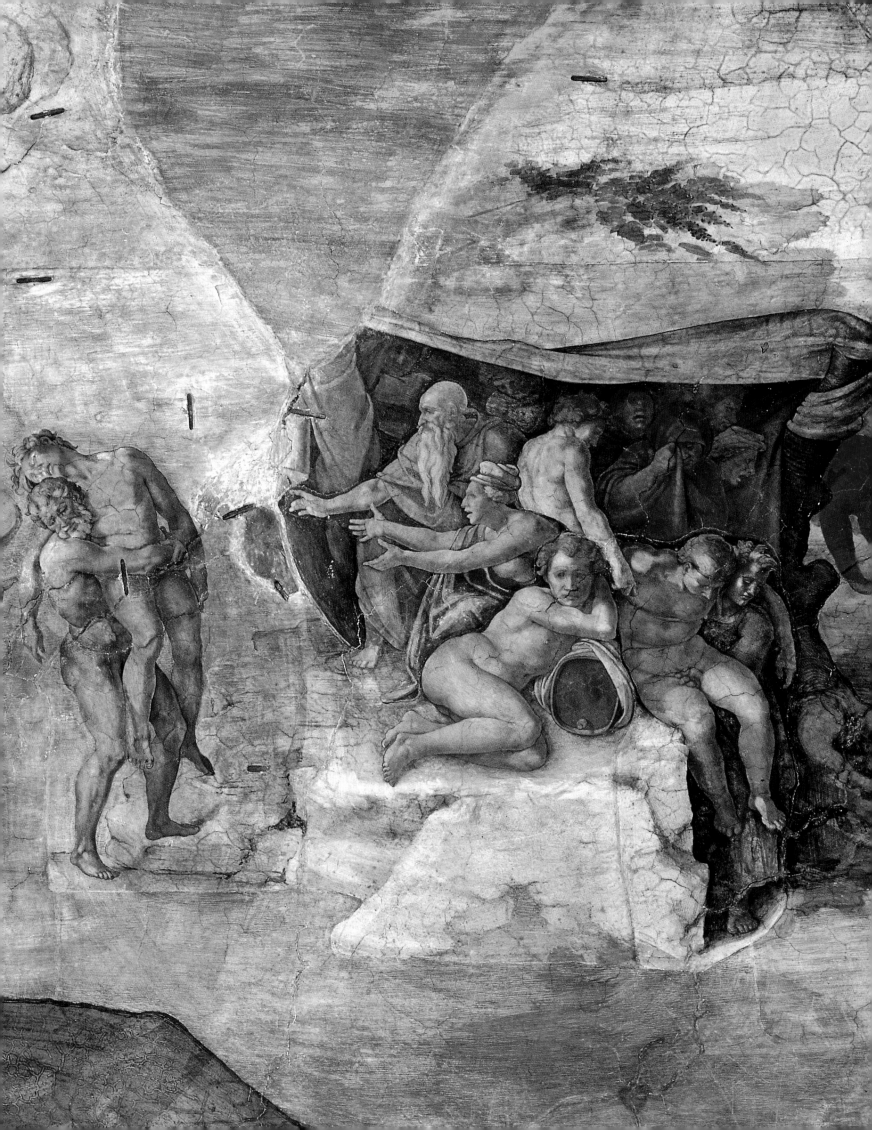

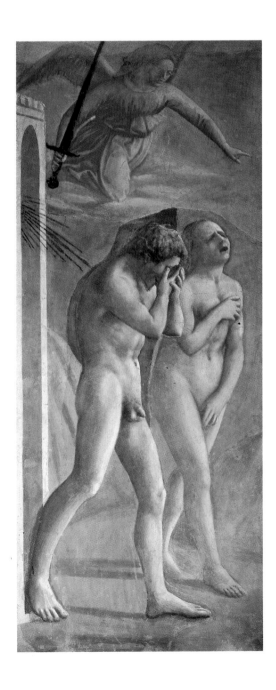

MASACCIO

The Expulsion from Paradise

1426-1428. Fresco in the Brancacci Chapel.
Santa Maria del Carmine, Florence.

OPPOSITE

MICHELANGELO

The Sacrifice of Noah

Detail. Middle fresco of the Sistine Chapel
ceiling before restoration.

Directly above the entrance is a fresco entitled *The Sacrifice of Noah*, whose meaning is difficult to interpret today. Some authors believe that it represents Noah making burnt offerings (Genesis 8:20) – while others have read it as "the Sacrifice of Isaac," or that of Cain and Abel. The task of interpretation is not facilitated by such details as the object which the figure astride a sacrificed ram is holding out, and which does not seem to be animal entrails; or the enigmatic, woman with the profile of a sorceress who is whispering something to the patriarch. Rosso Fiorentino, a famous Mannerist painter and great admirer of Michelangelo, painted the same subject in the fresco cycle he executed for François I's gallery at Fontainebleau in 1540.

The panel representing the *Garden of Eden* and *The Expulsion of Adam and Eve* introduces an entirely different conception of figures in a spatial composition. The complexity of the first panels here gives way to a clear, spare depiction of the events. The scene is set in a bare, almost abstract setting, a space out of time and history. The anatomy of the bodies is more and more graphically depicted, focusing the attention on the telling poses and gestures of the figures. This pictorial idiom, with muscular volumes picked out by strong contrasts of light and shade, is very close to sculpture in its effect.

To illustrate the temptation of Adam and Eve and their expulsion from the Garden of Eden, Michelangelo combined two successive episodes into one: temptation and the expulsion of the couple are represented in the same compositional space, separated only by the Tree of Knowledge of Good and Evil: "And the Lord God planted a garden eastward in Eden; and there he put the man he had formed. And out of the ground made the Lord God to grow every tree that is pleasant to the sight, and good for food; the tree of life also in the midst of the garden, and the tree of knowledge of good and evil." (Gen. 2:8-9).

For Buonarotti, painting at the beginning of the sixteenth century, the Earthly Paradise was no longer the medieval garden of delights full of blossoms and palm trees. Gone are the beatific beings that fill the paintings of Fra Angelico; gone also is the happiness that is such a conspicuous feature of Raphael's fresco in the Stanza della Segnatura, or of the Limbourg brothers' illuminations for the *Très riches heures du Duc de Berry*. The idea of *felix culpa* is completely absent here. Not only that, but the traditional view of Eve's preponderant responsibility is not represented; instead we see

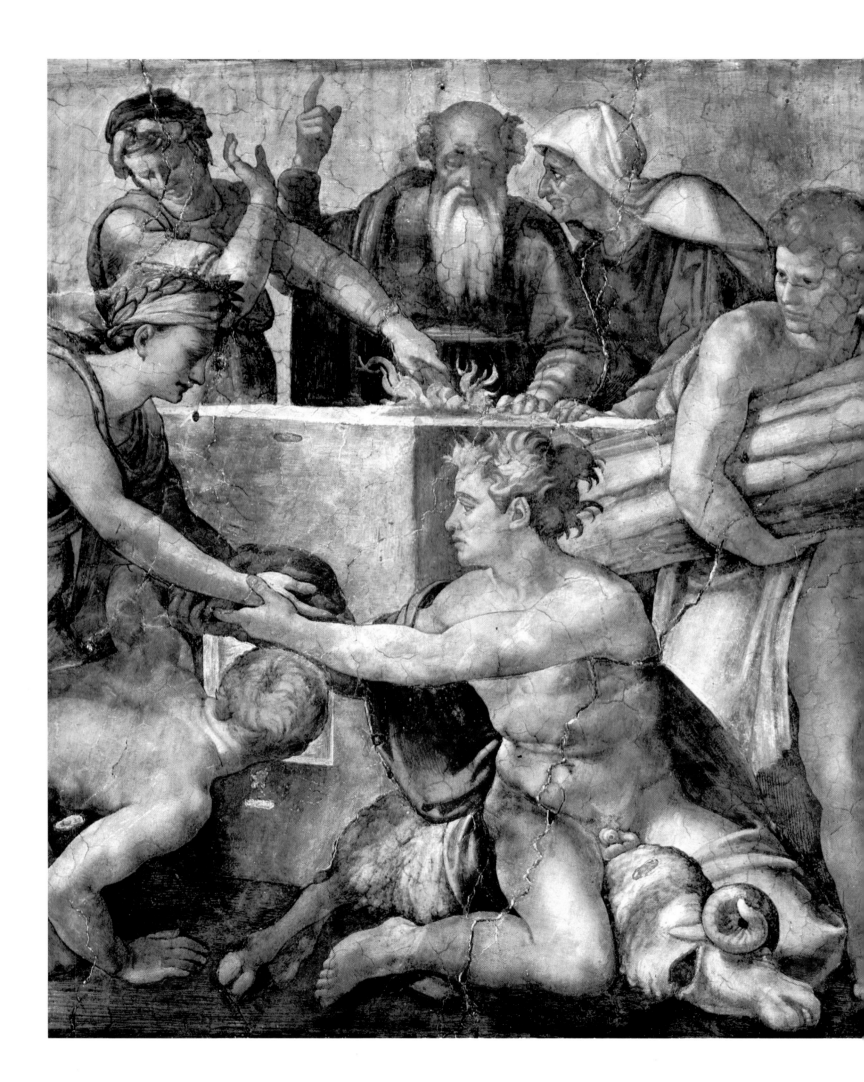

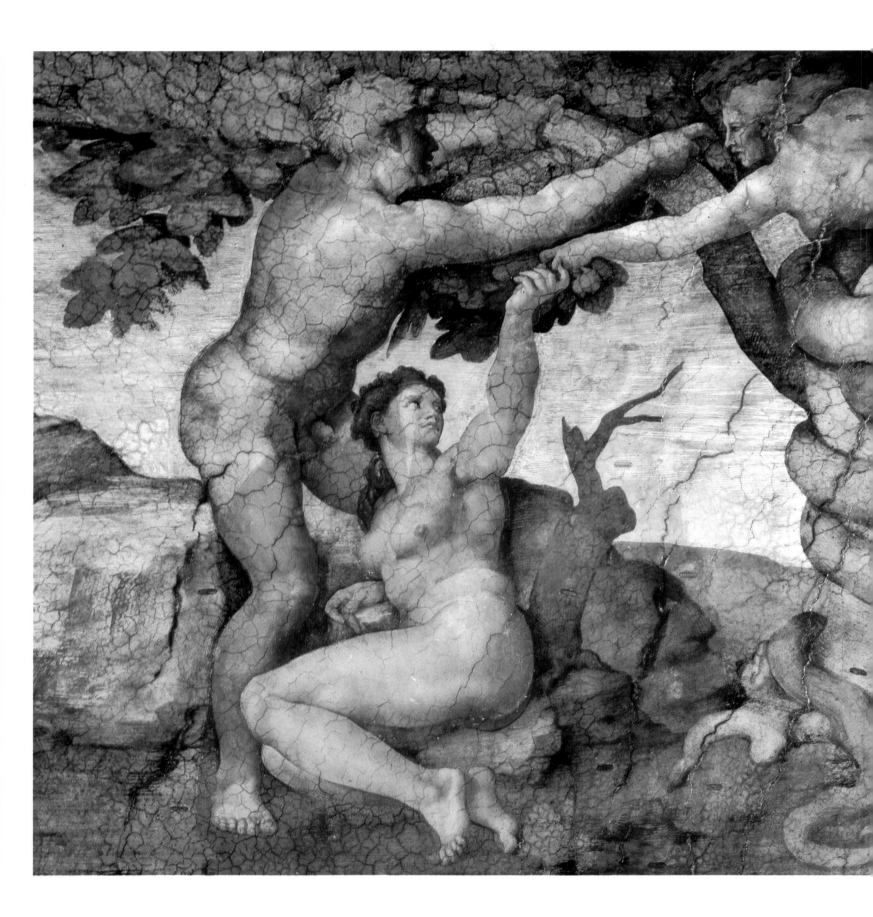

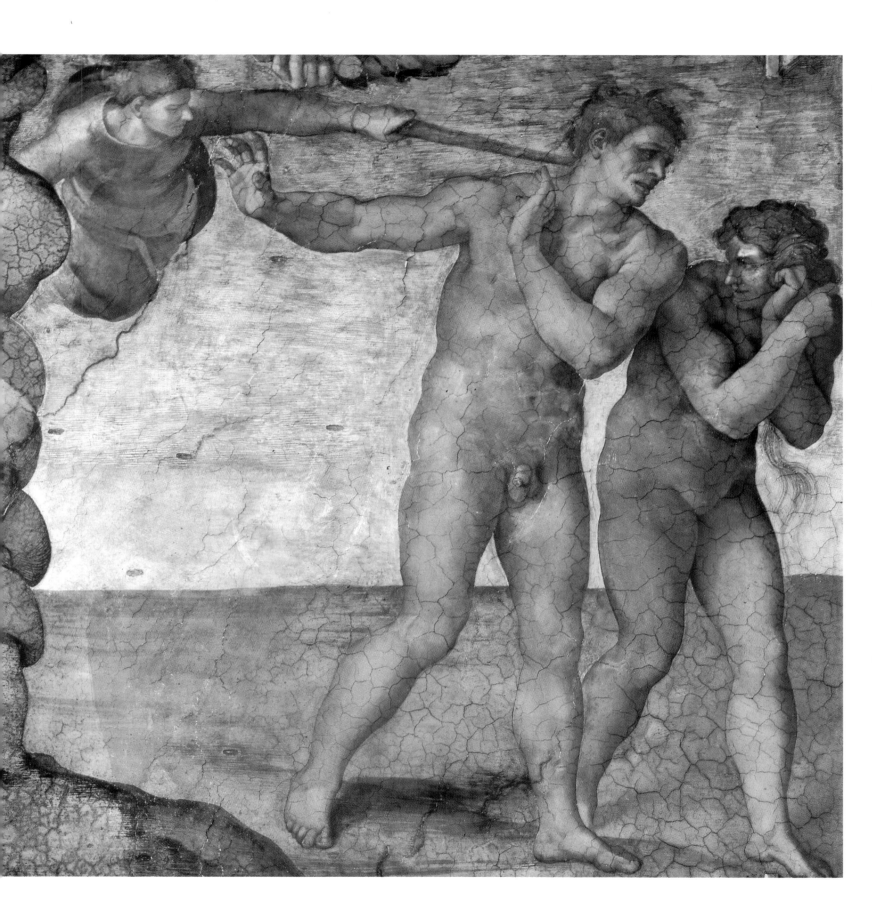

PREVIOUS PAGES

MICHELANGELO

The Garden of Eden

1509-1510. Middle fresco cycle
of the Sistine Chapel ceiling before restoration.
280 x 270 cm. (9 x 10 ¹/₂ ft.).

OPPOSITE

MICHELANGELO

**Sketch of Adam for the *Creation of Adam*
in the Sistine Chapel**

Around 1511. Red chalk.
Department of Drawings, Louvre Museum, Paris.

BELOW

MICHELANGELO

Androgynous figure in the *Creation of Adam*
Detail.

Adam eagerly grabbing the fruit, while Eve reaches out for it with an elegant and sensual gesture, their bodies joined in an ascending spiral of transparent eroticism. Next to Eve, at the foot of the tree, the roots take on the serpentine forms of the temptress twined around the tree. The landscape visible on the right is green, but deserted.

There are evident analogies between Michelangelo's fresco and the famous *Expulsion from Paradise* by Masaccio in the Chiesa delle Carmine in Florence. Here the angel of the Lord ("He placed at the east of the garden of Eden Cherubims and a flaming sword which turned every way...," Gen. 3:24), has no visible wings, and the gates have disappeared, as have the rays representing God's voice. Where Masaccio's Adam retained a sort of athletic dignity, Michelangelo's figure seems crushed by his fall from grace. Masaccio's Eve recalls the *Venus pudica* type of Antiquity her mask of grief notwithstanding, while Michelangelo's is quite different, similar in expression to his *Cumaean Sibyl,* broken in spirit and cringing with shame. The sculptural and well-shaped body of Masaccio's Eve has been replaced by one devoid of all beauty or sensual appeal. Michelangelo's Eve of the Expulsion displays no feminine graces, but rather a masculine build, although in the Temptation scene her anatomy is more nuanced, neither male nor female.

In his *Creation of Adam,* Michelangelo took a masterful step away from the traditional iconography. According to the Old Testament text, God created Adam in two distinct phases: first, in an eminently sculptural gesture, he fashioned his body out of a lump of earth and filled it with the breath of life: "And the Lord God formed man of the dust of the ground, and breathed into his nostrils the breath of life; and man became a living soul" (Genesis 2:7), the "the Lord caused a deep sleep to fall upon Adam, and he slept: And he took one of his ribs, and closed the flesh thereof... And the rib, which the Lord God had taken from man, made he a woman, and brought her unto the man" (Genesis 2:21-22).

Through the will of God, Eve emerges in a diagonal from the sleeping Adam's side, almost as if she were levitating, while the Maker stands motionless at the far right of the composition. This figure of God is closer to a prophet, a figure like Jeremiah, than to the ethereal divine presence looming in the panels above the altar. Yahweh[2] and Eve

2. Yahweh, – falsely transliterated as Jehovah – is an archaic form of the Hebrew verb "to be", and can be translated as "I am that I am."

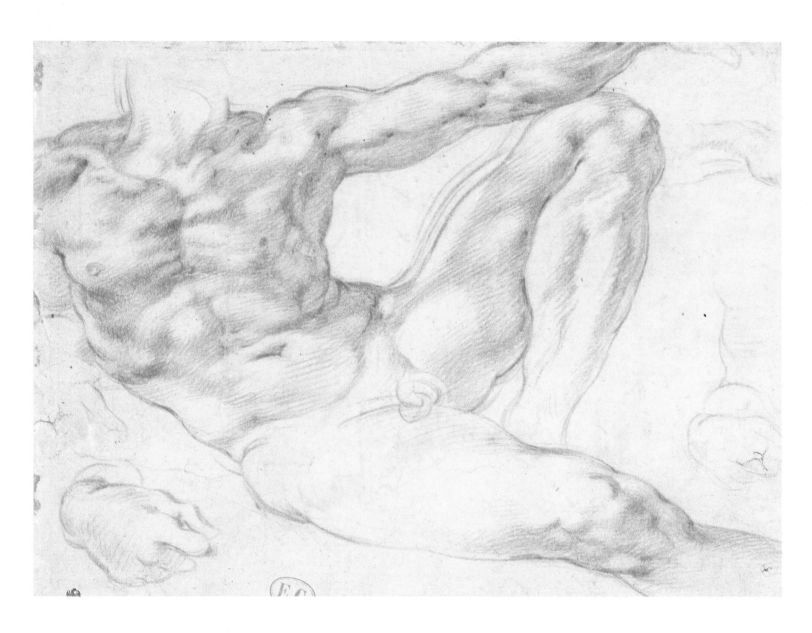

look at each other intently, locked in an intimate bond. Adam leans against a tree stump its meaning not entirely clear: the tree of death before the coming of the Messiah?

In the panel depicting the Creation of Man, Adam does not need to be animated with the breath of life; he is already physically complete and alive, reclining indolently, resting on one elbow, turning a delicate and nostalgic gaze towards his Maker, who is on the right. Adam's physique presents various peculiarities, such as a disproportion in the outstretched arm, which seems to have been "geometricized," and deep hollows around his neck. The position of the right leg and the form of the toes anticipate those of the figure of *Dawn* in the Medici Chapel at San Lorenzo, in Florence.

FOLLOWING PAGES
MICHELANGELO
The Creation of Adam
1510. Middle fresco cycle
of the Sistine Chapel
ceiling before restoration.
280 x 570 cm. (9 x 18 $^1/_2$ ft.).

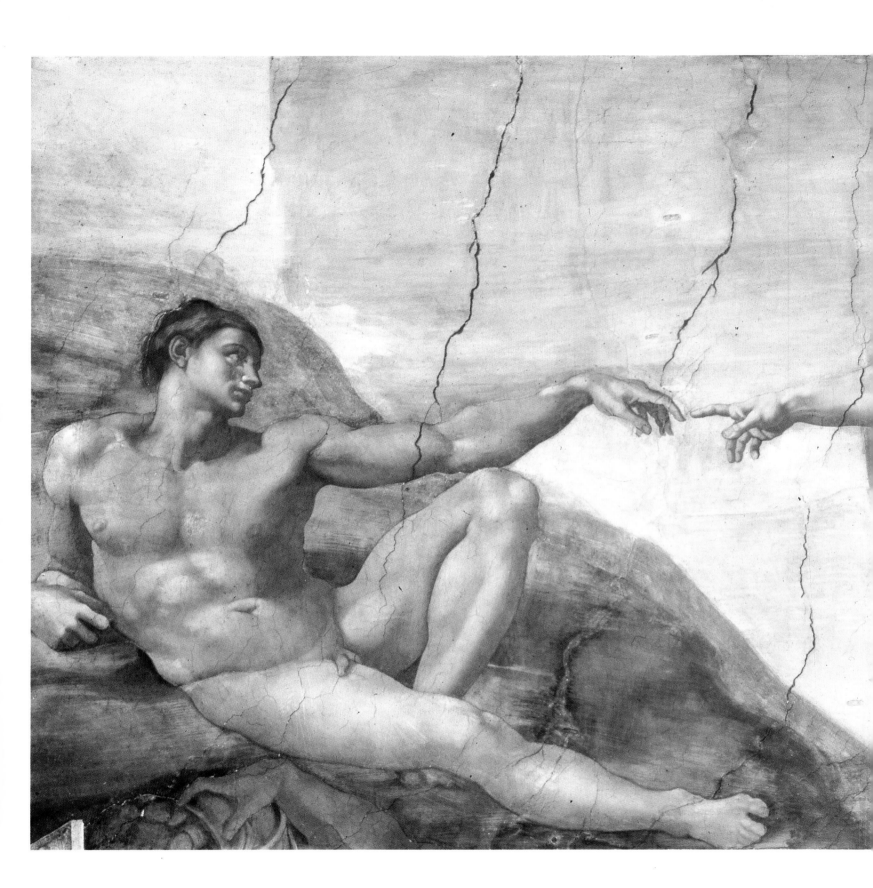

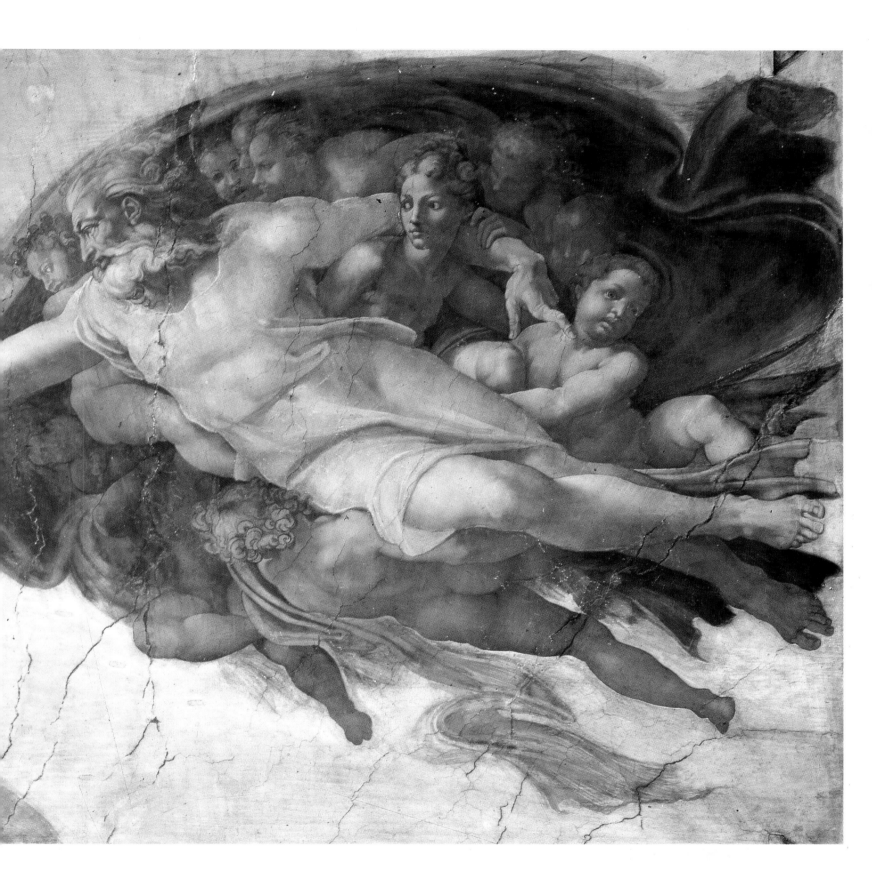

In this scene, God the Father is a vigorous old man, stern and fierce, like Moses in the Wilderness. He is going towards the first man on a cloud of billowing drapery, accompanied by mysterious beings. This Supreme Being may have been modelled on figures of Coelus, the ancient god of the heavens. His highly original pose, however, has something in common with the figures of Nike on victory arches[3].

Vasari, writing in the 16th century, described the accompanying figures as *alcuni putti*, or "various putti." But neither he nor Condivi offers any explanation for the extraordinary "female" figure nestled in the crook of God's arm. There is no clue to either its function or its sexuality.

3. Charles de Tolnay, *Michelangelo*, Flammarion, Paris 1970, p. 72 (Introduction).

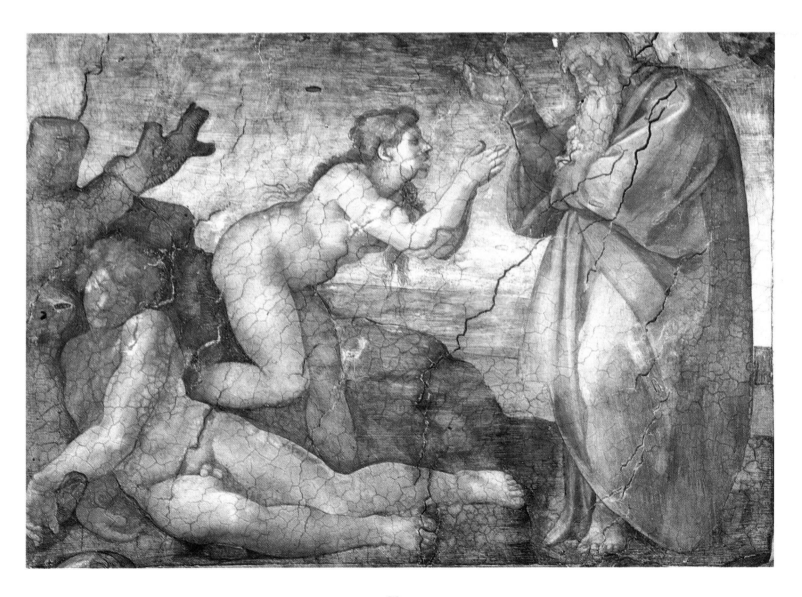

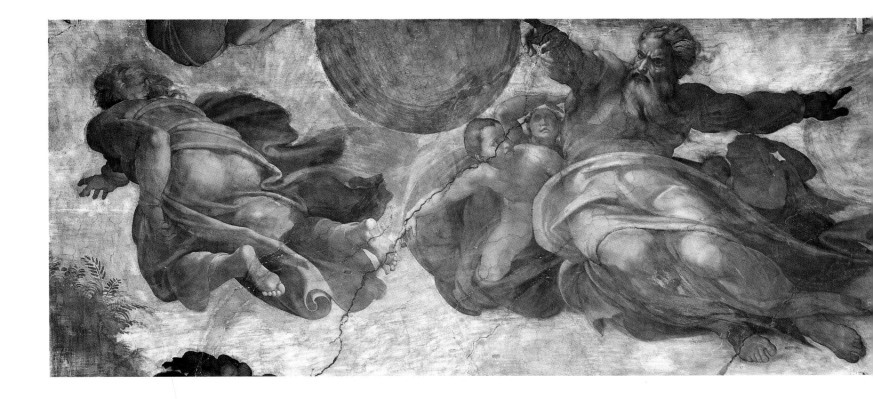

Is it male or female? This androgyne has the head of a woman, but no breasts, and somewhat virile arms. For more than three centuries, nothing more was said about this figure until the French photographer Adolphe Braun published an album presenting one hundred and twenty details of the Sistine Chapel ceiling in 1870. It then became obvious that it is female, giving rise to a torrent of interpretations that has yet to abate. The femininity of the figure encircled by God's arm has been confirmed by the latest restoration of the frescoes. This is another example of the many androgynes that peopled Michelangelo's work from his earliest years.

In the last three scenes from Genesis, situated just above the sacred zone over the altar, Michelangelo further simplified the spatial indications, eliminated naturalistic details and concentrated on the dynamic and all-powerful figure of Yahweh, master of the Heavens. From multiplicity back to the Supreme Being: I am that I am.

"In the beginning God created the heaven and the earth. And the earth was without form, and void; and darkness was upon the face of the deep. And the spirit of God moved on the face of the waters" (Genesis 1:1-2). The fresco representing *God separating the Waters and the Earth* has a whirling, airy dynamism that underscores God's gestures, and one can almost feel the wind gusting as it fills his ample draperies. The figure of the Creator hovering

MICHELANGELO

God Creating the Sun and the Moon

1511. Middle fresco cycle
of the Sistine Chapel
ceiling before restoration.
280 x 570 cm. (9 x 18 ¹/₂ ft.).

OPPOSITE

MICHELANGELO

The Creation of Eve

1509-1510. Middle fresco cycle
of the Sistine Chapel ceiling
before restoration.
170 x 260 cm. (5 ¹/₂ x 8 ¹/₂ ft.).

above the as yet uninhabited Earth is accompanied by three *putti*-like angels. The exact nature of the scene, however, is not entirely clear; there are details missing, even if we follow Vasari's account relating it to the Book of Genesis (1:9): "God said: let the waters under the heaven be gathered together under one place, and let dry land appear." In fact, the dominant image is that of God, which fills the pictorial space alone except for three cherubim cowering against his mighty body.

This splendid isolation is modified somewhat in the next scene, *God creating the Sun and the Moon,* in which Yahweh no longer occupies the whole space but floats with his arms outstretched, his two index fingers pointing in a gesture of creative power. Condivi wrote of this panel: "In the second space is the creation of the two great sources of light, in which He appears with arms outstretched, His right arm pointing towards the sun and His left towards the moon." Michelangelo's biographer goes on to explain that Yahweh is shown a second time in the same scene, on the left side of the composition. It is a very curious figure, seen from the back and highly foreshortened, anonymous, almost superfluous. He gives us no explanation, however, for the very expressive *putti* figures that crowd around the Creator on the right. They are referred to as *agnoletti,* or "little angels," and one of them hides his face in his turban to "protect himself from the evil influence of the moon." This feeling of anxiety or potential evil seems to be shared by the four cherubim. The combination of two sequential events in a single image reveals Michelangelo's attachment to certain medieval practices, which he perpetuated in his art.

In the last biblical episode, *God separating the Darkness and the Light,* which was the first act of creative differentiation, Yahweh is again shown in splendid solitude, an aerial being dominating the composition with his presence and projecting his will onto the elements. His body melts into the cloud masses to form a double spiral: "And God saw the light, that it was good: and God divided the light from the darkness" (Genesis 1:3). The general conception presents a cosmic union between the Creator's body and the primordial elements, which he disposes according to his will in a world devoid of gravity or earth-bound contingencies.

Opposite
MICHELANGELO
God Separating the Darkness and the Light
1511. Middle fresco cycle
of the Sistine Chapel
ceiling before restoration.
180 x 260 cm. (5 x 8 $^1/_2$ ft.).

82

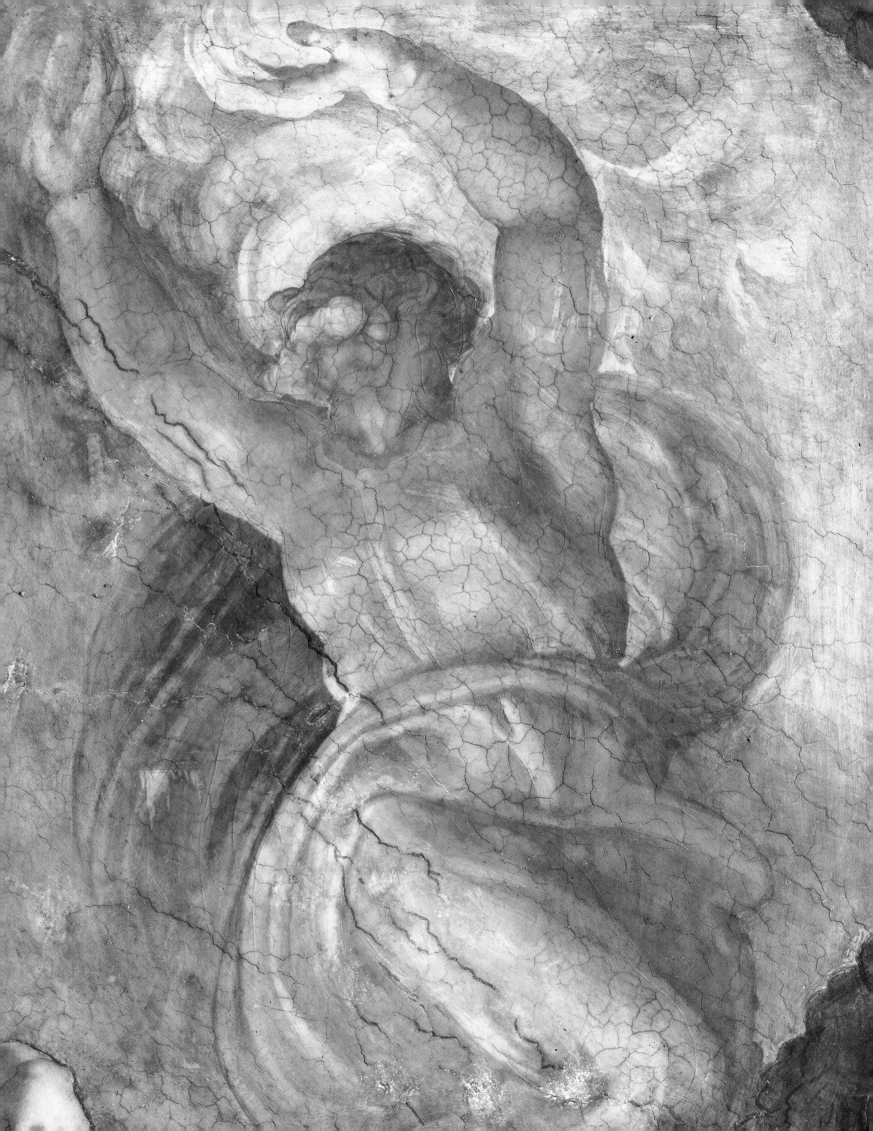

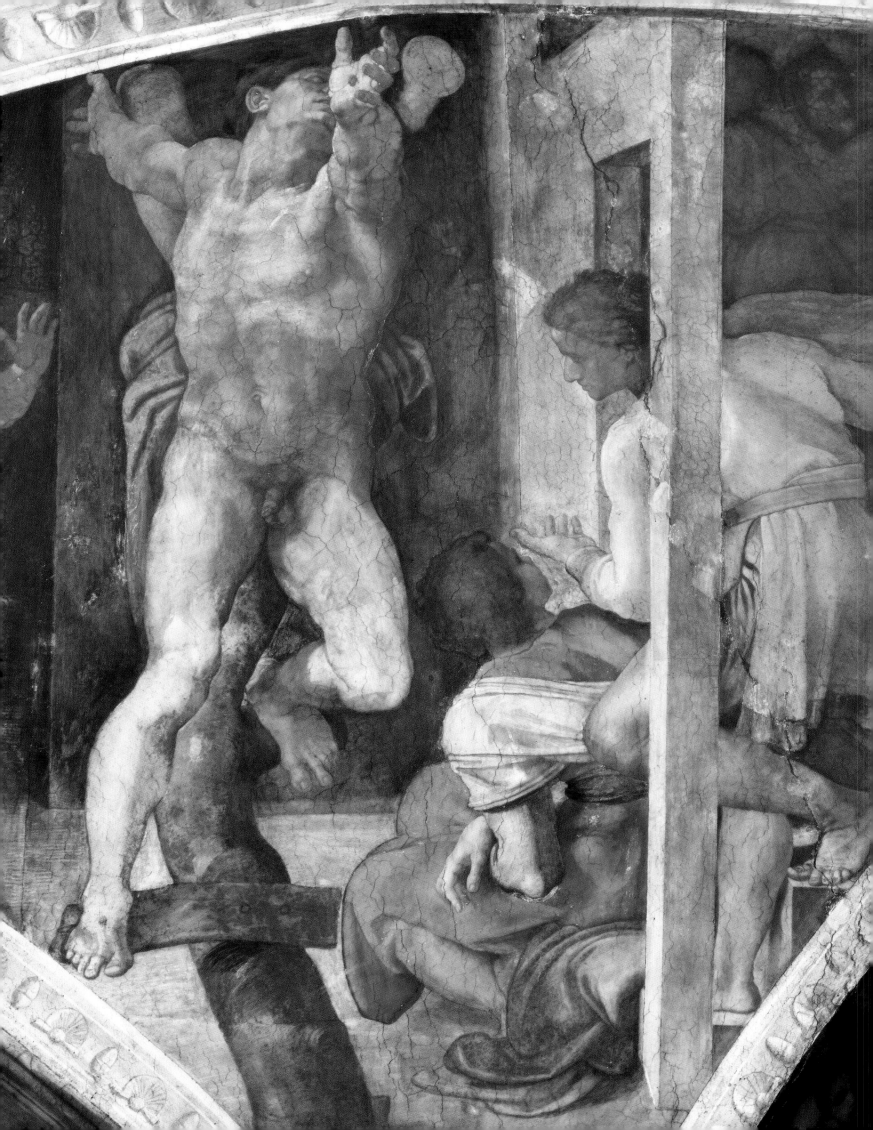

5 THE SISTINE CHAPEL Prophets, Sibyls, Attendants, and Monumental Nudes

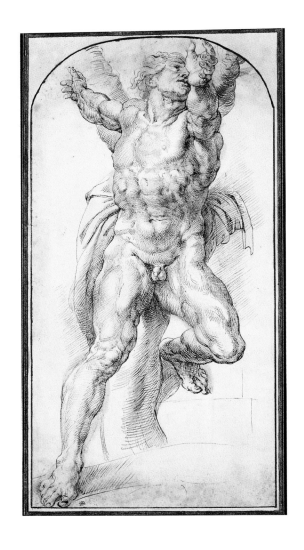

Since the Middle Ages, it had become the custom to combine the prophets of the Old Testament – the precursors of the Messiah – and figures of sibyls from the pagan world of Antiquity in a single iconographic cycle as premonitory figures heralding the coming Christian salvation and redemption.

But it is difficult to determine the exact reasons for Michelangelo's choice of figures for the Sistine Chapel ceiling. One indication may be in the general pictorial scheme: the central section of the ceiling leads from the entrance (Genesis) to the altar, which is dominated by the aerial figure of the Creator. This longitudinal arrangement is connected to the decorative cycle below (lunettes and Quattrocento frescoes) through the figures of the prophets and the sibyls, which articulate and punctuate the middle parts of the vault like so many mysterious and significant echoes. This conjunction is strongly underlined by the four scenes represented at the four corners of the ceiling. The artist chose scenes full of omens and violence, treating them with a more down-to-earth realism and dispensing with the grave, heroic and noble style of the long middle section.

The first scene, located in the corner pendentive to the left of the entrance, depicts *Judith and Holophernes*, a dramatic incident from the Bible: "And Judith was left alone in the tent with Holophernes, slumped in his bed, sodden with wine.... She stepped over to the bead, near Holophernes' head and unsheathed his scimitar.... She struck two blows

PETER-PAUL RUBENS
Drawing of Haman,
copy after the Sistine Chapel ceiling
Pen and ink touched up with oil.
42 x 21.5 cm. (16 $^1/_2$ x 8 $^1/_2$ in.).
Department of Drawings,
Louvre Museum, Paris.

OPPOSITE
MICHELANGELO
Haman and Esther
1511. Fresco. Corner pendentive
of the Sistine Chapel ceiling
before restoration.
585 x 985 cm. (19 x 32 ft.).

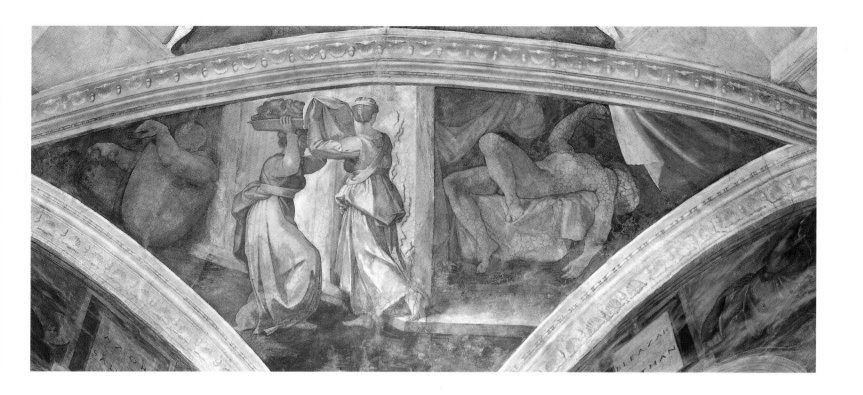

MICHELANGELO

Judith and Holophernes

Detail. Fresco. Corner pendentive
of the Sistine Chapel ceiling
before restoration.
570 x 970 cm. (18 ¹/₂ x 32 ft.).

OPPOSITE

MICHELANGELO

David and Goliath

Detail. 1509. Fresco. Corner pendentive
of the Sistine Chapel ceiling
before restoration.
570 x 970 cm. (18 ¹/₂ x 32 ft.).

to the neck with all her might and removed the head.... Shortly after, she left the tent and gave the head to her servant, who put it into a bag of provisions" (Judith 13:6- 10). In his depiction of this event, Michelangelo did not show the heroine in triumph, for, though she is leaving the tent, the perils are not yet past; they must still walk through the camp and avoid the guards. The elegant gestures of the two women contrast starkly with the horrible contortion of the decapitated body.

In *David and Goliath*, the corner pendentive to the right of the entrance, we see a depiction of the Jewish hero diametrically opposed to the famous 1504 statue in Florence. All of the iconographic details have changed: David appears as a frail, somewhat awkward adolescent wielding an overweight scimitar. Goliath is lying on the ground but raising himself on his powerful arms. The Philistine giant could still turn the tables on the youthful hero and win. It is interesting to note that the theme of a young man standing over an older man and defeating him was taken up again by Michelangelo, with slight modifications, in the sculpture group titled *Victory,* which he executed in 1532 for the tomb of Julius II.

Haman and Esther, which is also represented to the right of the entrance, is a biblical incident involving Esther, the niece of Mordecai and a former Jewish slave who became the wife of King Ahasuerus. After a series of conspiracies and persecutions against the Hebrew people, Haman was condemned to death by King Ahasuerus: "Behold, I have given Esther the house of Haman, and him they have hanged upon the gallows because he laid his hand upon the Jews" (Esther 8:7). Here again, Michelangelo strayed from the biblical and invented a bizarre crucifixion scene. The upper part of Haman's body is shown in extreme foreshortening, a true technical feat, considering the shape of the wall and the irregular triangular format of the pendentive. Haman's powerful chest and musculature are reminiscent of the *Laocoön* group, the Hellenistic masterpiece whose discovery in Rome in 1506 moved Michelangelo to tears. There are many interpretations of the figure of Haman, the most obvious one being that he is a prefiguration of the martyrdom of Christ, even though he played an inverse role as persecutor of the Jews. Seldom has a human figure so powerfully expressed the struggle against adversity, the desperate effort

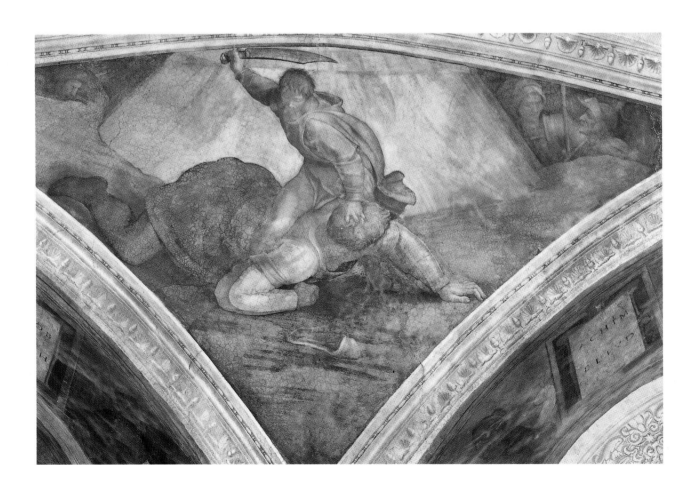

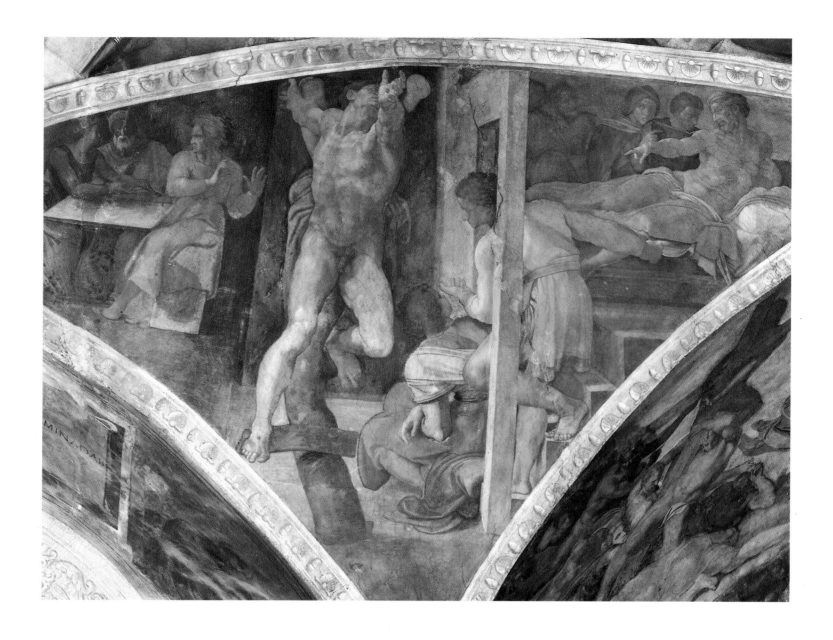

MICHELANGELO
Haman and Esther
Detail. 1511. Fresco. Corner pendentive
of the Sistine Chapel ceiling
before restoration.
585 x 985 cm. (19 x 32 ft.).

OPPOSITE

The Brazen Serpent
Detail. 1511. Fresco. Corner pendentive
of the Sistine Chapel ceiling
before restoration.
585 x 985 cm. (19 x 32 ft.).

to gain freedom, a theme that Michelangelo would transpose into sculpture in his *Slaves*.

The artist's independent spirit comes to the fore in his rendering of the *Brazen Serpent*, the subject of the fourth and last corner pendentive, in which the figure of Moses should play a predominant part. In the Old Testament account, the Hebrew people fleeing to Transjordania lost patience and rebelled against God and his prophet, Moses. As a punishment, Yahweh "sent fiery serpents among the people, and they bit the people; and much people of Israel died" (Numbers 21:6). The renegades then repented and begged Moses to free them from this affliction. "And the Lord said unto Moses, Make thee a fiery serpent, and set it

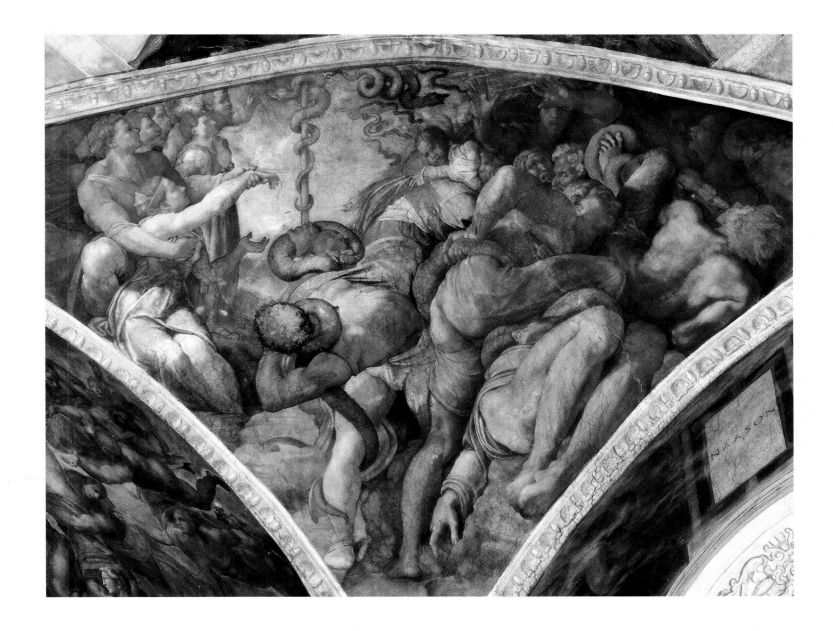

upon a pole: and it shall come to pass, that everyone that is bitten, when he looketh upon it, shall live" (Numbers 21:8).

Michelangelo's composition played with spectacular effects of compression, contortion and deformation of the bodies fallen prey to the plague of serpents but already saved by a serpent raised up on a pole like a paradoxical prefiguration of Christ the Redeemer. But where is Moses? Some authors think he is the young man holding the woman on the left, others, the figure at the upper right, his hands raised in terror. It would be more in keeping with Michelangelo's deep-seated pessimism, however, to conclude that the saviour is absent, and that the people are abandoned to divine vengeance

without hope of intercession. As far as style is concerned, the foreshortening of the figure against the cornice already contains the seeds of the Mannerism of such painters as Rosso, Beccafumi, Pontormo and Parmigiani.

Many interpretations, some pertinent, others extravagant, have been advanced for the iconography of the Sistine Chapel ceiling. The twenty large masculine nudes commonly referred to as the *Ignudi*, positioned in pairs to frame the nine central panels of the vault, have been the object of much discussion since the sixteenth century. During Michelangelo's lifetime, they were considered as symbols of a new golden age in the antique style inaugurated by the papacy of Julius II della Rovere. Pope Sixtus IV, the supreme pontiff when the chapel was built in 1473, was a member of the same family. It should also be noted that Donatello and Domenico Ghirlandaio, Michelangelo's painting master, had already created figures very close to these *ignudi*. From the iconographical standpoint, they were developed in the Quattrocento out of figures of angels without wings and bearing emblematic attributes. In some cases they have a ribbon round their heads, like the victorious athletes in Antiquity; in others they just display a healthy nudity seemingly for its own sake. This was surely not out of pure provocation on Michelangelo's part, but must have corresponded to more complex formal requirements and aesthetic meanings. In the Neoplatonic explanation of these great nudes, they represent distinct parts of the human constitution as envisioned by Platonic thought. According to this theory, the human microcosm was composed of three basic parts: the body, the rational soul and the intellect. Thus the *putti* holding up the cartouches represent the body, the little "attendants" of the sibyls and prophets symbolize the rational soul, and the monumental nudes along the vault stand for the intellect. The latter figures are conceived of as concealing symbolic intentions which, like so many others, are beyond our powers of comprehension. In any event, these figures present an astonishing variety of anatomical forms and psychological states, ranging from the melancholic and choleric to the dionysian.

As for the Old Testament prophets and Graeco-Roman sibyls that flank the central panels, they were already represented together in medieval iconography. A noteworthy example is the cycle painted on the façade of Siena

OPPOSITE
MICHELANGELO
Nude, or **Ignudo**
Fresco situated above the prophet Isaiah.
Sistine Chapel ceiling before restoration.

FOLLOWING PAGES
MICHELANGELO
Pair of Nudes, or **Ignudi**
1509-1510. Fresco situated
above the prophet Ezekiel.
Sistine Chapel ceiling before restoration.
185 x 395 cm. (6 x 13 ft.).

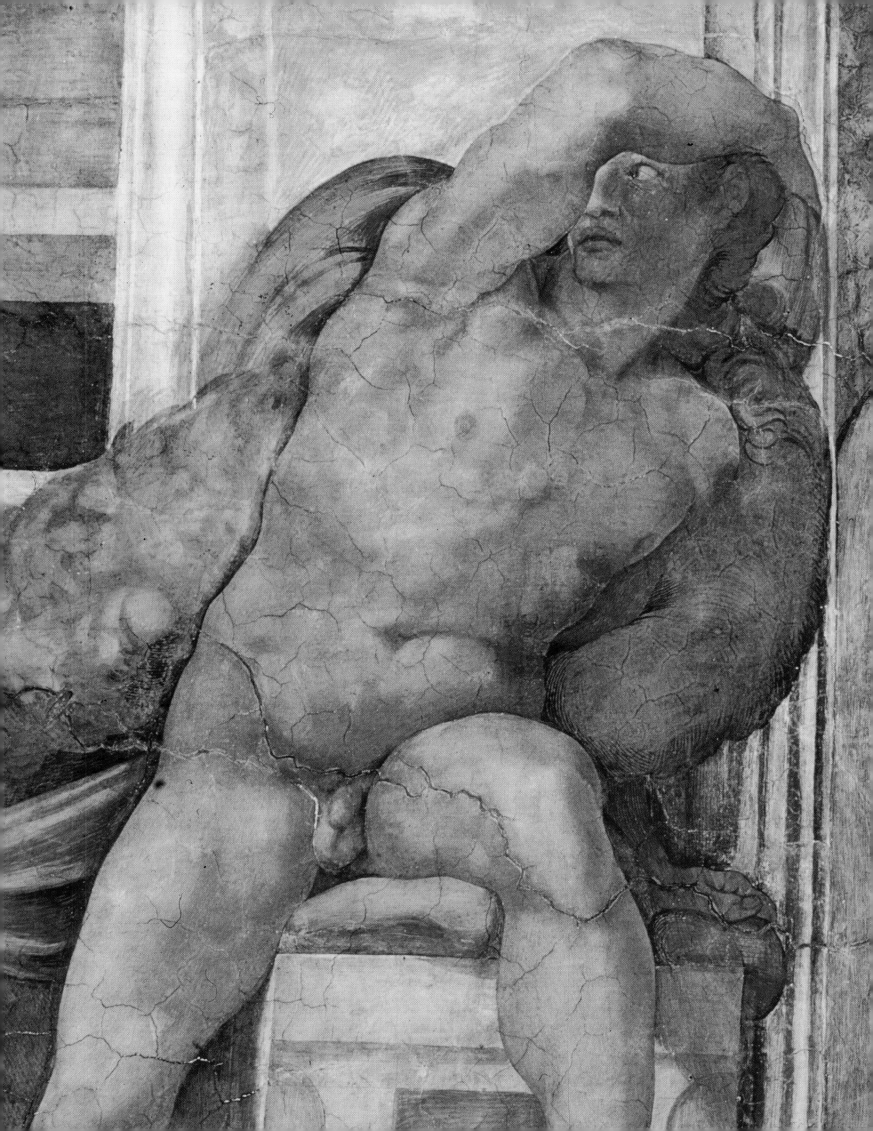

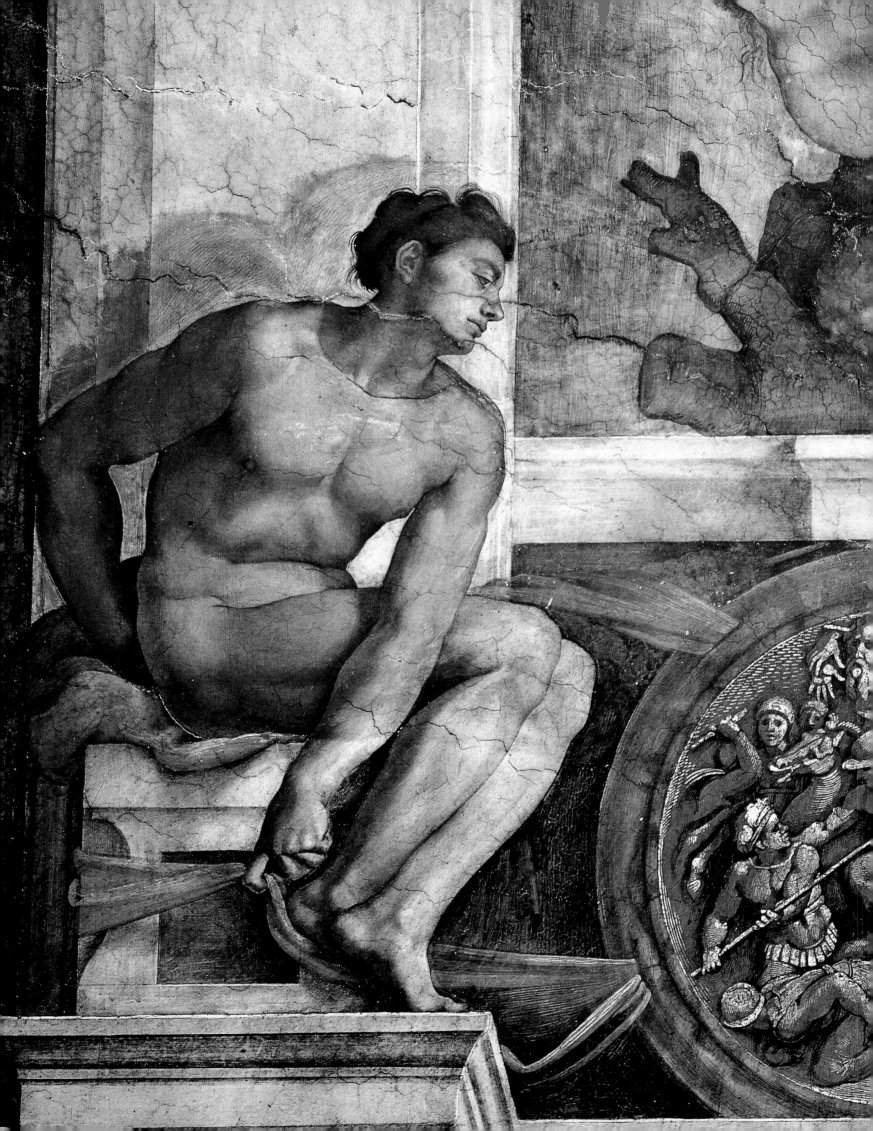

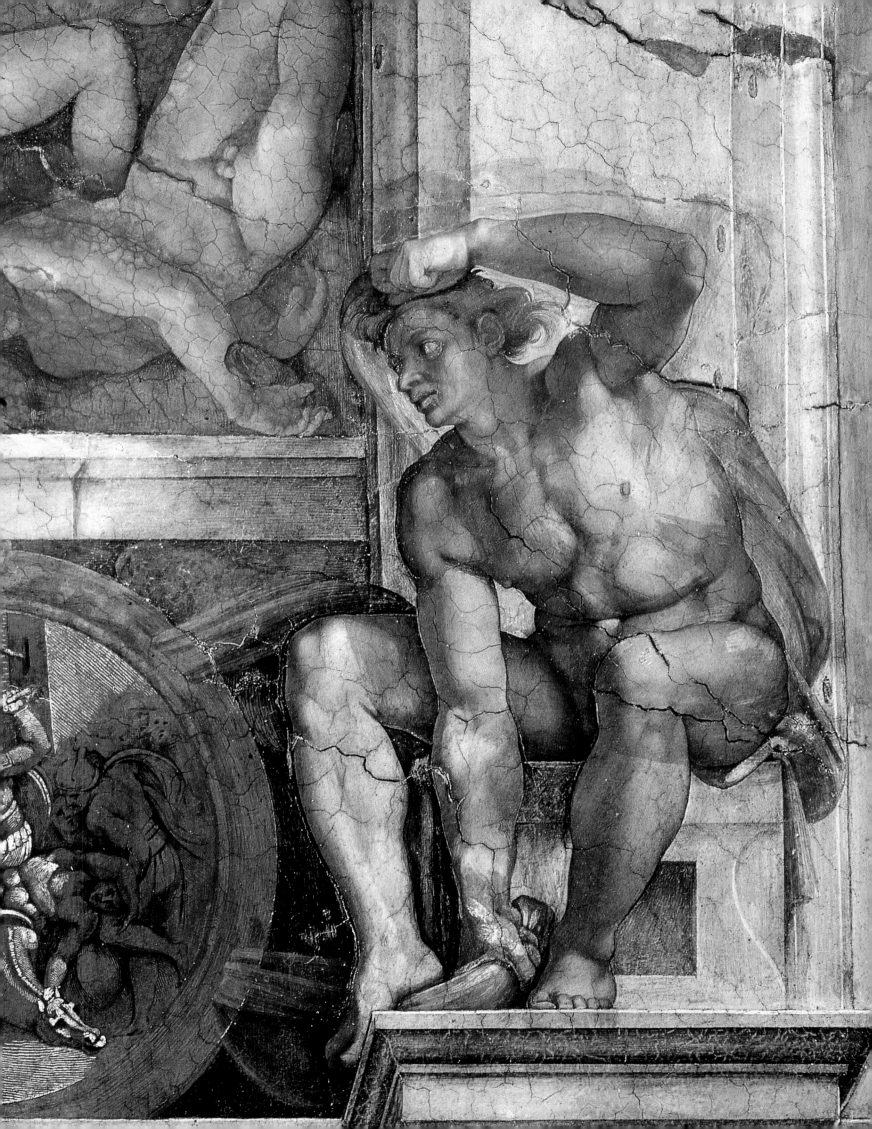

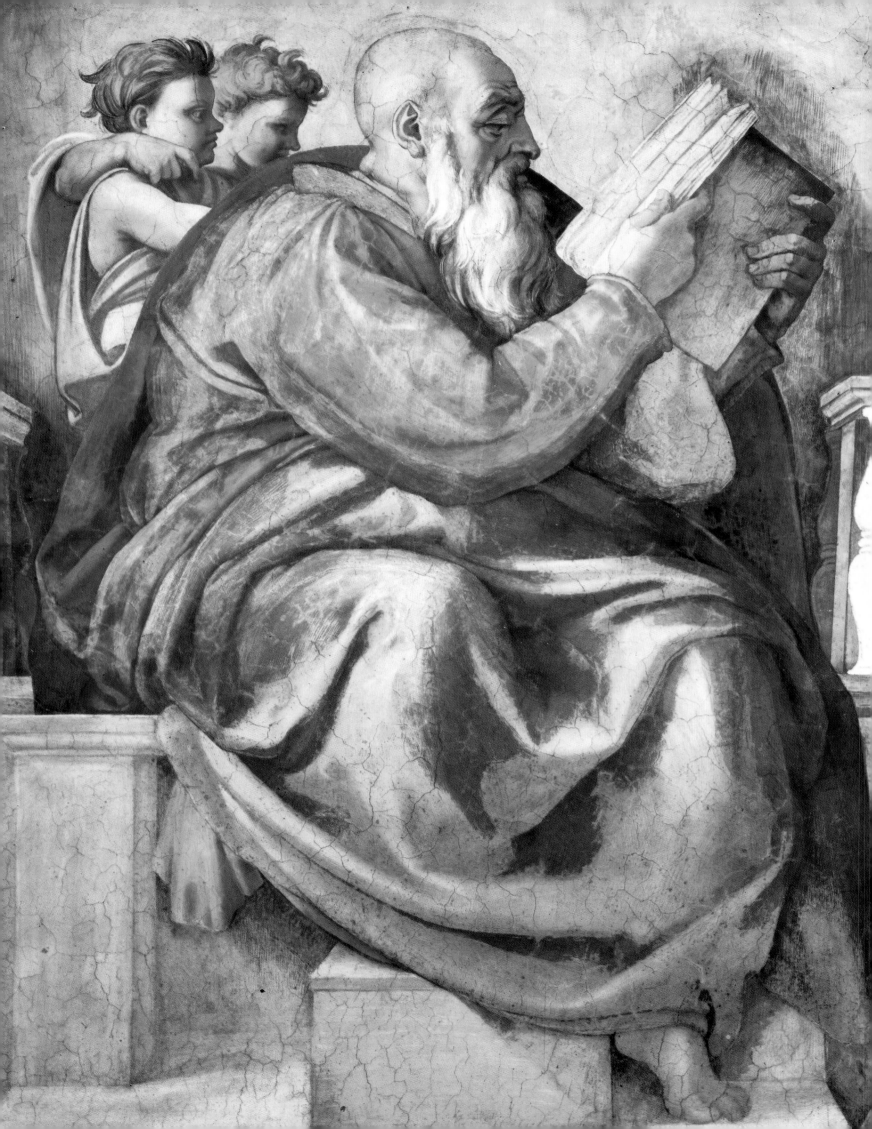

Cathedral by Giovanni Pisano in the late thirteenth century.[1] But, as we have already stated, we have no way of knowing the deeper reasons for Michelangelo's choice of these seven prophets and five sibyls, each holding a book of prophecies and accompanied by attendants in highly varied poses. The prophets are gigantic and increase in size from the entrance to the altar.

Although these figures are human, they have oracular powers, and could well be channels for the Divine Spirit which hovers above their thrones. Seers with monstrous bodies, women with ambiguous anatomies, all have an insight into divine matters through the special powers of their mind. On a more functional level, they unite the pagan world with the world of the Scriptures.

The prophet *Zechariah*, placed just above the entrance, opens the way to the altar. Draped in an ample cloak, he gazes intently, with furrowed brow, at an open book, taking no notice of his two attendants, who are both gazing at the book. Zechariah is a symbol of Law, of the papacy, and of Julius II's projects; he embodies reflection and the search for truth.

Among the female figures, the *Delphic Sibyl* is notable for her elegance, strength and seductive femininity. With a determined gesture, she holds an unrolled scroll in one hand and a piece of cloth in the other. She resembles antique models and recalls the Virgin of the *Doni Tondo*, but her two attendants come from another world. They face each other across an open book held by a figure that is more dionysian and closer to the animal world.

Opposite her, at the base of the vault, we see the superb figure of the prophet *Joel* absorbed in reading a manuscript. He is associated with Pentecost, an important occasion that was celebrated in the chapel during the conclaves by a mass to the Holy Ghost. This figure could be a likeness of the architect Bramante, but it may be just a typical humanist scholar.

For all its virile and classical beauty, the figure of the prophet *Isaiah* seems to be in the throes of doubt. He has interrupted his reading of a tome, holding his page with one finger, and turns toward his attendant, listening to what he is saying, yet displaying some anxiety. The attendant's floating

1. In his Mystic Lamb altarpiece from 1432 (Saint Bavon Cathedral, Ghent), Jan van Eyck also represented the sibyls of Cumaea and Eruthraea with the prophets Zechariah and Micah.

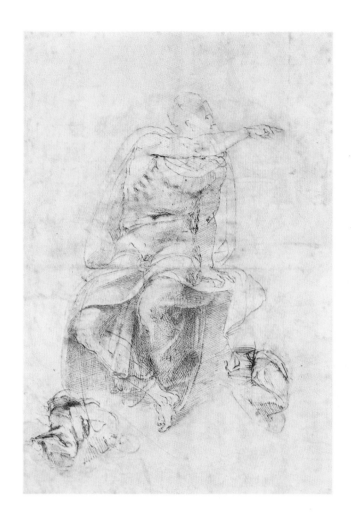

MICHELANGELO
**Study for one of the prophets
of the Sistine Chapel**
Pen and ink.
Musée Condé, Chantilly.

OPPOSITE
MICHELANGELO
The Prophet Zechariah
1509. Fresco. Sistine Chapel ceiling
before restoration.
Height 390 cm. (12 3/4 ft.).

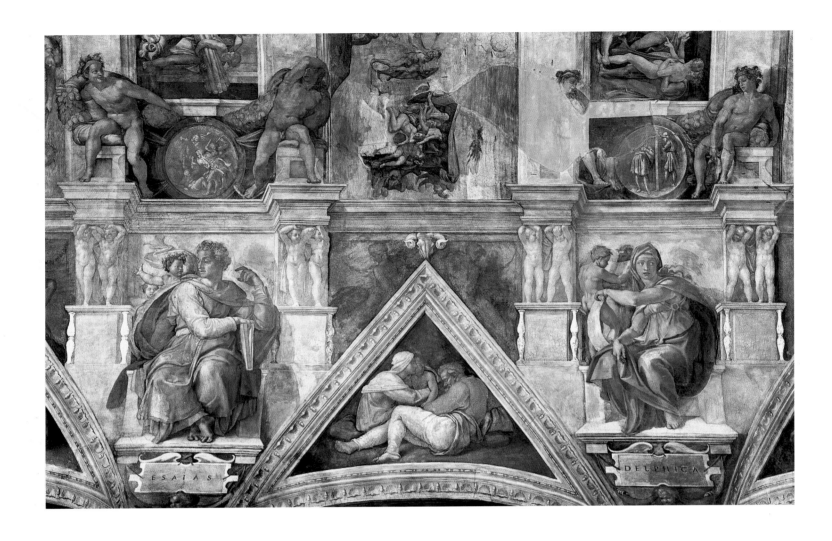

MICHELANGELO
The Prophet Isaiah and the Delphic Sibyl
1509. Fresco. Ceiling of the Sistine Chapel
before restoration.
Height 380 cm. (12 ft.).

OPPOSITE
MICHELANGELO
The Delphic Sibyl
Detail. Height 380 cm. (12 ft.).

green drapery leads the gaze upwards, toward the middle part of the vault, where *The Sacrifice of Noah* is represented.

Opposite Noah sits the *Erythraean Sibyl,* a figure with muscular arms turning the pages of a book on which only the letter "Q" can be deciphered. She gives the impression of turning towards the figure of *Ezekiel,* who seems to be calling her. One of her attendants is lighting a lamp that probably has a Christian significance, such as the immortality of the soul transcending the body's limitations. The other attendant is rubbing its eyes, as if dazzled by the sibyl's oracular powers.

Of all the figures in this cycle, the *Cumaean Sibyl* is surely the most disquieting. She is the embodiment of the seeress with unlimited and disturbing powers. With a somewhat sceptical expression, she is consulting the Book of Wisdom, but without seeming to find any trace of truth in it. Her relatively diminutive head, marked by age, is

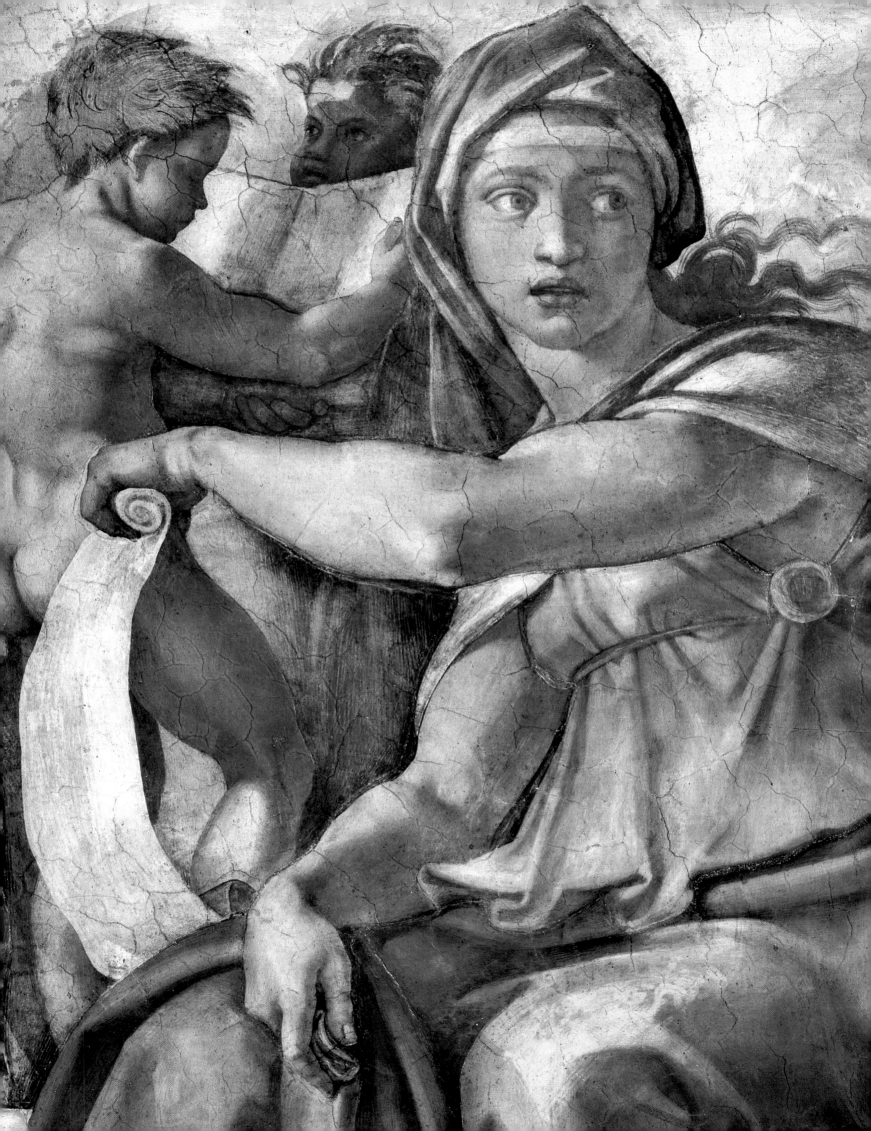

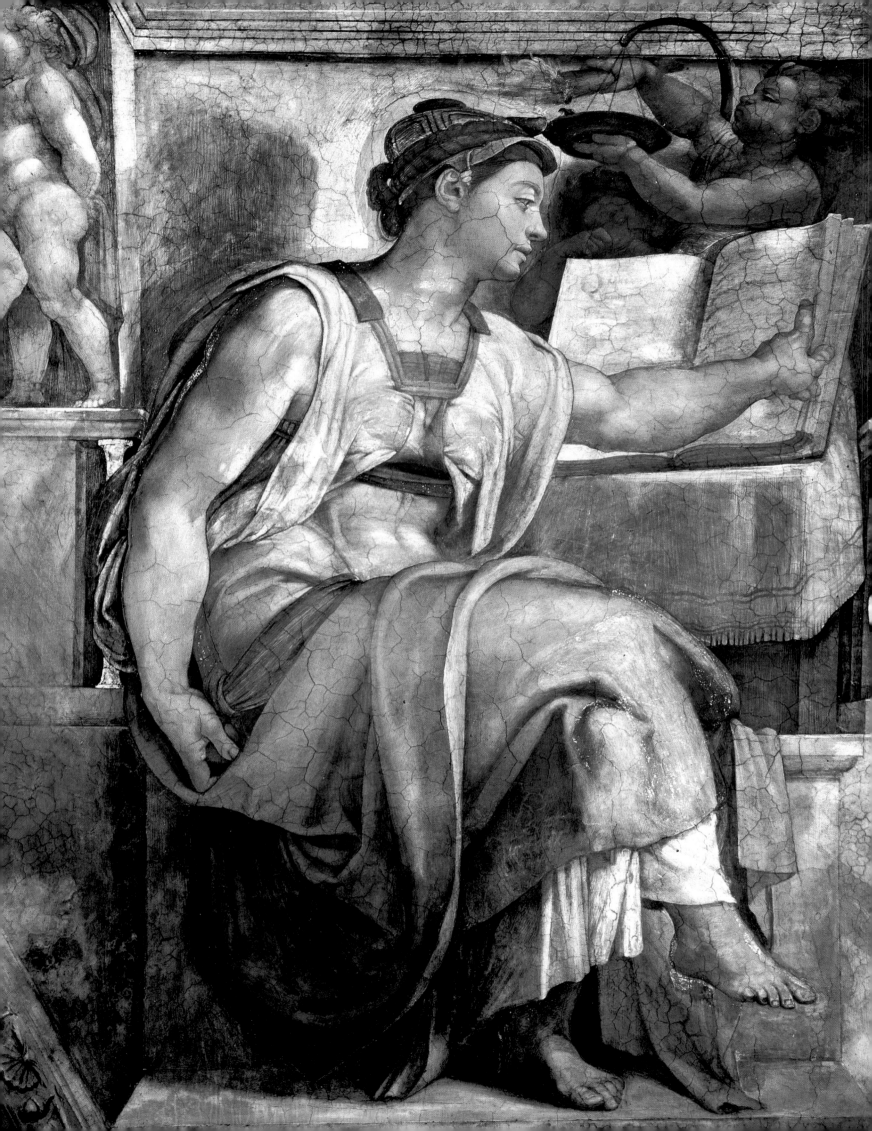

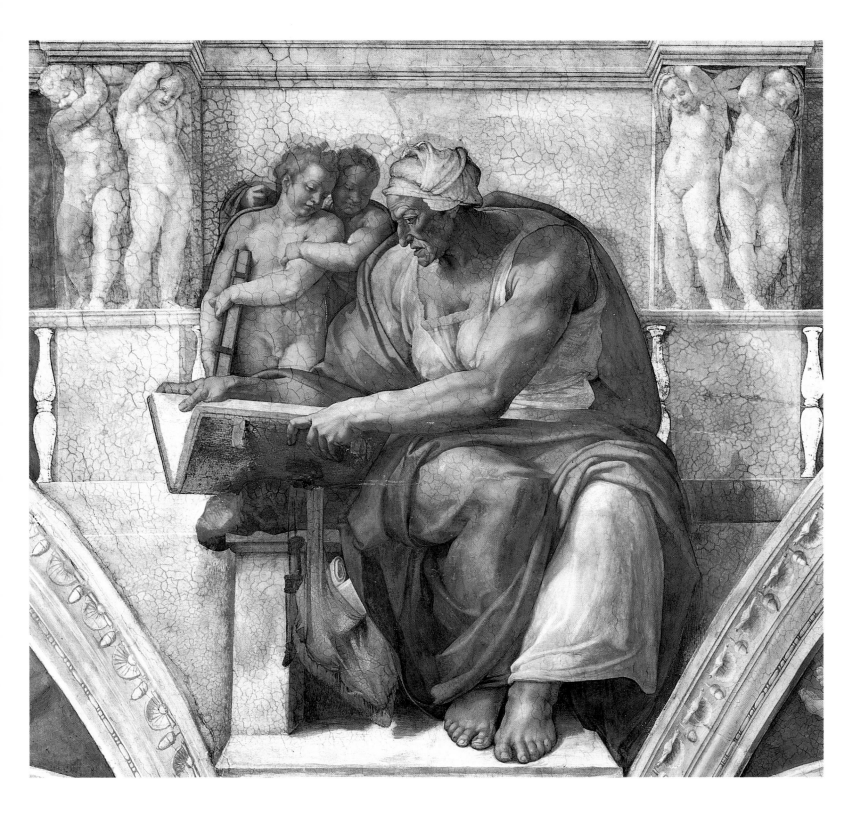

MICHELANGELO

The Cumaean Sibyl

1510. Fresco. Sistine Chapel ceiling
before restoration.
Height 380 cm. (12 ft.).

OPPOSITE

MICHELANGELO

The Erythraean Sibyl

1509. Fresco. Sistine Chapel ceiling
before restoration.
Height 380 cm. (12 ft.).

OPPOSITE

MICHELANGELO

The Prophet Ezekiel

1510. Fresco. Sistine Chapel
ceiling before restoration.
Height 380 cm. (12 ft.).

BELOW

ANDREA VERROCCHIO

The Baptism of Christ

Detail. 1452-1519. Oil on panel.
Uffizi, Florence.
The angel on the left was painted
by Leonardo da Vinci.

incongruous on so virile a body. Her muscular breasts are an anatomical mystery. Her massive feet contribute yet another bizarre note to this assemblage of ill-fitting anatomical parts that add up to something between a natural monstrosity and a menacing caricature.

Part-giant and part-witch, this odd figure may have had its source in a passage from Ovid which tells us that, in his anger, Apollo, the sibyl's tutelary deity and inspiration, condemned her to live for a thousand years.

The most dynamic and violent of the prophets is *Ezekiel,* who sits opposite the *Cumaean Sibyl.* Seemingly prey to a mixture of rage and puzzlement, he turns to the left, holding a scroll in his right hand. One of his attendant *putti* is represented as a simple mask above his shoulder, while the other is both more visible and remarkable in his attitude. This figure is clearly influenced by the angels of Leonardo da Vinci, and represents a return to the angel-ephebes of the Quattrocento. His gesture can be interpreted as a symbol of divine transcendence.

The prophet *Daniel,* whom one can imagine to be consulting the texts of the Last Judgment, is another personification of the humanist scholar in a pose similar to that of *Joel.* One of his attendants stands behind him, strangely covered by a veil, while the other takes on the role of a *putto*-caryatid and holds up his book. The wildly-dancing *putti* statues that flank the prophet introduce a note of joy and sensuality into this otherwise predominantly meditative scene.

Opposite the figure of *Daniel* sits the *Persian Sibyl.* This enigmatic, ageless figure is shown in lost profile view, turning her gaze away from the spectator, reading – with effort, it seems – from a small book. She is stooped, almost hunchbacked, perhaps even short-sighted. Vasari was much intrigued by this particular scene and its strange immobility, which is shared by the curiously draped attendants, and even by the *putti* figures on the throne.

The *Libyan Sibyl* presents an anatomical complexity and a vivaciousness of body and gesture that stand in strong contrast to the *Persian Sibyl.* Vasari characterized her attitude as "feminine," but this is hard to reconcile with the manly aspect of her back muscles. The sharp profile and the tightly-bunched and complicated hair give this figure both an elegant (the position of the leg and foot) and an intimidating appearance. She is setting down or picking up a heavy volume with a gesture that forms an unsteady, rising

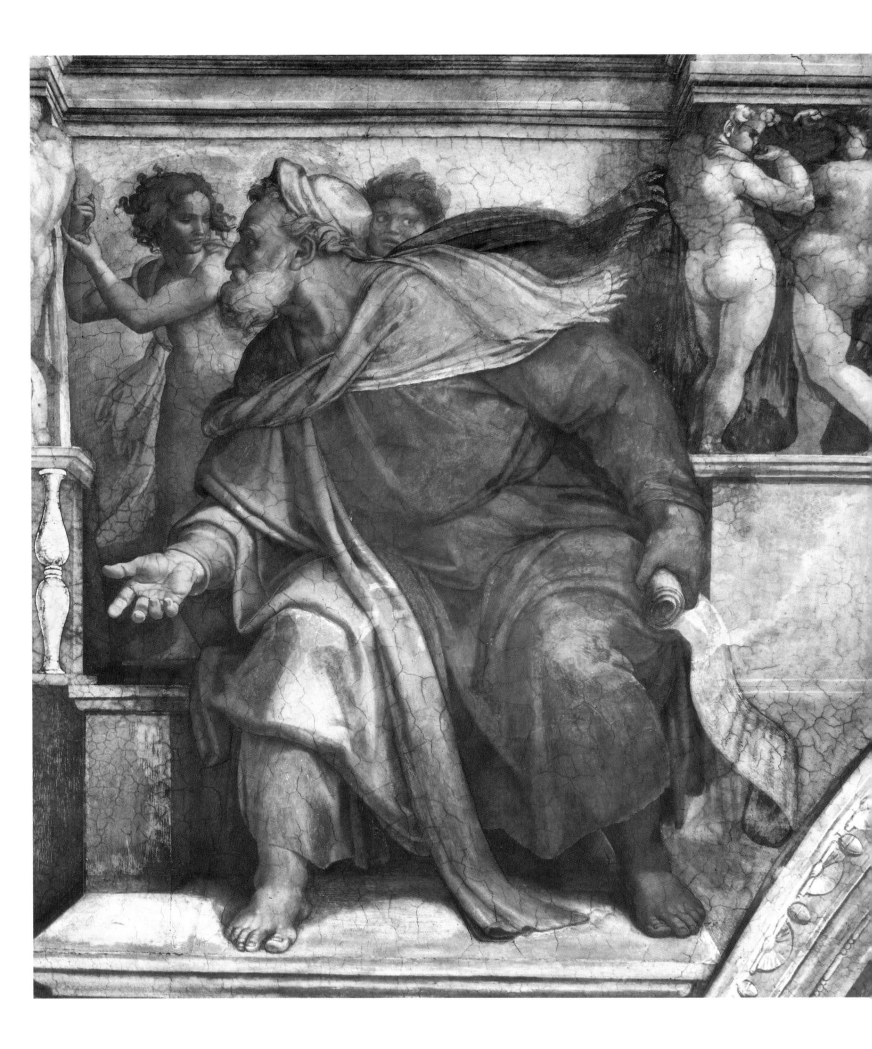

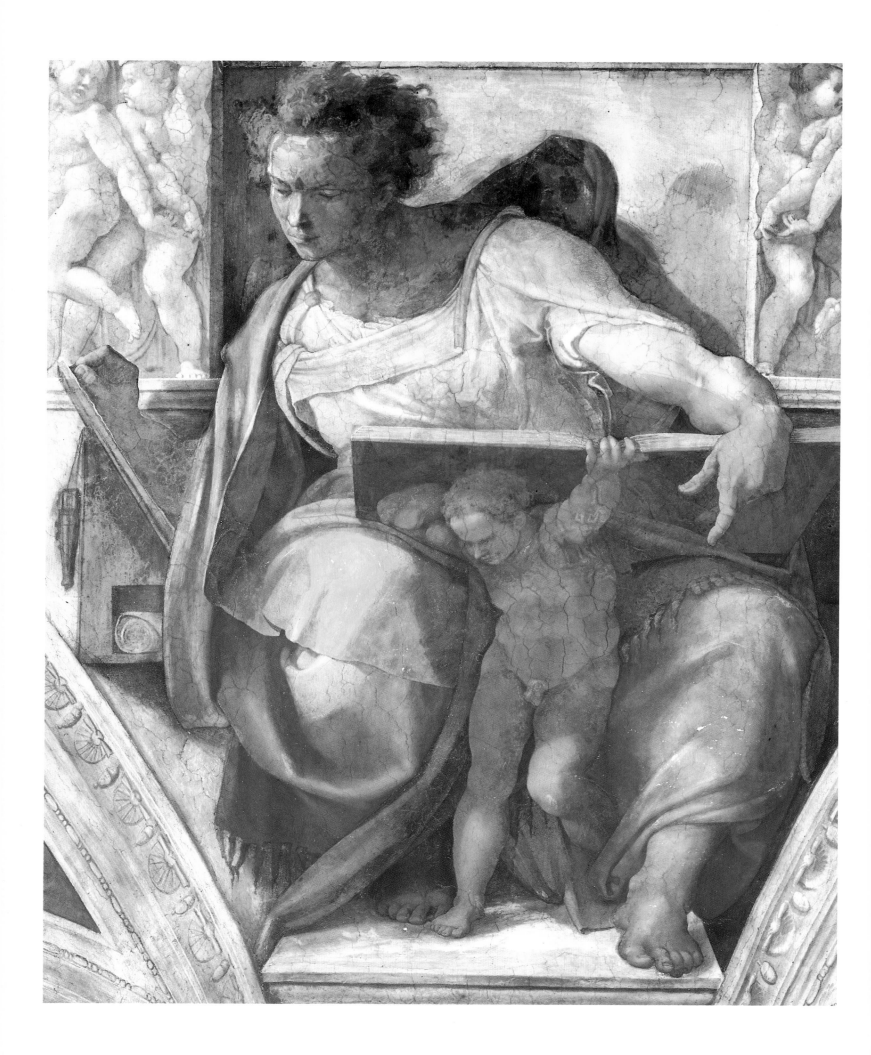

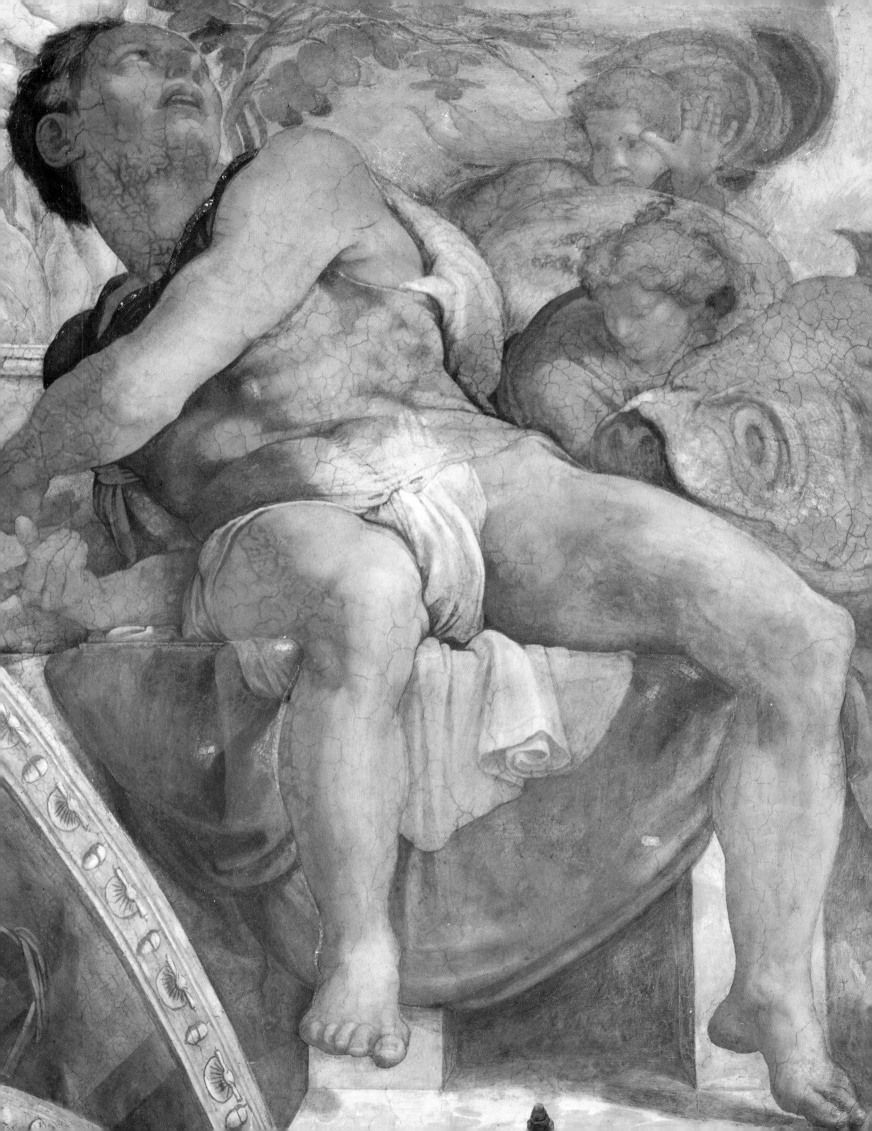

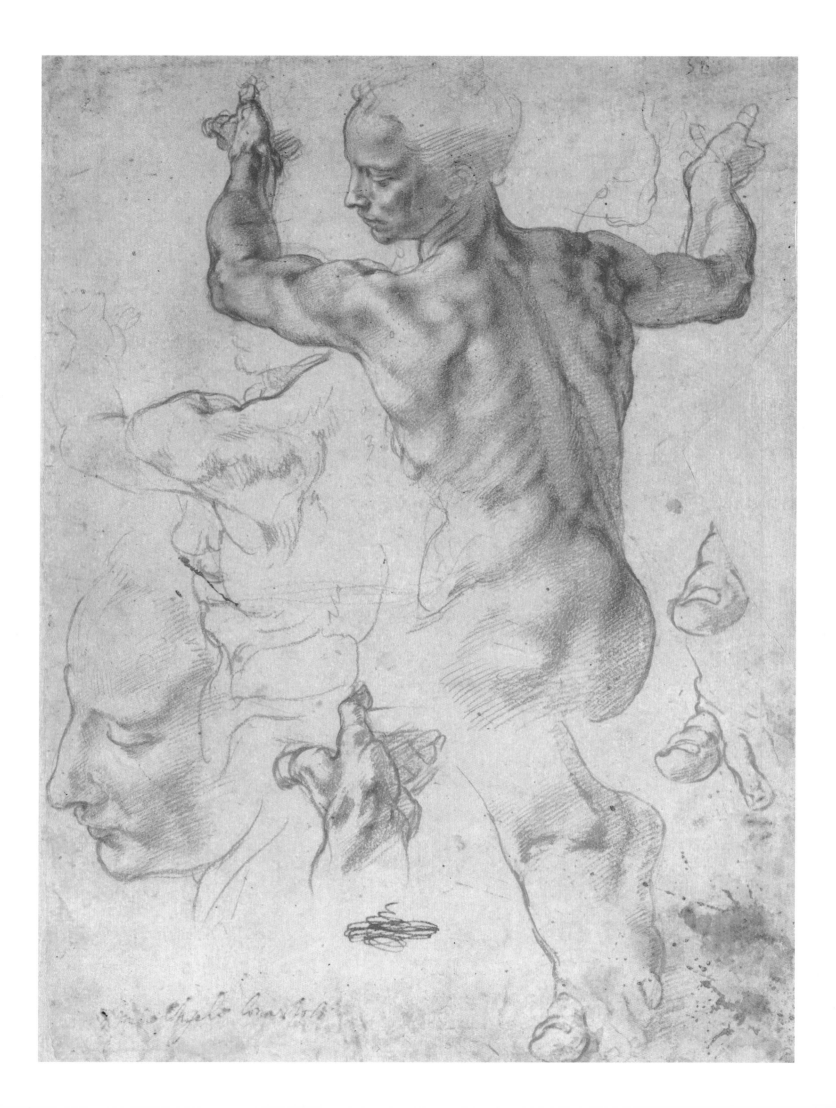

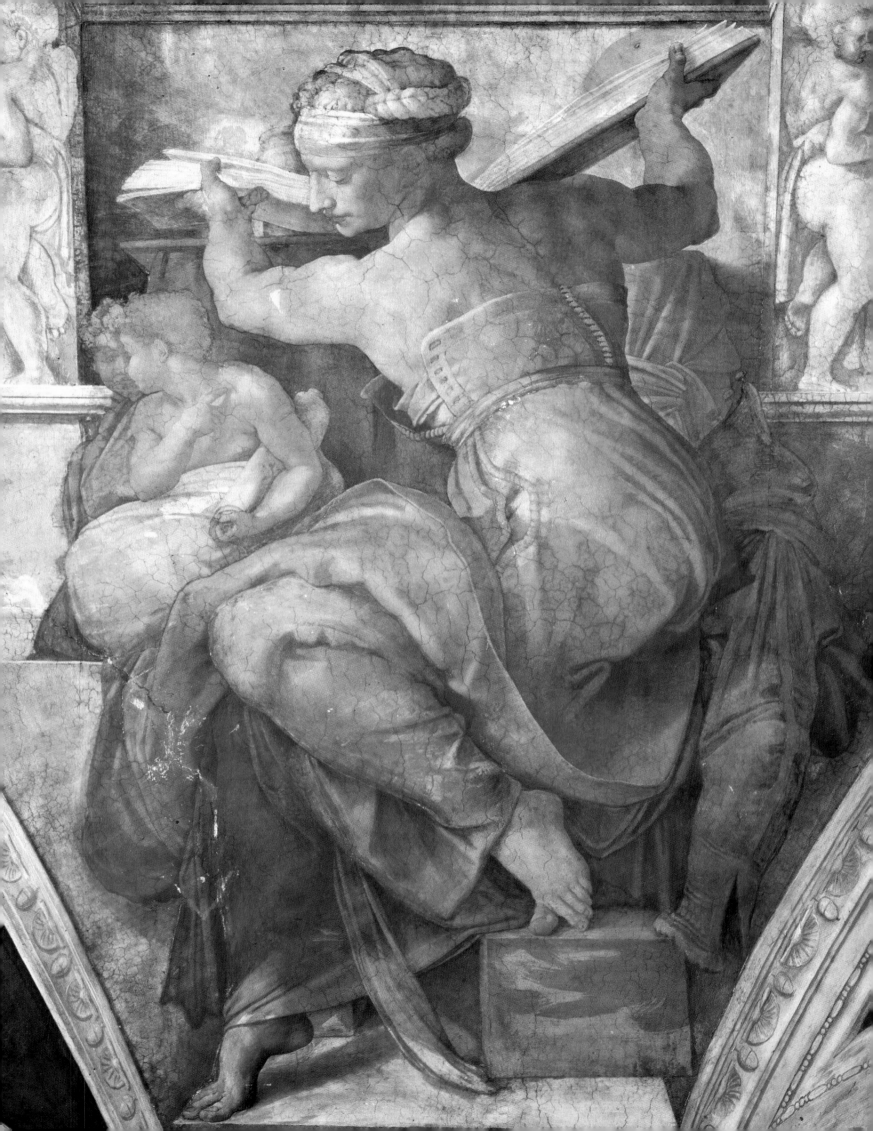

spiral. With its subtle perversity, this image gives a clear fore-taste of Mannerism.

Of all the prophets, *Jeremiah* seems to be the most tormented, as we can see from his apparent body language. He sits, hunched over and completely absorbed in his thoughts. His somewhat grave expression is set off by the very feminine-looking attendant standing behind him, sorrowfully bowing his head. Vasari speaks of the *"amaritudine,"* or bitterness, evoked by this figure. Michelangelo seems to have summed up in this one prophet all his own spiritual and physical weariness when faced with the mystery of Creation. The letter "M" on the base of the throne may suggest that this fallen Moses with no hope of salvation is a self-portrait. The subject is related iconographically to the *Saint John* on one of the bronze panels executed by Ghiberti for the first doors of the Florence Baptistery in 1424. Very much later, Auguste Rodin's *Thinker* was partly inspired by this melancholy prophet.

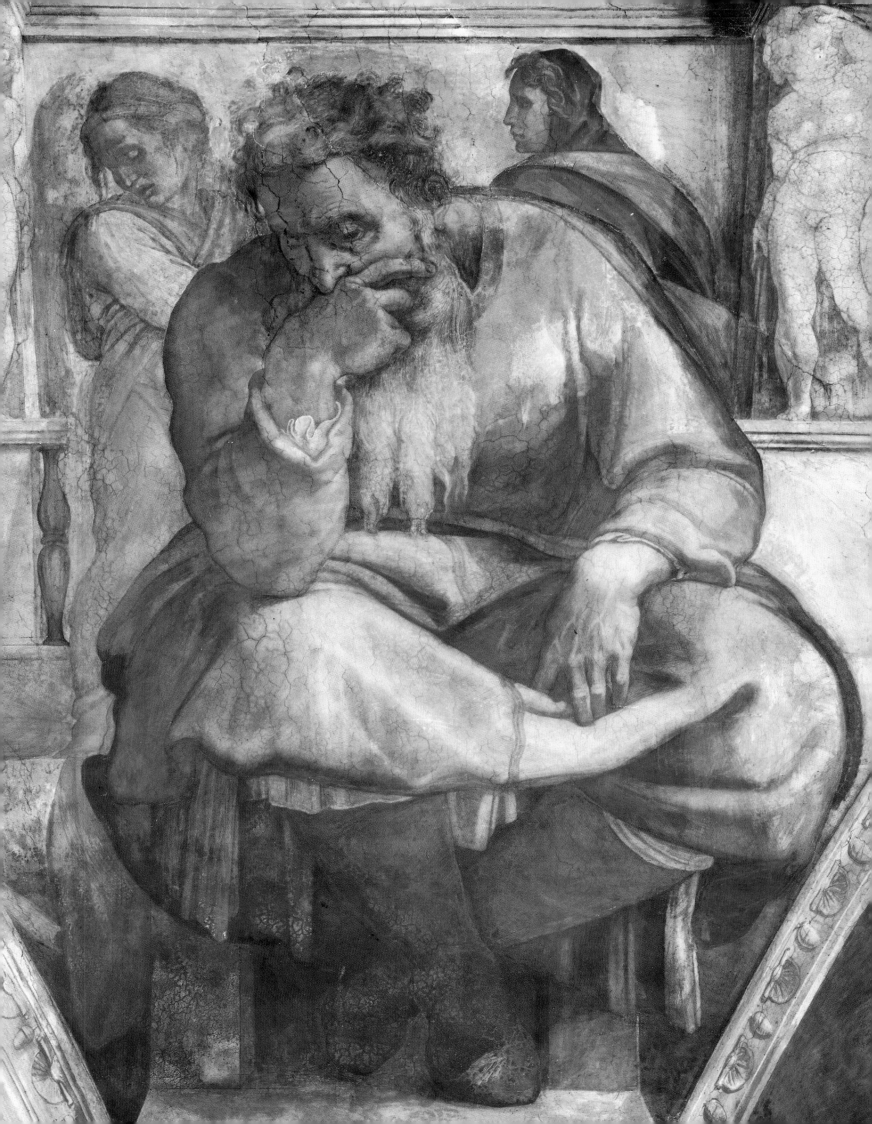

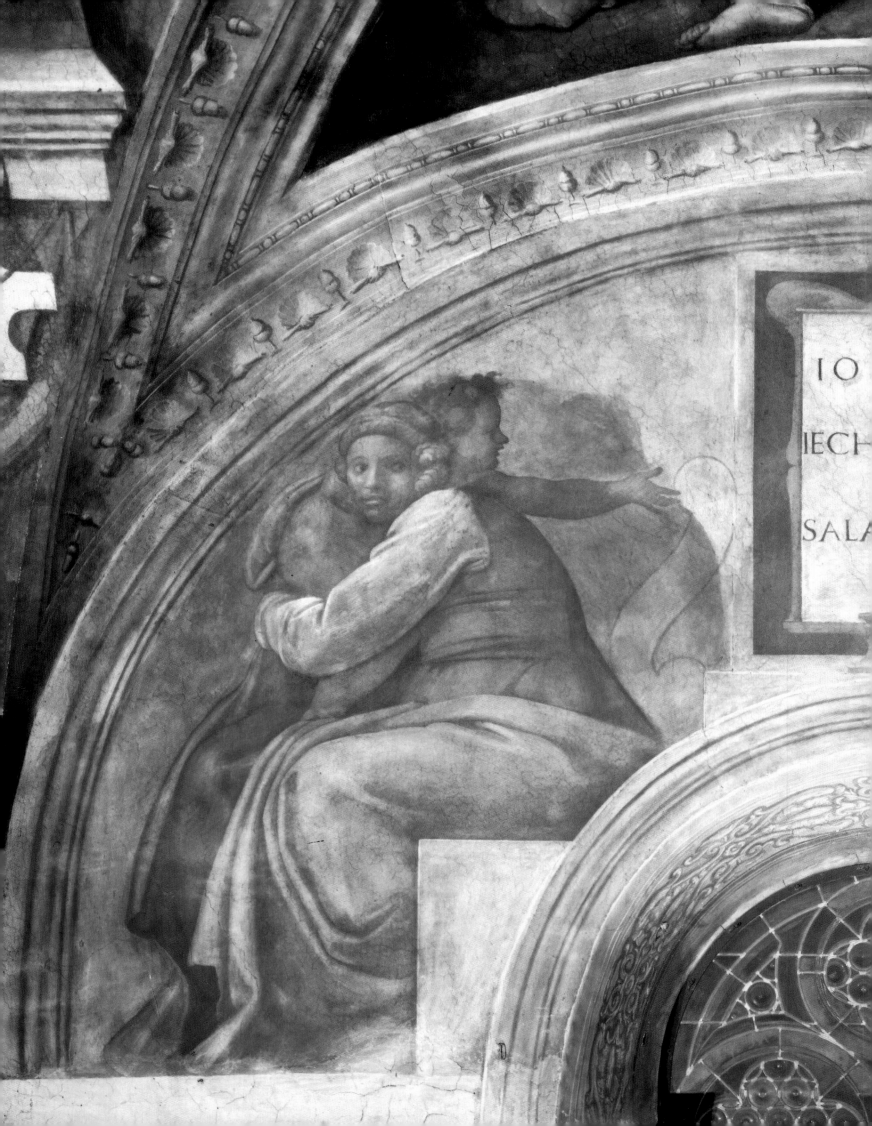

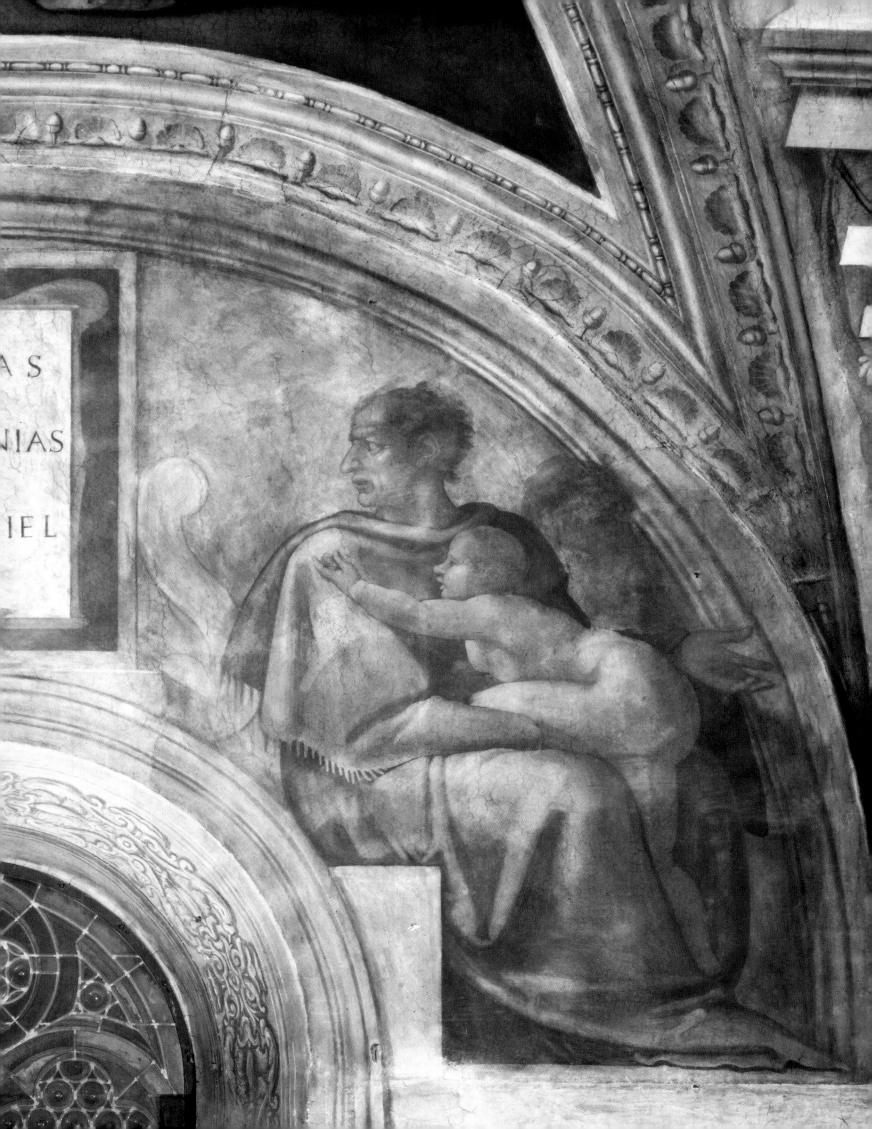

6 THE TOMBS OF THE MEDICI
Of Time and Power

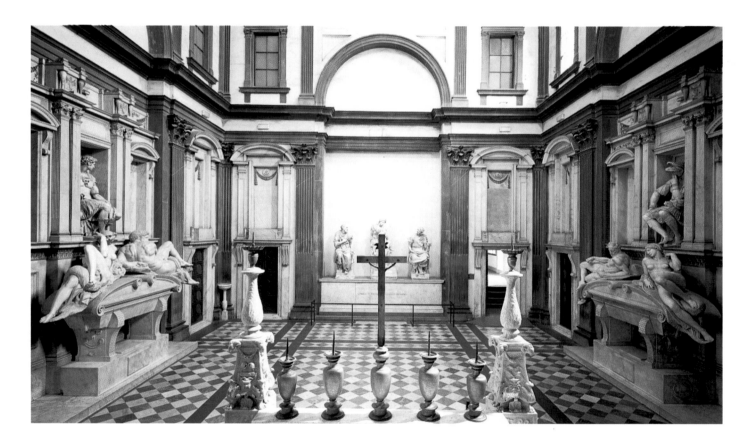

Michelangelo, who ranked sculpture above all the other arts, wrote: "I say that painting is at its most beautiful when it succeeds in imitating volume, and sculpture may be deemed bad when it seeks to imitate painting. And yet, it seemed to me that sculpture was the lamp that illuminated painting, and that between the two arts there is the same relationship as between the sun and the moon."[1]

Pope Leo X (Giovanni de' Medici), who entrusted Michelangelo with the design for the façade of San Lorenzo, the parish church of the Medici family, was the second son of Lorenzo the Magnificent, the artist's protector in Florence during his adolescence. The sculptor, whose great artistic ability was now common knowledge, enthusiastically set to

1. Letter to Benedetto Varchi, 1549.

MICHELANGELO
Interior of the Medici Chapel
1520-1534.
San Lorenzo, Florence.

OPPOSITE
MICHELANGELO
Dome of the Medici Chapel
Finished in 1524.
San Lorenzo, Florence.

work. Unfortunately, the project came to a definitive halt in 1520, probably because of the Vatican's financial difficulties.

In the same year, the pope – whose dynastic ambitions had been thwarted by the death of his nephew Lorenzo d'Urbino in 1519 – decided on the construction of a less costly monument and entrusted it to Michelangelo. In the same church of San Lorenzo he wished to erect a funerary chapel to commemorate four members of the Medici family: Lorenzo the Magnificent, his brother Giuliano, Lorenzo, the duke of Urbino, and Giuliano, the duke of Nemours.

Buonarotti accepted the task in November 1520 and submitted his first design. He worked on this project from 1520 until 1527, and from 1530 until 1534. During these same long years, he was also commissioned by Pope Clement VII (Giuliano de' Medici, the brother of Giulio) to design the famous Laurentian Library, which was also situated in the church of San Lorenzo. Brunelleschi, the founder of Renaissance architecture, had already left his stamp on this edifice by building a chapel, the Old Sacristy, which is rightly considered one of the major accomplishments of the early Quattrocento. Brunelleschi's chapel is a clear demonstration of the rules for architectural harmony as codified at the beginning of the Renaissance. Spatial unity is created by simple volumes: a cube crowned by a semi-spherical cupola. The structural elements, pilasters, ribs and cornices, are marked by grey stone that frames large areas of light-painted wall surfaces. This linear articulation is further emphasized by the regular forms of the eight *tondi* that decorate the pendentives and arches, and the four ceramic panels by Donatello that surmount the doors. The cupola is topped by a central lantern and pierced by eight bull's eye windows in the drum. What first strikes the eye is the three-stage progression from bottom to top: the first level marked by the doors and their corresponding arches, the middle level with broad arches and pendentives, and the cupola itself, which rests on a square base.

This building influenced Michelangelo to a certain degree when he undertook the construction of the new chapel, which became known as the New Sacristy. He personally drew up the plans. Like Brunelleschi almost a hundred years before him, he divided the volume into three zones, but underscored their articulations and separations even more strongly. A plan preserved in the Buonarotti Archives in Florence details this project: a lower level, the

realm of earthly reality, with the tombs of the dukes, decorated with light-coloured marble and *pietra-serena*, a greyish stone that was one of the characteristic features of Florentine Renaissance architecture. This first level had few openings. The second, or intermediary, level had large windows with triangular pediments, arches, fluted pilasters, and a serene geometrical order composed in the purest Quattrocento tradition. Above this came the celestial, or ethereal level in the form of a light-filled cupola, decorated as usual by four *tondi*. From the outset Michelangelo deliberately sought to create subdued light effects. Some historians think that this very plain, spare architectural space was to be painted at the level of the lunettes and cupola. Giovanni da Udine is supposed to have worked on it in 1532 and 1533, but his paintings were covered over by Vasari in 1556. However, tests on the walls in the 1970s failed to detect any paintings. If the walls of this funerary chapel had been covered with frescoes, our perception of it would have changed completely.

The cupola was finished in 1524. Cardinal Giulio de' Medici wanted a funerary monument to be erected directly under it, in the centre of the chapel: a great four-sided parallelepiped with four tombs. There may have been an alternative proposal that involved placing the four tombs in the four corners. In the end, Michelangelo's solution prevailed: one tomb per wall, making a total of four tombs, of which two were to be double. A year later he sculpted *Dawn* and *Night*, and prepared models of the other statues.

But history intervened in spectacular fashion. On 7 May 1527 the imperial troops of Charles V began the terrible sack of Rome, an orgy of plundering that lasted for three months. These dramatic events had repercussions in Florence, leading to the suspension of work on the Medici Chapel which was resumed only three years later. Michelangelo then set about it with such obsessive ardour that his friends feared for his life. The construction and decoration progressed with astounding speed until August 1532, when Buonarotti left for Rome. There, in 1534, he was commissioned by Pope Clement VII to create *The Last Judgment* in the Sistine Chapel and the Medici Chapel was abandoned. The artist never returned to Florence and never again saw his sculptures. Nine years later, his assistants, Niccolò Tribolo and Raphael da Montelupo, installed the statues on the tombs, possibly under the direction of Vasari

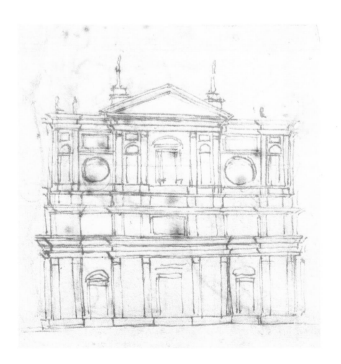

MICHELANGELO
Drawing for the façade of San Lorenzo
1517. Red chalk and charcoal.
14 x 18 cm. (5 $^1/_2$ x 7 in.).
Casa Buonarotti, Florence.

OPPOSITE
BRUNELLESCHI
Interior of the Old Sacristy
Around 1428. Located opposite Michelangelo's
New Sacristy (Medici Chapel)
adjacent to the left transept
of San Lorenzo, Florence.

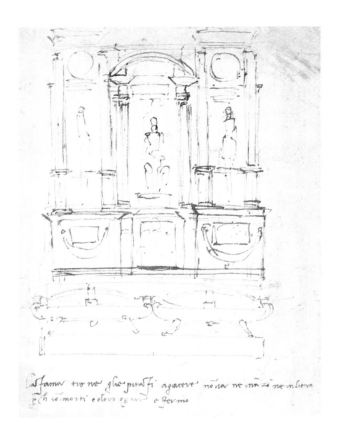

MICHELANGELO

Sketch for a double tomb

1520-1521. Pen and ink.
21 x 15.5 cm. (8 x 6 in.).
British Museum, London.

OPPOSITE

MICHELANGELO

Figure sketched on a wall

Found in 1976
beneath the Medici Chapel.
San Lorenzo, Florence.

himself. Michelangelo had executed only two statues of the dukes and the four figures of the times of the day. Many parts of *Day, Night, Dusk* and *Dawn* remained unfinished. This mysterious *non-finito* may well fascinate the spectator today, but it is not what the artist intended.

The remaining group of the *Virgin and Child,* which is barely roughed out, was carved by Buonarotti, but the figures of St. Como and St. Damian were sculpted, respectively, by Raphael da Montelupo and Giovannangelo da Montorsoli. A number of fragmentary sculptures have also been found, including the figure of a crouching adolescent nude, which suggests that the artist had planned to execute more statues for the niches and tombs, as well as for the upper parts of the chapel.

Contemporary accounts and documents attest to the complexity of Michelangelo's grand design – which unfortunately never became reality. He wanted to create figures of four rivers and two allegories of Heaven and Earth for the niches flanking Giuliano de' Medici's tomb, and two more allegories – possibly Will and Knowledge – for Lorenzo's tomb.

So much has been written about the hidden and obvious meanings of this chapel that it would be tedious to go into detail, especially as the various interpretations are often contradictory. It is more interesting to quote from Michelangelo's own notes: "The Heavens and the Earth... Day and Night talk and say: in our swift course we have carried Duke Giulio to his grave. It is therefore meet that he avenge himself. His vengeance consists in this: that because we have brought about his death, he has deprived us of light, and with his closed eyes he has closed our own, which no longer shine on Earth. What would he have done with us if only he had remained alive?"

Let us consider also the meaning attributed to this work from the sixteenth to the eighteenth century. This complex group of sculptures – destined to be completed by paintings, it should be remembered – was construed as an allegory of the secular, religious and military might of the great Medici family, which had provided the Roman curia with so many popes and cardinals. It was also seen as a transparent allusion to Time, the relentless devourer of all mortal beings, no matter how powerful or heroic. Confronted with the awesome mysteries of Time, human reason is left without words or images. Condivi confirms this reading: "A

114

man and woman representing Day and Night and, collectively, Time which consumes all. And, in order for his intent to be better understood, he gave to Night, which is in the form of a woman of wondrous beauty, the owl and other pertinent symbols, and to Day his symbols likewise. And to signify Time, he meant to carve a mouse, for which he left a little bit of marble on the work, but then he was prevented and did not do it; because this little creature is forever gnawing and consuming just as time devours all things."

Clearly the statues of Giuliano and Lorenzo were not intended to be realistic or faithful likenesses; they are spiritual portraits, idealizations meant to transcend earthly forms through their immortalization in marble. Thus they are not reproductions of exact facial features, but the expression of secular status and power (here symbolized by weapons, a marshall's baton, the poses, and references to Imperial Rome), worldly power confronted by the ruthless passage of time – symbolized by the four times of *Day* – which has inexorably led these princes to their splendid sarcophagi. The word sarcophagus is derived from a Greek word that literally means "flesh-eating." In his letters, Michelangelo referred to these late Church pontiffs and military commanders by the generic term *"capitani."* They were ennobled by Pope Leo X in a solemn ceremony in Rome. Giuliano died in 1515 and Lorenzo in 1519.

But the significance of this funerary chapel, with its linear architectural idiom and its three clearly-marked spatial divisions, may well go beyond plain walls decorated in the style of Antiquity. The walls may be seen as tangible limits beyond which opens another, more immaterial space, evoked by, but not represented in the marble. The formal dynamism of the statues, and even of the sarcophagi, is offset by the insurmountable barrier of the walls but the forms seem drawn towards the light-filled cupola. This ascending progression suggests another interpretation: the immortality of the dukes of Urbino and de Nemours is made possible by a work of art, their only access to the eternal celestial spheres, the realm of absolute light. Like so many figures frozen in marble, Time held them earthbound, imprisoned in their mortal forms, powerful though they may have been. Only art could free and redeem them in a higher synthesis. Using simple formal elements like stone, space and light, Michelangelo expressed a far-reaching philosophy of art. The

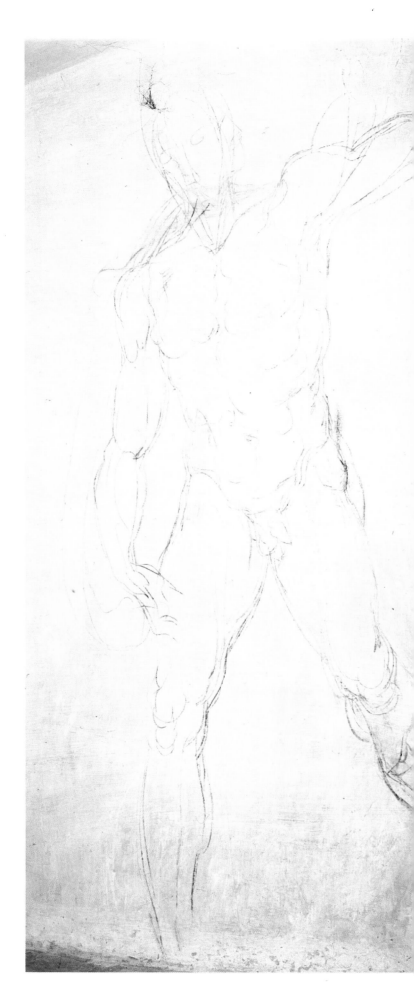

MICHELANGELO
Brutus
Around 1540. Marble.
Height 74 cm. (29 in.).
Bargello, Florence.

OPPOSITE
MICHELANGELO
Statue of Giuliano de' Medici
Marble.
Height 173 cm. (5 $^1/_2$ ft.).
Tomb of Giuliano. Medici Chapel,
San Lorenzo, Florence.

way the sculpture groups were installed in the sixteenth century – not necessarily according to Michelangelo's original plans – makes the gazes of the two *condottieri* converge on the figure of the Virgin nursing the Christ Child. A complex arrangement of poses and concepts that points to spiritual illumination. The Madonna is flanked by figures of St. Como beating his breast and St. Damian, a physician, holding a cup. These figures were sculpted by Giovannangelo Montorsoli and Raphael da Montelupo around 1533-1534.

The monument dedicated to the memory of Giuliano de' Medici (brother of Pope Leo X) is a busy architectural composition set against one of the chapel walls. The main figure sits in the middle of the middle register, flanked by two empty niches that were to house statues of *Heaven* and *Earth*. At Giuliano's feet stands a sarcophagus decorated with scrolls and the statues of *Day* and *Night*. It was completed around 1534.

A number of interpretations have been advanced for Giuliano's statue, all of them stressing his martial qualities: Vasari spoke of "pride," while others saw a personification of vigilance or of the active life. Yet others thought the figure represented his sanguine, choleric temperament. The marshall's baton indicated his leadership of the Church, while the coin in his left hand alluded to his generosity. Yet this impression of pride is considerably dissipated when one carefully considers the expression of the face and neck. The latter is too long and held forward in an attitude that contradicts the sense of moral rectitude, more evidently displayed in Michelangelo's bust of *Brutus*. Giuliano's head seems to have more kinship with the attractive youth of *Victory*, which was itself conceptually related to the *David* of 1504. The statue as a whole projects slightly from the niche, as if set on the threshold of another life. Michelangelo installed the statue himself in 1524, before abandoning the project and leaving for Rome. Strangely, the back of the figure and the seat, although completely hidden, have been given a high degree of polish.

Giuliano must have been in his prime when Michelangelo met him as a child, and he appears here both in the impressive guise of a Roman general and as a very sensitive, almost fragile person (note the position of the hands and legs, and the facial features). He brings a message of world-weariness and resignation from the Other World, a *memento mori* – "a reminder of death" – expressed by the

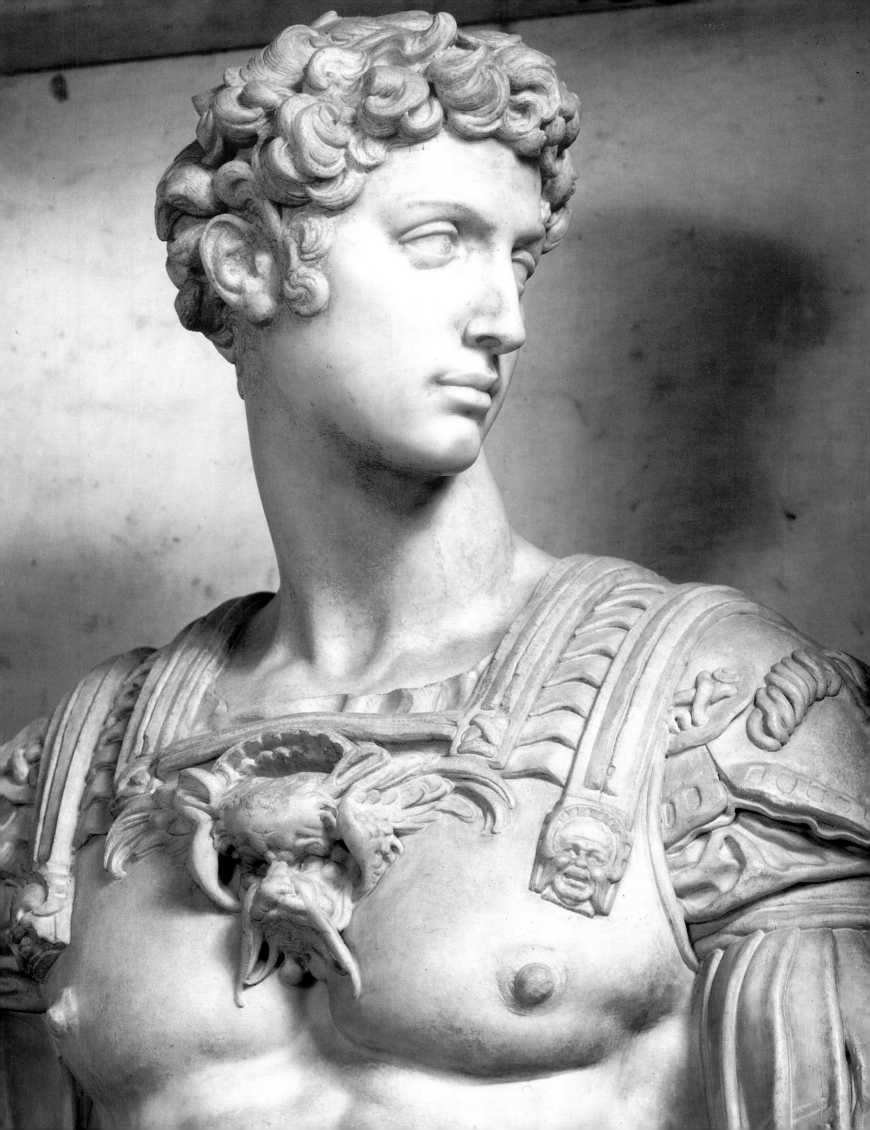

MICHELANGELO

Tomb of Giuliano de' Medici, Duke of Nemours

Around 1526-1534. Marble.
630 x 420 cm. (21 x 14 ft.).
Medici Chapel, San Lorenzo, Florence.

OPPOSITE

TOP

MICHELANGELO

Night

Unfinished marble. Length 192 cm. (6 ¼ ft.).
Tomb of Giuliano de Medici. Medici Chapel.

BOTTOM

MICHELANGELO

Day

Unfinished marble. Length 185 cm. (6 ft.).
Tomb of Giuliano de Medici.
Medici Chapel.

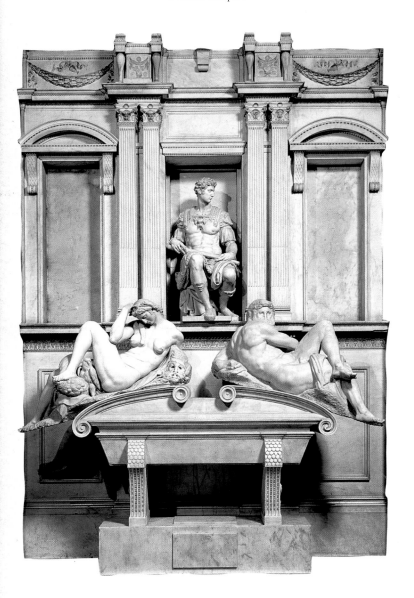

melancholy meditation of a powerful mortal on the brink of the irreversible passage to the grave, a clear summons to attend to the perennial question of Death.

Symmetrically and precariously perched on Giuliano de' Medici's sarcophagus are two statues personifying *Day* and *Night* whose origins may go back to the Roman river gods, the Tiber and the Arno. The Casa Buonarotti in Florence has a large clay model of four river gods which give us an idea of the sculptor's original intentions and the effect he wanted to achieve. The figure of *Day*, which Michelangelo called *"il di,"*[2] is free-standing, its head and hands only sketchily indicated. In his famous iconographical treatise, Cesare Ripa described this allegorical figure as a handsome winged youth represented on a chariot drawn by a pair of red horses and led by Aurora, who heralds the coming of the day. As attributes, the young man holds a circle and a torch.[3]

Michelangelo broke completely away from this iconography, and, despite the figure's incomplete state, we can see that he intended a very personal rendition of the subject. The extreme torsion of the body, especially the arms, one of which is held behind the back, while the other disappears on the farther side of the figure, is analogous to the position of the Child Jesus in the *Madonna of the Stairs*. The figure of *Day*, desperately trying to tear itself away from something – darkness? – is also comparable to the *Slaves* preserved in Paris and Florence. Here again, we have a sense of powerlessness expressed in purely physical terms, but with psychological and spiritual overtones. This is the revelation of the implacable and negative forces of Time, the perception of which leads to a sort of physical and emotional paralysis. When he was working on these figures, Buonarotti felt himself old, physically exhausted, and morally strained, although only in his early fifties, a respectable age in those days. His iconographical innovation was all the more daring as Day was usually identified with light, childhood, spring and the First Age of Man. Formally, the statue is divided into two halves: one elegant – the legs and drapery – the other violent – the contorted arms and unfinished facial features, which give this figure such a modern appearance. The drapery, which stops behind the back, was to have been extended.

2. K. Frey, *Die Dichtungen des Michelangelo Buonarroti*, XVII, Berlin, 1897.
3. Cesare Ripa, *Iconologia*, Torre d'Avorio ed., Fogola, Turin 1986, p. 185 (new edition of the book published by Tozzi in Padua in 1618).

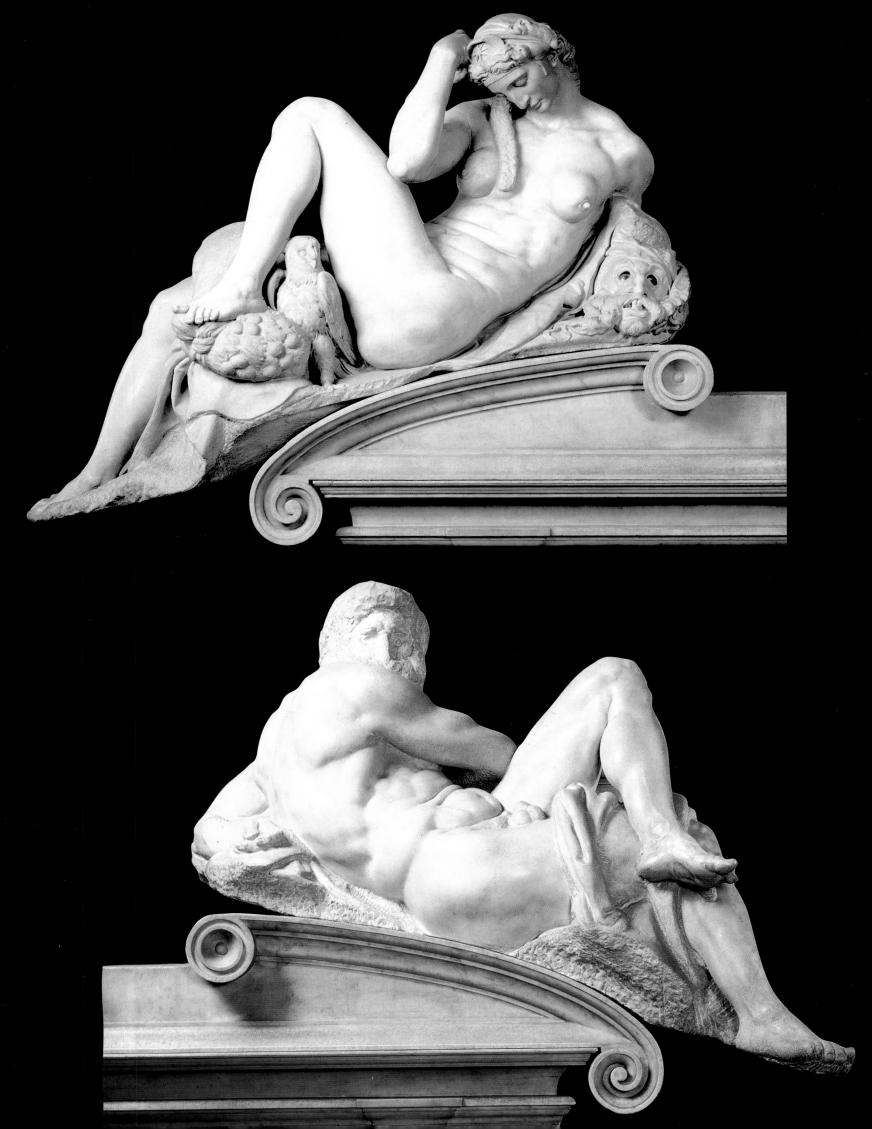

TOP
FLORENTINE SCHOOL
Leda and the Swan
Around 1540-1630. Oil on canvas.
105.4 x 141 cm. (3 ¹/₂ x 4 ¹/₂ ft.).
Copy of a lost Michelangelo.
The National Gallery, London.

BOTTOM
MICHELANGELO
Study for *Night*
Department of Prints and Drawings,
Uffizi, Florence.

Night, the antithesis and pendant of Day, the "Nyx" of the Ancients, daughter of Chaos and mother of Aetheus, represents the realm of primordial fears and darkness. Night is the source of other archetypal figures, such as Death, the Fates, Old Age and Nemesis. In Judeo-Christian cultures, the moon, the minor luminary, rules the night, just as the sun rules the day (Genesis 1:16), and together they exalt the glory of God (Psalms 19, 103). For Christians, night is the realm of error and Satan. In the Book of Revelation, Night is a woman clothed in light, with the moon at her feet, a symbol of the chthonic forces conquered by the Church. In the 1618 edition of Ripa's *Iconologia*, Night is personified by a woman with large wings dressed in a star-studded mantle. Her skin is dark and she wears a garland of poppy flowers, which, as the ingredient of opium, had become the symbol of oblivion, the sleep that comes with night. She holds two infants in her arms, one white, one black.

From this rich symbolic tradition, Buonarotti retained only a few features, which he profoundly transformed. His figure of night wears a diadem decorated with a crescent moon, the symbol of Diana (the Artemis of the Greek pantheon). Beneath her left shoulder is the grimacing mask of a satyr. Only the Greek profile lends a serene classical note to this otherwise tormented evocation of the forces of destruction. The position of the left arm and hand suggest melancholy meditation and deep absorption in night thoughts or visions. It is a strange allegory for the might of the great Medici! Michelangelo must have been torn between the rising republican movement in Florence at the time and the powerful family that had so generously protected him in his youth.

Buonarotti's tendency for a paradoxical division in numerous statues is evident here: the legs and arms are in motion, the head and thorax motionless as though meditating. The legs recall the more sexually explicit painting of *Leda and the Swan*, which has been lost. As an image of motherhood, childbirth, oblivion, sleep and the unconscious, this figure of *Night* offers no comfort; it is the antithesis of Light, the seduction of Evil as opposed to Good. It is yet another avatar of Time in its blind, unrelenting progress.

The contemplative image of Lorenzo the Magnificent is in partial contrast to the more alert stance of Giuliano on the opposite side of the chapel. Neither looks at the other. Lorenzo sits in a typically Michelangelesque *contrapposto*,

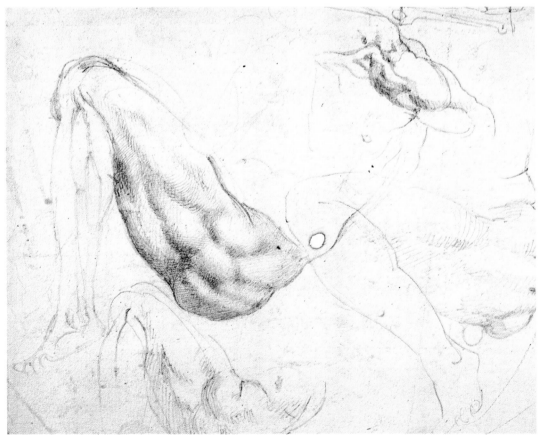

MICHELANGELO
Mural drawing
Found in 1976 beneath the Medici Chapel.
San Lorenzo, Florence.

OPPOSITE

MICHELANGELO
Statue of Lorenzo de' Medici
1524-1531. Marble.
Height 178.5 cm. (6 ft.).
Tomb of Lorenzo de' Medici. Medici Chapel,
San Lorenzo, Florence.

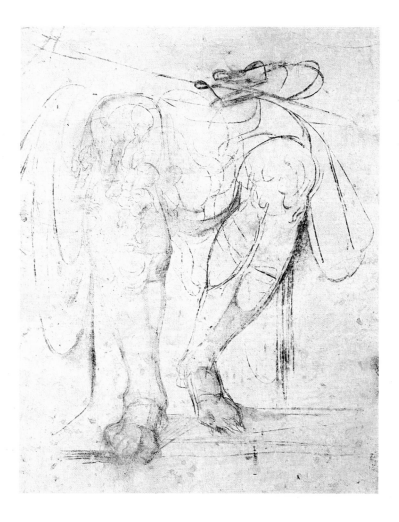

absorbed in his thoughts, not unlike the prophet *Isaiah* of the Sistine Chapel ceiling. The index finger of his left hand is pressed against his upper lip in the traditional gesture of silence. His head is crowned by a sort of helmet carved into the shape of an animal's (lion's?) head by Montorsoli, a martial attribute in sharp contrast to his meditative pose. He holds a crumpled piece of cloth in his right hand, while his elbow rests on a strange casket decorated with an animal's head identified by some as a bat. Money boxes of this design existed in Florence at the time, and so it may have been intended as a symbol of thrift, or moderation in spending. The casket is probably the work of Montorsoli. The statue's face, hands, breastplate and feet have been left unpolished. This melancholy image of a man totally absorbed in his thoughts probably inspired Rodin's *Thinker* centuries later.

According to Cesare Ripa, *Dusk* was personified by a dark-skinned young man with wings flying westward, his head crowned with a shining star, an arrow in his right hand and a moth in his left. It is a very beautiful image, but for his figure of *Dusk*, Buonarotti opted for a completely different iconography, an elderly, but very athletic man reclining in a relaxed pose, not unlike the boxers in Roman sculpture of the Hellenistic period. This man is past his prime, apparently worn out by the exertions of the day. He displays an air of detachment, almost indifference. His legs are crossed in an elegant pose analogous to that of *Day*. There is something calm and contemplative about him, and his features, although unfinished, could be a likeness of the sculptor himself. The upper portion of the body is quite summarily handled; there are still traces of the chisel on the body, which was evidently contrived to adapt to the forms of the sarcophagus. This powerful figure expresses the values of maturity, of experience brought to its highest creative potential, like the last glimmer of a glorious day.

The allegory of Dawn in Ripa's treatise appears under the guise of a girl with wings dressed in a yellow mantle and holding a lantern, an evident symbol of the coming light of day. Alternative attributes are a torch and a basket of flowers. In his rendition of this traditional figure, Michelangelo created an image of *Dawn* as original and unforgettable as his image of *Night*. Although clearly female, his figure has the athletic build of a man. She turns to face the spectator, her nudity

MICHELANGELO
Tomb of Lorenzo de' Medici
Around 1524-1534. Marble.
630 x 420 cm. (21 x 14 ft.).

Opposite

Top

MICHELANGELO
Dawn
Unfinished marble. Length 203 cm. (6 ½ ft.).
Tomb of Lorenzo de' Medici. Medici Chapel,
San Lorenzo, Florence.

Bottom

MICHELANGELO
Dusk
Unfinished marble.
Length 195 cm. (6 ¼ ft.).
Tomb of Lorenzo de' Medici. Medici Chapel,
San Lorenzo, Florence.

accentuated by a ribbon stretched below her breasts. Her face, with its frowning brow and half-open mouth expresses the pains of labour, yet her gaze is strangely absent and blank. This powerful and overtly seductive figure is charged with a disquieting tension that courses through her entire body, from the hand clutching a piece of cloth to the toes clasped around a piece of drapery at the limit of recognizable form. Unlike the other figures *(Day, Night* and *Dusk), Dawn* has a surprisingly simple, seductive pose. Her head is adorned with a strange double turban with an unfinished veil falling down her back. The face lies midway between classical Antiquity and the "Byzantine" Virgins of the Tuscan Trecento.

While the antique models for the figure of *Dawn* may be found in the river gods of the Arch of Septimus-Severus in Rome, Michelangelo transformed them in such a way that his sculpture became a wholly new creation, whose forms express the cosmic energy of time, life and death. Already in the sixteenth century, Vasari intimated that, in the unfinished parts of Michelangelo's sculptures, one could detect future developments. The statues in the Medici chapel once again raise the delicate aesthetic issue of *non-finito*. From his earliest works, Michelangelo confronted us with two types of unfinished work: an unwitting *non-finito* for purely external or practical reasons, and a deliberate *non-finito*, which, in fact, was rather rare. However, the difference between these two states is not always easy to establish, and we should avoid the temptation of imposing too modern a reading on his works. Details left in an unfinished state, a suggestive sketchiness, and the idea of work-in-progress as values in their own right were aesthetic options exercised by Rodin and other twentieth-century artists. But in Michelangelo's time, unfinished sculptures were seen as failures not as manifestations of a valid aesthetic strategy. Where the Sistine Chapel spectacularly demonstrated the awesome impact of the Creation and of Yahweh's might, the Medici chapel unfolds its secrets in contemplative mood, evoking the transition between life and death, and the passage of time towards the shores from which no one returns.

Between 1534 and 1544, Michelangelo wrote a series of poems in madrigal form their harshly dissonant verses expressing the frailty of the human condition and an obsession with old age and death. And yet he transcended these morbid considerations:

124

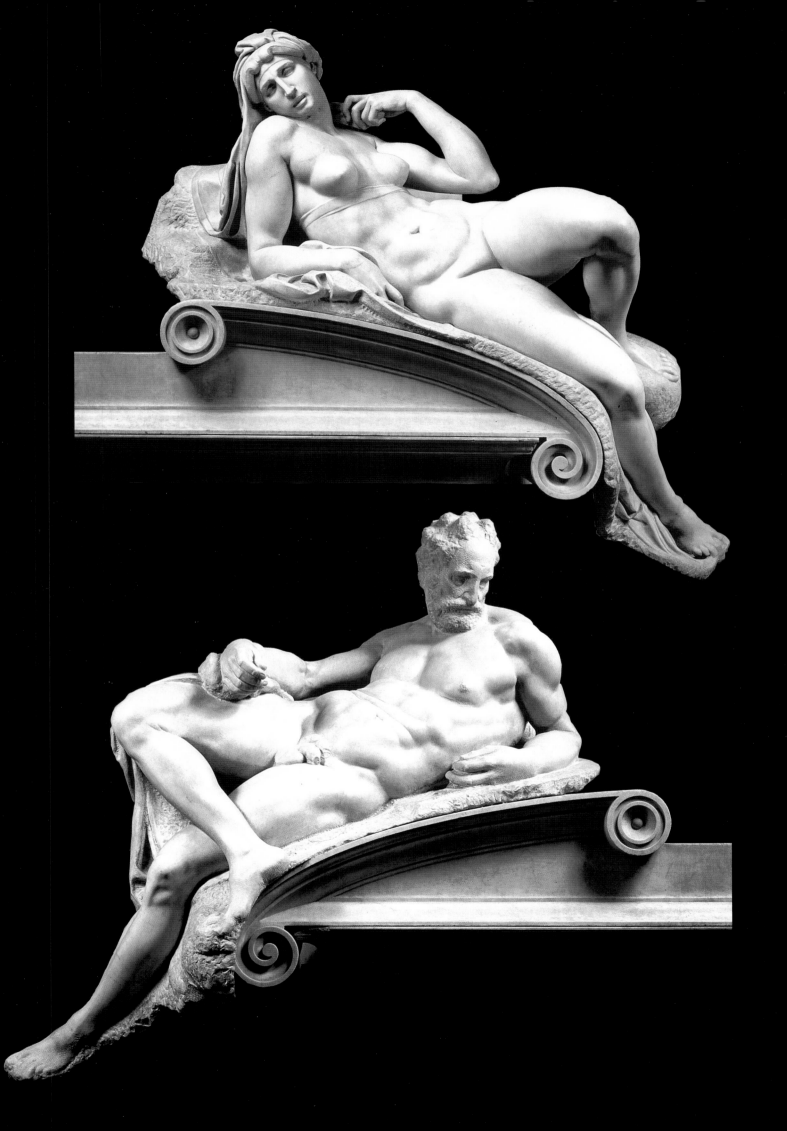

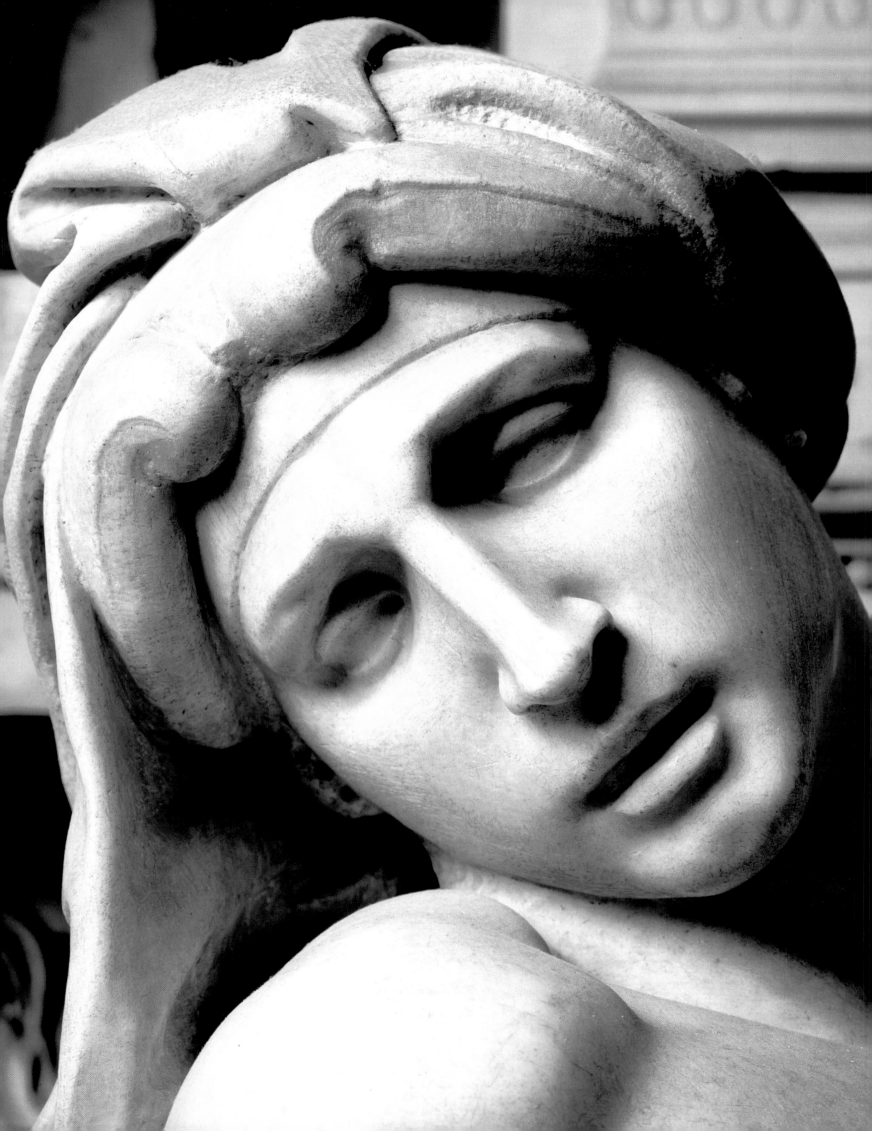

Those who speak of death imagine
A picture all too dark to behold;
While I know that my death, to my delight,
Will come gradually forth, full of beauty
And full of sweetness, too,
So lovely does my desire imagine it.
The greatness of life is entire in my death.[4]

In the New Sacristy in San Lorenzo, his underlying pessimism came to a sublimated resolution in the image of the Virgin nursing the Christ Child. The dukes on the threshold of Eternity are all gazing at her.

Installed on the wall facing the altar, this figure of the *Virgo lactans*, although unfinished, seems to be the culmination of a long series of images of the Virgin created since the beginning of the Quattrocento. Only the figure of the Virgin sculpted by Donatello in his 1435 *Annunciation*, with its noble bearing and haughty expression, is comparable to Buonarotti's Medici *Madonna*. Deprived of the architectural frame that was planned but never made, the figure of Christ's mother displays a surprising blend of nobility and spontaneity. Leaning slightly to the left to give her breast to a disproportionately large Christ Child, who seems well beyond the nursing age, she has a triangular face that recalls the *Bruges Madonna*, created by the artist in his youth, but also the face of certain masculine figures: *Christ*, *David* and *Victory*. With empty eyes, but an all-too-human gaze, she stares into the distance. She recalls the humble woman who was Michelangelo's wet-nurse and the wife of a stonecutter, and also his own mother, Francesca di Neri, who died in 1481, when he was only six years old.

"From boyhood Michelangelo was a hard worker, and to his natural gifts he added learning, which he was determined to acquire not through the efforts and industry of others but from nature herself, which he set before him as a true example." These remarks by Condivi seem to account perfectly for the blend of realism and ideal heroic sublimation that characterizes the *Medici Madonna*.

History sometimes serves up some pleasant surprises. The discovery in 1976 of one hundred and eighty drawings executed directly on the walls near the chapel built by Michelangelo caused a sensation. These invaluable artistic

4. Walter Binni, *Michelangelo scrittore*, Einaudi, Turin 1975, p. 59.

MICHELANGELO
Mural drawing
Found in 1976
beneath the Medici Chapel
in San Lorenzo, Florence.

Opposite
MICHELANGELO
Dawn
Detail. Tomb of Lorenzo de' Medici.
Medici Chapel, San Lorenzo, Florence.

DONATELLO
The Annunciation
Around 1433-1435. Marble.
Santa Croce, Florence.

OPPOSITE
MICHELANGELO
Virgin and Child
1524-1534. Marble.
Height 226 cm. (7 ¹/₂ ft.).
Medici Chapel, San Lorenzo, Florence.

documents were found in three different rooms adjacent to the Medici Chapel: in a small room to the right of the apse, on the walls of the apse itself, and in a long hallway directly beneath it. According to the curator at the time, ninety-seven of these drawings may be attributed directly to the hand of Michelangelo himself (fifty-four figures and forty-three architectural drawings), while the others can be ascribed to his students.[5]

The most interesting of these sketches presents analogies to the *Resurrection of Christ*, which Michelangelo probably intended to paint on the walls of the chapel. This large-scale drawing shows a male figure in motion with powerful anatomy; *pentimenti* are visible on the arms and legs. Another drawing may be related directly to the Eve of the *Garden of Eden* on the Sistine Chapel ceiling; it has the same pose, the same movement of the limbs, but with inverted positions. The sketch of one face recalls the famous *Laocoön* group which Michelangelo so admired, while others are reminiscent of figures in the Sistine Chapel, and one sketch even recalls the legs of the statue of Giuliano in San Lorenzo. Some of the drawings are tentatively attributed to Montorsoli, a most interesting hypothesis, for he was one of the two known assistants who worked with Michelangelo on the Medici Chapel. Others are of such high pictorial quality that they can be attributed to no other hand than Buonarotti's.

5. Paolo del Poggello, *I disegni murali di Michelangelo e della sua scuola nella Sagrestia Nuova di San Lorenzo*, Centro di Firenze, Florence 1979.

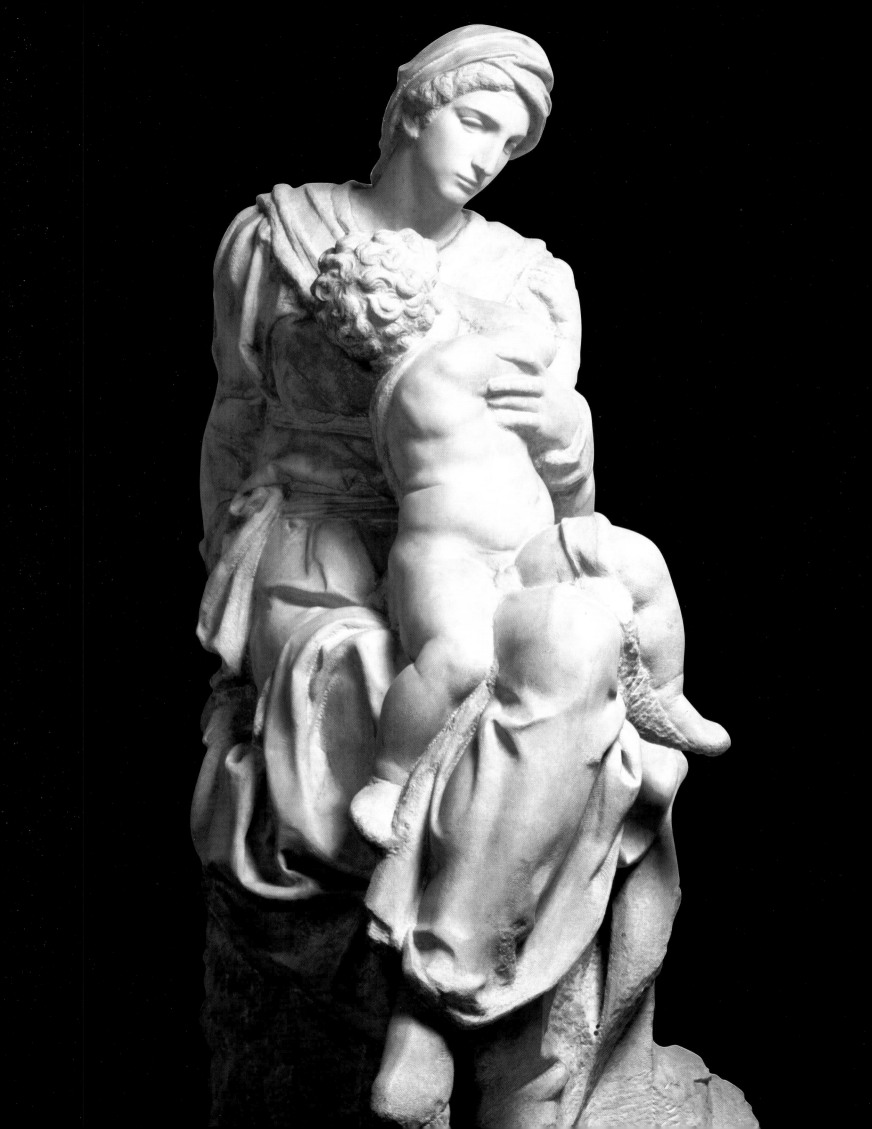

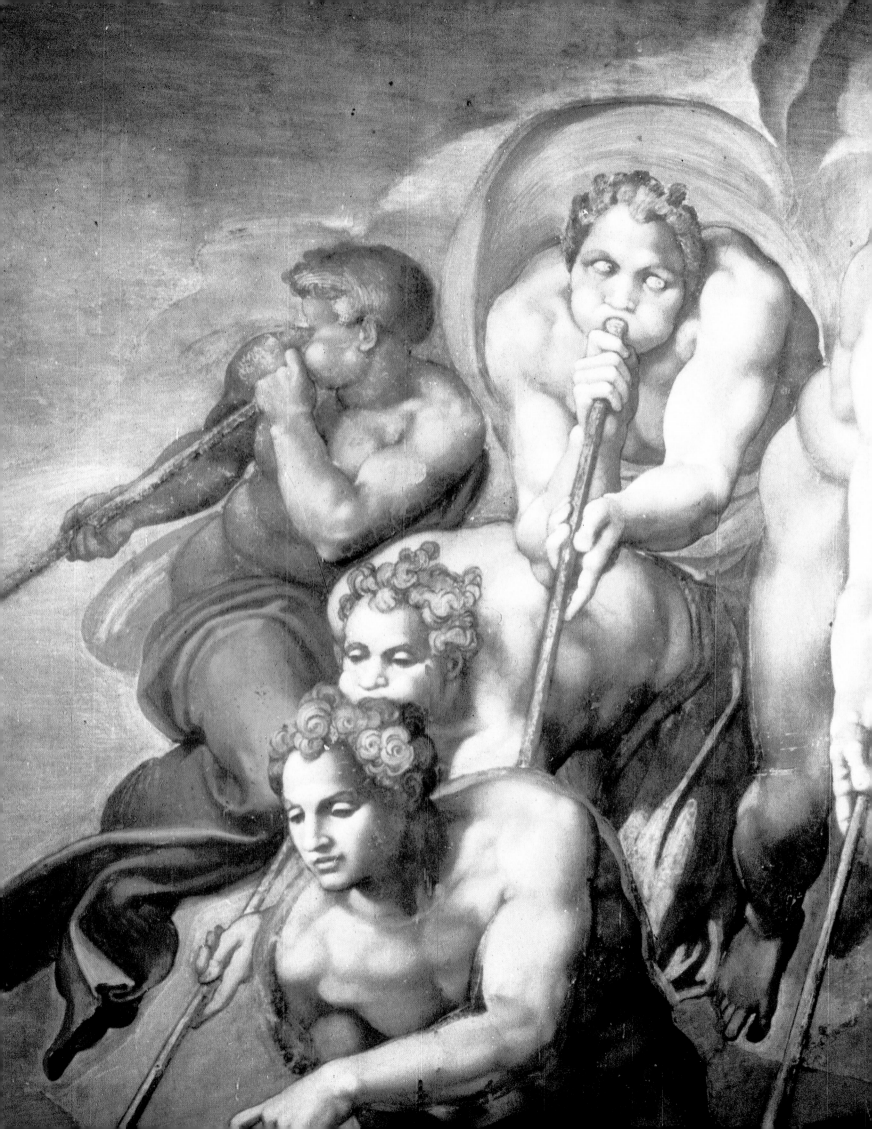

7 ATTRACTION AND AWE OF THE FUROR DIVINUS
The Last Judgment

Pope Julius II died shortly after the completion of the Sistine Chapel ceiling. His successor, Leo X, turned to Michelangelo's arch-rival, Raphael, and commissioned him to design ten tapestries representing the Apostles. They were hung for the first time during the Christmas celebrations of 1519 in the lower part of the chapel.

In 1533, however, the new pope, Clement VII, summoned Michelangelo to Rome to entrust him with another painting project in the Sistine Chapel. The historical context inspired the pontiff to have the altar wall decorated with a monumental fresco depicting *The Last Judgment*, and the opposite wall with a *Resurrection*. For some reason, the *Resurrection* was never realized. Scaffolding for the *Last Judgment* was erected between April and August 1535, and by 1537 the actual painting was well under way. The monumental fresco was unveiled on 31st October, 1541. All together, it featured some four hundred figures ranging in size from 2.5 to 2.6 metres. Vasari tells us that on the day of its inauguration the work was discovered "with wonder and astonishment by all of Rome and by the whole world."

A few words on the social and psychological state of the artist during this period would be in order. Since 1515, he had been too closely associated with the vicissitudes of the popes not to have been deeply affected by the crisis of the Reformation and the sack of Rome. Other factors made themselves felt while he was working on the *Last Judgment*, most of all his relationship with Vittoria Colonna, a woman of great learning and literary ability with whom he maintained

FRA ANGELICO
The Souls of the Damned
Detail of the *Last Judgment*.
San Marco Museum, Florence.

OPPOSITE
MICHELANGELO
The Angels Blowing the Trumpets of Death
Detail of the *Last Judgment* after restoration.
Sistine Chapel, Vatican.

131

FRA ANGELICO

The Last Judgment

Around 1431. Wood panel.
105 x 210 cm. (41 x 83 in.).
San Marco Museum, Florence.

OPPOSITE

ROGIER VAN DER WEYDEN

The Last Judgment

1445-1449. Polyptych, wood.
215 x 560 cm. (7 x 18 ft.).
Hôtel-Dieu, Beaune.

a passionate exchange of letters and poems. She introduced him to the "Italian Reformation," a movement that advocated profound changes within the Roman Catholic Church. Michelangelo, deeply hurt by the attacks of his detractors and hounded by his patrons and the demands of his family, often succumbed to inner torment and spells of acute anxiety. He had lost his father and beloved brother and his spirits fell so low that he wrote: "I am reproached every day, as if I had personally crucified Christ."

According to Condivi, his faithful biographer: "So great was Pope Paul's[1] love and respect for Michelangelo that... he did not ever want to displease him. In this work Michelangelo expressed all that the art of painting can do with the human figure, omitting no attitude or gesture." He drew on a variety of important sources for this work combining a great many references – pictorial, literary, historical and personal – in a powerful synthesis.

The theme of the Last Judgment had undergone a long and complex artistic evolution over the centuries. Its iconographic origins may be found in the mosaics of the church at Torello, near Venice, and were developed in an original direction by Giotto at the Scrovegni Chapel in Padua, and even further in the cycle painted by Orcagna in the church of Santa Maria Novella in Florence around the end of the fourteenth century. Beato Angelico painted a *Last*

1. Clement VII died in 1534.

Judgment that may still be seen at the convent of San Marco in Florence. Another noteworthy and influential example of this rich theme is the fresco executed by Luca Signorelli at the Cathedral of Orvieto.

In his own fresco at the Sistine Chapel, Michelangelo took up the main motifs of the Christian tradition, such as the central place given to Christ the Judge (Isaiah 66:15) and the Virgin Mary, and the depiction of the instruments of the Passion and Crucifixion. He also drew on the Dantesque repertory by representing the crowds of souls of the damned in Hell dominated by the figures of Charon and Minos. In his depiction of space, Michelangelo opted for a Medieval treatment, that is, without linear perspective or depth, and reducing landscape to a very minor role. The reasons for this choice have nothing to do with a nostalgic desire to return to the pre-Renaissance tradition, but more with the highly original and personal pictorial scheme that he conceived.

He broke away from the Medieval theological concept of Providence and introduced the more antique notion of *fatum*, the idea of an ineluctable Fate which leaves mortals at the mercy of fear and uncertainty. Where Fra Angelico had represented a neatly ordered cosmic scheme and the promise of eternal salvation in Paradise, Michelangelo eliminated all hierarchy and projected the Damned and the Saved alike on a flat space, joined in a single vast ascending movement. He did away with decorative framing devices and filled the entire space of the wall with tight clusters of figures, the

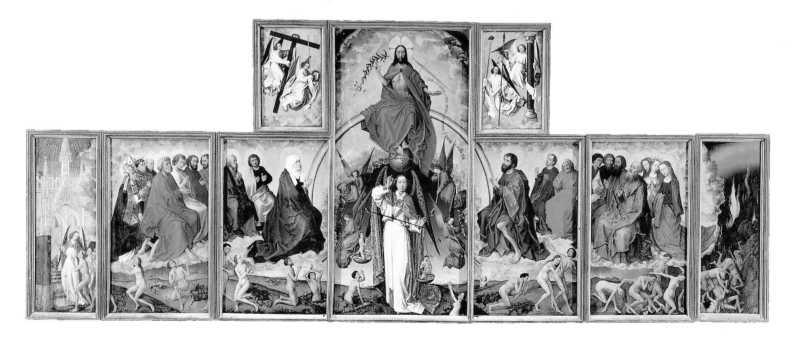

better to plunge the spectator into the human drama presided over by Christ, the ultimate arbiter. The formal characteristics of this figure, with one arm raised and the other lowered – an opposition that is duplicated in the legs – are a condensation of the movements of the souls, upward or downward depending on their respective merits (Matthew 24:31).

A drawing preserved at the Casa Buonarotti in Florence shows us that Michelangelo's initial design for the *Last Judgment* took into consideration the existing frescoes on the Sistine Chapel walls, especially Perugino's *Nativity* and *Moses Found in the Bulrushes*. The artist, however, soon diverged from this scheme and decided to occupy the entire wall surface, up to and including the lunettes, in which he depicted angels and the instruments of the Passion.

Obviously, the major source for this work is the Bible. According to Vasari and Condivi, not only was Michelangelo a devoted reader of the Scriptures, but he was also *amicissimo* – on very friendly terms – with many high prelates and cardinals including Polo, Crispo, Farnese and Bembo, who were able to guide and enlighten him, and even explain the more controversial passages. Condivi points out that "he also read, most attentively and assiduously, the Holy Scriptures of the Old and New Testament." In the case of the Resurrection of the Dead, he drew on the Book of Ezekiel, as had Signorelli at Orvieto Cathedral. In the Bible, the relevant passages read: "Again he said unto me, Prophesy upon these bones, and say unto them, O ye dry bones, hear the word of the Lord. Thus saith the Lord God unto these bones; behold, I will cause breath to enter into you, and ye shall live: And I will lay sinews upon you, and will bring flesh upon you, and cover you with skin, and put breath in you, and ye shall live; and ye shall know that I am the Lord" (Ezekiel 37:4-6). He also took his inspiration from the Book of Daniel: "And many of them that sleep in the dust of the earth shall awake, some to everlasting life, and some to shame and everlasting contempt" (Daniel 12:2).

Michelangelo experts all agree that a major literary influence was Dante Alighieri, whom he read avidly and sometimes imitated in his own writings. The sculptor was such a great admirer of the Medieval poet that he wanted to erect a monument to him in Florence. Already in the sixteenth century, Benedetto Varchi underscored this intense

OPPOSITE

TOP

GIOTTO

The Last Judgment
Detail. Around 1305-1309. Fresco.
Scrovegni Chapel
(also called Arena Chapel), Padua.

BOTTOM

LUCA SIGNORELLI

The Last Judgment
Around 1499-1504. Fresco.
Orvieto Cathedral.

PAGE 136

TOP

MICHELANGELO

Drawing for the *Last Judgment*
(no. 1705)
Around 1534.
Department of Prints and Drawings,
Uffizi, Florence.

BOTTOM (LEFT)

MICHELANGELO

Study for the *Last Judgment*
Around 1533-1534.
Bonnat Museum, Bayonne.

BOTTOM (RIGHT)

Study for the *Last Judgment* (no. 65)
Around 1533-1534.
Casa Buonarotti, Florence.

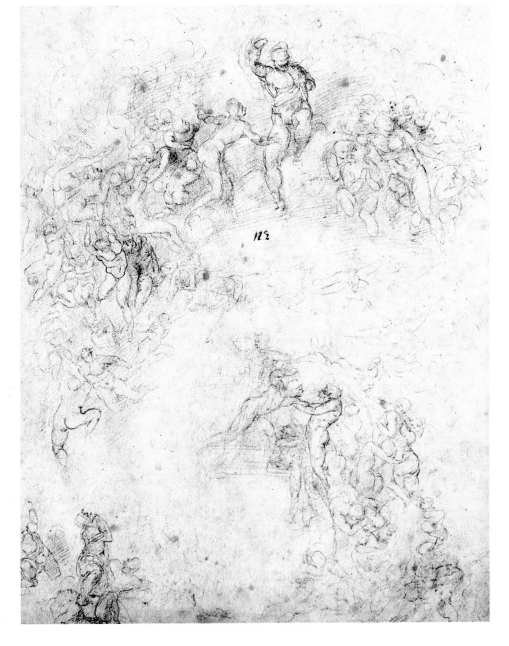

112

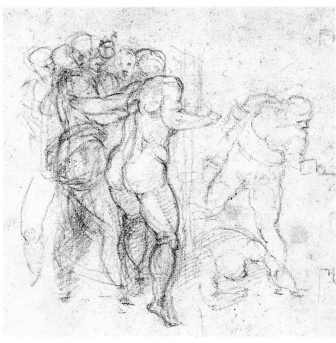

Opposite

MICHELANGELO

The Last Judgment

1535-1541. The fresco
before restoration.
Sistine Chapel, Vatican.

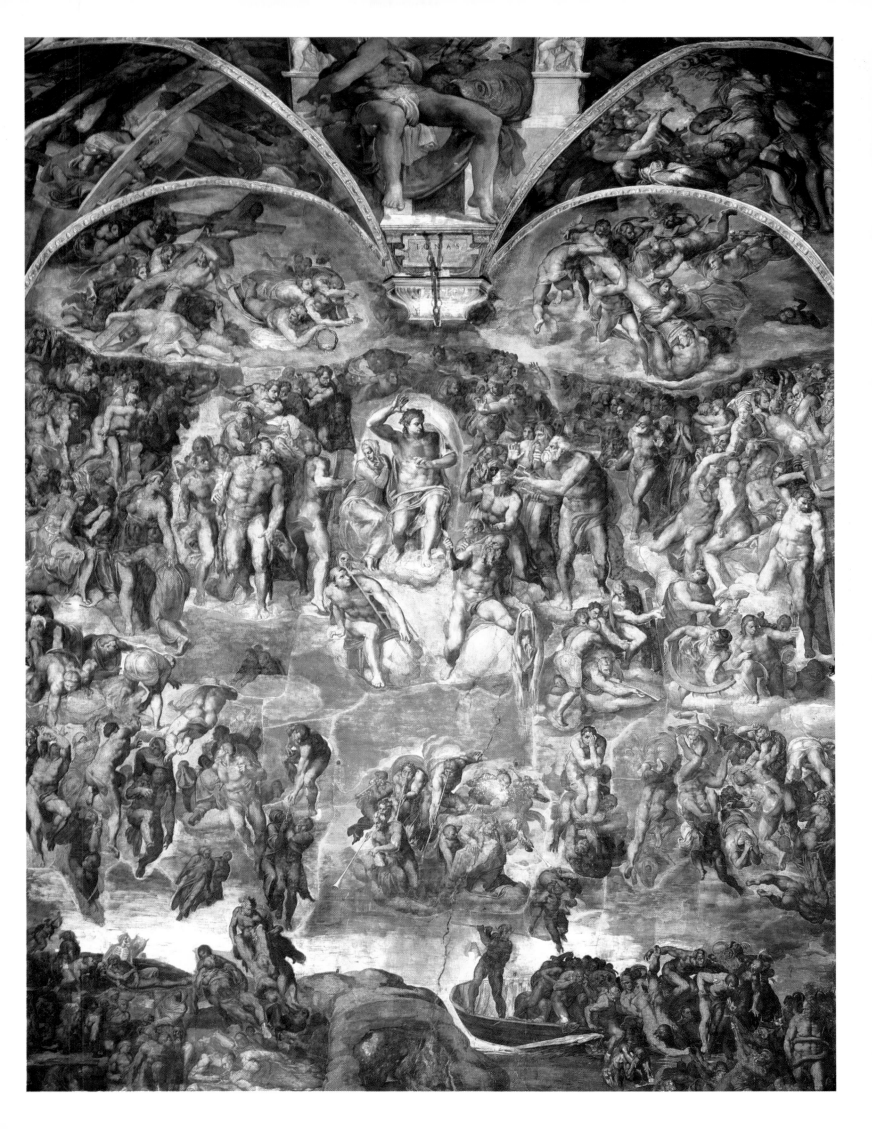

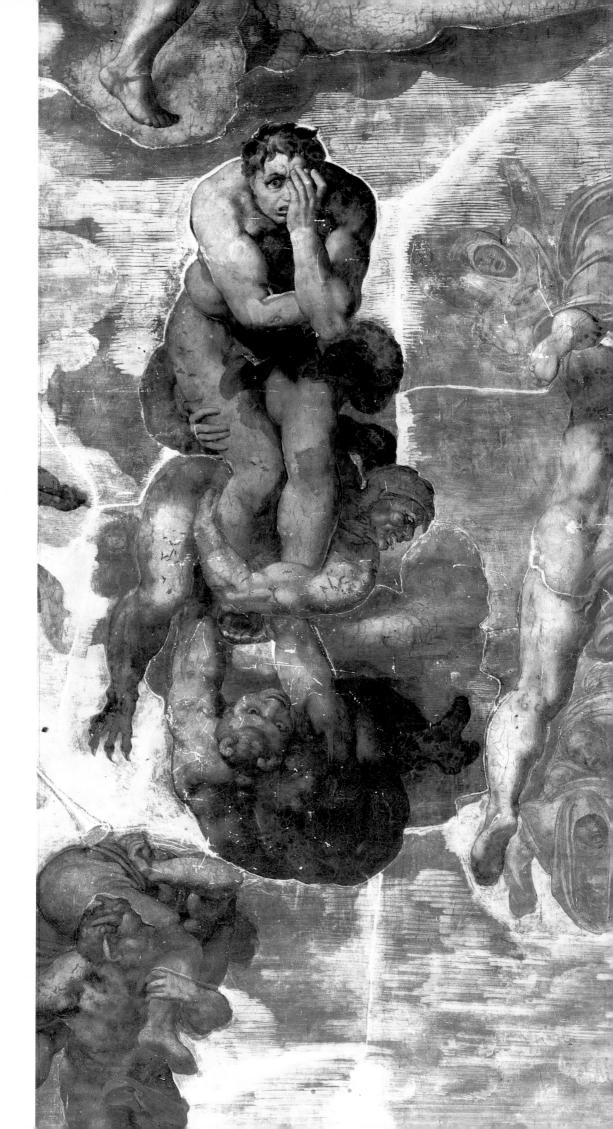

OPPOSITE

MICHELANGELO

The Souls of the Damned

detail of the *Last Judgment*.
The fresco before restoration.
Sistine Chapel, Vatican.

FOLLOWING PAGES

MICHELANGELO

The Resurrection of the Dead

Detail of the *Last Judgment*.
The fresco before restoration.
Sistine Chapel, Vatican.

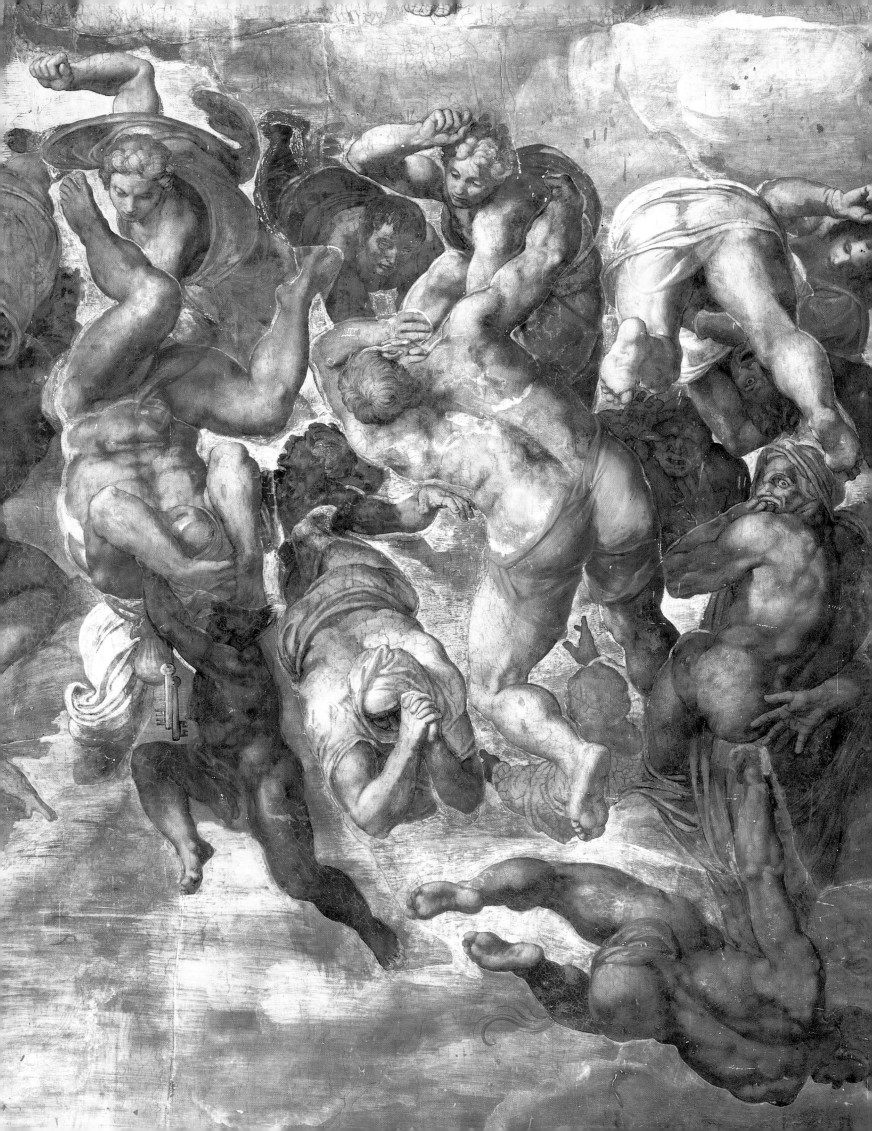

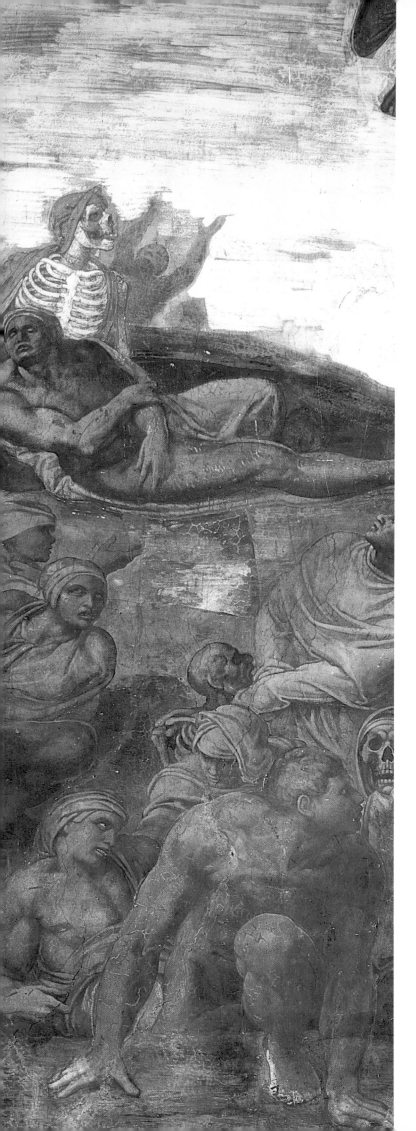

affinity in a book titled *Della maggioranza e nobilità delle arti* (On the Superiority and Nobility of the Arts), in which he mentions the special importance of Cantos X and XII of *Purgatory*. The influence of antique statuary may be seen in the anatomy of certain figures, most notably in that of Christ as Judge.

Nothing brings out Michelangelo's innovations and originality better than a comparison with the other major depictions of the Last Judgment from the Quattrocento. Both in Fra Angelico's panel at San Marco and in Rogier Van der Weyden's altarpiece at the Hôtel-Dieu in Beaune, the figures and spaces are disposed in strict symmetry.

Contrary to the Italian and Flemish tradition, Michelangelo reduced the colour-scheme to the extreme. Only the scenes of Hell at the lower right attract the eye with their bright reddish glare and this finds an echo in Christ's mandorla[2] and Mary's blue drapery. The entire apocalyptic drama, its religious message and emotional impact, have been designed to revolve around the figure of Christ sitting in judgment. The blue background and the greenish-browns of the bodies seem to have no other function than to structure the pictorial space and channel its formal dynamics.

In his polyptych at Beaune, Van der Weyden represents Christ sitting majestically on a red and yellow rainbow flanked by a sword and a lily, with angels on the side panels holding the instruments of the Passion. Fra Angelico depicted Christ surrounded by a double mandorla of red-winged cherubim and seraphim.

Michelangelo created an entirely new image of Christ. His head is apollonian, his chest herculean, possibly inspired by the Belvedere Torso, a sculpture by Apollonius discovered in Rome in the fifteenth century. There is, however, something strange about his pose: he is neither sitting nor standing and seems to be advancing towards the spectator. The figure of the Virgin is young and comely, even sensual in its twisting movement, not unlike certain representations of Venus. Christ raises his right arm in judgment, palm facing outward, while his gaze is directed to the left, where the Damned are being thrown into Hell. The archangel Michael weighing souls on a scale, represented in Fra Angelico's *Last Judgment*, and conspicuously placed in the middle of Rogier van der Weyden's altarpiece, is omitted. Where his predecessors had

2. A *mandorla* is an almond-shaped halo usually surrounding the figure of Christ in representations of the Last Judgment.

140

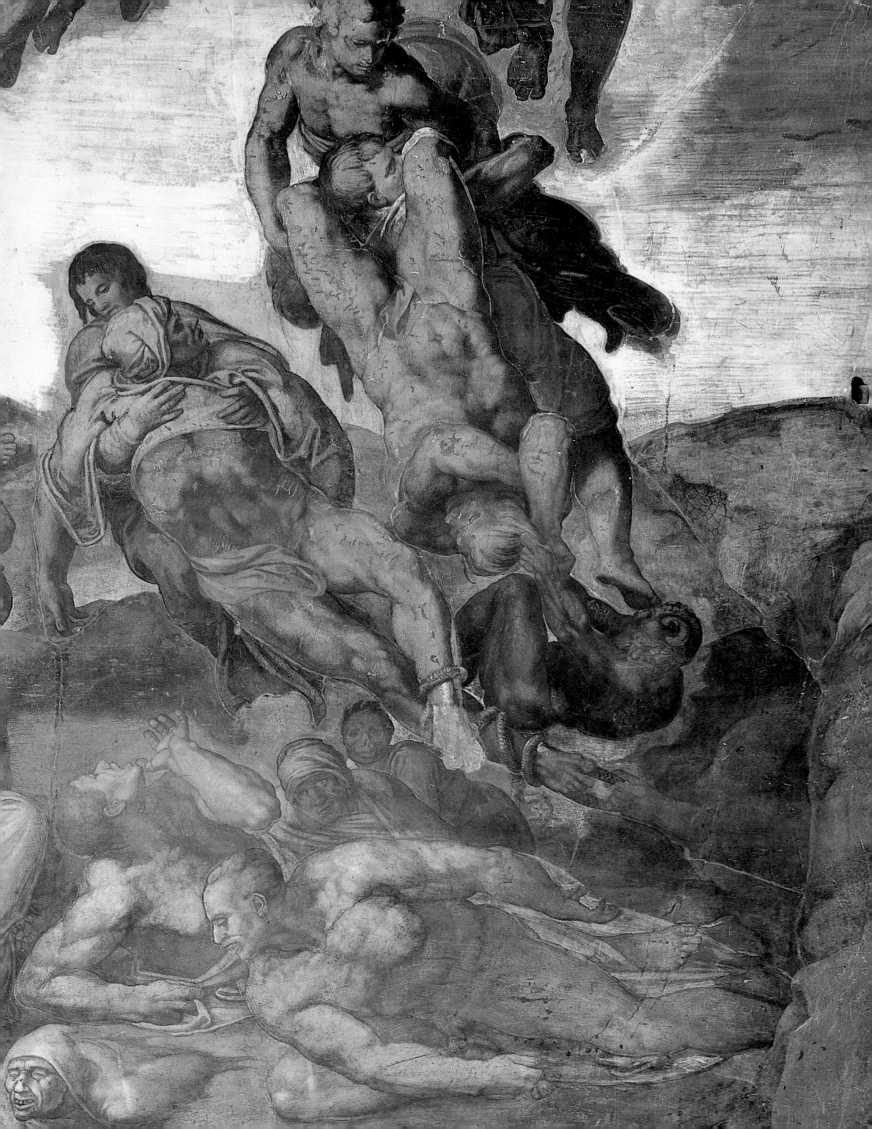

OPPOSITE
MICHELANGELO
Christ and the Virgin
Detail of the *Last Judgment.*
The fresco before restoration.
Sistine Chapel, Vatican.

clearly disposed Heaven and Hell to the right and left sides of Christ, Michelangelo created a vertical arrangement that left little room for the fires of Hell – visible at the lower right – and none at all for Paradise to which the crowds in Angelico's and Van der Weyden's orderly world could aspire. Hope has been banished, giving way to a fatal destiny against which any struggle would be futile. The idea of divine grace has also been left out, leaving the spectator to contemplate the Last Judgment in all its *terribilità*, with no hope of salvation.

In Van der Weyden's altarpiece, the dead have great difficulty in penetrating the earth's crust with great effort, remaining at ground level, where they are immediately separated into the Damned and the Saved. Fra Angelico divided the scene in two halves through the device of a line of open graves of somewhat antique inspiration. Michelangelo, on the other hand, draws the resurrected souls – some of them even portrayed as decomposing corpses – into an irresistible ascent towards the figure of Christ. Whereas artists before had taken care to represent the ritual of the weighing of the souls and their division into two groups – the Saved and the Damned – the scene in the Sistine Chapel exists in a state of suspended time, at the moment of the fateful decision itself, with the hopeful cringing no less than the sinners. It is a moment of terrible doubt and uncertainty, as if divine grace were in fact as awesome as eternal punishment.

In the whirl of salvation and damnation in his *Last Judgment*, Michelangelo returns to a more traditional, two-dimensional representation of space, but also a new complexity in the postures and movements. The human figures are clustered together, some in fear, others in a semblance of serenity, some with bodies intact, others with decomposing flesh, an endless gallery of masks expressing every kind of emotion, surging in relentless motion, drawn upwards on the right by the power of Christ's blessing, and hurled downwards into the flames of Hell on the left. The apollonian Christ and seductive Virgin are the only stable fixtures in the composition.

During the execution of this masterful *Last Judgment*, Michelangelo was living in a state of extreme solitude and bitterness, prey to fits of anger. He railed against the painter Sebastiano del Piombo who urged him to paint in oils instead of *a fresco*. He refused to let his nephew Lionardo visit him, "because he would increase my difficulties by

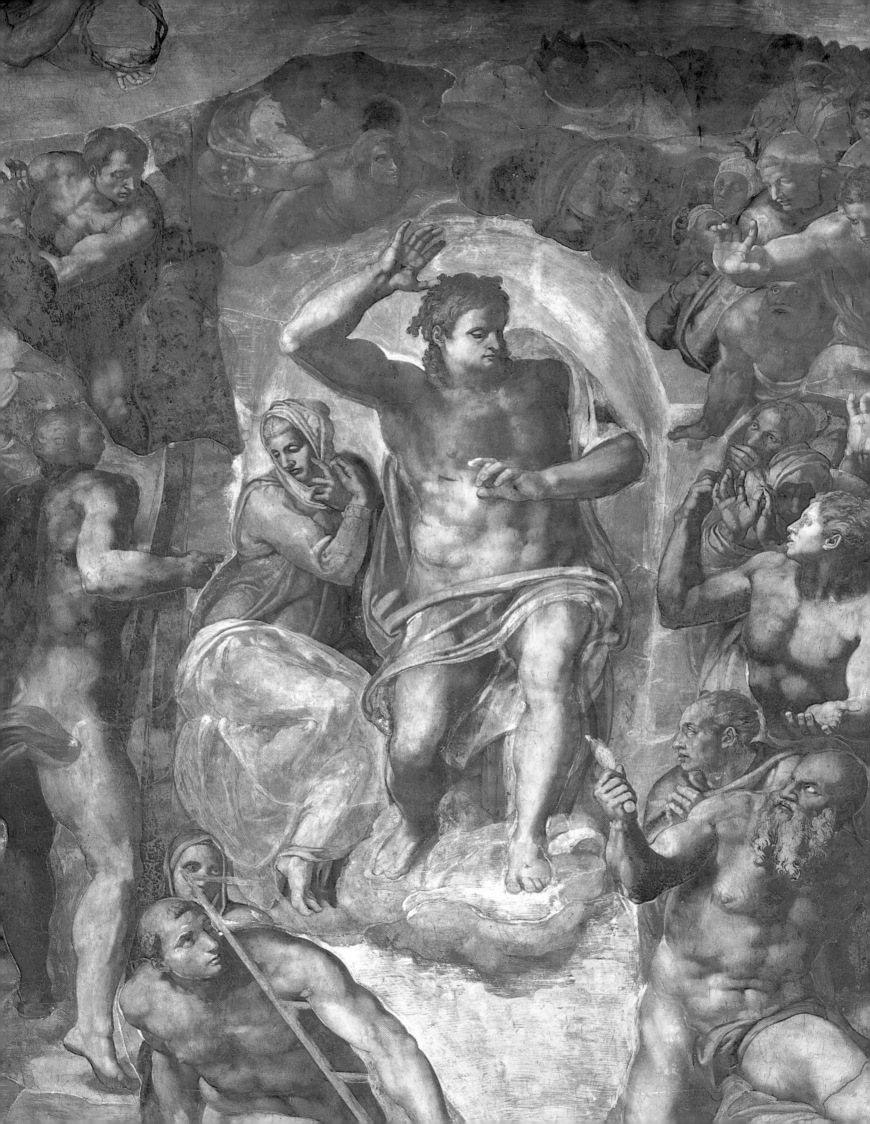

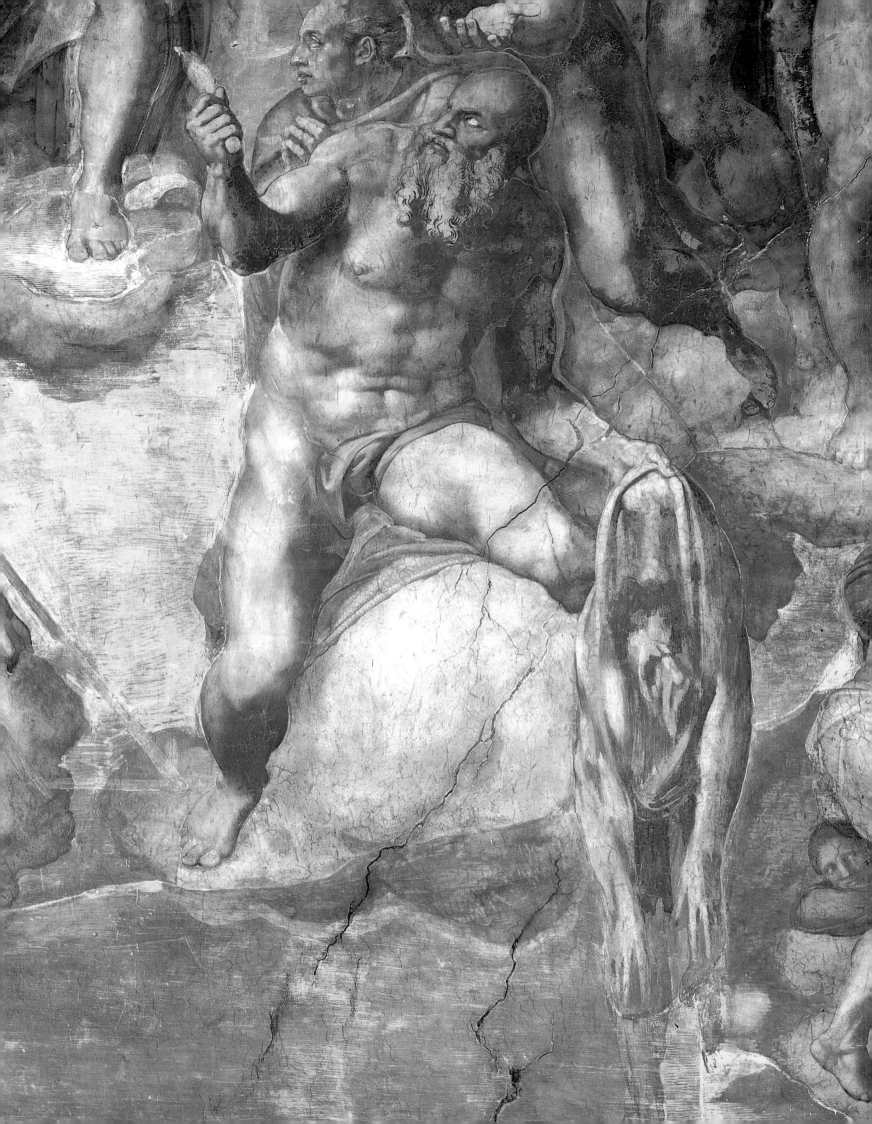

adding new worries to my existing preoccupations." He fell from the scaffold while he was painting, hurt his leg and barricaded himself in his apartments, refusing to see the doctor dispatched by the pope.

He also denied posterity most of his sketches and preparatory drawings. Vasari reports that on two occasions shortly before his death in 1564, he burned "a great many drawings and cartoons made by himself, so that no one could see his efforts and the ways his genius expressed itself." This is confirmed in a letter written to Cosimo I by Averardo Serristori soon after Michelangelo's death.

The *Last Judgment* contains two self-portraits of the artist enabling us to understand how he saw himself both socially and spiritually. The more significant is the one associated with St. Bartholomew, a martyr who was flayed alive, represented sitting on the right, directly at Christ's feet. He holds a knife and his grimacing flayed skin. Strangely enough, he is depicted with a beard, but the "skin" is beardless.

The discovery and interpretation of this image as a self-portrait of the artist was made in 1923 by an Italian physician, Francesco la Cava. The likeness was confirmed by comparisons with known portraits of Michelangelo, including the bronze bust by Daniele da Volterra now at the Accademia in Florence.

This astounding identification is generally accepted today, and reveals only too clearly the anguished image which the artist had of himself and deliberately chose to leave to posterity.

A number of traditional iconographical figures may also be identified in the fresco: St. Lawrence with the ladder-like grille, St. Bartholomew – a likeness of Aretino, who would become a vocal critic of Michelangelo's art – St. Paul and St. Peter with the keys to the Vatican, St. Catherine of Alexandria – originally depicted nude, but later draped for the sake of ecclesiastical decorum – St. Sebastian imitating the gesture of an archer, St. Basil, and another self-portrait as an old man at the far lower left. From Dante's *Human Comedy*, we can see the figures of Charon and Minos, respectively the ferryman and judge of Hell (*Purgatory*, cantos X and XII), an identification that had already been made in the sixteenth century. Many interpretations have been advanced for the other figures, but although interesting they have not been corroborated. Some figures have as many

MICHELANGELO
Saint Bartholomew
Detail of the *Last Judgment*.
The fresco before restoration.
Sistine Chapel. Vatican.
The face on the skin held
by the saint is believed to be
a self-portrait of Michelangelo.

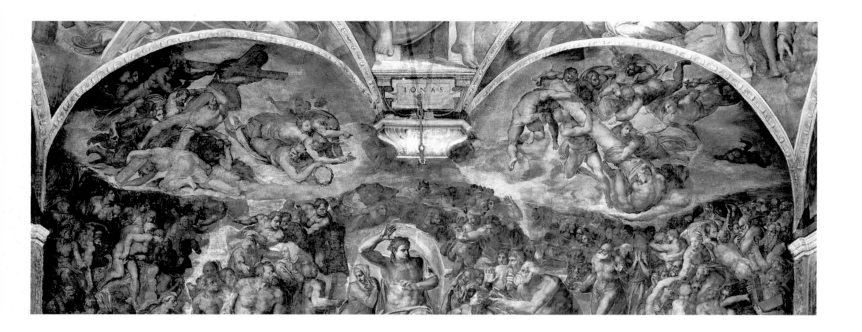

MICHELANGELO

The upper lunettes
of the *Last Judgment*

The fresco before restoration.
Sistine Chapel, Vatican.

OPPOSITE

MICHELANGELO

Saint Peter bearing the Keys

Detail of the *Last Judgment*.
The fresco before restoration.
Sistine Chapel, Vatican.

as three possible identities, while in the case of others – like the one that could be either Abel or Eve – the gender is indeterminate.

With their landscape elements – rocks, a lake and the mouth of Hell below – the two top lunettes are the only spaces treated with perspective. While the fresco itself is devoid of architectural elements, these lunettes feature two architectonic motifs involving the Passion: the column on which Christ was flagellated and the Cross, both diagonally oriented in the sky. These two parts are separate from the rest of the fresco, and show the terror inspired by these instruments of torture. The nude bodies are joined together, trying to sustain the crushing weight of the column and steady the Cross. Where the crucified Christ should be, there is a male figure seen from the back. Only in Leonardo da Vinci's famous sketch for the *Adoration of the Magi* do we find a similar intensity of emotion evoked by the coming of Christ. In fact, the figures at the top left – saints, martyrs and patriarchs – seem anything but confident; their faces are masks of sorrow and pain like those of certain figures in the *Flood* panel on the Sistine ceiling. The dramatically twisted body of *Jonah* which accentuates the median axis of the *Last Judgment*, adds a powerful note of cosmic resonance to the mural below. Michelangelo gave a slight tilt to the wall so that dust would not settle on it. He used drawings and cartoons, assisted by his faithful Urbino – his presence is documented in this case – who helped him prepare the pigments and adjust the scaffolding.

146

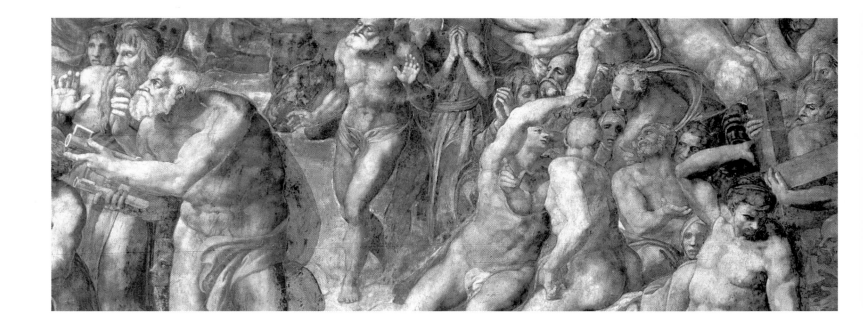

The Sistine Chapel fresco of the *Last Judgment*, so long awaited by the pope and his court, left no one indifferent when it was unveiled to the public. Although it provoked extremely different reactions, the general response was unmitigated admiration. Pope Paul III had long marvelled at this ambitious project, which he had known through the drawings shown him by the artist at the outset. His enthusiasm increased as the work slowly unfolded, and he turned a deaf ear to critics who were shocked by so much nudity. The pope was not alone in his appreciation of Michelangelo's work. The artist replied on 4 December 1541 to a letter full of praise from one Niccolò Martelli: "I see that you believe that I am just as God wanted me to be. I am a poor man of but little worth, and I am wearing myself out in the practice of the talent with which God endowed me, and this is in order to prolong my life as long as possible." Cardinal Cornaro, a man of noble lineage, also expressed his wonder and asked Michelangelo to paint a picture for him. Vasari, who gave thanks to God for being born in the age of Michelangelo, was unconditional in his praise and called the *Last Judgment* a "work sent by God." As soon as the fresco was shown, it became an artistic "icon" and many copies were made, the most important of which – because it was chosen by Michelangelo himself – was by Venusti[3].

But there was no lack of criticism. Biagio da Cesena, the master of pontifical ceremonies, saw the work while it

3. Museo Capodimonte, Naples.

was still in progress and qualified it as *"disonestissima,"* highly dishonest, for it displayed lascivious nudes in a holy place. He even went so far as to say that these figures were suitable for a common tavern, not the Vatican. Michelangelo got his revenge on the cleric by giving his features to King Minos, one of the judges of Hell, with a snake slithering up his leg. Cesena was horrified and pleaded with the pope to have his likeness wiped away, to which the latter wryly answered that he had "power over Heaven and earth, but not over Hell!" Many cardinals joined the shrill chorus of critics over the nudes, pointing out that, among other things, the figure of Christ was portrayed without a beard and too young, and that it lacked sufficient majesty. In a famous letter from 1545, Aretino suggested that the licentiousness of the figures represented was more fitting for the followers of Martin Luther! No detail of this dantesque composition was spared. Finally, on 21st January, 1564, the Council of Trent, meeting to counteract the spreading Protestant threat, decreed that some of the nudes must be veiled. This most delicate task was entrusted to Daniele da Volterra, who clad certain figures with ridiculous "undershorts" and earned the nickname *"Braghetta"* for his trouble. There were even some popes who want to destroy Michelangelo's work entirely.

But Paul III, the pope who commissioned the fresco of the *Last Judgment*, remained undeterred and even commissioned Michelangelo to decorate the Pauline Chapel, which had been built between 1537 and 1540. It is located to the north of the old basilica of St. Peter, between the Sistine Chapel and the Sala Regia. Two frescoes by Michelangelo executed between 1542 and 1550 – immediately after the *Last Judgment* – may still be seen there today.

The two frescoes were part of a cycle glorifying the two most famous martyrs and founding fathers of the Catholic Church. Of the one depicting the *Conversion of St. Paul*, which is stylistically related to the *Last Judgment*, Condivi wrote: "This is the last work of his in painting which has been seen to date; he finished it when he was seventy-five years old." Since the twelfth century St Paul had been traditionally depicted falling from his horse, blinded by the divine light of sudden conversion. Michelangelo shows him lying helplessly on the ground, an old man struck down by an athletic God depicted in extreme foreshortening and surrounded by a host of frightened, turbulent spirits similar to the figures on the Sistine Chapel ceiling. It is a powerful

MICHELANGELO
The Conversion of St. Paul
1542-1545. Fresco.
625 x 661 cm. (21 x 22 ft.).
Pauline Chapel, Vatican.

OPPOSITE
The Conversion of St. Paul
Detail.

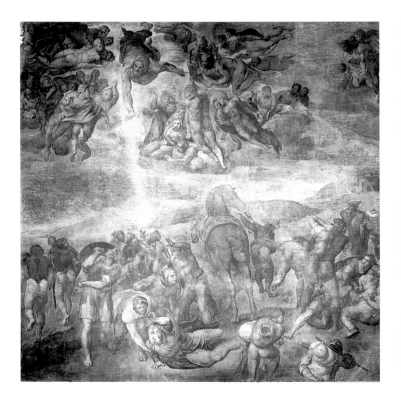

MICHELANGELO
The Crucifixion of St. Peter
1545-1550. Fresco.
625 x 662 cm. (20 ½ x 22 ft.).
Pauline Chapel, Vatican.

OPPOSITE

The Crucifixion of St. Peter
Detail.

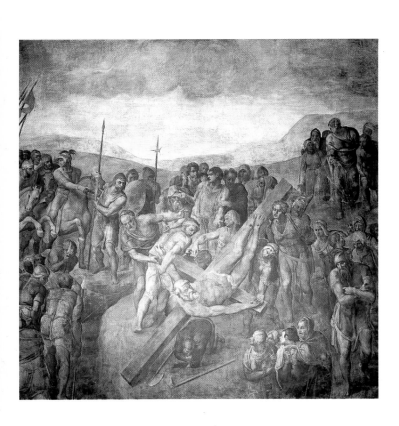

image: the avenging Christ hurtling through the heavens, smiting the all-too-human Paul with the full force of his light. On all sides there are reactions of terror and awe. Can such a theme be appropriately expressed with such emotions and attitudes? Is the figure of St. Paul yet another hidden self-portrait?[4]

What is most surprising about this composition is the complete absence of perspective, or central focus. The space is indeterminate, suspended, excentric. With Michelangelo's frescoes a new pictorial aesthetic was born, a foretaste of the free composition of a Tintoretto.

The second fresco, the *Crucifixion of St. Peter* depicts the martyrdom of the apostle and saviour of souls. He was in Rome in 44 AD and executed around 64-67 AD during the massive persecutions of Nero. According to legend, Peter considered himself unworthy to suffer the same martyrdom as Christ and so asked to be crucified upside down.

Here again there is no focal point in the barren outdoor setting. Michelangelo has arranged the figures into groups forming two irregular triangles converging toward the place of execution. The apostle lifts his head and fixes us with a fiercely searching gaze. Attendants manoeuvre the cross into position before placing it into the hole in the middle foreground, where it acts as the fulcrum of the composition. The painter deliberately contrived an effect of rotation through the diagonal orientation of the cross and the straining figures. None of the facial expressions betrays any hate or violence; there is just an anxious questioning as in *The Last Judgment.*

The spatial and temporal references of this crucial event are completely unclear; it seems to be taking place outside history, even sacred history, as suggested on the lower right by the strange figure of an old man standing with his arms crossed, looking very much like an executioner.

These two frescoes were Michelangelo's last monumental paintings. A fire broke out in 1545 and damaged the roof of the chapel but left the two large murals intact. What better sign of divine providence?

4. These frescoes were done at a time when Michelangelo identified more closely with his faith.

150

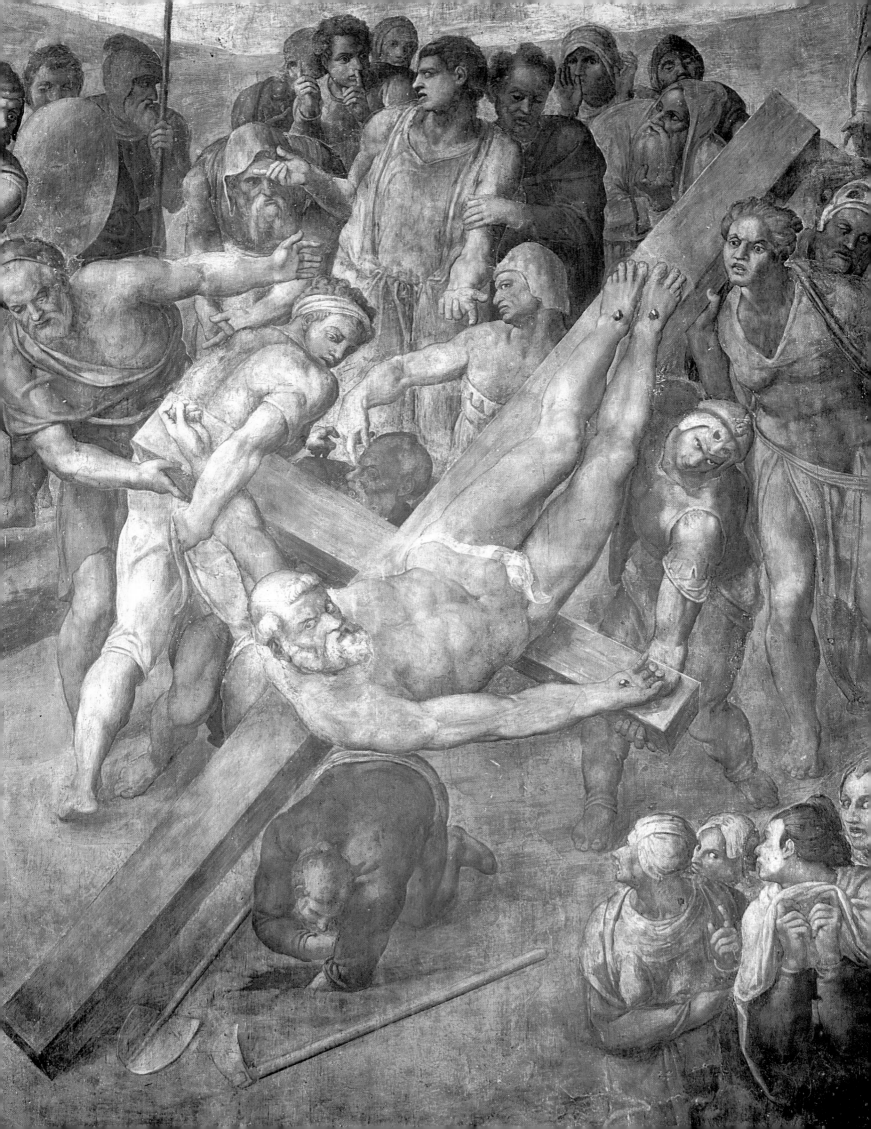

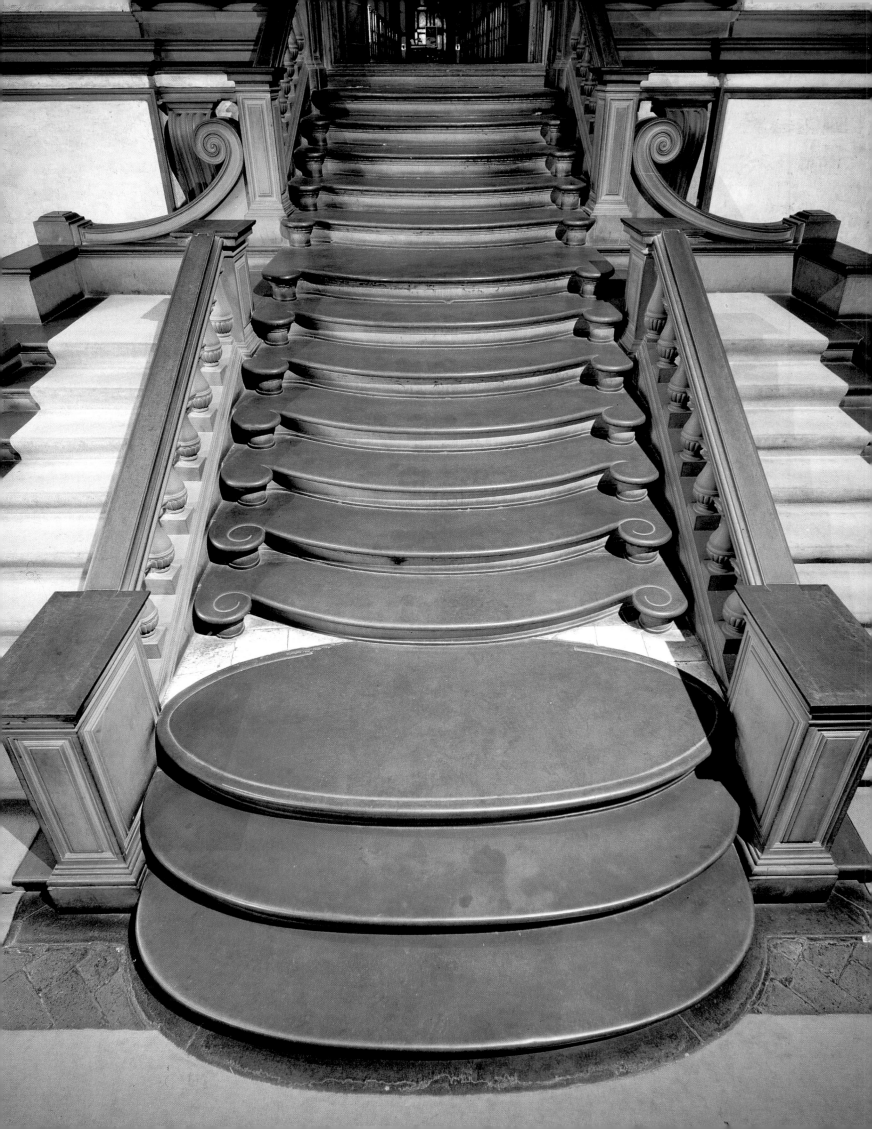

8 MICHELANGELO, ARCHITECT
Public Projects and Pontifical Power

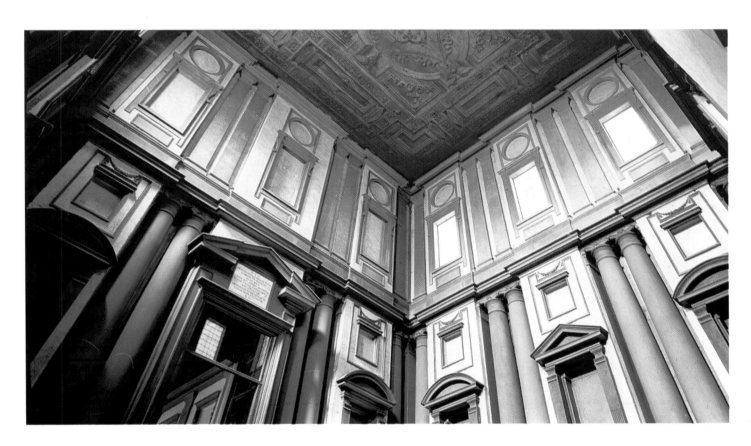

Although in June 1555 he wrote, "I have never had a thought in which death did not have the form of a sculpture," and although Vasari noted that "architecture was not his true art," Michelangelo was a remarkable architect and designer of urban spaces. His design for the Laurentian Library in the church of San Lorenzo in Florence was a major achievement combining both an architectural and a sculptural vision.

His talents as an architect were already well known when, in the autumn of 1523, Pope Clement VII called on him to build a library next to Brunelleschi's Old Sacristy. He began drawing plans for a rectangular hall. Already at this stage he included a vestibule with a monumental double

MICHELANGELO
Vestibule of the Laurentian Library
1524-1526.
San Lorenzo, Florence.

Opposite
MICHELANGELO
Staircase in the Vestibule
Laurentian Library.
San Lorenzo, Florence.
Ammanati built the stairs
after a terracotta model
sent by Michelangelo in 1558.

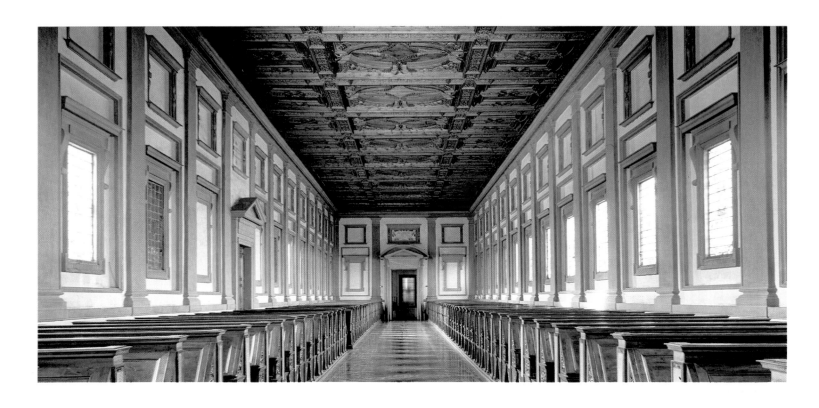

MICHELANGELO

The Reading Room

1524-1526. Laurentian Library.
San Lorenzo, Florence.

OPPOSITE

MICHELANGELO

Wall of the Vestibule

Begun in 1524. Laurentian Library.
San Lorenzo, Florence.

staircase leading up to the reading room. But the pope preferred a single staircase. And work progressed rapidly on this new scheme in 1525-1526. While the vestibule was under construction, Michelangelo designed the main doorway, as well as one for the reading room, and created the ceiling decoration. But in late 1526, economies had to be made and the pope insisted that work on the New Sacristy (Medici Chapel) take precedence over the library. A year later, when the pope had to flee the Vatican in the wake of the capitulation of Rome, work on the library stopped completely. Construction was resumed only in 1549-1550 – without Michelangelo, who had left Florence definitively for Rome – under the direction of Battista del Tasso and Antonio di Marco di Giano. Michelangelo was nevertheless the principal contributor to this project, having designed even the reading tables and lecterns. As sculptor, painter and architect, there is no doubt that he was an artist in the purest tradition of "Renaissance Man."

Although an architectural work, the staircase of the Laurentian Library leaves the spectator with an impression as profound as any inspired by his sculptures and paintings. Michelangelo made a terracotta model of the staircase in 1558 and sent it to Amannati to build it out of wood in the following year. Duke Cosimo de' Medici eventually chose to have it made of stone.

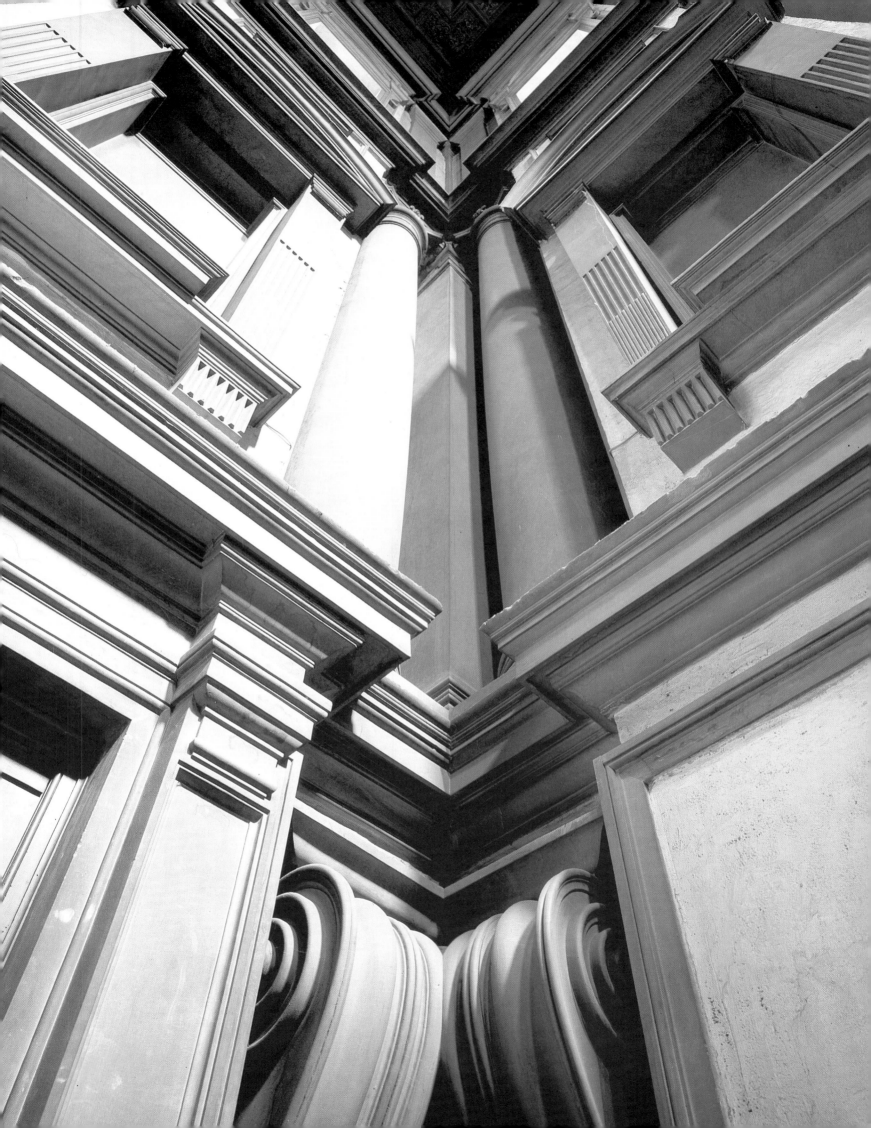

ITALIAN SCHOOL
View of the Capitol
Around 1554-1560. Drawing.
28 x 42 cm. (11 x 16 ¹/₂ in.).
Louvre Museum, Paris.

Bottom
ETIENNE DUPÉRAC
Michelangelo's project for the Capitol
1558. Engraving.
Bibliothèque Nationale, Paris.

The windows decorating the vestibule, as well as the broken pediment of the doorway to the library itself, are framed with a grey stone called *pietra serena* and have pediments recalling those of the Medici tombs in the New Sacristy. Although the vestibule is of relatively modest dimensions, the design of the staircase and the architectural syntax give the space a dynamic, expansive quality. The high-point is the staircase itself: it is divided into three separate flights at the bottom; the bottom three steps in the middle are elliptical in shape; halfway up it becomes a single flight flanked by two large scrolls leading to the Reading Room. Although designed by an artist who made no claims for his prowess as an architect, it is a stunning demonstration of what can be achieved by combining architectural and sculptural forms in a single vision. To be sure, not a few of the architectural elements of this library were directly inspired by the designs of his illustrious predecessors, Brunelleschi and Donatello, and even by those of his great rival, Bramante. But his major contribution was the linking of the vertical volume of the vestibule to the horizontal one of the Reading Room by a staircase conceived as both architecture and sculpture. The vestibule and Reading Room of the Laurentian Library are often cited as precursors of Mannerist architecture, which was innovative, sometimes irrational and consistently experimental.

With disconcerting ease, Michelangelo mastered this interplay of almost abstract forces, and transcended the narrow confines of function, decoration and anecdote. It could be said that Michelangelo's architecture marked the beginning of the modern phase of this art form, in which buildings were no longer merely adapted to functional requirements, but treated as symbolic spaces charged with tensions involving an underlying, internal logic of their own.

Ascanio Condivi clearly understood the role that architecture played in his master's life: "He dedicated himself to perspective and architecture with a degree of success which is demonstrated by his works. Nor did Michelangelo content himself merely with the knowledge of the principal elements of architecture, but he insisted on knowing everything that in any way pertained to that profession, such as how to build junctions, scaffolding and platforms, and he became as proficient as a professional."

In 1539, at the age of sixty-four, Michelangelo was appointed consulting architect for the re-designing of the

156

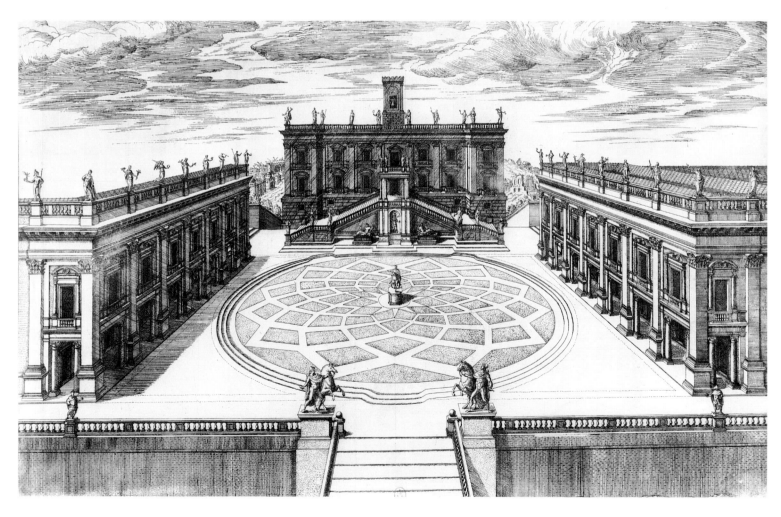

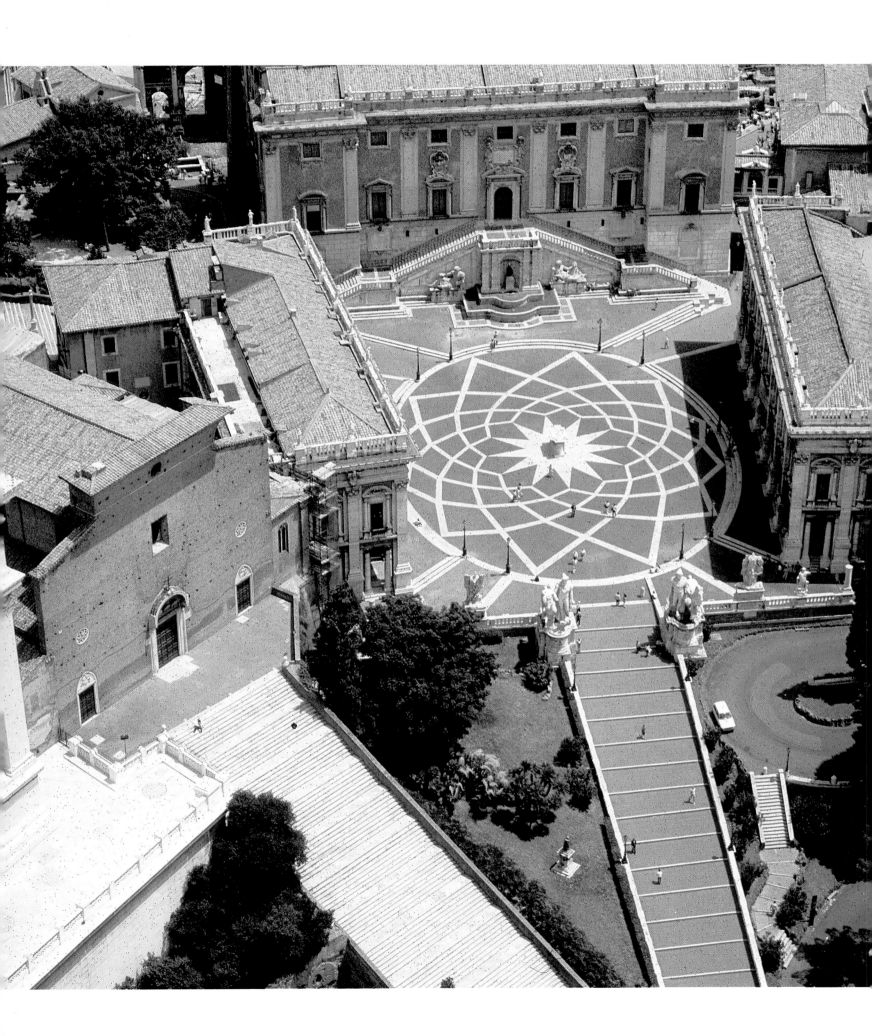

Capitol Square in Rome, in the centre of which the pope had installed the famous equestrian statue of Marcus Aurelius on a pedestal also designed by the Florentine artist. This was necessary because when the emperor Charles V visited Rome four years earlier, he had had to bypass the Capitol for lack of suitable access roads. The site was still in a deplorable condition as a result of the sack of Rome. On the south side stood the fifteenth-century building that housed the municipal offices, on the east side the palace of the Senate built from the vestiges of an ancient Roman *tabularium*, on the west an overgrown hillside, and on the north side, a steep wall that flanked another hill on which stood the church of Santa Maria in Aracoeli.

Michelangelo set out to design a new square that would become a suitable civic centre. His plans were a landmark in the history of town-planning. Faithful to the principle of symmetry dictated by the human body, Michelangelo elaborated the following scheme: in front of the Capitol, he created an open space symmetrically flanked by two buildings of similar design; in an arrangement not unlike a nose separating the eyes, he made the former *tabularium* the central element, preceded by two palaces on either side, the Palazzo dei Conservatori and the present-day Capitol Museum. Lack of funds hampered progress, and work continued well after the artist's death. Begun in 1547 and finished fourteen years later under the direction of the architect Giacomo della Porta, the senatorial palace owes little to Michelangelo's plans. Construction on the palace housing the Capitol Museum was begun only in 1603 and finally completed in 1650. Nevertheless, the overall scheme of the square with its monumental staircase designed by Michelangelo (and only slightly modified by Giacomo della Porta), the theatrical effect of the two slightly diverging palaces on the sides, and the Palazzo del Senatore acting as a backdrop, expresses a singular feeling for architectural forms involving a masterful play of tensions relieved by calmer spaces. The artist superbly integrated the trapezoidal form of the piazza – the Senate and the Palazzo dei Conservatori do not meet at right angles – to create an impression of convergent forces channelled down the hillside by the monumental stairs. By placing the statue of Marcus Aurelius so that it faces the city, Michelangelo clearly asserted the ancient foundations of the power of Rome, the capital of the world.

OPPOSITE

View of the Capitol today

FOLLOWING PAGES
LEFT
MICHELANGELO
Model for the Dome of St. Peter
1561. Wood.
Museum of St. Peter, Rome.

RIGHT

**The Dome of the Basilica
of St. Peter today**

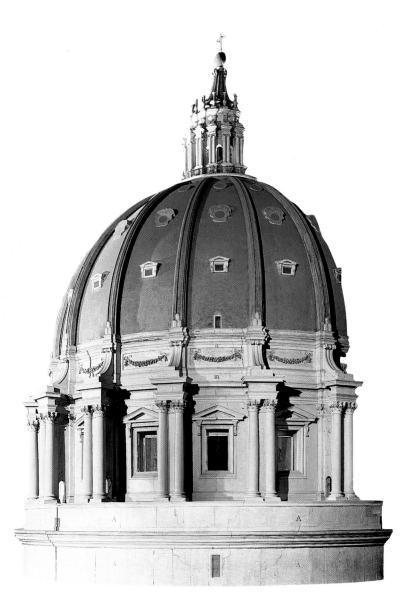

At the same time that he was working on these town-planning schemes, Buonarotti was also involved in purely architectural projects which took up more and more of his time. But in view of his age he had to content himself with drawing up plans while others carried out the work under his supervision.

In 1546, after the death of the architect Antonio da Sangallo the Younger, the pope forced Michelangelo – despite his initial refusal – to oversee the construction of the new basilica of St. Peter. This colossal undertaking involved major difficulties and no little risk.

The construction of a suitable martyrium over the tomb of the apostle had preoccupied the Vatican for many years. The most important work done so far had been started by Bramante at the behest of Julius II. When this great architect died in 1514, several successors were summoned including Raphael, Fra Giocondo and Giuliano da Sangallo, some of whom were in favour of a plan in the shape of a Latin cross, others a Greek cross. The project stalled until 1535, when Pope Paul III finally called on Antonio da Sangallo the Younger to take on the project. He opted for a compromise combining the two types of cross, then went on to execute a huge wooden model that was not only very expensive but took more than seven years to make. Construction continued on the basis of Sangallo's 1543 model until his death three years later.

When the pope called on the seventy-one-year-old Michelangelo to finish the project, the artist was very critical of the work of his predecessors and wary of probable criticism from Sangallo's supporters. When the pope insisted, he relented but refused to accept any remuneration. On 1st January, 1547 he was officially appointed superintendent of the construction of the Basilica of St. Peter. Michelangelo was very critical of Sangallo's design, especially the many ambulatories which he said would create "so many dark hiding places... offering opportunities for infamies of every kind, such as hiding places for outlaws... the raping of nuns and other crimes, so that when the church closed it would take twenty-five men to thoroughly search the premises."

From his drawings and plans, it can be inferred that he wanted to create a more compact form for the basilica, steering away from Sangallo's scheme – which he found divided the space too much – and towards a plan closer to a true Greek cross. Following the plan drawn up with the

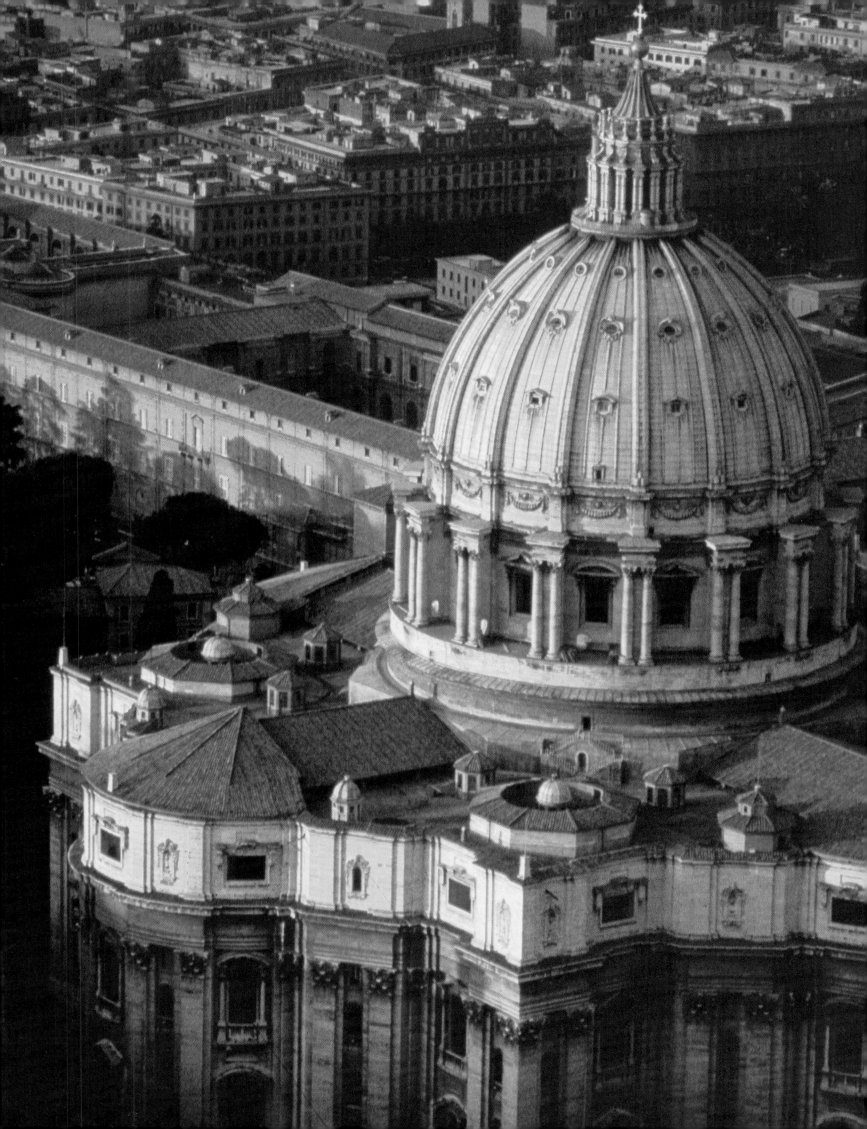

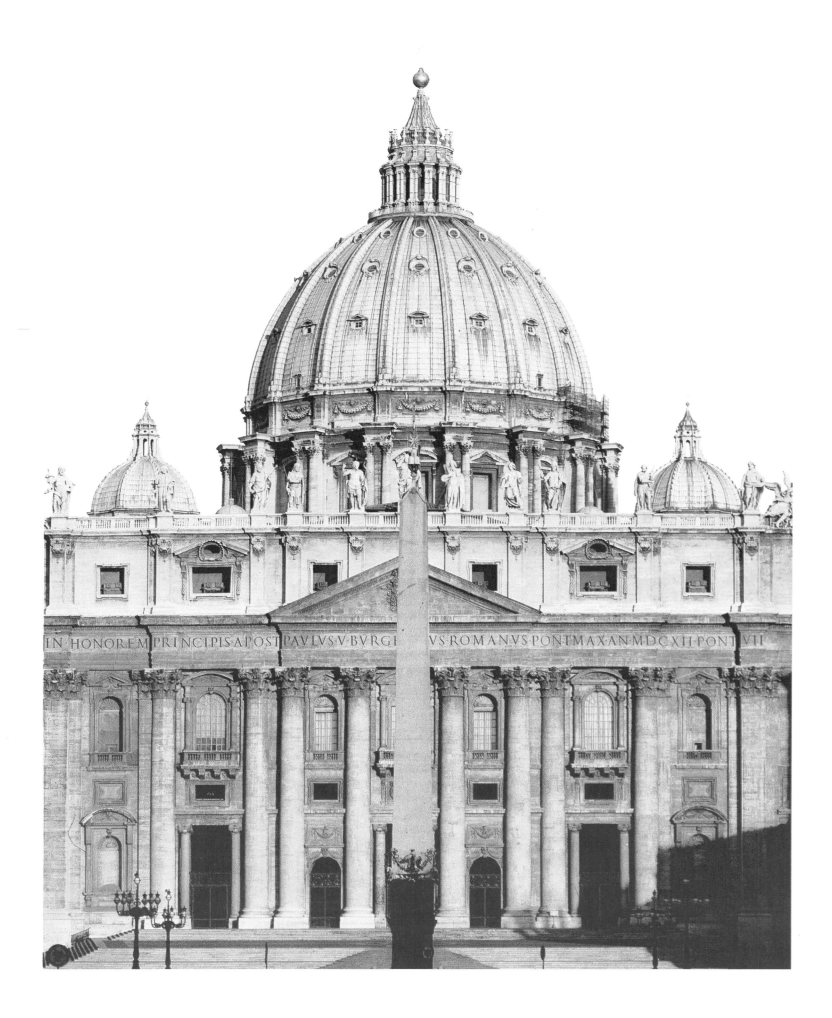

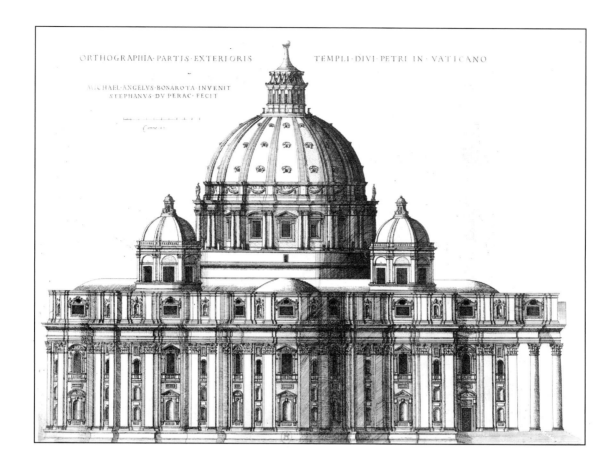

ORTHOGRAPHIA · PARTIS · EXTERIORIS TEMPLI · DIVI · PETRI · IN · VATICANO

MICHAEL · ANGELVS · BONAROTA · INVENIT
STEPHANVS · DV · PERAC · FECIT

supreme pontiff in 1546-1547, Michelangelo undertook the supervision of the construction work. Old age and illness, however, prevented him from spending much time at the building site, and he had to surround himself with helpers and assistants. The first phase involved the demolition of Paleochristian ruins and certain parts already built by his predecessor. In 1549, the artist concentrated his efforts on the drum that was to support the huge dome. Three years later, in February 1552, a banquet was held to celebrate the completion of the lower cornice of the drum. Michelangelo's original plan called for a hemispherical dome in keeping with Bramante's first design, and not an ogival dome, as Sangallo had wanted. For reasons of architectural stability, he eventually designed a more pointed dome.

This modification is confirmed by his 1561 wooden model, showing the inner shell of the dome as hemispherical, and the outer shell ogival. But some scholars think that the changes were made by Della Porta. The latter, who had also worked on the Capitol, later solved the problem with the engineer Domenico Fontana by building a pointed dome on top of Michelangelo's drum.

ÉTIENNE DUPÉRAC

**Michelangelo's project
for the Basilica of St. Peter**
1558.
Bibliothèque Nationale, Paris.

OPPOSITE

Façade of St. Peter Basilica
Finished in 1612 by Carlo Maderno.

FOLLOWING PAGES

Aerial view of St. Peter Basilica
The lantern planned
by Michelangelo for the dome
was built by Giacomo della Porta.

The general shape of the building is a cube decorated with four smaller domes and an attic. On Michelangelo's model, which was approved by the pope, we can see that the lantern at the top of the dome was an adaptation of Brunelleschi's design for the cathedral of Santa Maria del Fiore in Florence; essentially, a *tempietto*, or small circular temple surrounded by a balcony. This connection is explicitly documented in a letter dating from 1547 from Michelangelo to his nephew Lionardo asking him to measure Brunelleschi's lantern. But the actual construction of the dome had to wait until 1557, when the façade was finished. In that same year, Michelangelo made a clay model of the dome; then, between 1558 and 1561, a more detailed version was made according to his instructions. Until Michelangelo's death in 1564, the construction was directed by Tommaso da San Gimigniano, Tullio da Parma and Battista da Carrara. The dome was finally completed with certain modifications of the outer shell by Giacomo della Porta between 1588 and 1590, long after the artist's death. But the latter architect remained faithful to the general thrust of his illustrious predecessor's ideas. Three years later, the lantern planned by Buonarotti was raised on top of the mighty dome, a fitting symbol of the far-reaching power of the Roman Catholic Church.

The existing façade of St. Peter's, the result of many years of planning and construction, was built by Carlo Maderno, who finished it in 1612, at the beginning of the Baroque era. In 1657, the great sculptor and architect Bernini built the colonnade in front of St. Peter's thus opening it up to the city of Rome and, beyond, the entire Christian world.

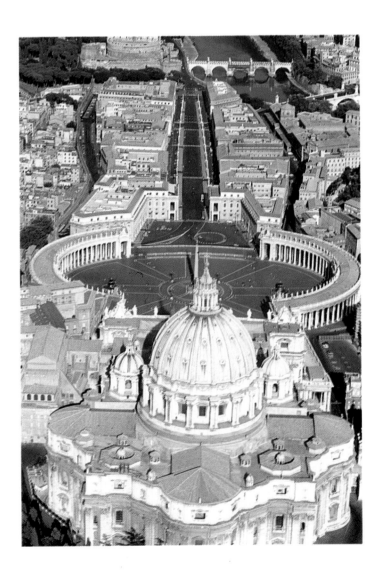

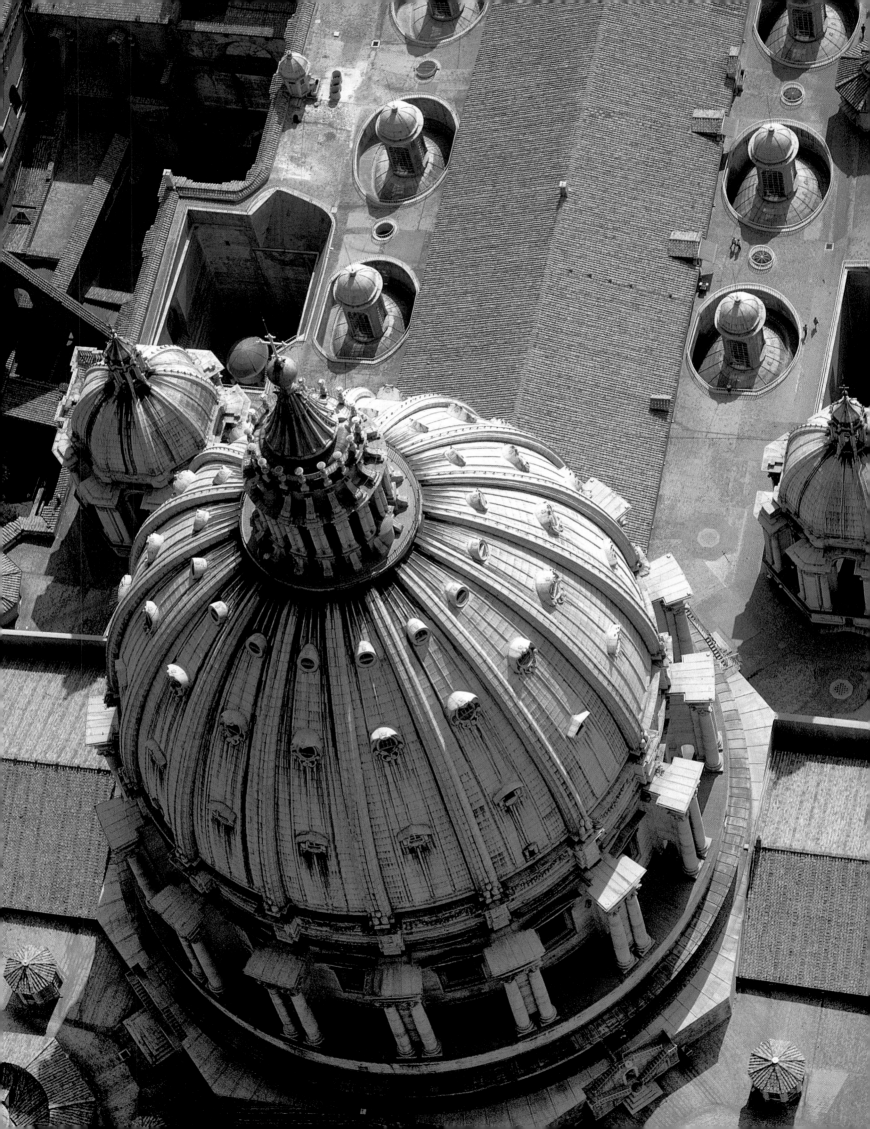

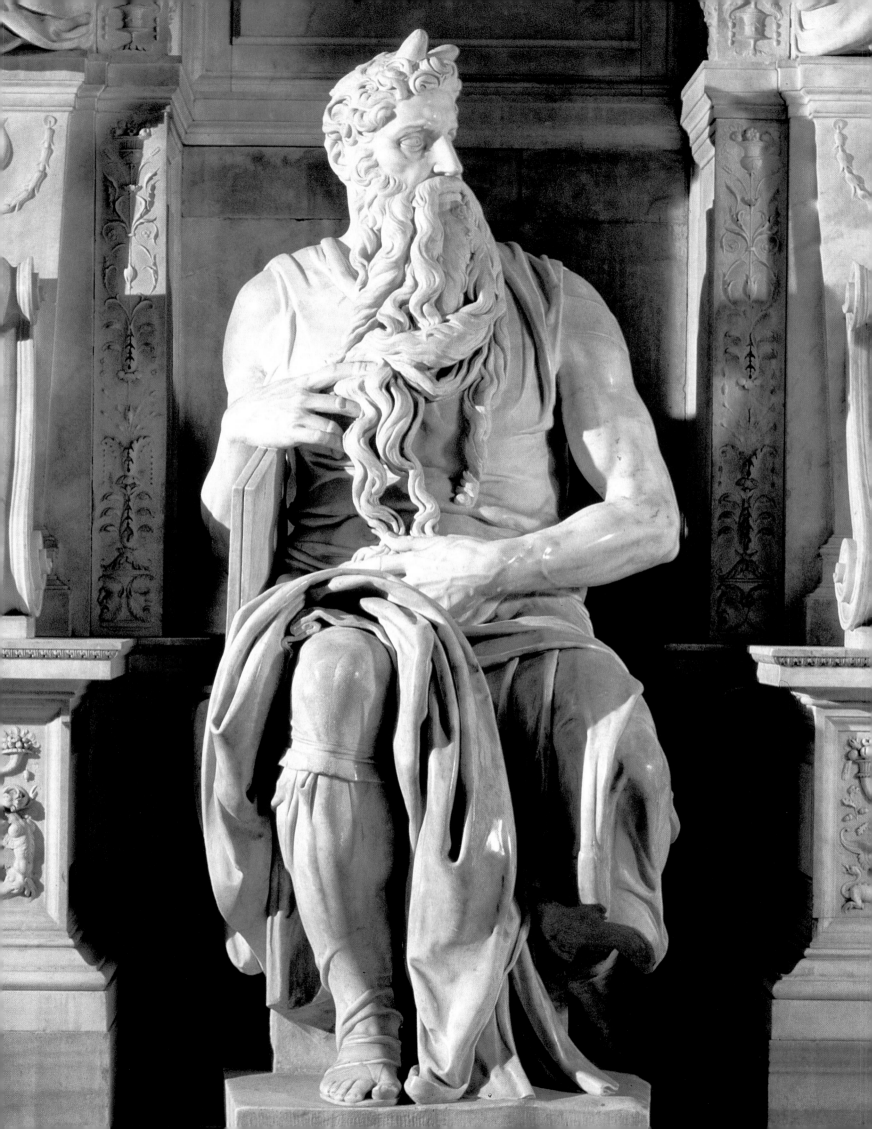

9 FROM REVOLT TO COMPASSION
The Slaves and the Pietàs

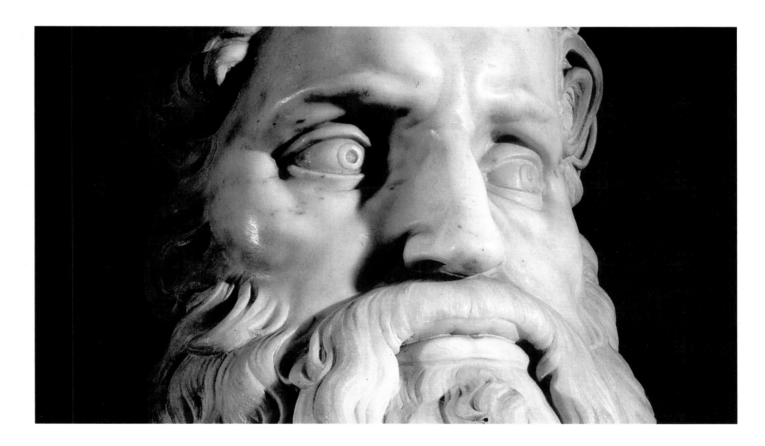

Michelangelo's enduring passion and major preoccupation throughout had always been sculpture. Among the statues that were to decorate the tomb of Julius II, the famous figure of *Moses*[1] stands out for its incomparable power. Sculpted in the round and entirely polished – except for a few minor details – the fearsome and daunting legislator of the Hebrew people is represented as a seated giant with a long flowing beard, turning resolutely to the right. Condivi described it in these terms: "The face is full of life and intelligence, such as to inspire both love and terror, which

OPPOSITE
MICHELANGELO
Moses
1513-1516. Marble.
Height 235 cm. (7 ³/₄ ft.).
Tomb of Julius II.
San Pietro in Vincoli, Rome.

ABOVE
Moses
Detail.

1. Today the statue of *Moses* stands on the tomb of Julius II in San Pietro in Vincoli, Rome.

DONATELLO
St. John the Evangelist
Around 1410-1415. Marble. Height 210 cm. (7 ft.).
Museo dell'Opera del Duomo, Florence.

OPPOSITE LEFT
MICHELANGELO
Dying Slave
1513-1516. Marble. Height 229 cm. (7 ½ ft.).
Louvre Museum, Paris.

OPPOSITE RIGHT
MICHELANGELO
Rebellious Slave
1513-1516. Marble. Height 215 cm. (7 ft.).
Louvre Museum, Paris.

was perhaps the truth. In line with tradition, he has two horns on his head, not far from the top of his forehead,"[2] a symbol of wisdom and divine inspiration. Both posture and movement reach a high degree of sophistication. An unbroken rhythm courses through the tense, concentrated face, the arms, chest, and mighty legs. With his right arm and hand he holds the Tablets of the Law and strands of the beard that descends into his left hand, momentarily resting in his lap. Supposed to be an allegorical portrait of Pope Julius II, the statue of *Moses* expresses a supreme effort at self-control, a powerful body containing the inner turmoil. Many similarities have been noted between this figure and antique statuary, especially the figures on the Trajan Column, and more obviously the statue of *St. John the Evangelist* by Donatello. In Michelangelo's own work, scholars have noted analogies with certain figures of the Sistine Chapel ceiling, especially those of *Joel* and *Jeremiah. Moses*, a giant hesitating between holding his strength in check and unleashing his vengeance is at the opposite extreme from the *David*, even if certain similarities are also visible.

The biblical patriarch has none of the tranquil, concentrated nobility of the young hero, but is charged with the *terribilità* that was to dominate the art of the sixteenth century. A tremendous power on the verge of exploding, anger on the brink of a final catastrophe. The position of the massive, sinewy legs, suggesting movement, is close to that of the figure of Giuliano de' Medici, the pensive *condottiere* of the Medici Chapel in Florence.

A t the same time as the *Moses*, Michelangelo sculpted six figures of *Slaves* for his initial design for the tomb of Julius II. Four of these may be seen at the Accademia in Florence, the remaining two at the Louvre. The most frontal of these figures *The Dying Slave* was probably intended to be placed in front of a pilaster to the left of the middle of the tomb. Behind his back, we can see the barely sketched-out figure of a monkey holding a round object in its paws. Many interpretations of this significant detail have been advanced: *simia naturae* (Condivi), a symbol of the art of Painting which "apes" nature; an allusion to the animal-like

2. "When Moses came down from Mount Sinai... his face shone..." (Exodus 34,29). In the Vulgate, this aura, the reflection of God's glory, is translated as "horns".

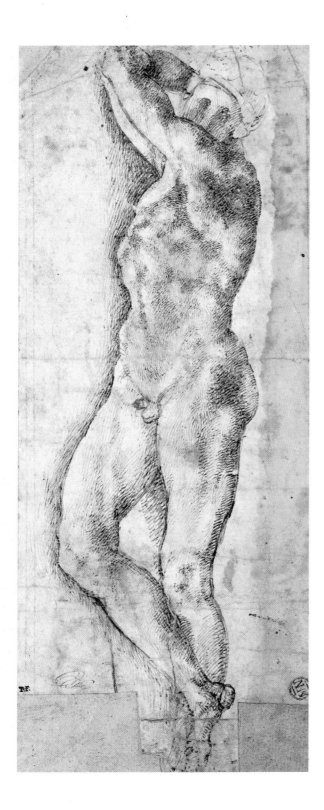

MICHELANGELO
Study for a *Slave*
Red chalk, graphite and brown ink.
Department of Drawings, Louvre Museum, Paris.

OPPOSITE

MICHELANGELO
Slave, or **Atlas**
1519. Unfinished marble.
Height 277 cm. (9 ft.).
Accademia delle Belle Arti, Florence.

inferiority of man, whose soul is chained to a body, and so on. In fact this figure is not dying at all, but rather absorbed in a dream-like state that somewhere between the languorous sensuality of an adolescent ephebe and the wistfulness of a captive restrained none too convincingly by bonds girding his chest and shoulders. The body stands in a precarious balance, like a sleepwalker, and the gesture made by the left arm is surely closer to that of a Venus revealing her charms than to anything else. As Charles de Tolnay put it, he is "a dreaming adolescent trying to shake off the bonds of sleep." If nothing else, this is a further example of the sexual ambiguity that characterizes so many of Michelangelo's nudes.

On the other hand, with its realism and dynamism, *The Rebellious Slave* is closer to Roman sculpture. Several parts are only barely roughed out; and, once again, near the left knee, we can make out a monkey's head in profile. This statue seems more down-to-earth, closer to the figures of prisoners on the arches of triumph of Imperial Rome. The figure's left arm twisted behind its back and the right foot firmly planted on the base together express a resolute effort at breaking free. Michelangelo again used the formal principle of an ascending spiral to make the figure dynamic. The two sculptures allude to a state of bondage, a situation of extreme constraint from which they must at all cost escape. In other words, they express a determined aspiration to spiritual, aesthetic and political freedom. In the same way, Michelangelo, although bound by social, human and world-ly limitations, remained essentially free.

The series of four *Slaves* at the Accademia in Florence express the same tension, the same struggle to free the spirit from the inertia of shapeless matter, only to create images that are forever captive of a motionless block of stone.

The intended placement of these imposing and impressive figures on the tomb of Julius II remains conjectural, for the monument was never finished as originally planned. At the sculptor's death, his nephew Lionardo offered four of the *Slaves* as a gift to Duke Cosimo de' Medici. The duke, whose main residence was at the Pitti Palace in Florence, entrusted the architect Buontalenti with their installation in a grotto in the Boboli Gardens, a bizarre and slightly overdone curiosity adjacent to the palace. And so for centuries, these splendid sculptures were kept imprisoned in a world of artificial stalactites and stalagmites,

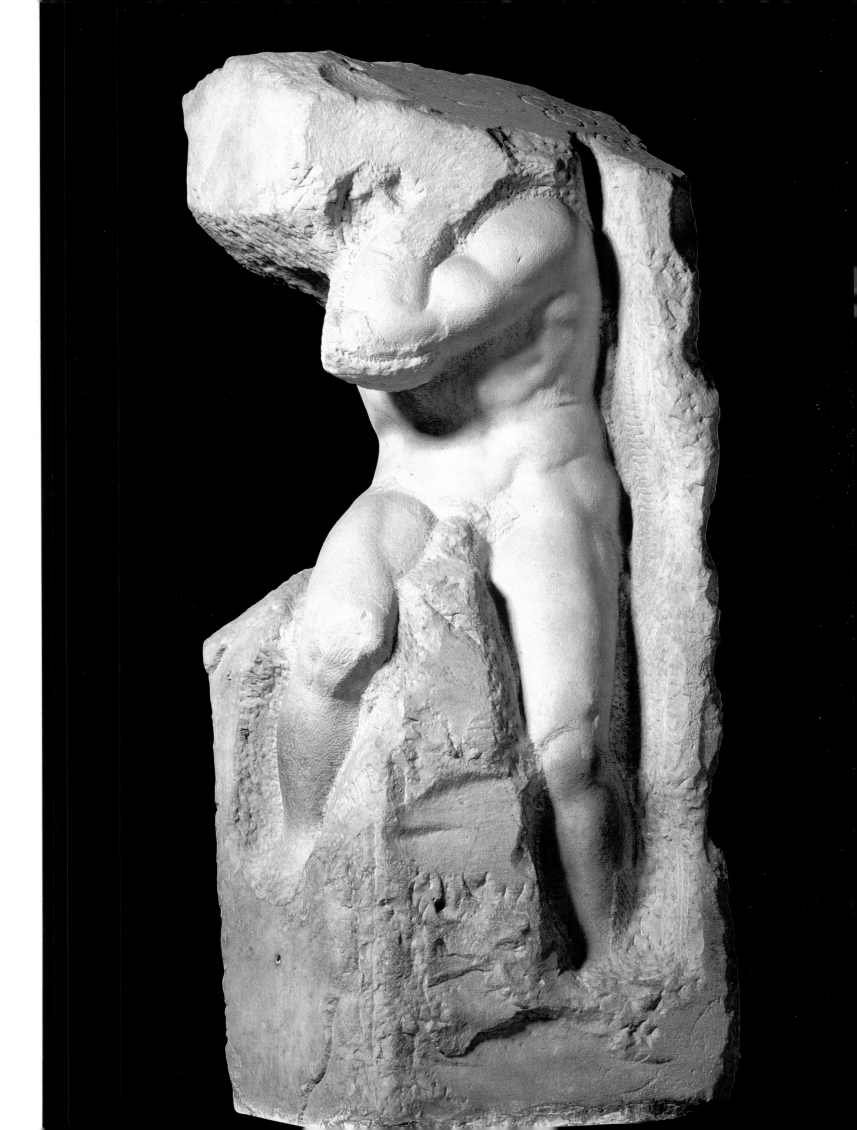

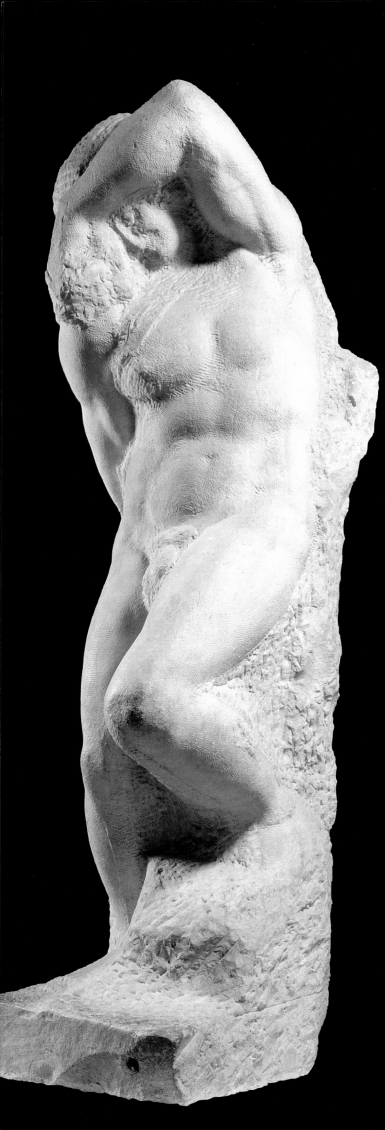

far from the light of day, until 1908, when they were finally transferred to the Accademia. They may be seen today in the company of the *Pietà da Palestrina* and *Saint Matthew* in a room whose main attraction is the giant figure of *David* standing under the dome of the museum.[3]

The first response to these *Slaves* is to try to understand the meaning of their poses and efforts. There is nothing very natural about the gestures of the *Young Slave*, the *Bearded Slave*, the *Awakening Slave*, or the one called simply *Atlas*. Like the *Ignudi* of the Sistine Chapel ceiling, they do not display any set poses that one can readily fit into a logical sequence of movements. They seem to be crushed by the abstract forces of figuration. Given their un-finished state, it is tempting to read into them an opposition between *finito* and *non-finito*, between the more or less fully-formed bodies or limbs and the formless material of the marble untamed by the sculptor's chisel. Like the Titans in the Greek myths, they struggle with all their might to free themselves from an unbearable physical and mental condition. Classical Graeco-Roman references abound: the Titans relegated to Hades, Prometheus chained to a rock, the processions of prisoners on Roman triumphal arches.

The imagery of constraint was nothing new in Michelangelo's work, but a leitmotif dating back to his youth. The diagonal strip that runs across the chest of the *Young Slave* could well symbolize bondage of a material or spiritual nature, as could the same bands that appear on the figure of the *Bearded Slave*. But the figures of the *Awakening Slave* and *Atlas* seem to be prisoners of the formless block of marble itself. These three statues, in themselves remarkable variations on the theme of the *non-finito*, present not only a great complexity of forms, gestures and poses, but also a disquieting impression of primal fears countered only by muscular effort. Of the four, only the *Young Slave* seems to be related to the *Dying Slave* in the Louvre, while displaying even more sensuality and grace.

This struggle and highly conflictual situation, is related to another leitmotif of Michelangelo's sculpture: the theme of self-constraint, a totally original approach unknown in any sculpture before.

The protagonists of this sculptural drama are prisoners of their own bodies and poses, unrelieved by any discernible

3. The statue of *David* now standing in the Piazza della Signoria in Florence is a copy. The original is in the Accademia.

172

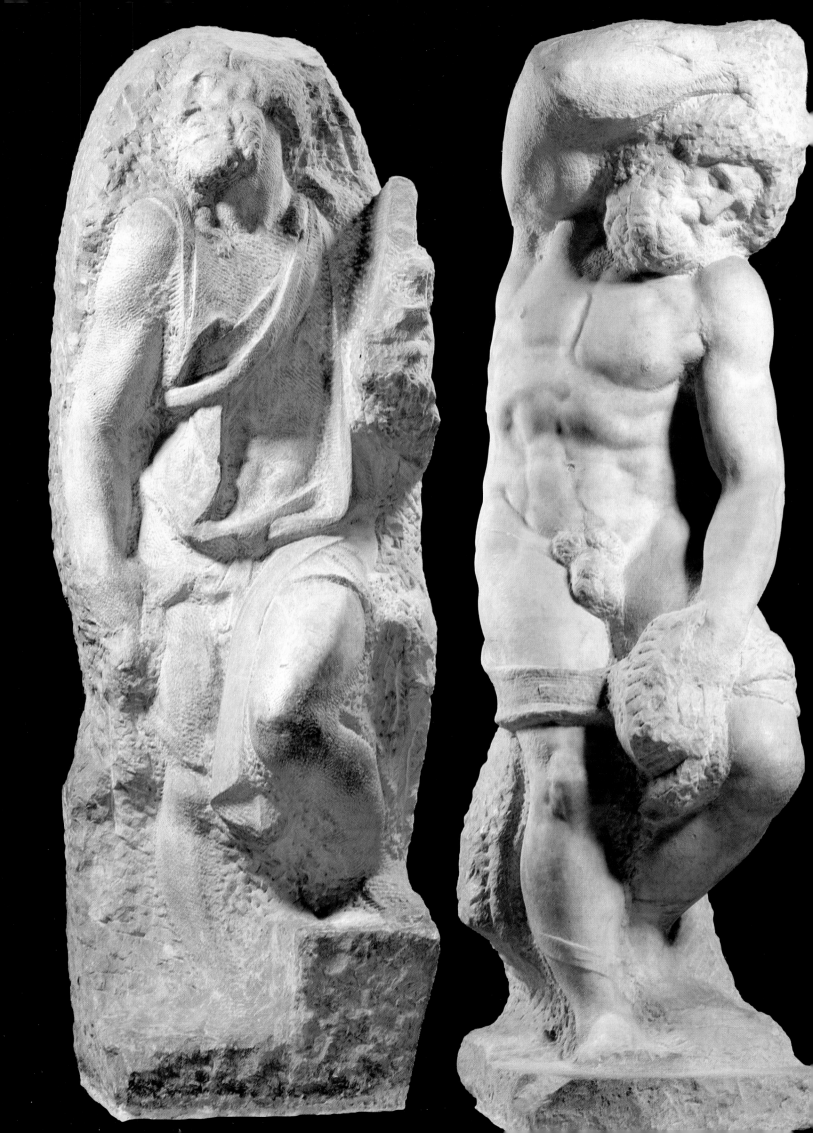

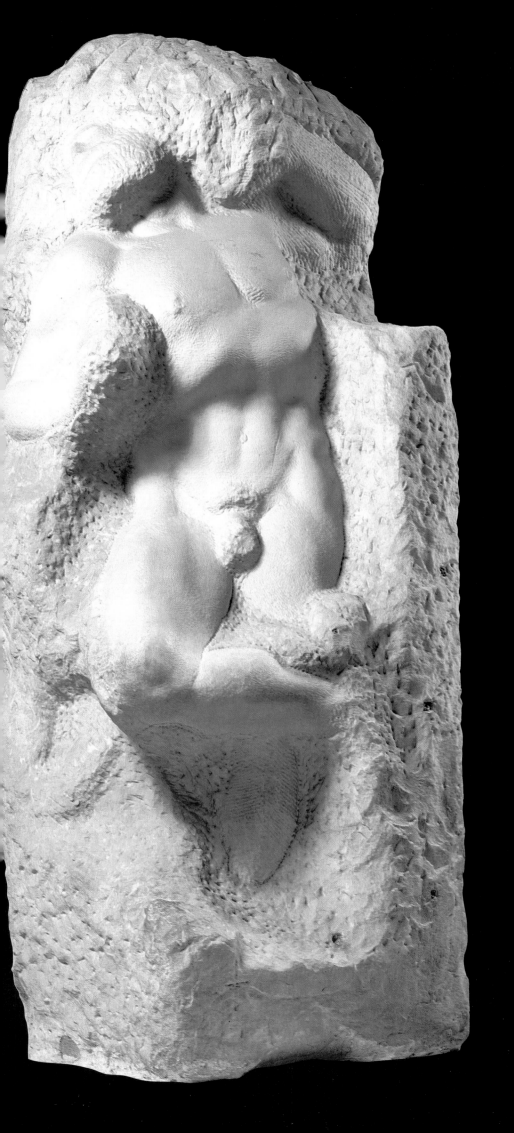

MICHELANGELO

Awakening Slave

1530-1533.
Unfinished marble.
Height 267 cm. (8 ³/4 ft.)
Accademia
delle Belle Arti, Florence.

OPPOSITE

MICHELANGELO

Pietà da Palestrina

Around 1555-1557. Marble.
Height 253 cm. (8 ft.).
Accademia
delle Belle Arti, Florence.

PAGE 172

MICHELANGELO

Young Slave

1530-1533.
Unfinished marble.
Height 256 cm. (8 ft.).
Accademia delle Belle Arti,
Florence.

PAGE 173 (LEFT)

MICHELANGELO

Saint Matthew

1530-1533.
Unfinished marble.
Height 271 cm. (9 ft.).
Accademia
delle Belle Arti, Florence.

PAGE 173 (RIGHT)

MICHELANGELO

Bearded Slave

1530-1533.
Unfinished marble.
Height 263 cm. (8 ¹/2 ft.).
Accademia
delle Belle Arti, Florence.

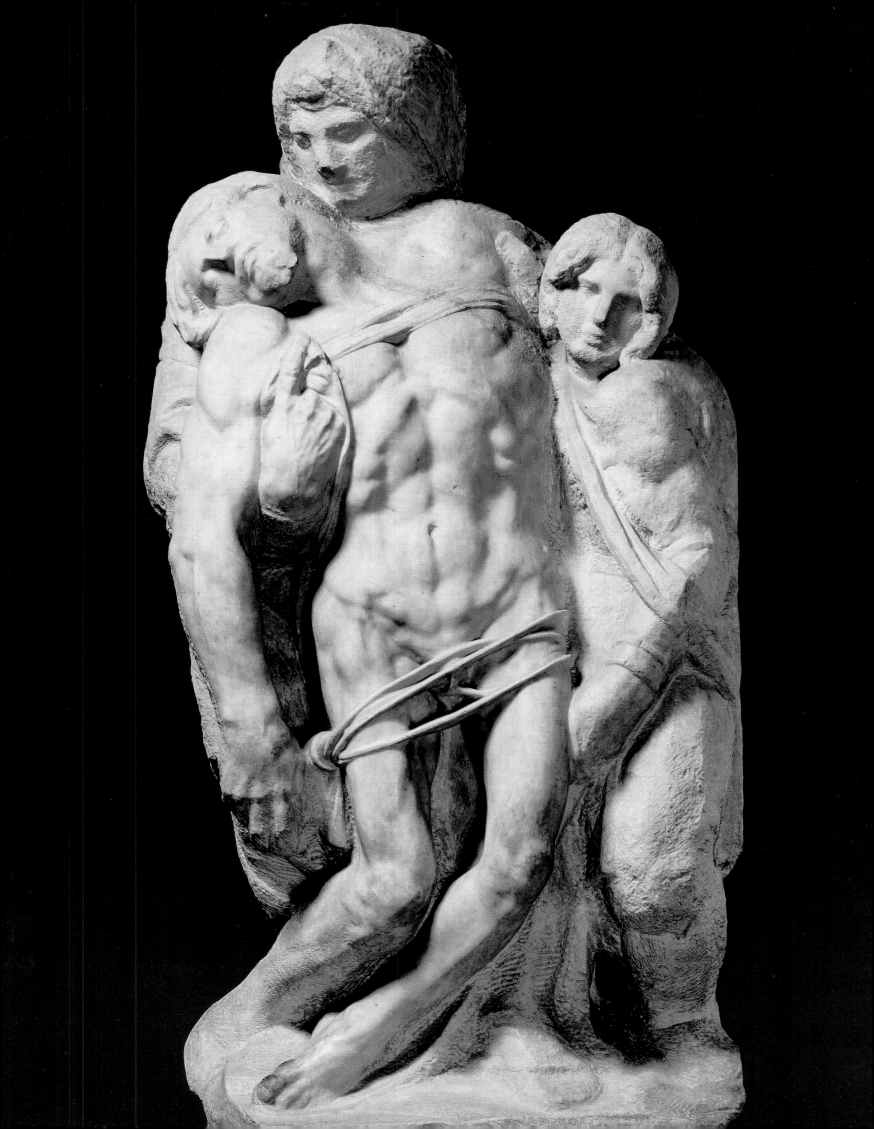

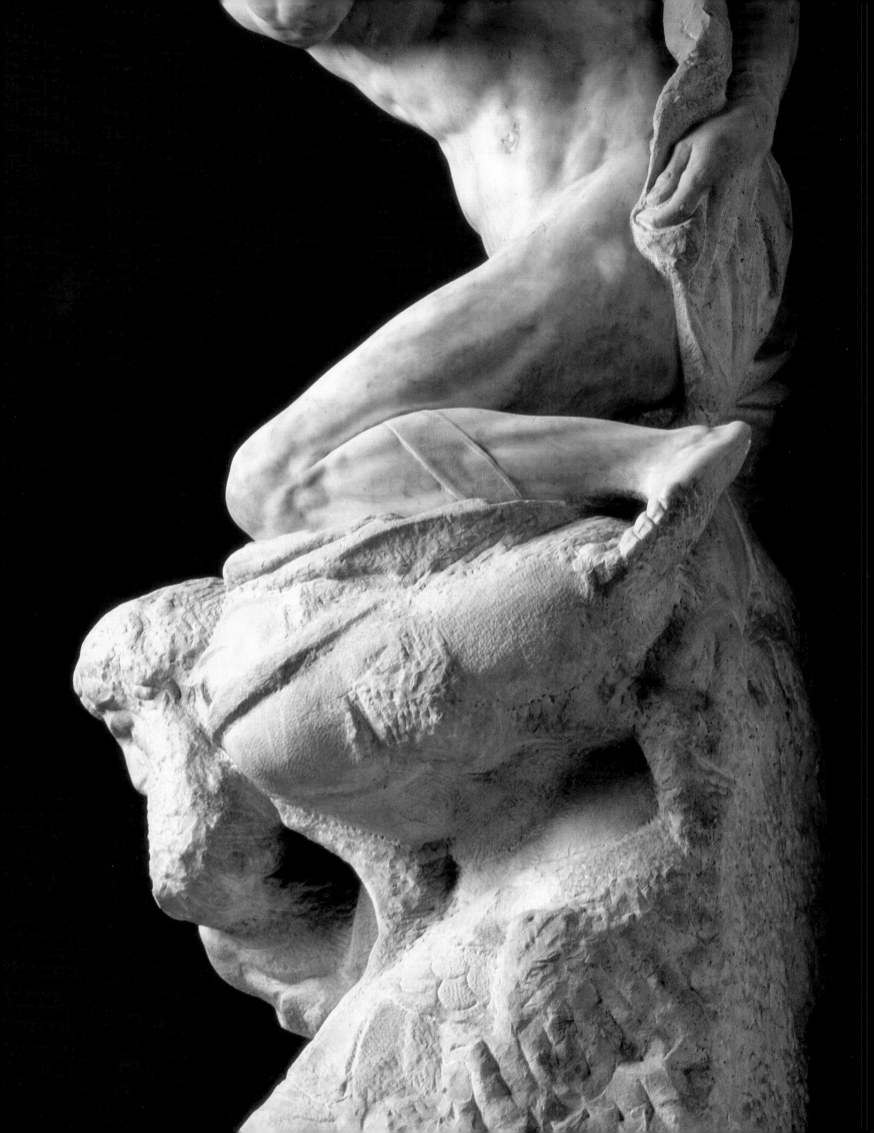

opposing force. This theme was already present in the figure of the Infant Jesus huddled against his mother's body in the *Madonna of the Stairs*, which the artist sculpted when he was eighteen years old. This pose is all the more surprising as the heroic Virgin was supposed to protect the Son of God. The figure of the *Rebellious Slave* in the Louvre, with the violent juxtaposition of its arms and the bonds around its back, is also the prisoner of a mysterious constraint. In the Medici Chapel at San Lorenzo, the figure of *Day* also exhibits this very contrived position of the arms. And a similar posture is found in one of the *Ignudi* of the Sistine Chapel ceiling; the one adjacent to the fresco panel representing *God Separating the Waters from the Earth*, which is also locked in an elegant gesture of the arms. The theme of restraint in Michelangelo's work appears as an expression of a deep inner conflict.

In a sculptural group entitled *Victory*, another work executed for the unbuilt tomb of Julius II, Michelangelo again demonstrated the great violence that underlies most of his work. This larger than lifesize work has never been as appreciated as it deserves. After the artist's death in 1564, it was transferred to the Palazzo della Signoria in Florence and placed in the Royal Chamber. Significantly, at the time Lionardo Buonarotti and Daniele da Volterra wanted to install this statue on Michelangelo's own tomb. In 1868, *Victory* was moved to the national sculpture museum in the Bargello, where it stayed until it was returned in 1921 to the Palazzo della Signoria (Palazzo Vecchio), where it remains today.

Some scholars argue that the head of the young man was executed by Vincenzo Danti, but most specialists attribute the whole group to Michelangelo. This remarkable sculpture has a long and distinguished iconography stretching back to classical times. The figure of a victorious warrior crushing his enemy has had many avatars; on the one hand, there was the ancient cycle of Hercules and his Twelve Labours – Hercules and the Hydra of Lerna, Hercules and Cacus, etc. – and on the other, the more recent Quattrocento treatments of the subject of David and Goliath, which was as important a theme for Donatello as it was for Michelangelo. To this lineage could be added the famous statue by Donatello and Nanni di Banco representing the *Sacrifice of Isaac*, in which we see a heroic

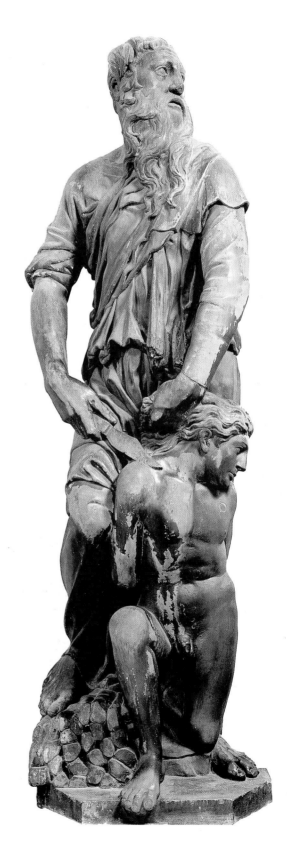

177

Isaac passively submitting to his fate at the hands of his father, Abraham. In his *Victory* group, Michelangelo on the contrary depicted an undraped young hero crushing with his full weight a captive old man.

The head of the statue, though unfinished, has very youthful features, and the chest displays a veritable Herculean build. This young face recalls not just that of Giulio, Duke of Nemours, in the Medici Chapel in San Lorenzo, but also, and perhaps even more, the *David* in the Accademia, an early work executed by Buonarotti in 1504. This strange ephebe stares with blank eyes into the distance, like the *David*, while posing not without a certain elegance on the back of a kneeling old man with sketchily-indicated facial features: low forehead, classical profile and prominent beard. The young man displays a detached, rather affected attitude and holds a piece of cloth that runs behind his back in a way that is strangely reminiscent of the thong from David's sling. This group is a further example of the painter-sculptor's fundamentally original approach. His real concern was not the slavish representation of specific morphologies but rather the depiction of archetypes personifying the problems of humanity, such as conflict, doubt and death.

We cannot identify the head of the old man as a self-portrait of the artist overcome by the sensual personification of youth: the brow is too low, the nose too classical, the beard too thick. But it can certainly be seen as a symbol of the inevitable victory of fate or Time personified by a youth overwhelming an old man subject to the contingencies of his age. This would be perfectly in line with the pessimistic ideas expressed by Michelangelo in his letters and poems. Towards the end of his eightieth year, in December 1555, the great artist was assailed by premonitions and dark omens. As if to confirm them, on 3rd December, his faithful and irreplaceable assistant, Urbino, died. Around this time, too, the sculptor mutilated and abandoned the Florence *Pietà* originally intended for his funerary chapel, but which was to be installed in the cathedral of Santa Maria Maggiore. Prevented from destroying it at the last moment by his students, he relented and entrusted it to Tiberio Calcagni who tried to finish it.

T he subject of the *Pietà*, or Lamentation of Christ, had long been a focus of the artist's aesthetic, spiritual and personal concerns. As early as 1498-1499, the young

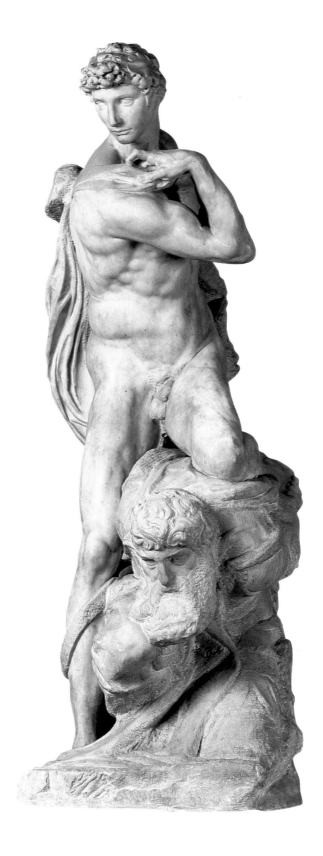

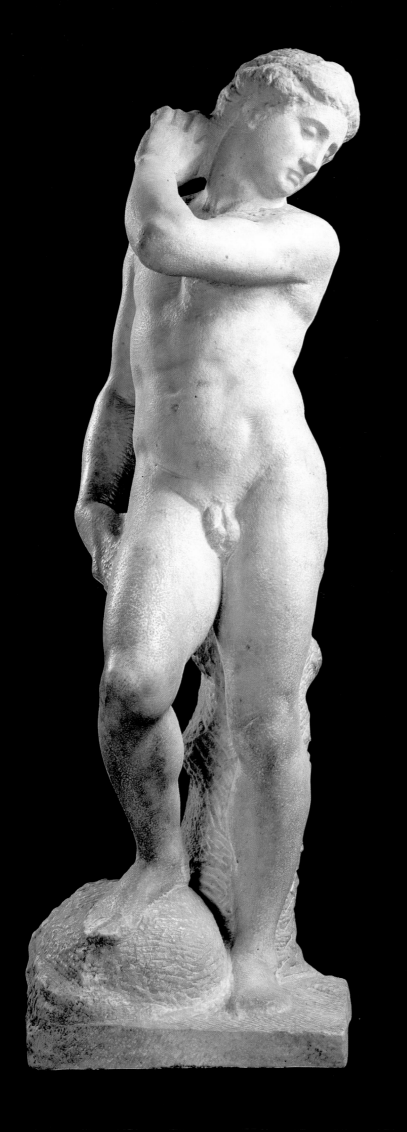

Pages 176, 178 and 179
MICHELANGELO
Victory
1530-1533. Marble.
Height 261 cm. (8 ¹/₂ ft.).
Palazzo Vecchio, Florence.

Page 177
DONATELLO
The Sacrifice of Isaac
1421. Marble.
Height 188 cm. (6 ft.).
Museo dell'Opera
del Duomo, Florence.

This page
MICHELANGELO
Apollo, or **David**
Around 1530. Marble.
Height 146 cm. (5 ft.).
Bargello, Florence.

Opposite
MICHELANGELO
Hercules and Cacus
Fired terracotta.
Height 41 cm. (17 in.).
Casa Buonarotti, Florence.

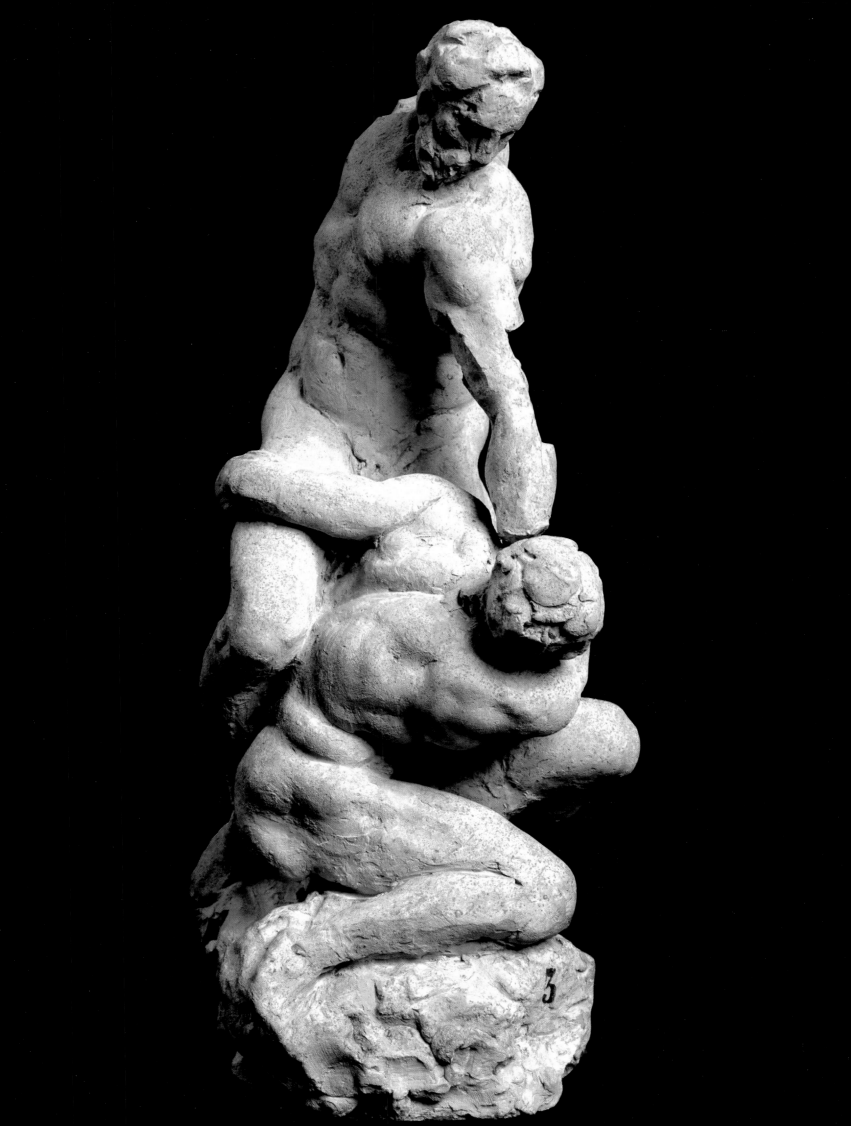

Buonarotti had dazzled the Florentine and Roman public with a *Pietà* that was a veritable sculptural tour de force (today exhibited in the basilica of St. Peter). Rarely has such eloquence been achieved in marble. In this admirable group, he combined perfect technical mastery with a highly sophisticated formal approach, thus surpassing even the great Donatello. The later Florentine *Pietà* – the one on which he vented his frustration with a hammer before handing it over to one of his students – marked the beginning of a period of turbulent spirituality, when even his chisel was not strong enough to coax the desired forms out of the stone. Not surprisingly, therefore, we soon notice that Christ has no left leg and that many other parts of the sculpture have been barely roughed out. The scene represented here is, strictly speaking, not a classic Pietà, but rather a synthesis of the Entombment and Lamentation of Christ. The figure of Mary Magdalene is the work of Calcagni. We learn from Vasari that the face of the figure standing in the middle is a self-portrait of the sculptor.

After Michelangelo's death, Vasari wanted to recover this statue to put it on the master's tomb in the church of

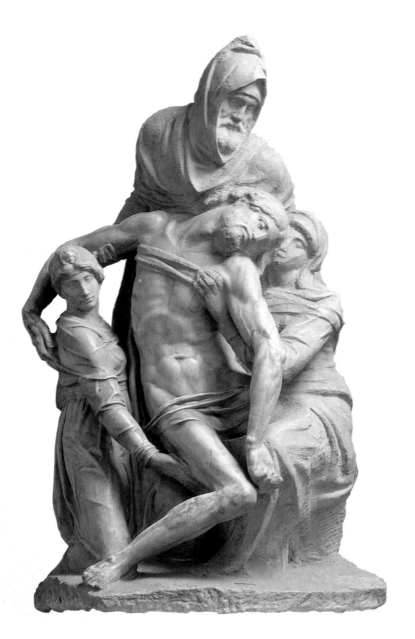

MICHELANGELO

The Florentine Pietà

Around 1547-1555. Marble.
Height 226 cm. (7 ft.).
Museo dell'Opera del Duomo, Florence.

OPPOSITE

MICHELANGELO

The Florentine Pietà

Detail.
Michelangelo gave his likeness
to the figure of Joseph of Arimathaea.

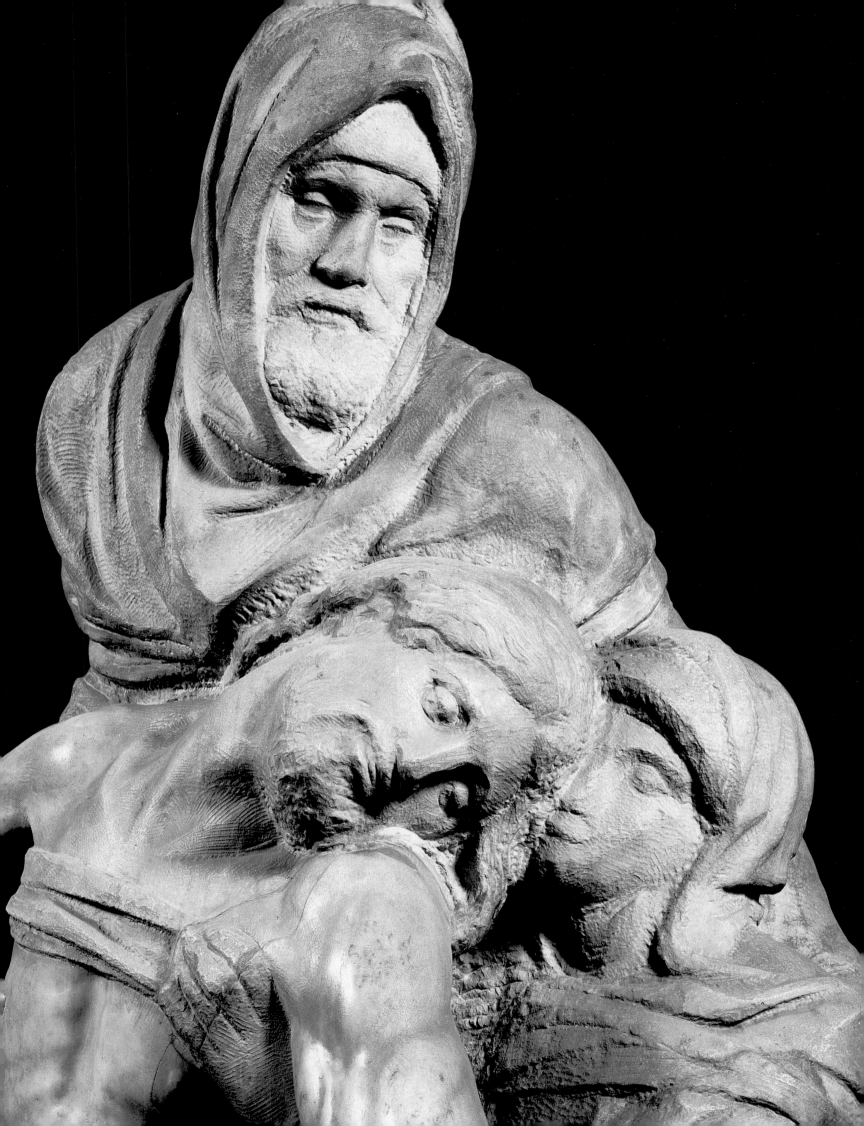

Santa Croce in Florence, but this proved unfeasible. In the seventeenth century, Cosimo III de' Medici had it removed for storage in the cellar of San Lorenzo. It was finally transferred to a more fitting location in the Cathedral of Santa Maria del Fiore in 1721.

The Florence *Pietà* group is composed according to a classic pyramidal scheme, at the apex of which appears the hooded head of Joseph of Arimathaea – probably a self-portrait of the artist. As far as the latter figure is concerned, the four gospels all agree that, after Christ's death, a pious man, Joseph of Arimathaea obtained permission to bury His body in a tomb, probably the one he had intended for himself (Matthew 27: 57-61, Mark 15: 42-47, Luke 23: 50-56, John 19: 38-42). The first three evangelists mention the presence of Mary Magdalene and of another Mary, the mother of Joseph and James. In Michelangelo's work, the

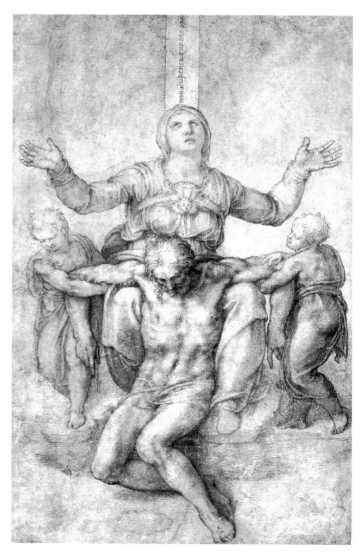

OPPOSITE

MICHELANGELO

Sketch for the *Rondanini Pietà*

Around 1555. Charcoal. 11 x 28 cm. (4 x 11 in.).
Ashmolean Museum, Oxford.

BELOW

MICHELANGELO

Pietà

Around 1538-1540. Charcoal. 29.5 x 19.5 cm. (12 x 8 in.).
Isabella Stewart Gardner Museum, Boston.

PAGE 186

MICHELANGELO

The Rondanini Pietà

Around 1555-1564. Unfinished marble.
Height 195 cm. (6 ft.). Sforza Castle, Milan.

PAGE 187

The Rondanini Pietà

Detail.

Virgin Mary supports the body of Christ as if to prevent it from sliding irremediably into death. An impossible, unnatural gesture, but perhaps a comprehensible one for a mother.

In considering the figure of Joseph of Arimathaea, and especially the posterior part of the group, we notice that this figure, an image of the sculptor-philosopher himself, is the dynamic mainstay of the entire composition. He looks with saddened gaze, but acts with determination; the unfinished portions of the statue accentuate the solemn and mystical aspect of his features.

If we accept that this figure is a self-portrait, then the spiritual message of the sculpture becomes perfectly clear. Around Christ's chest there is a strip of cloth very similar to that of the *Slaves*; Joseph of Arimathaea, as a projection of the sculptor himself, accompanies the Messiah's body to its

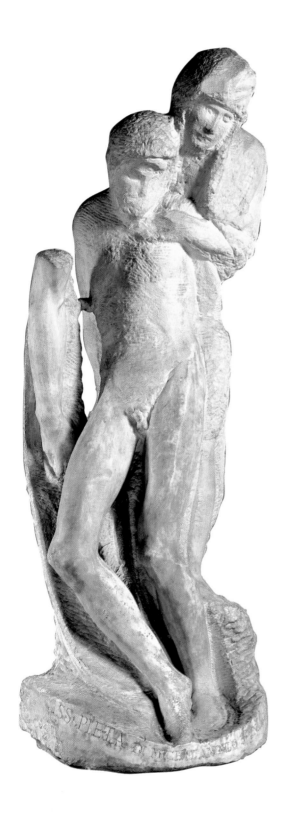

last resting place. The somewhat stiff figure of Mary Magdalene (sculpted by Calcagni, it should be remembered), stands apart, at a remove from this gentle, yet monumental progression to the grave. With his own death in mind, Michelangelo had written to Vasari about his assistant Urbino: "In living, he kept me alive, in dying he has taught me how to die; without discontent, but with a desire for death." These words still resound in the stone of this *Pietà*.

In February 1564, although ill, Michelangelo was working on his last sculpture, one of his most supremely moving works, the *Rondanini Pietà*, exhibited today at the Sforza Castle in Urbino. He had begun working on it twelve years earlier, then taken it up again in 1555, after trying to destroy the one that is today in the Cathedral of Florence. He brought it to its present state shortly before his death, and it stands as his most fitting artistic testament. Probably inspired by medieval versions of the subject showing Christ and Mary standing, this *Pietà* inspires an awe that is both sacred and profane. The figure of Christ barely emerges from the formlessness of the stone, to which, in fact, it seems to be returning, as if to its source. The body is only roughly indicated, as if mutilated. This extreme *non finito* gives the group as a whole a strong human feeling as well as spiritual intensity. Christ's amorphous body seems to be weightless, held back from the edge of the abyss by Mary's compassionate love, by the fusion of two beings in a single destiny.

On 16th February 1564, Michelangelo Buonarotti had been bedridden for several days and expressed the wish that his body be taken to Florence. In his last moments, he told those present to think of the death of the Saviour. On 10th March, his nephew Lionardo arrived with his body in Florence, where it was lain to rest in a tomb made by Vasari at the church of Santa Croce. Vasari gave an account of the funeral in a letter to Cosimo I de' Medici: "The catafalque was of great beauty, so much so that I cannot find the words to describe its grandeur and majesty."

What remains of Michelangelo, beyond a rich legacy of masterpieces, is the image of a bold, honest and often tormented man, one who claimed the freedom that has become the natural condition of modern art. He was one of the greatest artists the world has known.

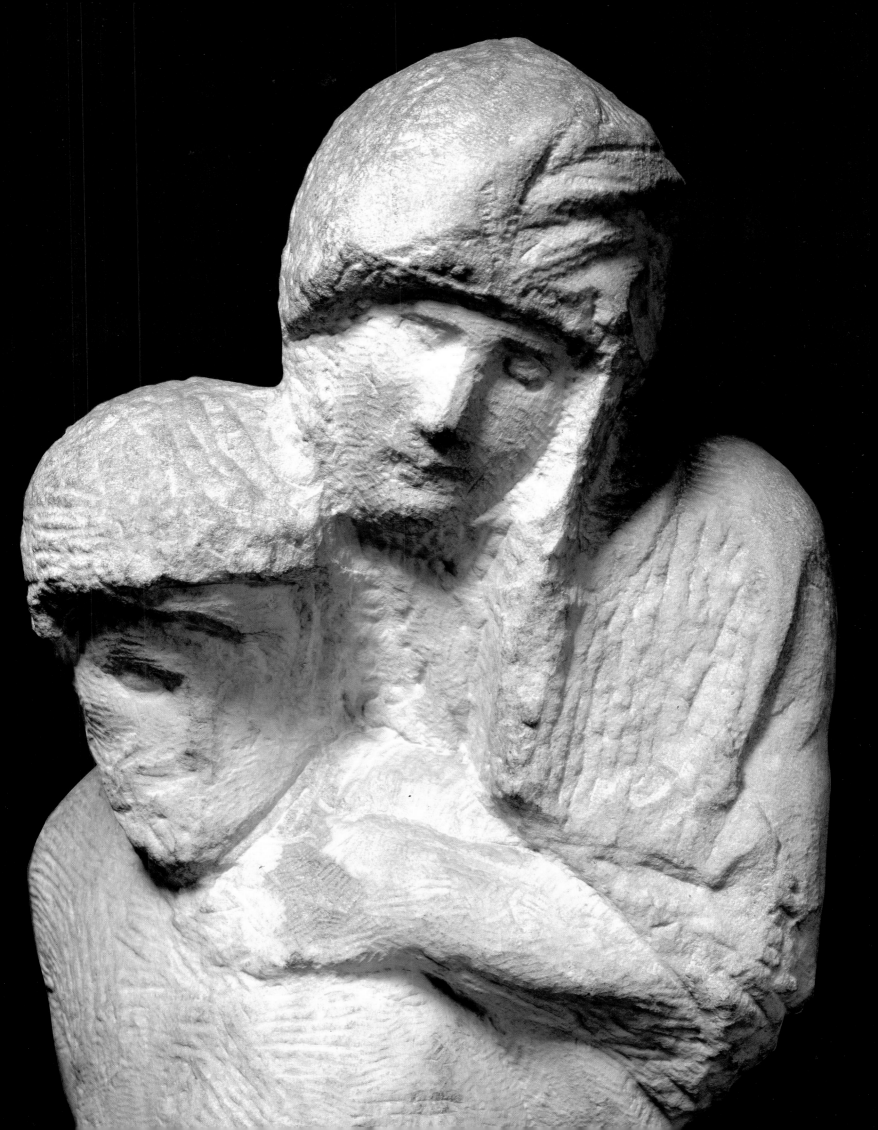

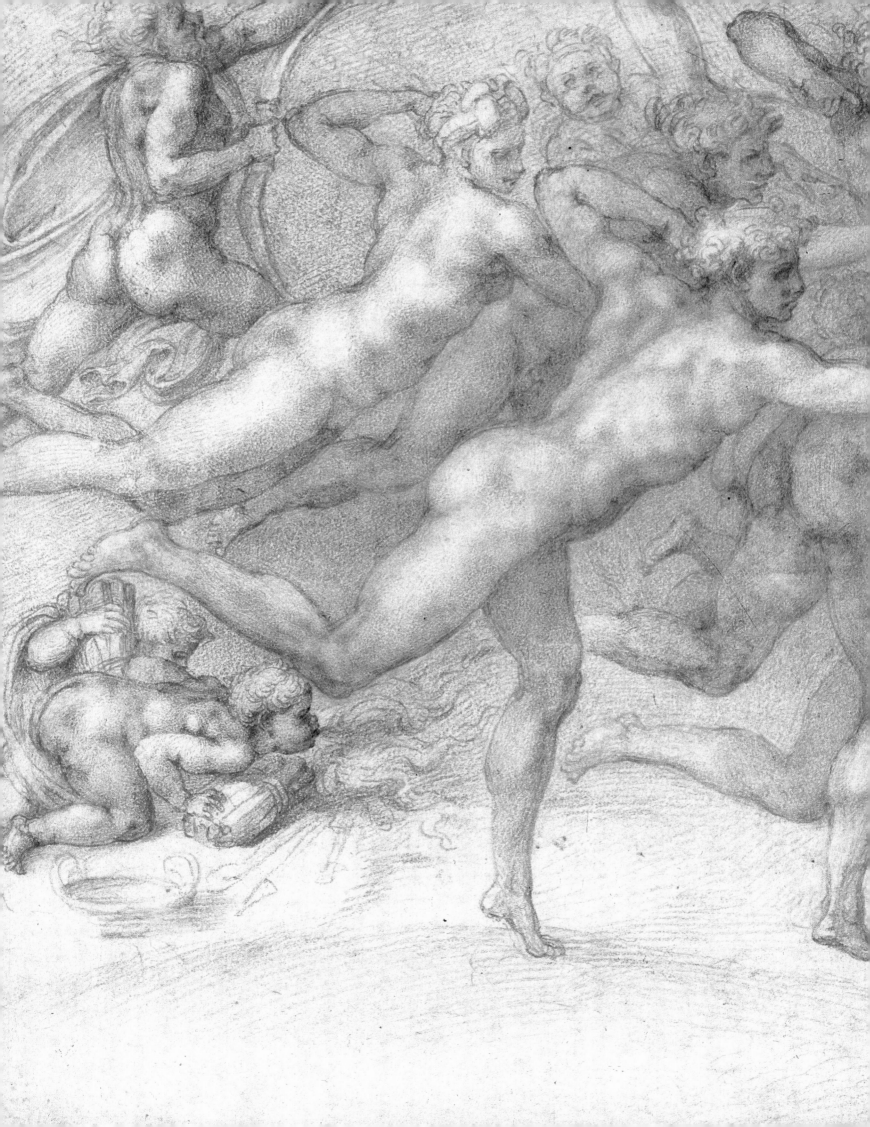

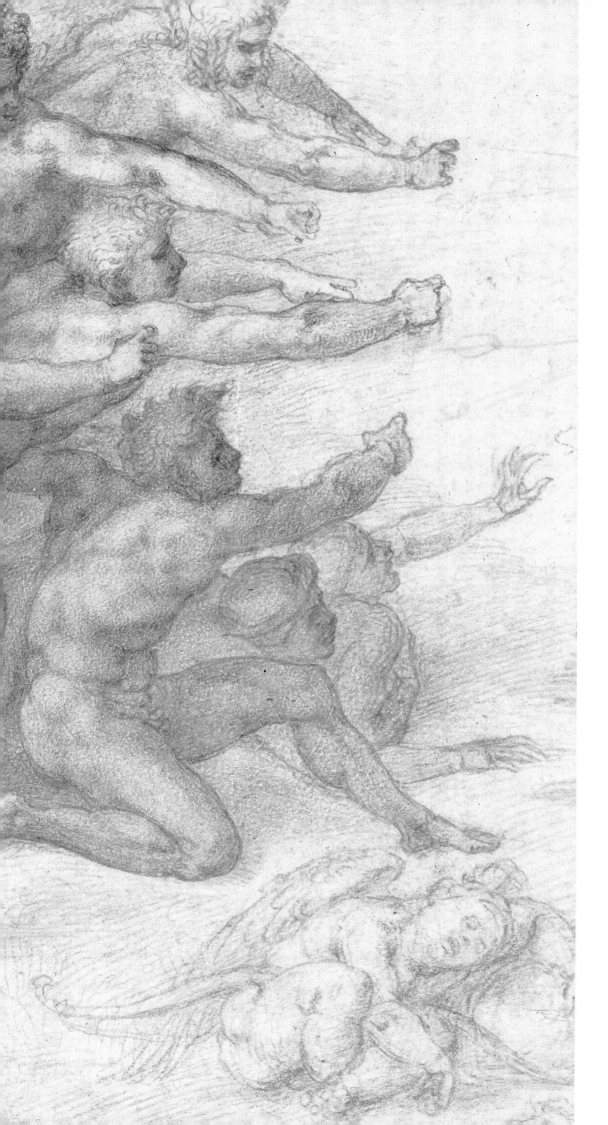

MICHELANGELO

Archers shooting at a Herm

1533. Red chalk.
21.5 x 32 cm. (9 x 13 in.).
Reproduced
with the kind permission of
Her Majesty Queen Elizabeth II.
Royal Library, Windsor.

PAGE 190

MICHELANGELO

The Resurrection

1512. Charcoal.
36 x 22 cm. (14 x 9 in.).
Reproduced
with the kind permission of
Her Majesty Queen Elizabeth II.
Royal Library, Windsor.

PAGE 192

MICHELANGELO

Head of a God

1532-1534. Red chalk.
20.5 x 16.5 cm. (8 x 6 in.).
Ashmolean Museum, Oxford.

PAGE 195

MICHELANGELO

Resurrection

1532-1533. Charcoal.
32.5 x 28.5 cm. (13 x 11 in.).
British Museum, London.

PAGE 196

MICHELANGELO

Head of a God

28.5 x 23.5 cm. (11 x 9 in.).
British Museum, London.

PAGE 199

MICHELANGELO

Self-Portrait with Turban

Pen and ink.
36.5 x 25 cm. (14 x 10 in.).
Department of Drawings,
Louvre Museum, Paris.

PAGE 200

MICHELANGELO

The Fall of Phaeton

1533. Charcoal.
41.3 x 23.5 cm. (16 x 9 in.).
Reproduced
with the kind permission of
Her Majesty Queen Elizabeth II.
Royal Library, Windsor.

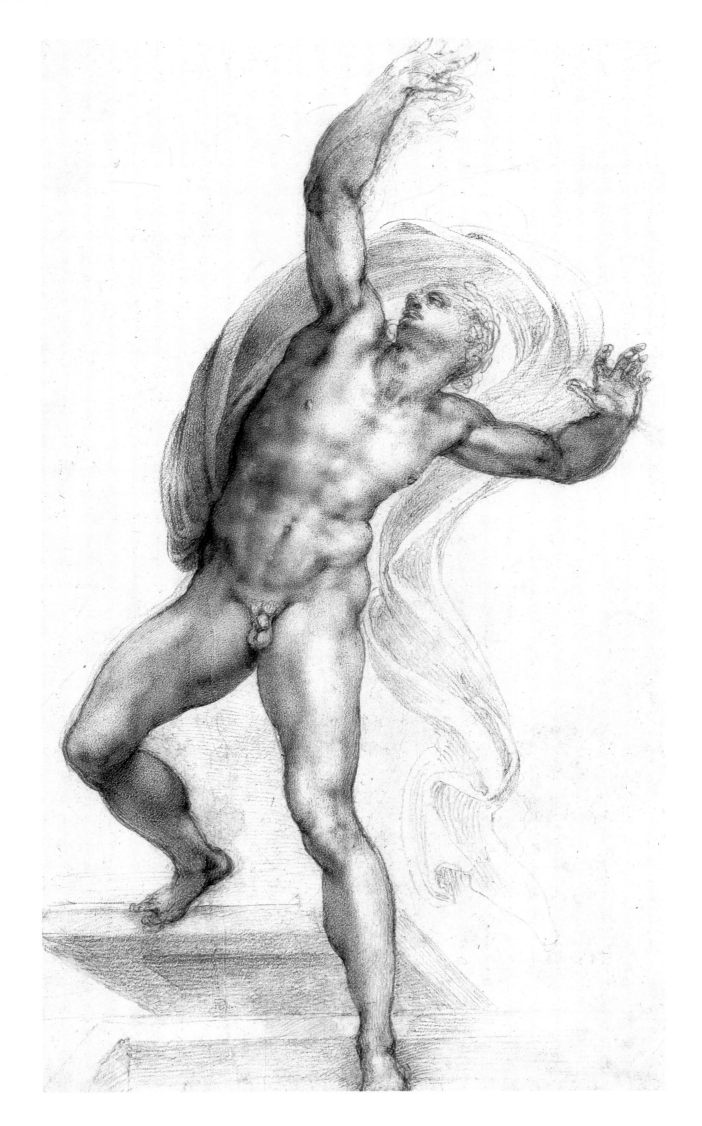

NINE SONNETS OF MICHELANGELO
translated by Elizabeth Jennings[1]

TO GIOVANNI DA PISTOJA
ON THE PAINTING OF THE SISTINE CHAPEL

Like cats of Lombardy and other places
Stagnant and stale, I've grown a goitre here;
Under my chin my belly will appear,
Each the other's rightful stance displaces.

My beard turns heavenward, my mind seems shut
Into a casket. With my breast I make
A shield. My brush moves quickly, colours break
Everywhere, like a street mosaic-cut.

My loins are thrust into my belly and
I use my bottom now to bear the weight
Of back and side. My feet move dumb and blind.
In front my skin is loose and yet behind
It stretches taut and smooth, is tight and straight.

I am a Syrian bow strained for the pull –
A hard position whence my art may grow.
Little, it seems, that's strong and beautiful
Can come from all the pains I undergo.
Giovanni, let my dying art defend
Your honour, in this place where I am left
Helpless, unhappy, even of art bereft.

1. Extracts from the book *The Sonnets of Michelangelo,* translated by Elizabeth Jennings, Carcanet Press
Limited, Manchester 1988.

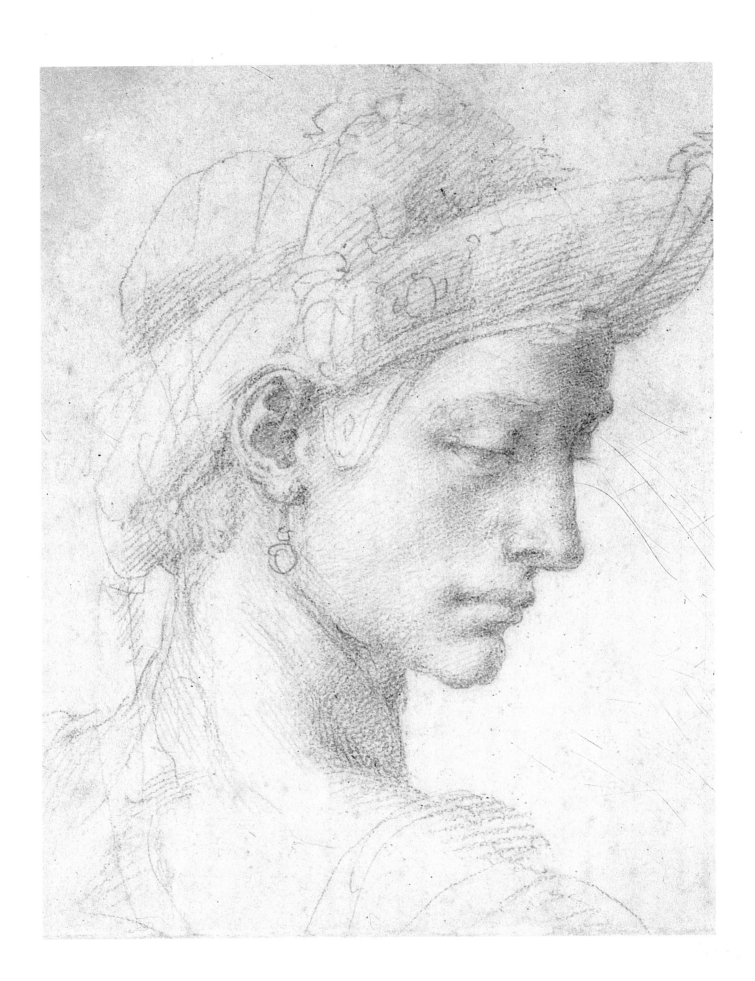

To Pope Julius II

My Lord, of all the ancient proverbs, this
Is surely true – 'Who can doth never will'.
You have believed in saws and promises
And blest those men whom falsehoods, not truths, fill.

Always I have been faithful and would give
Honour to you as rays do to the sun.
Yet all my pain has never made you grieve,
The less I please, the more work I have done.

Once I have hoped to climb by means of your
Great height, but now I find we rather need
Justice and power, not echoes faint indeed.

Heaven, it appears, itself is made impure
When worldliness has power. I live to take
Fruit from a tree too dry to bear or break.

To Tommaso de' Cavalieri

This glorious light I see with your own eyes
Since mine are blind and will not let me see.
Your feet lend me their own security
To carry burdens far beyond my size.

Supported by your wings I now am sped,
And by your spirit to heaven I am borne.
According to your will, I'm pale or red –
Hot in the harshest winter, cold in sun.

All my own longings wait upon your will,
Within your heart my thoughts find formulation,
Upon your breath alone my words find speech.

Just as the moon owes its illumination
To the sun's light, so I am blind until
To every part of heaven your rays will reach.

On the death of Vittoria Colonna

If my rough hammer makes a human form
And carves it in the hard, unyielding stone,
My hand is guided, does not move alone,
But follows where that other worker came.

Yet the first worker, God, remains above,
Whose very motion makes all loveliness.
To make a tool I need a tool, but his
Power is the first cause and makes all things move.

That stroke which in the forge is raised most high
Has the most strength. Now she who lifted me,
Has, by her death, been raised much higher still.

So I am left unfinished now until
She gives her help to God himself that I
May be completed, not abandoned lie.

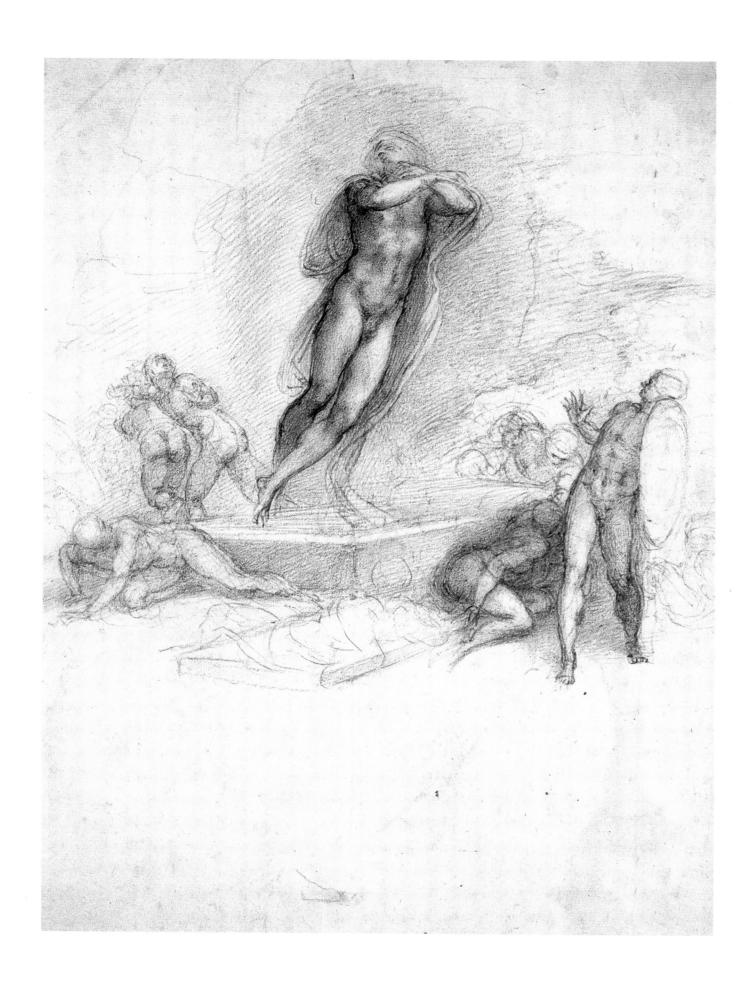

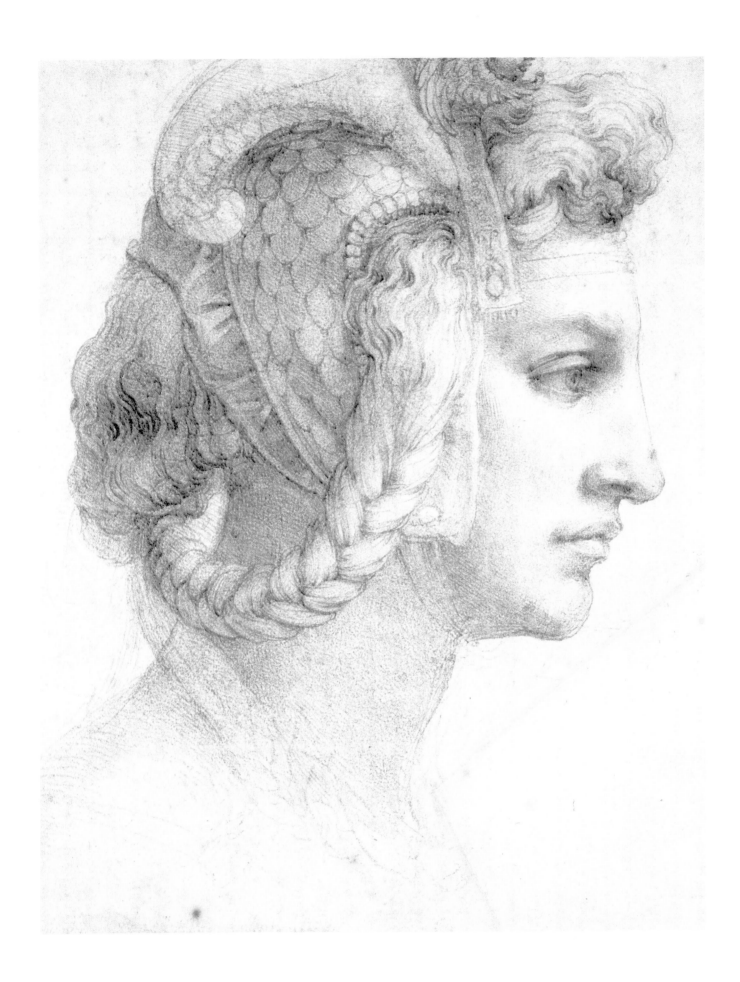

TO VITTORIA COLONNA

Oh happy spirit, who with so much zeal
Remembers me though I am soon to die.
Among so many others joys you feel
The wish to greet me. What great loyalty!

You, who delighted me when I could see
Your face, now comfort me within my mind.
You bring new hope to all my misery
That old desires will always leave behind.

Finding in you a willingness to plead
My cause, although you have so many cares,
He who now writes returns you thanks for this.

It would be shame and usury to press
These ugly pictures on you when I need
To bring to life again your loveliness.

TO THE SAME

To be more worthy of you, Lady, is
My sole desire. For all your kindnesses
I try to show, with all I have of art
And courtesy, the gladness of my heart.

But well I know that simply by my own
Efforts I cannot match your goodness. Then
I ask your pardon for what's left undone,
And failing thus, I grow more wise again.

Indeed, I know it would be wrong to hope
That favours, raining from you as from heaven,
Could be repaid by human work so frail.

Art, talent, memory, with all their scope
Can never pay you back what you have given.
At this, a thousand tries would always fail.

TO GIORGIO VASARI

Already now my life has run its course,
And, like a fragile boat on a rough sea,
I reach the place where everyone must cross
And give account of life's activity.

Now I know well it was a fantasy
That made me think art could be made into
An idol or a king. Though all men do
This, they do it half-unwillingly.

The loving thoughts, so happy and so vain,
Are finished now. A double death comes near –
The one is sure, the other is a threat.

Painting and sculpture cannot any more
Quieten the soul that turns to God again,
To God who, on the cross, for us was set.

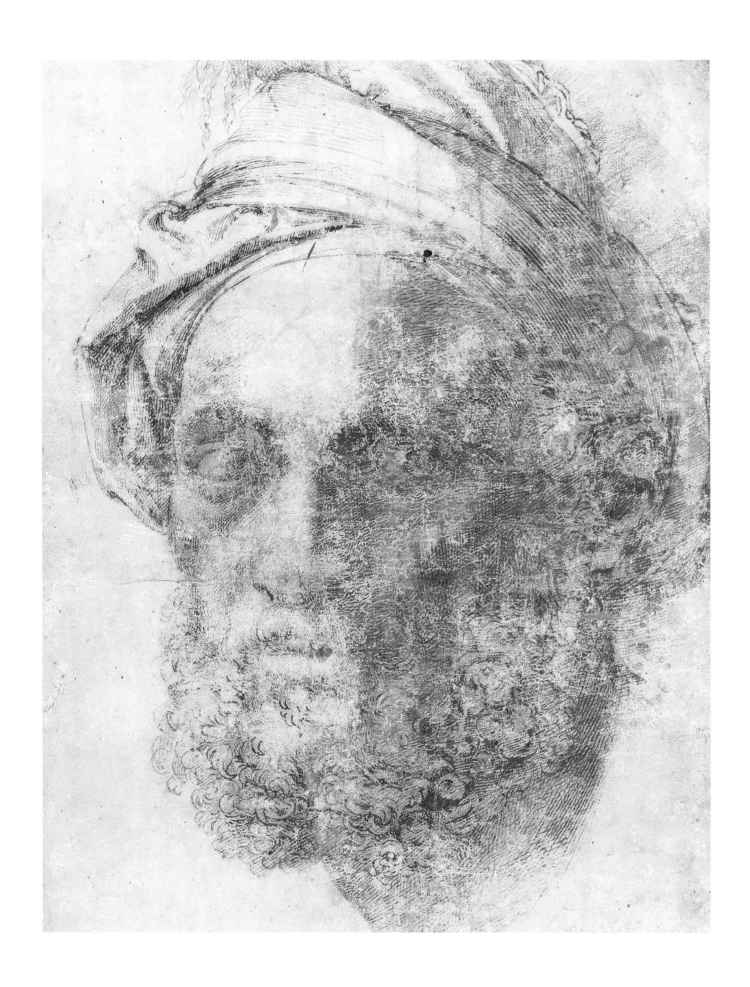

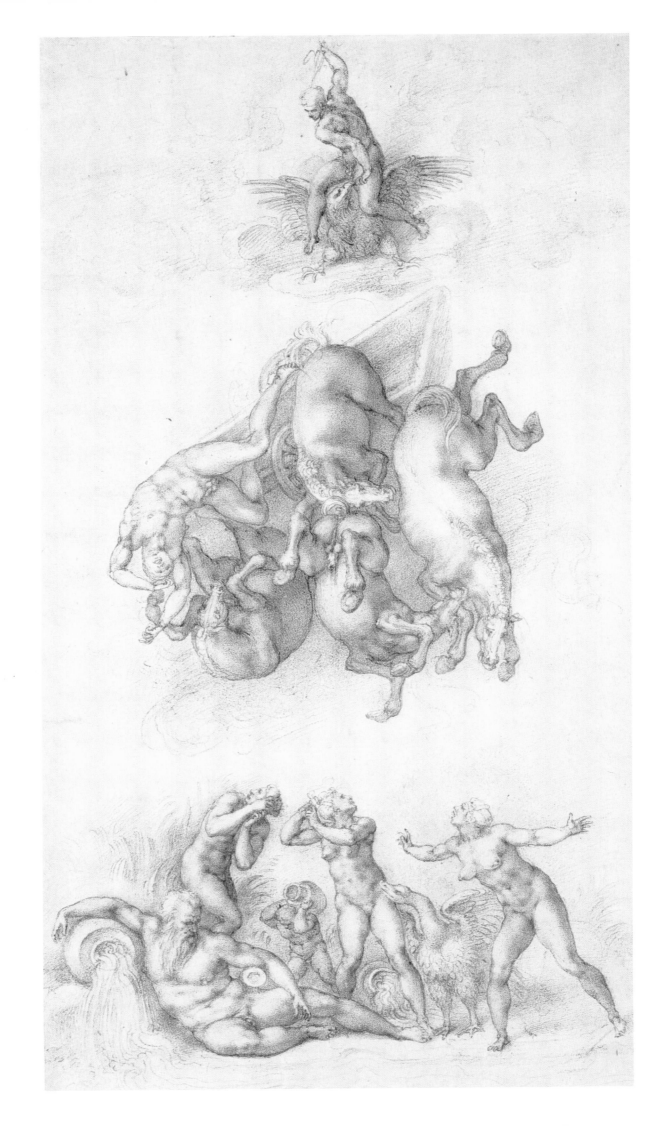

TO GIORGIO VASARI
ON 'THE LIVES OF THE PAINTERS'

With pen and colours you have shown how art
Can equal nature. Also in a sense
You have from nature snatched her eminence,
Making the painted beauty touch the heart.

Now a more worthy work your skilful hand,
Writing on paper, labours and contrives –
To give to those who're dead new worth, new lives;
Where nature simply made, you understand.

When men have tried in other centuries
To vie with nature in the power to make,
Always they had to yield to her at last.

But you, illuminating memories,
Bring back to life these lives for their own sake,
And conquer nature with the vivid past.

ON DANTE ALIGHIERI

From heaven he came, in mortal closing, when
All that was worst and best had been observed.
Living, he came to view the God he served
To give us the entire, true light again.

For that bright star which with its vivid rays
Picked out the humble place where I was born –
For this, the world would be a prize to scorn;
None but its Maker can return its praise.

I speak of Dante, he whose work was spurned
By the ungrateful crowd, those who can give
Praise only to the worthless. I would live

Happy were I but he, by such men scorned,
If, with his torments, I could also share
His greatness, both his joy and exile bear.

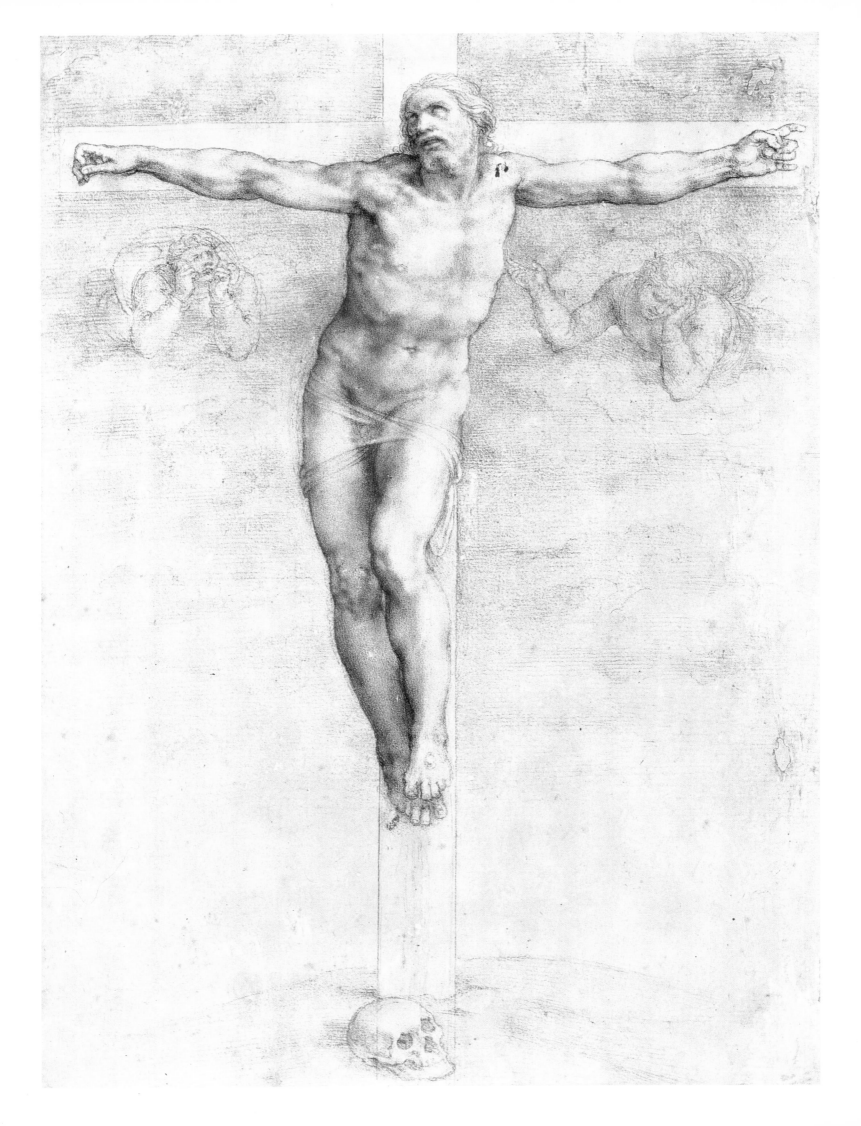

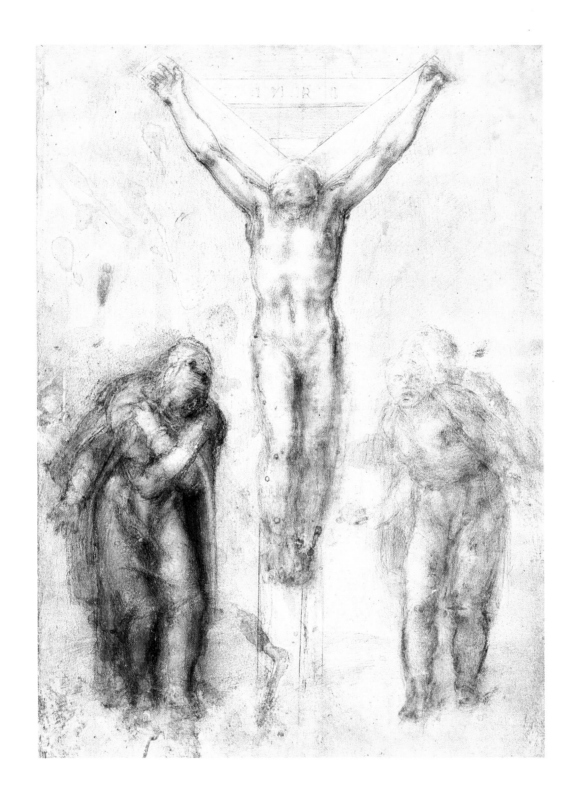

MICHELANGELO

Crucifixion with the Virgin and St. John

Around 1550-1555.
Charcoal touched up with white pigment and grey wash.
41.5 x 28.5 cm. (16 x 11 in.). British Museum, London.

OPPOSITE

MICHELANGELO

Crucifixion

Around 1540. Charcoal
37 x 27 cm. (15 x 11 in.). British Museum, London.

BIOGRAPHY

1475 6 March, birth of Michelangelo in Caprese, a village in the Apennine Mountains. He was the second son of Lodovico di Lionardo Buonarotti Simoni, *podestà*, a Tuscan administrator. Among the ancestors of this formerly noble family were moneychangers and soldiers, but no painters, unlike other artists of the period. His four brothers were: Lionardo (1473-1510), Buonarotto (1477-1528), Giovansimone (1479-1548) and Sigismondo (1481-1555). Michelangelo's uncle, Francesco, was a moneychanger. The artist described himself as being "of very noble lineage." He lost his mother, Francesca di Neri, at the age of six, an event that surely accounts for many of his characteristics. At the end of March 1475, he was entrusted to a wet-nurse married to a stone-cutter in Settignano, near Florence, while the family returned to Florence.

1481 The family lived in the Via dei Bentaccordi, near the church of Santa Croce; Michelangelo received basic instruction at the school run by Francesco da Urbino.

1485 Michelangelo's father and uncle oppose the child's wish to become an artist, considering this profession unworthy of the family's social standing.

1488 Encouraged by his friend Francesco Granacci, Michelangelo became an apprentice in the Florentine workshop of the famous Ghirlandaio brothers, but stayed only a year. He learned how to draw after the great masters of the past (Giotto, Masaccio) and from life.

1489 Thanks to Granacci, Michelangelo is accepted into Lorenzo de' Medici's "art academy." His master is Bertoldo di Giovannni, a student of the great Donatello. Lorenzo treats him like a son. He was able to study the art of classical Antiquity and frequent such Neoplatonic philosophers as Politian, Ficino, Beniveni and Pico della Mirandola. It was during this period that he decided to devote himself to sculpture. Angered by his constant teasing, one of his fellow-students, the sculptor Torrigiani, struck him in the face and broke his nose, mutilating him for the rest of his life.

1492 Upon Lorenzo's death, Michelangelo returned to his family. Although it was forbidden by the Church, he dissected cadavers, with the help of the prior of Santo Spirito, for whom he sculpted a wooden Crucifix (April 1492).

1494 Sensing the imminent fall of the Medici family, Michelangelo fled to Bologna, where he was received by Gianfranco Aldrovandi. He executed several sculptures for the church of San Domenico, and read the vernacular classics: Dante, Petrarch, Boccaccio.

1495 Return to Florence.

1496 In late June Michelangelo was in Rome in search of patrons.

He lived poorly in the hope of assisting his family. To achieve this he later invested money in land and in the hospital of Santa Maria Novella in Florence.

One of his acquaintances was Cardinal Riario, a cousin of the future Pope Julius II, and he worked for the wealthy banker Galli. He executed the Vatican *Pietà*, originally intended for the tomb of the French cardinal Bilhères de Lagraulas (1499). This was the beginning of a lifelong preoccupation with this subject.

1501 In the spring Michelangelo returned to Florence. On 16th August he was given the commission for a marble statue of *David*, and began working on a painting of the Virgin and Child for Agnolo Doni (*The Doni Tondo*), on a sculpture of the same subject (*The Bruges Madonna*) and on the *Taddei Tondo*. He was by then a well-known artist.

1503 The *operai* of Florence Cathedral built a workshop for him at the corner of Borgo Pini and the Via della Colonna.

1504 After much deliberation, a committee of thirty artists decided to install the *David* in front of the Palazzo della Signoria. Michelangelo began work on the cartoon for *The Battle of Cascina* to be painted opposite Leonardo da Vinci's fresco of the *Battle of Anghiari* in the Palazzo Vecchio. Neither work was completed.

1505 Michelangelo was in Rome to sign the contract for the tomb of Julius II, the beginning of a long sculptural fiasco for which he executed a number of statues. In the end a simplified version was executed by other artists. The original plan called for forty statues and many bas-reliefs.

1508 Buonarotti was entrusted by Pope Julius II with painting frescoes on the Sistine Chapel ceiling at the Vatican (1508-1512). Raphael worked on the decoration of the Vatican *Stanze* and was influenced by Michelangelo.

1512 The artist bought an estate near Florence.

1513 Michelangelo lived at the Macello dei Corvi (which no longer exists), near the Trajan Forum. Cardinal Giovanni de' Medici, the son of Lorenzo the Magnificent, was elected to the papacy with the name Leo X (1513-1521). He gave Michelangelo the title of "Palatine Count," although he preferred the clear and harmonious visions of Raphael to the complex nudes of Buonarotti. He also entrusted the artist with designing a façade for San Lorenzo, a project that was never realized.

1516 Michelangelo stayed in the Apennines to quarry marble at Carrara and Petrasanta.

1518 He bought a house in Florence in the Via Mozza (today San Zanobi) and adjoining land for the purpose of restoring the family fortunes.

1519 Pope Leo X decided to build a library next to San Lorenzo and a funerary chapel for the Medici (the New Sacristy). The contract for the façade is cancelled and Michelangelo describes himself as a "poor, ignoble and crazy man." But he accepted the two new commissions.

1520 Death of Raphael Sanzio on 6th April. Michelangelo's supporters in Rome see no more obstacles to his path in the Eternal City.

1521 Death of Pope Leo X; the new pope, Hadrian VI (1522-1523) has no new projects for Michelangelo.

1523 Cardinal Giulio de' Medici elected pope under the name Clement VII. His pontificate lasts until 1534.

1527 The sack of Rome; Pope Clement VII held prisoner in the Castel Sant' Angelo, but managed to escape. Michelangelo remained in Florence.

1529 Buonarotti named governor of the fortifications of Florence, proclaimed a Republic since 1527.
On 21 September, he fled Florence, taking all possessions with him fearing they would be requisitioned for the war. He returned in November.

1530 Florence again in the hands of the Medici. The pontifical governor, Baccio Valori, ordered Michelangelo's assassination because of his political stance. He goes into hiding with the help of Figiovanni, the prior of San Lorenzo. In November work resumed on the Medici chapel in San Lorenzo.

1532 Michelangelo met the young Roman nobleman Tommaso Cavalieri, a humanist and scholar. Their intense "platonic" relationship induced Michelangelo to establish himself in Rome. Their friendship lasted until his death.

1534 Death of Michelangelo's father at the age of 91. Death of Pope Clement VII. The artist makes Rome his permanent residence.

1535 The new pope, Paul III (1534-1549), commissioned Michelangelo to paint the *Last Judgment* for the Sistine Chapel. The pope appoints him "Supreme Architect, Sculptor and Painter of the Apostolic Palace." The artist is sixty years old and has health problems in spite of his well-ordered, spartan lifestyle.

1538 Meets Vittoria Colonna, marchioness of Pescara and widow of Francesco d'Avalos. Under her influence, Michelangelo adopted the doctrine of justification by faith alone that was close to certain Protestant ideas. He dedicated many religious poems to her and admired her with a melancholy fervour. This remarkable woman enhanced Michelangelo's faith, which grew over the years. His renewed religious beliefs are expressed in a fresco for the Pauline Chapel, *The Conversion of Paul* (1545).

1541 Inauguration of the *Last Judgment* in the Sistine Chapel; astonishment and scandal over the nude figures.

1542 Julius II's tomb is still unfinished. Michelangelo says he spent his youth "chained to this tomb." He suffers further from the legal action of the pope's heirs.

1543 In a letter he asks his nephew Lionardo not to call him Michelangelo Simoni or sculptor any more but simply Michelangelo Buonarotti, for, he says, "that is how I am known."

1546 The ailing Michelangelo is treated by Luigi del Riccio. In a letter he reproaches his nephew Lionardo for spending too much money, concluding: "You have all been living at my expense for the past forty years."
In April, he promised the French king François I a marble sculpture, one in bronze, and a painting; no trace of these projects remains. In November, Pope Paul III ordered him to continue the construction of the new basilica of St. Peter interrupted by the death of Sangallo the Younger. In December, Michelangelo sent 2000 *scudi* to his nephew Lionardo to buy a house in Florence. He finished the façade and interior courtyard of the Palazzo Farnese and drew plans for the square at the Capitol. He complained of gallstones that keep him bedridden.

1550 Under Pope Julius III, Michelangelo devoted himself to various new projects.

1555 The Inquisition spreads under Paul IV Carafa and Michelangelo is denounced as a heretical "Lutheran." The offensive parts of the nudes in the Sistine Chapel are "clothed."

1559 Unlike his predecessor, Pope Pius IV (1559-1565) surrounded himself with a splendid court and was a patron of the arts while consolidating the anti-Lutheran Counter-Reformation. Michelangelo is entrusted with major architectural commissions: the construction of the Pia Gate (1561), the transformation of the Baths of Diocletian, and the design of the church of Santa Maria degli Angeli.

1564 Weakened by fever, Michelangelo worked on the *Rondanini Pietà*. He died in Rome on 18th February, in the presence of his closest friends. According to his wishes, his body was taken secretly to Florence where he is buried in a tomb built by Vasari in Santa Croce (1572).

LOCATION OF MICHELANGELO'S MAJOR WORKS

BOSTON ◆ Isabella Stewart Gardner Museum
Pietà (drawing)

BRUGES ◆ Notre-Dame
The Bruges Madonna

FLORENCE ◆ San Lorenzo, the Laurentian Library:
the Vestibule and Stairs,
the Reading Room
◆ San Lorenzo, the Medici Chapel (New Sacristy)
Virgin and Child
Tombs of Lorenzo and Giuliano de' Medici
◆ Casa Buonarroti
The Battle of the Centaurs
Crucifix (wood)
The Madonna of the Stairs
Hercules and Cacus
Facade of San Lorenzo (drawing)
The Pia Gate (drawing)
◆ Cathedral
The Florentine Pietà
◆ Accademia
David
Saint Matthew
The Palestrina Pietà
The Awakening Slave
The Bearded Slave
The Young Slave
Slave, also called *Atlas*
◆ Uffizi Museum
The Doni Tondo
◆ Bargello
Bacchus
Brutus
David, also called *Apollo*
The Pitti Tondo
◆ Palazzo Vecchio
Victory

LONDON ◆ British Museum
Crucifix (drawing)
Head of a God (drawing)
The Resurrection (drawing)
A Double Tomb (sketch)
The Sistine Chapel Ceiling (sketch)
◆ National Gallery
The Madonna of Manchester
Entombment
◆ Royal Academy
The Taddei Tondo

MILAN ◆ Sforza Castle
The Rondanini Pietà

MUNICH ◆ Graphische Sammlung
St Peter,
after Masaccio's *Tribute Money* (drawing)

NEW YORK ◆ Metropolitan Museum of Art
The Libyan Sibyl (study)

OXFORD ◆ Ashmolean Museum
Putto (study)
The Rondanini Pietà (study)
Head of a God (drawing)

PARIS ◆ Louvre Museum
Dying Slave
Rebellious Slave

ROME ◆ The Farnese Palace
◆ The Capitol Square
◆ Santa Maria sopra Minerve
The Resurrected Christ
◆ S. Pietro in Vincoli, Tomb of Julius II
Moses
Rachel
Leah
◆ Vatican, Museo Petriano
The Dome, the interior
Piètà
Wooden model of the Dome of St. Peter's
◆ Vatican, Pauline Chapel
The Crucifixion of St. Peter
The Conversion of St. Paul
◆ Vatican, Sistine Chapel
The ceiling fresco cycle
The Last Judgment

SIENA ◆ Cathedral
Saint Peter

VIENNA ◆ Albertina
Three draped male figures
after a lost Masaccio (drawing)

WINDSOR ◆ Royal Library
The Punishment of Tytos (drawing)
The Fall of Phaeton (drawing)
Archers Shooting at Hermes (drawing)
The Resurrection (drawing)

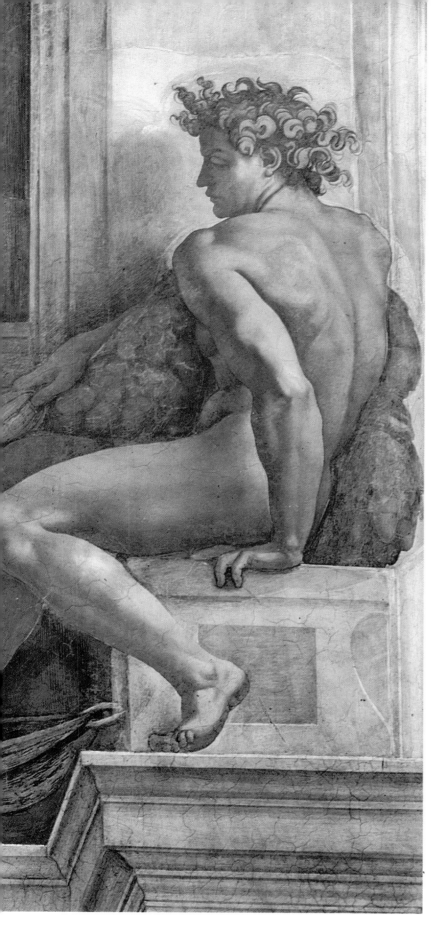

MICHELANGELO

Nude, or **Ignudo**

1509. Fresco located above the prophet Joel.
Sistine Chapel ceiling before restoration.

BIBLIOGRAPHY

U. Baldini, *L'opera completa di Michelangelo scultore*,
 Rizzoli, Milan 1973.

P. Barocchi, *I disegni della Casa Buonarroti
 e degli Uffizi*, Florence 1962.

W. Binni, *Michelangelo scrittore*, Einaudi, Turin 1975.

A. Chastel, *Art et humanisme à Florence au temps
 de Laurent le Magnifique*, Flammarion, Paris 1959.

R.J. Clements, *The Poetry of Michelangelo*,
 New York 1965.

A. Condivi, *The Life of Michelangelo*,
 trans. by Alice Sedgwick Wohl,
 ed. by Helmut Wohl, Phaidon, London 1976.

A. Condivi, *Le vite di Michelangelo Buonarroti*,
 Karl Frey, Berlin 1987.

C. Gilbert (trans.), *Complete Poems and Selected Letters
 of Michelangelo,* R.N. Linscott (ed.), New York 1963.

F. Hartt, *Michelangelo, The Complete Sculpture*,
 New York 1968.

G. Milanesi, *Les correspondants de Michel-Ange*,
 Paris 1890.

E. Panofsky, *Studies in Iconology*,
 Viking, New York 1962.

C. Pietrangeli, G. Collaluci, N. Gabrielli,
 La chapelle Sixtine: la voûte restaurée,
 Citadelles & Mazenod, Paris 1994.

P. Portoghesi, B. Zevi, *Michelangelo architetto*,
 Einaudi, Turin 1964.

E. Ramsden (ed.), *The Letters of Michelangelo*,
 2 vols. Stanford University Press 1963.

R. Salvini, E. Camesasca, C.L. Ragghianti,
 La Cappella Sistina in Vaticano, Milan 1965.

A. Stokes, *Michelangelo: A Study in the Nature of Art,*
 London 1955.

Ch. de Tolnay, *Michelangelo*, 6 vols.,
 Princeton University Press 1945.

Ch. de Tolnay, *The Sistine Ceiling*,
 Princeton University Press 1943.

Ch. de Tolnay, *The Medici Chapel*,
 Princeton University Press 1945.

Ch. de Tolnay, *Michel-Ange*,
 Flammarion, Paris 1970.

L. de Vecchi, *Michel-Ange*,
 Chêne, Paris 1986.

PHOTO CREDITS

Albertina Graphische Sammlung, Vienna: pp. 29, 52. Alinari-Giraudon, Paris: pp. 36 (top, left), 60, 63, 67, 69 (top and bottom), 73, 74-75, 76, 78-79, 80, 81, 83, 92-93, 98, 101, 112, 207, back cover. Artephot, Paris: pp. 36 (bottom), 39. Ashmolean Museum, Oxford: pp. 40, 184-185, 192. Raffaello Bencini, Florence: pp. 5, 12, 16, 17, 18, 20, 25, 27 (left and right), 33 (top), 35, 110, 111, 116, 117, 118, 119 (top and bottom), 124, 125 (top and bottom), 126, 129, 152, 168, 171, 172, 173 (left and right), 174, 175, 176, , 178, 179, 180, 181, 182. Bibliothèque Nationale de France, Paris: pp. 157 (bottom), 163. Bildarchiv Preussischer Kulturbesitz, Staatliche Museen zu Berlin, Berlin: pp. 43. Bridgeman-Giraudon, Paris: p. 61. British Museum, London: pp. 114, 195, 196, 202, 203. G. Dagli Orti, Paris: p 100, 134 (top), 166, cover. Edimédia, coll. Cercle d'Art, Paris: p. 94. Dr. Georges Gester, Rapho, Paris: p. 165. Giraudon, Paris: pp. 53, 133, 136 (bottom, right). Erich Lessing, Vienna: pp. 2, 24, 26, 72, 131, 132, 167. Lauros-Giraudon, Paris: p. 95. Metropolitan Museum of Art, purchase, 1924, Joseph Pulitzer Bequest (24.197.2), New York: p. 104. Museum of Fine Arts, Gift of Quincy A. Shaw, courtesy of Quincy A. Shaw Jr., and Mrs. Marian Shaw Haughton, Boston: p. 13. National Gallery, London: p. 121 (top). Nippon Television Network Corporation, Tokyo: pp. 56-57, 58-59. NTV/Citadelles et Mazenod, Paris: p. 130. RMN, Paris: pp. 8, 15, 23, 28 (left and right), 38, 45, 77, 85, 157 (top), 169 (left and right), 170, 199. Guido Alberto Rossi/Altitude, Paris: pp. 158, 161, 164. Royal Collection, Her Majesty the Queen, Windsor: pp. 10, 188-189, 190, 200. Royal Academy of Arts, London: p. 33 (bottom). Scala, Florence: pp. 6, 19, 20, 21, 22, 30, 31, 32, 36 (above, right), 41, 42, 47, 48 (top and bottom), 51 (top), 55, 65, 70-71, 84, 86, 87, 88, 89, 91, 96, 97, 99, 102, 103, 105, 106, 107, 108-10, 113,115, 121 (bottom), 122, 123, 127, 128, 134 (bottom), 136 (top and bottom, left), 137, 138-139, 140, 141, 143, 144, 145, 146, 148, 149, 150, 151, 153, 154, 155, 160, 177, 183, 186, 187. Staatliche Graphische Sammlung, Munich: p. 14. Isabella Stewart Gardner Museum, Boston: p. 185 (bottom). Pierre Terrail archives, Paris: p. 51 (bottom). Mike Yamashika, 1988, Rapho, Paris: p. 162.